MATISSE

Nicholas Watkins

NEW YORK
OXFORD UNIVERSITY PRESS
1985

Phaidon Press Limited, Littlegate House, St Ebbe's Street, Oxford

First published in Great Britain by Phaidon Press Limited, 1984
© 1984 by Phaidon Press Limited

First published in the United States by Oxford University Press, Inc., New York, 1985

LC 84-16512
ISBN 0-19-520464-6

Printing (last digit): 9 8 7 6 5 4 3 2 1

Printed in Great Britain

FRONTISPIECE: *The Clown* (1938–43) from *Jazz*. Stencil print after a paper cut-out maquette. *c.* 41 × 30.5 cm. Tériade, Paris, 1947.

MATISSE

Contents

For Nadia

Preface

Although Picasso has attained public pre-eminence as the modern artist of our century, it is Henri Matisse (1869–1954) who is rightfully regarded as the leading painter. During his very long career, Matisse also achieved a considerable reputation as draughtsman, sculptor, printmaker, and designer. In the Vence Chapel of 1948–51, he gave final proof of his ability to unite all these different media within architecture, and thus stake his claim for a place in the pantheon of art alongside the masters of the Renaissance. The magnitude of Matisse's very traditional ambition sets him apart from all his contemporaries and conflicts with his early reputation as a leader of Fauvism, the first avant-garde movement of the twentieth century, which was ostensibly dedicated to the overthrow of established conventions.

Matisse's art and life thus confront us with a series of paradoxes. He was a radical artist who accepted traditional subjects, means, and ambitions. He was brought up within a tradition of tonal realism, small-scale painting, and intimate domestic subject-matter, and he continued to believe that art should be based on reality; yet he went on to achieve a grand decorative art of imaginative colour. Despite living through times of war, civil strife, and intense suffering he produced an *œuvre* of unprecedented calm, even serenity. Lastly, the country which created the conditions for the emergence of his art did not at first appreciate it, and his reputation was largely the product of foreigners, like the American Stein family and the Russians Sergei Shchukin and Ivan Morozov, who made little distinction between painting and decoration.

These paradoxes can be partly accounted for by locating his art and life within the historical context of France during this period. However, the danger in this approach is that we tend to lose sight of the very qualities that distinguish his art. I have therefore chosen to analyse and describe key works in depth, so that they are not seen as prisoners of their genesis, mere products of a too narrowly defined socio-cultural context, but as paintings in their own right, that exist in our time, space, and imagination and are able to give us enormous pleasure.

In my research I have been helped by Matisse's daughter, the late Madame Marguerite Duthuit, by his son Pierre Matisse, by Madame Lydia Delectorskaya, by Madame Ginette Signac, and by Pierre Schneider, who all generously shared their knowledge and answered my various questions. I owe a great debt to earlier studies of Matisse's art, in particular by Georges Duthuit, Alfred Barr Jun., Gaston Diehl, and Raymond Escholier, and to more recent publications by Aragon, Pierre Schneider, Dominique Fourcade, Jack D. Flam, Albert E. Elsen, Sir Lawrence Gowing, Victor Carlson, John Neff, Jack Cowart, John Elderfield, and Isabelle

Monod-Fontaine. The actual paintings provided the primary source material for this book, and numerous museums, galleries, private collectors, dealers, and auction houses kindly allowed me to study works in their possession, even when not readily available. The staffs of many institutions in Britain, France, America, Denmark, and Russia were also most helpful in giving me access to conservation reports and documentary material in their archives. Several libraries were of great assistance—often at short notice. Among those individuals and organizations who helped me in my work I would especially like to thank Françoise Cachin, Catherine Khramer, Robert Ratcliffe, Stephen Rees Jones, Vladimir Daskaloff, Alister Warman, Michael Brick, Robert Short, Stavros S. Niarchos, Mr and Mrs Ralph F. Colin, Dr Ruth Bakwin, Joseph Pulitzer Jun., Mrs John Wintersteen, Nathan Cummings, William S. Paley, Mr and Mrs William A. M. Burden, Mark S. Weil, Stephen Somerville, the late Victor Waddington, Hester van Royen at Waddington Galleries, Lefevre Gallery, Marlborough Fine Art, Redfern Gallery, Sotheby's, Christie's, Tate Gallery, Royal Academy, Courtauld Institute of Art, Victoria and Albert Museum, Madame Hélène Adhemar at the Galeries du Jeu de Paume et de l'Orangerie, Isabelle Monod-Fontaine and Antoinette Rezé-Huré at the Musée National d'Art Moderne (Centre Georges Pompidou), Musée du Petit Palais, Bibliothèque Nationale, Musée Matisse (Le Cateau), Colette Audibert at the Musée Matisse (Nice-Cimiez), Marie-Claude Beaud at the Musée de Grenoble, Musée de l'Annonciade (Saint-Tropez), John Elderfield at the Museum of Modern Art (New York), Lowry S. Sims at the Metropolitan Museum of Art, Acquavella Galleries, Museum of Fine Arts (Boston), Deborah Gribbon at the Isabella Stewart Gardner Museum, Douglas G. Schultz at the Albright-Knox Art Gallery (Buffalo), Edward B. Henning at the Cleveland Museum of Art, the Detroit Institute of Arts, Timothy Lennon, Inge Fielder, Courtney Donnell, and Harold Joachim at the Art Institute of Chicago, Dr Gregory Hedberg at the Minneapolis Institute of Arts, Joan Bernbaum and Jack Cowart at the St Louis Art Museum, Gerald D. Bolas at the Washington University Gallery of Art, Susan Cumins and Victor Carlson at the Baltimore Museum of Art, Anne d'Harnoncourt at the Philadelphia Museum of Art, The Barnes Foundation (Merion, Pa.), National Gallery of Art (Washington), James McLaughlin and John Gernand at the Phillips Collection, The Dumbarton Oaks Collection, Henrik Bjerre at the Statens Museum for Kunst (Copenhagen), Pushkin Museum of Fine Arts (Moscow), and Hermitage Museum (Leningrad).

I am deeply grateful to all those who made this book possible. I would like to thank Simon Haviland of Phaidon Press for commissioning the book and for maintaining faith in its transformation from a specialist study, primarily for painters, to a work of more general interest; Bernard Dod, Margaret Amosu, David Morgenstern, and the staff of Phaidon Press for ensuring that the production went smoothly and without any traumas, on my part; Geoffrey Saunders for reading the first draft of the manuscript and John Rignall for reading the second; Mrs Hazel Dyke for typing the final manuscript with speed and accuracy; and above all John Golding and Anthea Callen without whose support and encouragement this book would probably not have been written. My task was greatly facilitated by my head of department David Phillips, by travel grants from our Central Research Fund, and by the assistance of our clerical and library staffs. My second research trip to the United States resulted from a British Academy Award. Finally, I thank my family for their tolerance and understanding as they became resigned to the fact that my long-time enthusiasm for Matisse's art had become a way of life.

<div align="right">

Nicholas Watkins
Faculty of Art and Design
Coventry (Lanchester) Polytechnic

</div>

1 The Early Years, 1869-1896

1. *Self-Portrait.* 1939. Charcoal on paper,
37 × 26.5 cm. Private collection.
Henry Matisse confronts us, at the age of
nearly seventy, like an oriental master,
totally in control of himself and of every line.

Henri Matisse presented the disconcerting picture of a radical, avant-garde artist who looked poised, detached, and stylish, as in his self-portrait (Plate 1) executed in 1939, shortly before his seventieth birthday. It is drawn with an assured economy. The lines possess their own life as they flow around the face, describing the salient features in abbreviated signs seemingly incised into the pristine whiteness of the page. Every element of the drawing assumes a significance over and above its narrowly descriptive function. Even the whiteness of the page acts as a powerful symbol; the white represents nothing other than the purity of light itself, from which all the colours of the spectrum originate. Any hint of labour is suppressed. Like a juggler or acrobat, Matisse believed that every gesture had to be thoroughly rehearsed in order to present an image of relaxed spontaneity in the final act. His obsessions with line, light, style, and personality are four of the outstanding hallmarks of his art.

We must examine Matisse's personality in more detail because he believed, like his hero Cézanne, in the Romantic idea that the expression of his personality was, in the last analysis, the real subject-matter of his art. However, even though we may sense the personalities of these two great artists behind their paintings, seldom have two artists' personalities been more difficult to define outside a consideration of their actual work. Perhaps it would be true to say that seeing themselves as outsiders in society, they were searching for an identity through art.

Art for Matisse was a highly serious business and he reflected the dignity of his profession in his appearance. He had no apparent doubts about the validity of art, only constant anxieties as to his ability to achieve it. Described by contemporaries as either Bohemian or middle class, likened to a German professor or even a French businessman from the north, he carried the professional ethos of the successful nineteenth-century academic artist into the twentieth century. His fellow art student, André Derain, saw Matisse as just the right respectable type to persuade his doubting parents that a career in art was a viable proposition. Later on in his own career, when he could afford it, Matisse had his suits made by one of the most expensive tailors in Paris. The apparent disparity between the normality of his appearance and life-style and the seemingly revolutionary audacity of his art caused some observers concern. For example, the American journalist Clara T. MacChesney, spurred on by the violent public reaction to Matisse's paintings at the famous New York Armory Show of modern art in 1913, published an interview with Matisse held at his home at Issy-les-Moulineaux, a suburb of Paris, in which she expressed surprise at finding not an unkempt, Bohemian eccentric but an ordinary, healthy individual living in a villa, surrounded by a walled garden tended by a

gardener. And Matisse, quite understandably annoyed by this observation, replied, 'Oh, do tell the American people that I am a normal man; that I am a devoted husband and father, that I have three fine children, that I go to the theatre, ride horseback, have a comfortable home, a fine garden that I love, flowers, etc., just like any man.'

It is easy to over-emphasize Matisse's bourgeois appearance and life-style. Quite unlike the popular French stereotype of a bourgeois, he was prepared to sacrifice material comfort in order to simplify his life and concentrate on his art. For a large part of his career he lived in rented accommodation and hotel rooms, with a few prized but not necessarily valuable possessions, when he could well have bought all the trappings that go with a wealthy man's way of life.

Matisse, in the eyes of his contemporaries, appeared fully conscious of his own worth. Egotistical, like most artists, and pedantic, he could—when he so chose—be humorous and very entertaining. He was a good mimic, and his imitations of some of the pompous people he had come across were well known among his friends. In his highly articulate and persuasive 'Notes of a Painter', published in 1908, he left one of the most coherent and influential statements on artistic theory written this century. A recurring view of his public image is given by the American Leo Stein, one of his first collectors and students: 'Matisse—bearded, but with propriety, spectacled neatly, intelligent; freely spoken, but a little shy—in an immaculate room, a place for everything and everything in its place both within his head and without.' His spectacles, according to Picasso's mistress Fernande Olivier, acted as a barrier behind which he hid, giving very little away. As he grew older, his natural shyness led him to withdraw into himself and develop his own internal spiritual life to an unusually high degree. He came to look more and more like a benign oriental despot; he reminded Martin Fabiani, his dealer in the early 1940s, of a Persian lord.

It is hardly surprising that people, with the exception of his faithful female attendants and a few close friends, found Matisse difficult to get on with. Alexander Liberman, who photographed most of the leading artists in France in the 1940s, regarded Matisse as the most awesome of them all: 'physically and emotionally he kept his distance'. He generally preferred women to men, both in his life and in his art, probably because they posed no threat and looked after him, creating the atmosphere of domestic calm and comfort he required for his work. His men friends tended to be divided between those whose talent, intelligence, and integrity he respected, and those whom he had known for most of his adult life and could call upon whenever he needed them. The picture that emerges of Matisse is of a man who really believed that his art and personality meant more to him than anything else. If he strikes us as a cold person, it should be borne in mind from the outset that he compensated for this in his art and created an *œuvre* of almost unprecedented warmth and appeal.

The serenity of Matisse's art should not be taken as a direct reflection of his normal state of mind. Behind the barriers that he set up, he was extremely tense. Glimpses of this private side to his personality come out in some of his self-portraits and in the observations of those who knew him. 'Completely absorbed in himself and his art, Matisse could think and talk of nothing else,' wrote the daughter of his painter friend Simon Bussy in an unpublished memoir. 'Art was a hard taskmaster and his apparently effortless creations cost him blood and sweat and agony.' There are stories of Matisse, finding the tension unbearable, dragging his wife out on over-long walks at night. Paradoxically, he believed that it was only through his work that he could ever feel truly free from anxiety. Art took on a kind of religious significance in his life; it became a way of ordering and making sense of experience,

of resolving contradictions and tensions, and of bestowing value. In the decade before his death in 1954 he seemed completely at one with the work which he had created and which, in a sense, had created him.

Matisse allows us to follow the process by which he struggles to achieve a balance of forces in a painting, a point of harmony. His tensions and changes of mind become part of the necessary dynamic of a work, and the final impression is one of pure joy. 'What I dream of', he wrote in his 'Notes of a Painter', 'is an art of balance, of purity and serenity, devoid of troubling or depressing subject-matter, an art which could be for every mental worker, for the businessman as well as the man of letters, for example, a soothing, calming influence on the mind.' But it is the complexity of its origins, and the seriousness of its purpose, that rescues his work from being merely attractive decoration and makes it great art.

Because the contradictions in Matisse's attitudes and ambitions could never be resolved, only balanced against each other, they acted as a constant irritant and a source of inspiration. It was one of his great strengths that he saw his own situation with such clarity and intelligence that each problem became a separate issue in the genesis of a work. On the one hand, he wanted to think with the accumulated weight of tradition, and, on the other, to force the pace and search for new methods of expression in his efforts to make a novel contribution to the art of painting. He wanted to maintain the monumentality and integrity of the human figure and, at the same time, to reconcile the figure with a flat, decorative surface. He wanted somehow to find a balance between what he saw as the romantic and rationalist sides of his own temperament.

His obsession with his own personality was accompanied by a hypersensitivity towards his pictorial means. Few Western artists have studied their instinctive responses to the same extent as Matisse, and attached so much importance to the constructional and expressive potential of the traditional means at a painter's disposal: canvas surface, quantity and quality of paint, brush-mark, colour, and line. For him each of these possessed its own particular character which had to be respected as it was brought into harmony with the others. A change in even a single patch of colour would often result in the whole painting being altered. 'I cannot copy nature in a servile way,' he explained. 'I am forced to interpret nature and submit it to the spirit of the picture. From the relationship I have found in all the tones there must be a living harmony of colours, a harmony analogous to that of a musical composition.'

Matisse's ideas, attitudes, and art become clearer when set in the contexts of his home background, the society in which he grew up, and his artistic education.

Henri Émile Benoît Matisse was born on 31 December 1869 at Le Cateau (formerly Cateau-Cambrésis) in Picardy, in the home of his maternal grandparents, the Gérards. His mother, Anna Héloïse Gérard, came from one of the oldest families in the town; the Gérards had been glovemakers and tanners there for centuries. Matisse grew up at Bohain-en-Vermandois, a village nearby, where his father Émile Hippolyte Henri Matisse, who also originated from Le Cateau, had set up as a druggist and grain merchant, after an earlier career in Paris as an assistant in a draper's shop, La Cour Batave, where he had met his wife, then working as a milliner. Both parents were therefore from solid commercial stock. Although Matisse was to choose a very different profession, he inherited his father's commercial aptitude, as many a dealer found to his cost. His brother, Émile Auguste, whom he hardly ever mentions, was born in 1872.

Le Cateau is situated near Cambrai on the main road running from Arras to Sedan. Formerly a wool manufacturing town, it took its name from the château that

belonged to the bishops of Cambrai. This area of French Flanders, lying between Paris and Brussels, with its open rolling country and distant low horizons punctuated by church spires, has been one of the traditional battlefields of Europe. Wellington made Le Cateau his headquarters on entering France in 1815, and, nearly a hundred years later, four British regiments made their last stand there in the battle of 26 August 1914. Many of the landmarks and buildings that Matisse would have known as a child (during the aftermath of defeat in the Franco-Prussian War of 1871), and sometimes later painted, were damaged or destroyed during the First World War: the *hôtel de ville* at Le Cateau, which now houses the little Matisse museum, had to be substantially restored; the aqueduct beyond Honnechy was blown up during the German retreat; his relation's eighteenth-century château, Les Boheries, on the banks of the Oise, was similarly razed.

Nothing of the grim history of the region comes out in Matisse's work. His stated intention to avoid troubling or depressing subject-matter and his quest for spiritual freedom and peace through art are symptoms of his reaction against the realities of the historical situation and the restrictions of his provincial upbringing. Even the subdued tonality and deep spatial recession of his native landscape appear diametrically opposed to his love of bright colour and his lifelong emphasis of the flat, two-dimensional surface of a painting.

Matisse's reaction was quite typical of French society in general during the so-called *belle époque.* The period from 1871 to 1914, during which he formed his attitudes and ideas and developed his mature art, witnessed peace, prosperity, and exceptional technological, economic, and social change. The Third Republic, quite unexpectedly, brought the political stability that allowed the average Frenchman in the right position to settle down and make money. A mood of often frenetic gaiety was taken as a natural expression of the times. It was made to appear as though celebrations to commemorate the end of one century and the birth of the next had become a way of life. But the images of pleasure papered over areas of social injustice, gross inequality, instability, and unrest, and ideas as to how changes should be effected in society were as divided as at any time in history. A step back was as common as a step forward; the urge to forge a new vocabulary in all fields was accompanied by a conscious reassertion of traditional values and practices.

However, such a view of French society in the *belle époque* applied only to Paris and not to the provinces. New ideas would hardly have been regarded as issues in Bohain-en-Vermandois, and the gaiety of Paris must have seemed a far cry from the routine of provincial life. A sensitive, intelligent adolescent could have noticed little change in the pattern of local politics, petty rivalries, and intrigues.

Matisse was a late starter. His time at school was unremarkable and, unlike his younger rival Picasso, he demonstrated no evidence of a precocious artistic talent. He first attended the local school at Bohain-en-Vermandois, and then, at the age of ten, moved on to the *lycée* at Saint-Quentin, the nearest main town. His father had done well enough in business to send him to study law in Paris in the autumn of 1887; he passed his diploma in August 1888. Apparently he never visited the Louvre during his year in Paris, and on returning home he became a lawyer's clerk in Saint-Quentin. He progressed from doodling at the office to attending drawing-classes from 6.30 to 7.30 in the morning, before going to work. These were held at a school mainly for tapestry and textile designers in Saint-Quentin, the École Quentin-Latour. This may be of some significance given his passion for the decorative arts. But the real turning-point in his career came when he took up painting in 1890, at the age of twenty, during a prolonged period of convalescence after appendicitis. His mother, who was herself artistic and painted china, gave him a paintbox and he began, he recalled, by copying prints of Swiss landscapes sold in

2. *Still-Life with Books*. June 1890. Oil on panel, 21.6 × 25.4 cm. Nice-Cimiez, Musée Matisse.
One of Matisse's first two paintings, which he kept in his studio and exhibited thirty years later at the Bernheim-Jeune gallery.

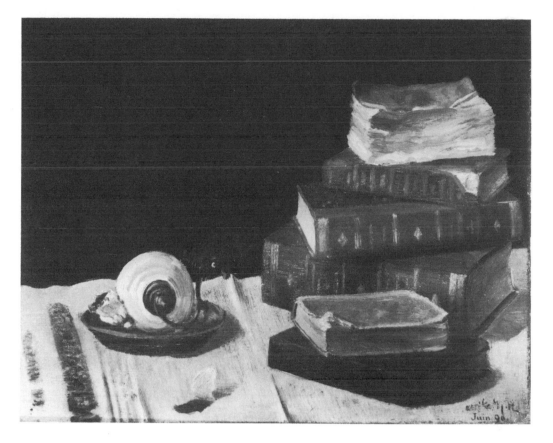

albums. He also studied F. A. Goupil's *Manuel général de la peinture à l'huile*, first published in 1877, a popular textbook on technique and the principles of art, intended by its author to uphold professional standards at a time of neglect.

The convalescence, which followed what was in all probability a minor nervous breakdown in addition to his illness, brought to a head Matisse's bitter frustration, almost claustrophobia, at feeling himself trapped in a narrow, unfulfilling legal career, and led him to decide to become a painter. The activity itself was more important to him than what he painted. Taking up painting, he felt, was tantamount to throwing open a door to freedom. That moment evidently stuck in his mind, as he recalled it with some clarity in his eighties: 'Then I was free, solitary, quiet, whereas I had always been rather anxious and bored in the various things I was forced to do. It was with the constant knowledge of my decision, although I knew I had found my true path, where I felt at home and not up against a stone wall as in my previous way of life, that I took fright, realizing that I could not turn back.' He set about his new career guided by the work ethic drummed into him by his parents, summed up by their words, 'Don't waste time!'

The possibility of attaining personal freedom through art has been one of the most enduring of Romantic beliefs. Matisse's exact contemporary and friend, Pierre Bonnard, spoke about his decision to become an artist in very similar terms: 'I think that what attracted me then was less art itself than the artistic life, with all that I thought it meant in terms of free expression of imagination and freedom to live as one pleased ... at any cost, however, I wanted to escape from a monotonous existence!'

Matisse's first paintings, apart from copies, were still-lifes. The little panel *Still-Life with Books* (Plate 2) is self-consciously signed in reverse ESSITAM and dated June 1890. It has the intensity of the awkward exercise of a novice, focusing on a carefully arranged pile of books in the isolation of his room. The books are established in mid-tones, between the light table-cloth in the foreground and the evenly painted dark background.

The subject-matter, colour scheme, and technique of these first still-lifes probably owe more to Matisse's reading of Goupil than to anything he might have seen in the neighbouring museums of Arras, Cambrai and Lille. Goupil advocated starting painting with a still-life set up with simple forms that could be lit in different ways, using a restricted palette reminiscent of the *ébauche* or laying-in phase of a painting. The main objectives of the *ébauche* were to establish the principal light and dark areas and to provide a stable base of earth colours on which to build. Goupil called on the authority of Apelles, the greatest of the Greek painters, in support of his advice to begin by using only four colours, white, yellow ochre, vermilion red, and black.

Matisse obtained his father's permission to give up the law and study painting in 1891 or early 1892, and he left for Paris. A local painter, Philbert-Léon Couturier, recommended him to study with Adolphe-William Bouguereau (1825–1905), who was the very epitome of the successful Salon artist of his day: winner of the Grand Prix de Rome in 1850, he was made first *chevalier*, then *officier*, and finally *commandeur* of the Légion d'honneur. Whatever Matisse's father's private worries about the desirability of his son, whom he probably considered to have little talent, opting for an insecure career in art, he loyally supported him with an allowance until 1903, when he became exasperated by Matisse's unwillingness to court popular success as an academic painter. Matisse was by that time thirty-three, with a wife and three children to support. But even then his father continued to help out, having the whole family to stay for long periods in the winters of 1902–3 and 1903–4.

Paris was the cultural centre of Europe—indeed, of much of the world—certainly up to 1914. No other city could offer such depth of background to the modern movement as represented by Impressionism, Post-Impressionism, and Symbolism. The cultural hegemony of Paris was resisted by Vienna, Munich, and Moscow, but never seriously challenged. Paris of the 1890s, moving in the complex, ever-changing patterns of fashions and ideas, provided the base from which the artistic achievements of the first fourteen years of the twentieth century sprang, and an exceptional company of young talent, both native and foreign, was attracted to the capital, ranging from Matisse, Braque, and Léger to Brancusi, Gris, and Picasso.

There is no indication at this time that Matisse would ever become a leading figure in the modern movement. He went through a traditional art school training, copied paintings in the Louvre, and continued to paint modest still-lifes in a conservative style of tonal realism. (The quiet tonal painting of Matisse's juvenilia would have seemed much more realistic to his contemporaries than it does to present generations, unaccustomed as we are to the artificial illumination of that time: Paris was lit by gas lamps, and houses, particularly in the provinces, by oil lamps and candles, which gave a gradual transition from intense highlights to deep shadows.) Yet it was during this period that he began patiently to lay in the resources and absorb the experiences on which he was to draw throughout his career.

As a taciturn, young provincial in Paris, earnestly trying to make up for lost time in his new career, Matisse could not afford to get too deeply involved in the more outrageous manifestations of the *belle époque.* He was the archetypal sober observer, who missed nothing; he would make *croquis* (quick sketches from life) at music-halls, while others were relaxing. He did not forget these formative experiences. Specific personalities and acts from the circuses and music-halls, even from his first stay in Paris as a law student in 1887–8, surfaced half a century later in the subject-

matter of *Jazz* (see Plates 189, 190, 206, 207), his first major cut-out project of the early 1940s. These performers included Monsieur Loyal, ringmaster of the Cirque de l'Impératrice and the Cirque Napoléon, who died in 1889; the Codomas, the celebrated trapeze artists; a cowboy act, possibly from the Folies Bergères; as well as sword-swallowing, knife-throwing, and diving into a tank.

Parisians who lived through the *belle époque* looked back on it with nostalgia, and so in later life did Matisse, despite all his struggles and personal difficulties. It was during this period that his daughter, Marguerite, was born. The circumstances of her birth in 1894, like so much else in Matisse's private life, are still shrouded in mystery. Her mother appears as a shadowy servant figure in several of his paintings, including *The Dinner Table* of 1897 (see Plate 10), his first major painting.

By the 1890s Paris had assumed its present shape (that is prior to the recent high-rise buildings infringing the skyline, and the motorway destroying the peace along the banks of the Seine). Baron Haussmann's boulevards had opened up the city for both easy access and crowd control, after the civil disturbances and the Commune massacres of 1871, for which the Sacré-Cœur on the crest of Montmartre was built to atone; while the Eiffel Tower, constructed for the Great Exhibition of 1889, had become a symbol of modernity and progress.

Matisse did not paint the new sights of Paris. It is one of the ironies of art that a man does not necessarily have to be overtly interested in the human condition to become one of the greatest figurative artists of all time. Paris, as it appears in Matisse's paintings, is virtually without people: figures are occasionally fleetingly registered but never fully characterized. His *Path in the Bois de Boulogne* (see Plate 31) is a landscape rather than a park where the wealthy paraded and pleasure could be had behind trees. In fact his views of Paris belong to a landscape tradition.

Developments in the light-filled, more brightly coloured painting of the nineteenth century derived from painting landscapes in the open air. Matisse's painting trips to the island of Belle-Île, off the coast of Brittany, in the summers of 1895, 1896, and 1897, where Claude Monet (1840–1926), that master of light, had painted in 1886, are evidence that he regarded landscape painting as the source of his growing preoccupation with light and colour. The studio in Paris (really a small apartment) at 19 Quai Saint-Michel, to which he moved in 1895, overlooked two of the most picturesque views in any city—the Seine and Notre-Dame on the right (see Plates 27, 28), and the Pont Saint-Michel and the Louvre on the left—and he treated them repeatedly as landscape motifs, without any of the hustle or bustle of big city life.

On arrival in Paris, Matisse entered Bouguereau's class at the Académie Julian, and in October 1892 enrolled in evening classes at the École des Arts Décoratifs. The Académie Julian was an independent art school run by artists of official standing who coached students for the *concours des places*, the entrance examination to the École des Beaux-Arts, and provided them with the necessary formal recommendation. It was Matisse's overriding objective in his first year in Paris to pass this exam. He failed in the *concours* of 1892 and then worked independently in the 'Cours Yvon', the large glass-enclosed court of the École des Beaux-Arts, where students drew from casts of Greek and Roman sculpture, hoping to attract the attention of a professor and be invited to work informally in his studio. Eventually Matisse was noticed by, and joined the studio of, Gustave Moreau (1826–98), who had been appointed professor, *chef d'atelier*, in January 1892. Matisse was officially accepted by the École des Beaux-Arts after the *concours* of February 1895, having scored, out of 20 in each section, 17 in life drawing, 3 in perspective, 4 in modelling, 0 in architecture, and 13 in history, which gave him a total of 37 out of

100, and put him in 42nd place out of the 86 accepted. He remained in Moreau's studio until his marriage and a brief trip to London in January 1898.

Matisse made many of his closest friends at art school: Georges Rouault, Jules Flandrin, Charles Camoin, Simon Bussy, Jean Puy, Henri Manguin, and, above all, Albert Marquet (1875–1947). To earn money, Matisse and Marquet painted metres of palm leaves for the decoration of the Grand Palais, erected for the Universal Exhibition of 1900. They remained friends throughout their careers, working together on a number of occasions and exchanging paintings. Marquet's modesty and sincerity made him an easy companion. In his painting he never departed from naturalistic appearances to the same extent as Matisse—in fact Matisse regarded Marquet as his peer when it came to faithfully recording the appearance of an outdoor motif.

Never an outstandingly gifted natural draughtsman, Matisse possessed what counted for more than facility in the long run—tenacity and vision. Seldom has an artist turned his initial difficulties and deficiencies to such advantage. He produced bad drawings on occasions throughout his career; but he inevitably fought back and left us with some of the greatest drawings in the whole history of art.

Much as Matisse later reacted against his academic training, it continued to inform his ideas and art. Drawing was regarded as the basis of art, and he shared that assumption. He would often proceed from a detailed shaded drawing to a synthesis of the form, executed in a few essential lines. For him drawing was not only an exploratory activity, a way of coming to grips with the subject, it was also the means by which he organized all the different elements into a work of art. Drawing came to play an increasingly important role in his work, until it achieved, in his eyes, equal status with painting as an art-form in its own right (see Plates 139, 165, 193, 215, 220). A few years before his death he wrote, 'I believe study by means of drawing to be essential. If drawing belongs to the realm of the Spirit and colour to that of the Senses, you must draw first to cultivate the Spirit and to be able to lead colour through the paths of the Spirit.'

Academic drawing instruction centred on the gradual mastery of the human figure, from copying engravings and drawing plaster casts, to drawing and painting the live model. In learning how to draw, a student entered an idealized world, peopled with plaster casts of famous antique statues, the silent guardians of classical culture, which still set the standards of perfection.

Matisse's study of 1892 after Lysippus's *Hermes adjusting his Sandal* (Plate 3) is a good example of one of his few surviving student drawings after a cast. Placid areas of plaster are given a nervous, muscular energy, firmly contained by the contours, which are seemingly 'cut' into the page, like a relief from a block of marble.

Another type of drawing after the cast, the *dessin ombré* (the shaded drawing), related more to Matisse's paintings and had important consequences for his use of colour. It demonstrated that in the control of tonal values lay the means of conveying both emotion and structure in a work. Any painting or drawing has its own scale of values, lying between the lightest and darkest tones. The luminosity of a cast, under controlled lighting conditions, made it a perfect vehicle for the study of tonal values. The student was taught to see the cast in a scale, ranging from the highlights to the darkest shadows; the more *demi-teintes* or tonal-value steps in the transition between the two poles, the softer and more moody the final effect. The human eye moves from dark to light; by manipulating this perception an artist can build up a pictorial structure through the relationship between the light and dark areas in a work. The key to Matisse's use of colour lies in his sensitive control of tonal-value relationships. He could make even a dull colour appear bright through its precise tonal placement.

3. *Hermes adjusting his Sandal* (after a statue by Lysippus). *c.* 1892. Graphite on paper, 61.9 × 47 cm. Nice-Cimiez, Musée Matisse. Matisse began at art school by drawing casts of famous antique statues, a practice he continued throughout his career. A cast of the Apollo Piombino, placed in a niche, later presided over his own school in the former Couvent du Sacré-Cœur.

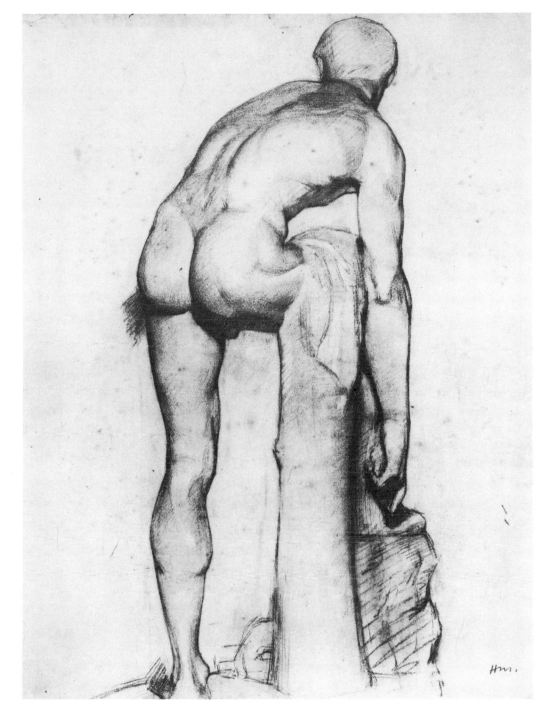

The student soon moved on from drawing the cast to drawing and painting the posed nude model, a study called the *académie*. The transition was eased by the model adopting a classical pose, and the student tended to depict the model in terms of the classical canons of figural beauty, which he had been conditioned to accept through drawing the casts. During the winter of 1899–1900 the human figure began to assume a central position in Matisse's subject-matter. He drew and painted a whole series of powerful, experimental *académies* (see Plates 24, 25). By 1908 he could write in his 'Notes of a Painter', 'What interests me most is neither still-life nor landscape, but the human figure. It is that which best permits me to express my almost religious awe towards life.'

Looking back over his long career, Matisse identified his spell with Bouguereau as providing the established dogma against which he continued to react. After all, he had become an artist as a passport to personal freedom, so it came as a shock to

find that art for Bouguereau involved repetitive labour, the ability to transcribe faithfully surface appearances, and a willingness to make facsimiles of his own work, if it proved popular. Disillusioned, Matisse had retreated to Bohain-en-Vermandois in 1892, and it was apparently only a visit to the museum at Lille to see the Goyas that restored his faith in art.

It is one of the paradoxes of the modern artist's position that the recognition of art as a highly demanding, learned profession, requiring the patient acquisition of skills and a profound understanding of the appropriate conventions and techniques, naturally conflicts with the Romantic notion of the artist as a genius, born with the burning desire to express himself regardless of all constraints. Taken to extremes, this could lead, on the one hand, to unimaginative work, executed without thought or feeling, and, on the other, to a point—and this has happened—where an artist could exhibit himself as a work of art. Matisse had the intelligence to see through this crude polarity. He realized that the work of art possesses its own intrinsic ability to move the spirit and its own conventions by which the personality of the artist is expressed, and that, to be of any consequence, art has to measure up to the greatest works of the past.

Matisse cast Bouguereau as the mindless copyist to highlight the qualities he strove for in his own work. Both believed that art should be based on reality, but Matisse wanted to evoke a subject through the interaction of each element of pictorial construction, rather than to represent it literally. His reaction to Bouguereau is quite understandable, although a little unfair. He himself made his own students start off by drawing the cast when, in order to make some money, he later opened a private academy, which ran from January 1908 to the spring of 1911. Quite simply, he liked neither Bouguereau nor his art, whereas Gustave Moreau enjoyed his respect and affection. Instead of delivering negative criticisms, Moreau gave him sympathetic encouragement, stimulated his imagination, and taught him how to look at and use the art of the past. When Matisse's *The Dinner Table* of 1897 was attacked, Moreau, despite his personal reservations, came out in its defence.

Moreau's teaching was novel, not only because he discounted the necessity of producing Prix de Rome winners; he also encouraged students to paint from the start, in order to develop their gifts as colourists. By 1896 the influential critic Roger Marx, who supported Moreau's students by persuading the State to buy their copies of old masters, and later wrote the preface to the catalogue of Matisse's first one-man show at Vollard's in 1904, identified Moreau's studio as a revolutionary haven which harboured 'all those who meant to develop their powers according to the dictates of their individuality'.

Moreau did not alter the academic curriculum but, in the Romantic tradition of Delacroix, shifted the emphasis from highly finished work to the generative stage represented by the *esquisse peinte*, the painted sketch. This was an imaginative exercise in which the student was encouraged to experiment with bold brush-strokes and unmixed colour to suggest the compositional effect of the final work. The free facture and bright colour of Matisse's paintings of 1905 (see Plates 40, 42, 43, 47) are a direct outcome of this shift, which had become quite general by the mid-1890s. Moreau continually emphasized the role of the imagination in the successful use of colour. 'Pay close attention to one thing,' he urged. 'If you want to think in terms of colour you must have imagination. If you have no imagination you will never be a good colourist . . . Colour ought to be thought, dreamed, imagined . . .'

Even more important than the *esquisse peinte*, in its effect on the later development of Matisse's art, was Moreau's emphasis on the copying of old-master paintings in

4. *The Dinner Table* (after Jan Davidz. de Heem). *c.* 1893. Oil on canvas, 73 × 100 cm. Nice-Cimiez, Musée Matisse.
Matisse took great pains with this copy, which provided him with inspiration for a number of his own major paintings (see Plates 10, 78). In contrast to the original, however, it is built up in strongly brush-marked opaque paint rather than transparent glazes.

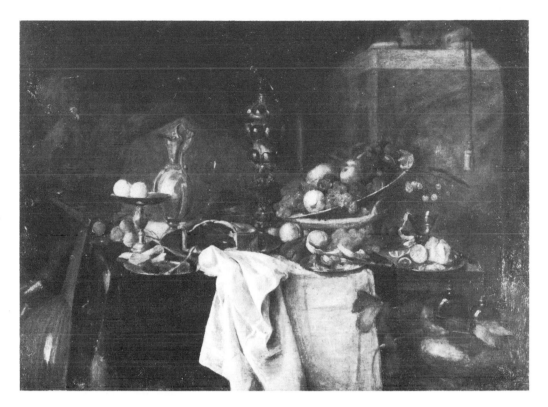

the Louvre. Matisse told Pierre Courthion that he owed his knowledge of the Louvre to Gustave Moreau: 'He took us there, and taught us to see and to question the old masters.' Moreau was a more inspiring teacher in the Louvre than in the studio. He saw the copy as a means of teaching technique as well as a method of cultivating good taste. One of Matisse's fellow students, Henri Evenepoel, reported Moreau as saying that the qualities which distinguished the masters were style, *matière* (which is perhaps best translated as a well-constructed paint surface), and the arabesque or all-over surface rhythm. The arabesque became a major feature in the evolution of Matisse's decorative art. Moreau's passion for Botticelli earned his students the nickname 'the Botticellis'. He admitted to his favourite student, Georges Rouault, however, that one could not always be inspired by the purest sources.

Matisse copied about nineteen paintings in the Louvre between 1893 and 1900, and they fall into three broad categories. The first, which includes copies of three paintings by Poussin, introduces in his work a monumental art dealing with the human figure. The second category, comprising copies of eighteenth-century French paintings by Watteau, Fragonard, and Boucher, can be characterized as intimate celebrations of pleasure, a theme that was to occupy him at different times throughout his career. The third, and by far the most important, category in his early development, still-lifes and domestic interiors, includes copies of the Dutch masters and Chardin.

Two of Matisse's paintings from this last category, after Jan Davidz. de Heem's *The Dinner Table* (Plate 4) and Chardin's *The Ray* (Plate 5), demonstrate both the importance of the copies for his art and the two types of copy that he distinguished: 'exact' copies, usually executed to sell to the State (buying student copies was the State's way of dispensing patronage and, in theory, of maintaining standards), and what he called 'emotional impressions' or 'personal translations'.

Such was Matisse's reaction against—and, at the same time, dependence on—the realistic traditions of the nineteenth century that his statements on the copies tend to concentrate on the emotion aroused by a painting and the personality behind it rather than on the subject represented. He firmly believed, however, that

art should be based on reality, and his whole career can, in a sense, be seen as an attempt to find ways of expressing this reality without describing it literally. His subject became not so much the figure or object as his responses to it, expressed through the relationships of his pictorial means.

Matisse maintained that he started by copying, probably in 1893, de Heem's *The Dinner Table*. Although his copy is much smaller than the original, it initiated as a major genre his subsequent treatment of the still-life in an interior. The State, in fact, never purchased his copy, and he did not have to buy it back, as was previously believed. It remained in his studio and played a seminal role in the evolution of such major paintings as *The Dinner Table* of 1897 (see Plate 10) and *The Dinner Table (Harmony in Red)* of 1908–9 (see Plate 78), and in late 1915 he used this familiar composition to demonstrate his assimilation of Cubism in *Variation on a Still-Life by de Heem* (see Plate 115).

Matisse learned from the de Heem that the expressive power of still-life painting depends on the organization of the formal elements in terms of their related shapes. He was to adopt de Heem's device, seen in his copy of *The Dinner Table*, of introducing the major formal theme at the sides of a painting—in this case the circular shapes of the mandolin on the left and the cooler on the right—and then

5. *The Ray* (after Chardin). 1894–1900. Oil on canvas, 115 × 142 cm. Le Cateau, Musée Matisse.
The frontality of *The Ray*, the careful juxtaposition of light and dark areas, and devices such as the white cloth and knife leading the eye into the picture are features which Matisse absorbed into his art.

6. *Interior with a Top Hat.* 1896. Oil on canvas, 80 × 94.9 cm. Paris, private collection.
The top hat, *chapeau haut de forme*, was an indispensable adjunct to the attire of a well-dressed Parisian gentleman in the *belle époque*.

playing variations on the theme across the surface, and in and out of depth, in association with the shapes of the smaller elements in the still-life.

The copy of Chardin's *The Ray* is in no way an 'exact' reproduction executed for sale. One critic, Pierre Courthion, went as far as to say that he regarded it as the first work in which he could recognize Matisse's own style. Whole areas of the surface are built up in broad areas of densely worked paint. There are numerous *pentimenti* (evident changes of mind), which show how he altered the position of objects over a period in order to investigate the significance of their relationships. According to Matisse's own testimony, he painted it 'schematically' and worked on it 'for six and a half years, and then left it unfinished'.

Matisse was influenced by Chardin more than by any other painter he copied. Borrowings from Chardin occur throughout his *œuvre*; they can clearly be seen in the mid-1890s behind his early attempts to achieve drama and tension in the presentation of a limited number of still-life objects (see Plate 8). Later, around 1911–12, he became interested more in Chardin's technique. He did not want to imitate it, but it suggested a way of retaining interest in the large, seemingly

monochromatic fields of colour that he was using at the time, through the delicate modulation of the relative temperatures of the neighbouring tones. It is at first difficult for the non-painter to understand that the same colour can appear as either warm or cool. Matisse even considered black as subject to the same variation in temperature as the other colours: 'Black with ultramarine blue has the warmth of tropical nights, tinted with Prussian blue, the freshness of glaciers.' The near-monochromatic red of the magnificent *Red Studio* of 1911 (see Plate 88) varies in feeling from hot orange in the 'light' to cool violet in the 'shadow'.

Far from seeing the close study of paintings by other artists as a recipe for plagiarism, Matisse believed, as he told the poet Apollinaire in his first major interview in 1907, that 'the personality of the artist develops and asserts itself through the struggles it has to go through when pitted against other personalities'. This ability to work under the accumulated weight of tradition and still produce something significantly new was one of his greatest strengths.

Matisse is known to have destroyed much of his early work. The few surviving original paintings of 1895–6 are closely related to the subject-matter and restricted tonal palette of his first paintings executed at Bohain-en-Vermandois and his copies of the Dutch masters and Chardin. This may tell us something important about Matisse. There is a remarkable persistence throughout his *œuvre* of a limited number of subjects and plastic problems. To a certain extent paintings grew out of his response to his own paintings. It was as though he was searching for a quality of more enduring interest to himself than perfection: the identification of his own personality, which he could only define and develop through art. Perhaps proof of this hypothesis comes in the interview with Apollinaire, when Matisse says, 'I found myself or my artistic personality by looking over my earliest works. They rarely deceive. There I found something that was always the same and which at first glance I thought to be monotonous repetition. It was the mark of my personality which appeared the same no matter what different states of mind I happened to have passed through.'

Matisse's total self-absorption, his narcissism, is symptomatic of a general breakdown, evident by the 1890s, in the relationship between the modern artist and his public, which has continued to the present day. Artists have become much more aware of their isolation and indefinite function in society, and increasingly self-conscious about the whole process of making art. One one level art is unloved and unwanted, and on another held to be enormously important, with artistic freedom becoming symbolic of a free society. But for an artist it is often difficult to reconcile the notion of artistic freedom with the constraints of a definite commission, just as it is equally difficult for a potential patron to be told what he can or cannot have. The patron of modern art, really the collector, ends up by buying not a subject in the traditional sense—a portrait of his wife or perhaps a view of his house—but a piece of a famous artist's personality, a signed work by a Matisse, a Picasso, or a Braque. The artist becomes creator, critic, and consumer of his own work, and it is left to a new priesthood of professional interpreters to explain his art to an uncomprehending public.

In this context the studio interior took on new significances as subject-matter. It provided the artist with a means of asserting and analysing his personality and status, as in a self-portrait; of studying his creative process, for the subject represented is at one level the act of making a painting; and of reassessing his past work and other artists' works placed in the room—an acknowledgement that all art grows from art.

Interior with a Top Hat of 1896 (Plate 6) introduces this very important subject in

7. *The Reader.* 1895. Oil on panel, 61.5 × 48 cm. Paris, Musée National d'Art Moderne, Centre Georges Pompidou. Matisse's models are no *femmes fatales* of the *belle époque*, but servant figures who work to produce comfort and peace in a picture, as they presumably did in life.

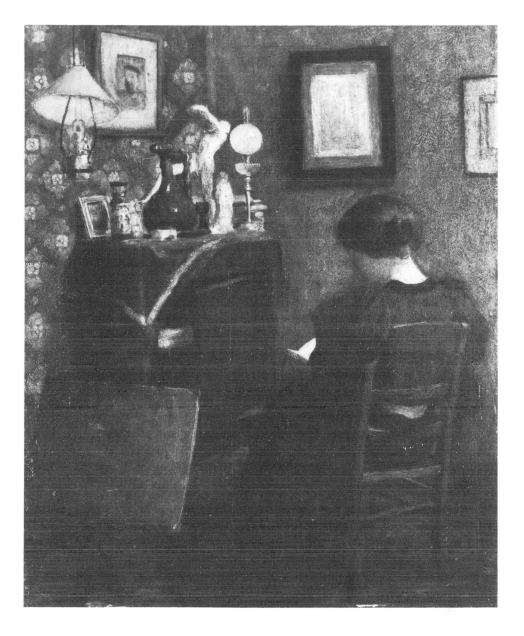

Matisse's *œuvre*. His empty chair acts as an open invitation to view his life and work as presented through the articles in his room. Paintings, frames, and canvases are arranged around the walls. It may be interpreted as a statement both of professional dignity by the inclusion of the top hat, and of Bohemian indifference to ordered comfort and domestic routine in the clutter of open books.

The studio interior for Matisse was also a place of retreat, where he could achieve through work the peace of mind he seldom experienced in the world outside. Sometimes a female model, occupied in some tranquil pursuit, would set the mood of the interior, as in *The Reader* (Plate 7), painted on a panel in the winter of 1895. This mood can be traced back to his convalescence after appendicitis, when he escaped the harsh, masculine monotony of office life for the bedroom, with his mother in attendance. The wish to perpetuate a condition of comforting feminine warmth remained with him throughout his life. It was one of his greatest triumphs that he managed to transcend what could quite easily have become a cloyingly intimate, hermetic world and produce a grand decorative art, which came to a conclusion with the paper cut-out mural schemes executed in the last two years of his life. He needed the stimulus of a particular interior and would have to change rooms in a house, like an Impressionist painter of landscapes who had exhausted a motif. This was only resolved, it can be argued, with *The Parakeet and the Mermaid*

8. *The Bottle of Schiedam.* 1896. Oil on canvas, 73 × 60 cm. Moscow, Pushkin Museum of Fine Arts.
The representation of the shadows cast by the knife handle, fruit, and silver vase are the first indication of Matisse's interest in light as a subject.

of 1952 (see Plate 203), an imaginative mural scheme which evolved around his bedroom walls and enveloped him in a peaceful world of his own making. The studio interior became a *hortus conclusus*, an enclosed paradise garden, a metaphor for harmony itself.

The still-life is related to the studio-interior theme, but it is more intellectual in that the selection and organization of the elements are matters of choice, and the total effect is conveyed not so much by what these objects are as by how they are painted. Matisse was generally little interested in describing the textures of objects, and in this period still-life elements act as vehicles for tones of different values just as later they act as vehicles for colour. *The Bottle of Schiedam* (Plate 8), painted in 1896, anticipates this transition from tonal values to colour in a simplified Chardinesque composition, split between the dark background and the light of the table-cloth in the foreground, with notes of colour provided by the peaches.

The subject-matter and style of Matisse's first interiors and still-lifes were popular in the 1890s; and it also must have been very convenient for the young artist to begin by depicting his own studio and the objects that surrounded him. Much of our interest in his early work derives from the recognition in retrospect of

9. *Belle-Île.* 1896. Oil on canvas,
59 × 72 cm. Paris, private collection.
While Matisse was working outdoors,
particularly during his trips to Belle-Île in
the summers of 1895, 1896, and 1897, the
silvery greys seen in this painting gradually
gave way to an Impressionist palette.

the themes and plastic problems which were to occupy him at different times throughout his career. Unassuming as these paintings undoubtedly are, they already show Matisse experimenting with ways of suggesting spatial depth while retaining pictorial flatness, and of using tonal values both as a constructive element and to convey emotion, in a limited range of subject-matter.

One of the distinguishing features of Matisse's mature art is the way that he actively involves us in the whole chromatic substance of a painting's surface. This results in part from his novel method of suggesting spatial depth. Instead of seeming to peer into a picture from the outside, we are made to feel inside it, looking about, and experiencing the impact of the forms and colours. The former effect derives from the Renaissance tradition of constructing a linear perspectival box behind the picture plane within which the objects are placed, like a stage behind the proscenium arch in a theatre; the latter owes more to the decorative tradition of the tapestry and carpet, in which the sensation of depth is conveyed by the relationships between the shapes and colours while the integrity of the two-dimensional surface is respected.

We can witness the conflict between these two methods in Matisse's early work. In *The Reader* the repetition of the rectangular shapes from the back of the chair to the paintings on the wall behind leads the eye in a circle around the surface and in and out of depth, whereas the still-life objects on the cupboard are awkwardly crowded behind each other in recession. Similarly, in *Interior with a Top Hat* there is a contrast between the treatment of the cluttered objects on the table in perspective and the decorative display of the rectangular shapes around it.

Matisse's early inability to handle objects convincingly in depth was remarked on by his contemporaries. Short-sightedness, coupled with the wish to somehow

25

'possess' the figures and objects he was painting, caused him to work very close to his subjects, which resulted in a complexity of viewpoints and a general flattening of the background. Some of Matisse's sitters found it very disturbing to have his chin practically resting on their knees. Art for Matisse was about expressive relationships and feelings, and from the start he had an abhorrence of fixed systems like linear perspective. His evolution of an alternative method of suggesting spatial depth is a prime example of his turning an initial difficulty to complete advantage.

Matisse's art of colour depended on his mastery of tonal values. The term 'tonal values' does not imply a specific style, and in this early period we can see him experimenting with different conventions. *The Reader* combines the use of an overall mid-tone—in relation to which the other elements are painted either as dark against light or as light against dark—with a tonal gradation from a dark foreground to a light background characteristic of Vermeer. An overall mid-tone is also used in the background of *Interior with a Top Hat*. However, in *The Bottle of Schiedam* Matisse moved away both from the gradation of values in perspective and from the mid-tone techniques to a development of the system of contrasting a light foreground against a dark background first seen in *Still-Life with Books* (see Plate 2).

There is still something awkward about the spatial organization of the objects in *The Bottle of Schiedam*, but the general flatness of the foreground and background, the clarity of contrasts, and the boldness of the composition of the table top, tipped up towards the picture plane, all indicate that Matisse had been looking at still-lifes by Manet, perhaps in the retrospective exhibition held at the Société des Peintres-Graveurs in 1893 to mark Manet's death a decade earlier.

It is one of the curious facts about Matisse that he was avowedly unaware of the modern developments in painting, while his close contemporaries in Paris, Pierre Bonnard (1867–1947), Jean Édouard Vuillard (1868–1940), and Maurice Denis (1870–1943), inspired by Gauguin, formed the Nabi group and were already exploring alternatives to Impressionism. A very diluted form of Impressionism had even been absorbed into academic painting by the 1890s. Despite Matisse's claim that his introduction to an Impressionist palette—'soon I was seduced by the brilliance of pure colour'—came during a trip to Brittany in the summer of 1895 with the painter Émile Wéry (who also had an apartment at 19 Quai Saint-Michel), this is not confirmed by his paintings of that time. Henri Evenepoel described Matisse in 1896 as a 'refined painter, skilled in the art of greys', which is an apt reference to the tonality of the landscapes of 1895 and 1896. His seascapes painted on Belle-Île are idiosyncratic in their swirling greys and general mood of isolation, but they are studies rather than large-scale, finished works. *Belle-Île* (Plate 9), signed and dated May 1896, is actually inscribed with the word *pochade*, which means an outdoor study.

In 1890 Pierre Puvis de Chavannes had broken with the Salon des Artistes Français, often scathingly referred to as 'Bouguereau's Salon', and, together with Rodin and Meissonier, founded the Salon de la Société Nationale des Beaux-Arts, better known as the Salon du Champ-de-Mars. The Salon du Champ-de-Mars exhibited four of the seven paintings that Matisse submitted in 1896: *The Reader*, two still-lifes, and an interior view of Moreau's studio. *The Reader* was a popular Salon subject in an acceptable style, and it was bought by no less a person than the wife of the President of the Republic, Madame Félix Faure, for the official summer residence of Rambouillet. Matisse was no sycophant, but he saw that one of the keys to patronage lay with the Salon presidents who could get his work shown. Puvis de Chavannes made it possible for him to become an associate member of the Salon du Champ-de-Mars in 1896, and, at the age of twenty-six, he appeared destined to a moderately successful, conservative career in art.

2 A Time of Experiment, 1897–1904

In the year following the Salon du Champ-de-Mars of 1896, Matisse embarked on the uncertain course which eventually led to his becoming one of the leading figures in twentieth-century art. The next seven years, from the winter of 1896–7 to his first one-man exhibition at Vollard's in June 1904, were a time of experimentation in which he set out to come to grips with modern art, to try new media—namely sculpture and printmaking—and slowly to build up a reputation as a modern artist. Matisse's art and aesthetic theory were firmly rooted in the cultural life of the late 1890s. Never before had a generation of artists been faced with such a wide range of ideas and styles; and it is not surprising, given Matisse's cautious temperament, that he took some time to explore them.

During the latter half of the 1890s and the first years of the twentieth century most of the groups and organs that came to represent French opinion between the two World Wars emerged, from the right-wing group *Action française*, founded by Charles Maurras in 1899, to the left-wing organ *Humanité*, started by Jean Jaurès in April 1904. Increasing radicalism in national politics was the popular expression of a wish to consolidate and defend republicanism. One of the principal rallying-points of the disparate elements within the radical movement was their common desire to undermine the outstanding bastions of reaction, such as the Church. Nationalism became the State religion, fuelled by the loss of Alsace-Lorraine in 1871. It was ironical in a time of radical governments that nationalism should have found an outlet in an unprecedented period of colonial expansion, during which France became a colonial power second only to Great Britain.

From the 1870s to the 1890s the guiding spirit behind republican politics, philosophy, and literature—and to a lesser extent art—was the philosopher Auguste Comte, who had died in 1855. His not wholly original doctrine, called Positivism, stated that true knowledge is scientific and based on the meticulous description of visible phenomena. Positivism was enormously successful, partly because it provided a suitable rationale for republican anti-clericalism, and partly because it justified the current belief in science and material progress. Science promised health, improved transport, prosperity, and comfort; and it appeared to supersede the artist's task of giving a true description of man's view of himself and the world.

Scientific and industrial exhibitions were extremely popular. A quite staggering figure of some 39 million people visited the Palace of Electricity at the Universal Exhibition of 1900. Art could in no way compete with such mass appeal. Even the popular demand made of art, that it should give a realistic depiction of the visible

world at moderate cost, was more than adequately fulfilled by the invention of the camera. About 17 per cent of the visitors to the Universal Exhibition were already carrying cameras. Photography was the popular visual art-form of the second half of the nineteenth century, just as film became that of the twentieth. On 28 December 1895 Lumière gave the first public film show in the basement of the Grand Café, boulevard des Capucines. France was the first country to treat film as an independent art-form, rather than as a branch of mass entertainment.

By the 1890s poets and painters of the avant-garde, loosely grouped under the label Symbolists, including Gustave Moreau, Gauguin, and the Nabis, had reacted against the whole notion of science and material progress associated with Positivism, and in doing so they had cut themselves off from the aspirations of the broad mass of society. To their horror, material progress—once regarded as a means to an end—had now become an end in itself. They felt that it was necessary to assert spiritual, non-material values; many of them became interested in mysticism and the occult. Gauguin's departure for Tahiti in 1891 epitomized the Symbolists' flight from the realities of French society. Matisse himself, perhaps inspired by tales of Gauguin's search for an alternative vision, visited Tahiti in 1930.

Of more lasting significance for Matisse and for the future of modern art was the Symbolists' quest for a new artistic language, which they hoped could function outside a narrowly descriptive framework. Photography, and later film, perpetuated the vocabulary of nineteenth-century French Realism in the popular domain, and the pressure was on avant-garde artists to look for new objectives and subject-matter which the camera could not tackle. The Symbolists equated Realism with materialism, which they regarded as a superficial view of reality bound up with the representation of surface appearances. Art, they felt, was a form of knowledge whose spiritual task was to express the mysterious aspects of existence. Their emphasis on the autonomy of the work of art as a decorative object in its own right led to the breaking-down of the barrier between the fine and the decorative arts and to the belief that the abstract elements of the artistic vocabulary could be so composed as to appeal directly to the emotions of the spectator, like music. In his preface to the catalogue of the nineteenth exhibition of Impressionist and Symbolist painters of 1895, Maurice Denis concluded: 'In their work they prefer to achieve expression through the work as a decorative entity, through the harmony of forms and colours, through the physical substance of the paint surface, to expression by the subject.' Many of these ideas were anticipated in previous Romantic rejections of rationalism and materialism, but their reformulation in Symbolism posed a new challenge to the prevailing styles and orthodoxies.

The poet Stéphane Mallarmé (1842–98) was the dominant intellect behind the Symbolists' aesthetic programme. Matisse later came close to Mallarmé's objective 'to paint not the thing, but the effect that it produces' in his belief that he could transcend everyday appearances and achieve a state of harmony, a dream inspired by reality, only by contemplating the relationships between things. He paid homage to Mallarmé in his magnificently rhythmic and pure line illustrations for *Poésies de Stéphane Mallarmé*, which was published by Albert Skira in 1932 (see Plates 156, 158, 171).

The artistic avant-garde's association with revolutionary politics (from which the name derived in the mid-nineteenth century) survived in the sympathy felt by some members of the Neo-Impressionist and Symbolist circles for anarchism and Utopian socialism. This was less a reflection of any practical political involvement than an expression of their disillusion with, and lack of a role in, the emerging industrial society. Too many artists were being produced to be absorbed by the market. The avant-garde saw itself as a class apart from society, pursuing art for self-expression, self-

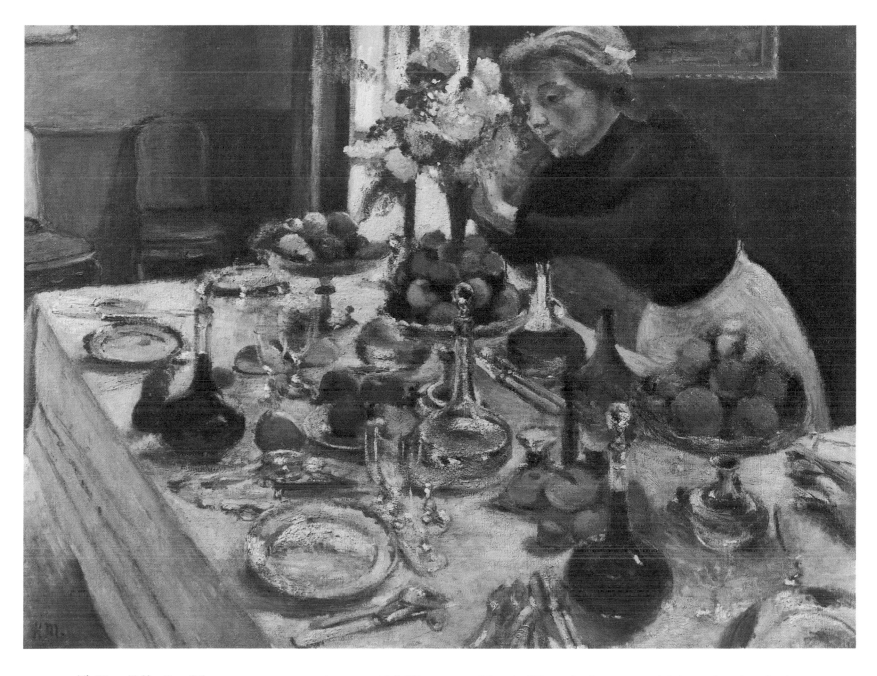

10. *The Dinner Table.* 1897. Oil on canvas, 100 × 131 cm. Stavros S. Niarchos Collection.
This is Matisse's first major painting. The dinner table is set out as a feast for the eye and not for guests to sit at; the only two chairs are placed against the back wall, like an old couple watching a dance. Light, colour sounding out in the forms of the fruit, and the novel compositional arrangement of the table on the diagonal introduce three of his principal preoccupations of the next four years. He was not to attempt another major exhibition painting until *Luxe, calme et volupté* in 1904–5.

assertion, or self-fulfilment, and for the life-style that came with it, rather than in the expectation that it could either really change the world or bring much in the way of material reward. The avant-garde adopted an anti-bourgeois stance, perhaps because most of them came from the bourgeoisie. Matisse's fellow Fauves (see p. 41), Derain and Vlaminck, employed the belligerent vocabulary of anarchism. Vlaminck wanted to burn down the École des Beaux-Arts with his cobalts and vermilions.

For Matisse the avant-garde spirit was the competitive innovatory drive behind modern art. He believed that it resulted from artistic freedom and independence, rather than from any association with political or scientific developments, although both these factors must have contributed to the general mood of experimentation and change at the time. Even when he lost the leadership of the avant-garde to Picasso and Cubism, its spirit remained a powerful motivating force in his work; with his last paper cut-out mural schemes of the early 1950s he finally re-entered the history of the avant-garde.

Matisse's gradual interest in modern art was awakened during his second summer painting trip to Belle-Île, following his success at the Salon du Champs-de-Mars of

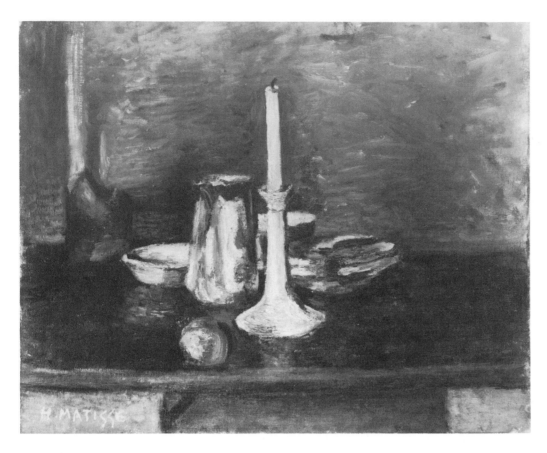

11. *Still-Life with a Candlestick.* 1896–7. Oil on canvas, 35 × 55 cm. Nice-Cimiez, Musée Matisse.
The influence of Impressionism is most noticeable in the representation of the reflected lights and shadows on the bowl, jug, candlestick, and lemon. The lemon, for example, is bathed in a jarring green shadow.

1896. There he met a friend of Monet and Rodin, the Australian painter John Peter Russell, who gave him two drawings by Van Gogh and finally introduced him to Impressionism.

Matisse was not ready for Van Gogh's art, nor for recent developments in Impressionism. He evidently felt that he was taking a great risk in abandoning a seemingly safe career for the second time in his life. He was at first reluctant to relinquish the style and subject-matter that had earned him his success, but outdoor working and contact with Impressionism at Belle-Île caused him to lighten his palette. Back in Paris that winter, he set himself the pictorial problem of integrating brighter colour into a traditional tonal-value structure, using again Chardinesque still-lifes for subject-matter. *Still-Life with a Candlestick* (Plate 11) is conceived in terms of tonal values, with the dark table-top juxtaposed against a light background. Brighter colour and freer brushwork are introduced to suggest the play of light without destroying this basic relationship. It was not until 1899, having experimented with Impressionism and then Neo-Impressionism, that he turned his attention to concerns that had preoccupied the avant-garde earlier in the 1890s.

In the mid-1890s the older Impressionists were winning widespread, though selective, recognition. Between 1874 and 1894 the prices of their paintings rose in some cases by as much as 500 per cent. The bequest by Gustave Caillebotte, the collector and amateur painter, of sixty-seven paintings by his fellow Impressionists—Renoir, Cézanne, Degas, Manet, Monet, Pissarro, and Sisley—to the Luxembourg, the museum of contemporary art in Paris, confronted the authorities with the decision whether to acknowledge Impressionism officially. After internal opposition and a public outcry, a compromise was reached. Thirty-eight of the paintings were accepted, including all seven by Degas, but only eight of the sixteen by Monet, seven of the eighteen by Pissarro, and two of the five by Cézanne.

Matisse was deeply affected by the Caillebotte bequest, when it was exhibited at

the Luxembourg early in 1897. Possibly at Moreau's instigation, he decided to synthesize his new discoveries in a major exhibition painting, *The Dinner Table* (Plate 10), for the Salon du Champ-de-Mars of the spring of 1897, to consolidate his reputation gained the previous year. This was a painting designed to impress. Under the influence of his copy of *The Dinner Table* by Jan Davidz. de Heem, the simple meal being laid in a rustic interior depicted in his *Breton Serving Girl* of 1896 is transformed into a sumptuous *haut bourgeois* table overburdened with objects competing for our attention. Matisse's mistress, dressed as a maid, looms over the centre of the table putting the final touches to a bouquet of flowers. The scene is set *contre-jour* (against the light). Light pours in from the window behind the table and blends in with the white table-cloth to create a pool of luminosity linking the foreground and background. It is a scene of luxury and comfort which would have been familiar to a patron, though not to Matisse at this time. With the general increase in prosperity and the migration of peasants to the towns, most of the middle classes, including 20 per cent of established artists, kept servants.

Any misgivings Matisse may have had about starting a career as a modern artist must have beem amply confirmed by the reception of *The Dinner Table*. Coming so soon after the opening of the Caillebotte bequest, conservative critics saw in it the unfortunate manifestation of Impressionism. It was only hung at the Salon—albeit badly—because Matisse had the right, as a recently elected associate member, to send in work without submitting it to the jury. The painting remained unsold until 1904.

The archetypal Impressionist painting can be characterized as a relaxed celebration of what gives pleasure to the eye. But *The Dinner Table* is far from relaxed. The painting's preoccupation with light and colour looked Impressionist only to eyes accustomed to a form of academic Realism. What strikes us now is the strangely compelling tension caused by Matisse's evidently laborious struggle to reconcile different representational conventions current at the time: linear perspective with a more decorative realization of pictorial space; tonal value with colour; Realist colour faithful to the local colour of objects with Impressionist colour faithful to a dominant colour scheme dictated by the action of light. The head and shoulders of the maid, seen at eye-level, are roundly modelled with feeling and tenderness, but her torso rapidly narrows down to a flatly painted pinafore, wedged in by the curious alignment of the table in two opposing directions. The bouquet of flowers sprouts out of nowhere. The table is banked up towards us, but the objects rush away in perspective.

The surface of *The Dinner Table*, pitted and scoured with scrapings-out and reworkings, commemorates this painterly battle. Matisse wanted on the one hand to model the objects on the table in opaque local colour and on the other to dematerialize them and make light the prime vehicle in the representation of reality. His employment of the traditional nineteenth-century technique of painting the highlights in impasto (thick opaque paint) and the shadows thinly meant that the white and transparent objects are distinguished in the highlights from the white table-cloth by extremely heavy impasto. Moreau is reported as saying that he could hang his hat on the nuggets of white on the stoppers of the decanters.

Apparently undaunted by the hostile reception of *The Dinner Table*, Matisse persisted with Impressionism. In February 1897 Evenepoel noted: 'My friend Matisse is going in for Impressionism at the moment and can no longer think except along the lines laid down by Claude Monet.' Monet began his career as a colourist by painting outdoors on the northern coast of France, and Matisse followed suit, going back to Belle-Île that summer. He renewed contact with John

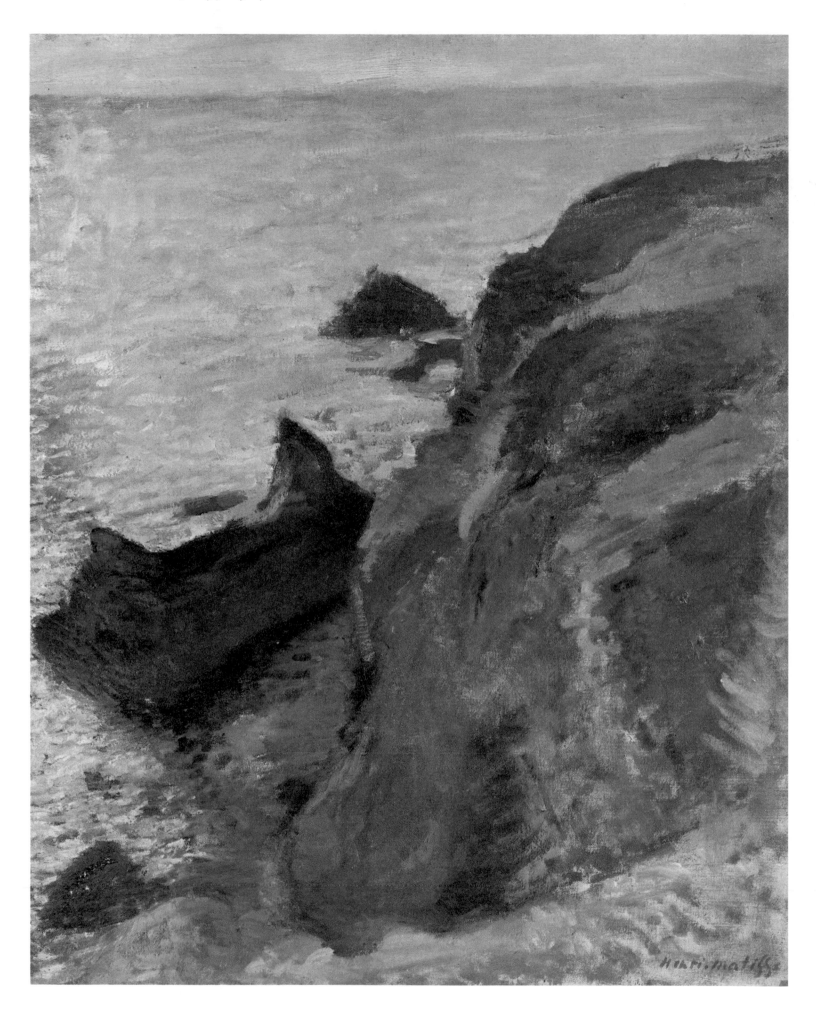

13. *First Orange Still-Life.* 1899. Oil on canvas, 56 × 73 cm. Paris, Musée National d'Art Moderne, Centre Georges Pompidou. This is one of a series of still-lifes begun in Toulouse and continued in Paris in which Matisse passed from Impressionist, descriptive colour to something more spontaneous and expressive. He evidently felt that the colouristic solution was very audacious because he did not exhibit it until the Salon des Indépendants of 1905, the year of his first Fauve paintings.

12. *Rocks and the Sea (Belle-Île).* 1897. Oil on canvas, 65.1 × 54 cm. Paris, private collection.
Matisse's debt to Monet's Belle-Île canvases of the 1880s, of which there was a good example in the Caillebotte bequest, is very evident in his choice of motif and composition, in the broken brushwork used to evoke the palpitating sensation of light, and in the dominant foreground colour scheme of contrasting pinks and greens.

Peter Russell and painted the picturesque motifs chosen by Monet in the 1880s, which afforded the dramatic juxtaposition of the rhythmic patterns of light on the waves and cliff faces, as in *Rocks and the Sea* (Plate 12).

On Matisse's return to Paris in the autumn of 1897, Moreau objected to the increasingly bold brush-strokes and sketchiness of his summer's work. Moreau equated the outdoor sketch with the direct perceptual sensation of nature and not with a finished work of art in its own right. Matisse, too, was worried. Emotional profundity and the feeling of permanence associated with his first original paintings and his Louvre copies had been sacrificed for a more transient vision of brighter colour and freer brushwork geared to the evocation of the play of light. How could he best combine the essential features of both? Like Cézanne, Van Gogh, and Gauguin before him, he turned to Camille Pissarro (1830–1903) for advice.

Of the older Impressionists, Pissarro was the most open to young artists and new ideas, and yet, paradoxically, his style in the 1890s was the most conservative of them all. He wanted, like Matisse, to retain the 'spontaneity and freshness' of Impressionism while putting a work of art through a contemplative process in order better to arrive at the realization of his own sensations. He saw traditional drawing and modelling through colour allied to chiaroscuro (the illusion of solid form achieved through the gradation of tonal values from light to shadow) as the means to achieve these ends. Pissarro criticized Matisse's use of white instead of colour to create light in *The Dinner Table* and advised him to study Turner.

33

14. *Still-Life with Apples.* 1897. Oil on
canvas, 39 × 47 cm. Chicago, Consolidated
Foods Corporation.
Matisse gave *Still-Life with Apples* to Madame
Fontaine as a wedding present. He met his
future wife at the wedding, where she was a
bridesmaid.

The other great issue facing Matisse was resolved more speedily; he decided to
ask Amélie Noémie Alexandrine Parayre to marry him. He had known her for only
a couple of months. They met at the wedding reception of a mutual friend, to
whom Matisse dedicated and gave *Still-Life with Apples* (Plate 14) as a wedding
present. Their civil wedding on 8 January 1898 was followed by a religious
ceremony. Amélie, who was born on 16 February 1872 at Beauzelle, Haute
Garonne, soon dedicated herself to the furtherance of Matisse's career. The birth of
their two sons, Jean in 1899 and Pierre in 1900, did not prevent her opening and
running a small milliner's shop at 25 rue de Châteaudun from October 1899 to
support the family. She even found time to model for him. Her self-discipline,
neatness, and love for materials and patterns—which she shared with her
husband—gave her appearance an oriental quality. Matisse and his fellow Fauves
were later to paint her on a number of occasions as a Japanese lady wearing a kimono
(see Plate 33).

Matisse and Amélie went to London on a brief honeymoon, which gave him the
opportunity to look at the Turners. He hoped that Turner would provide the link
between Impressionism and tradition. As it turned out he found 'a great similarity
between Turner's watercolours and Claude Monet's paintings in the way they were
constructed with colour'.

On their return to Paris, Matisse was no nearer to finding his direction. Rather than
risk being caught up in what he called 'the bewildering cross-currents of recent
painting', he decided that they should leave Paris for a long stay in Corsica and then
Toulouse, his wife's home town. Matisse's sojourn in the south had as dramatic an
effect on his art as it had had on another artist from the north, Vincent van Gogh
(1853–90). Van Gogh's career had taken a similar course to Matisse's. He began by
drawing, started painting with a variant of his native Dutch Realism, progressed to
Impressionism in Paris, and discovered the full emotive power of pure colour when
he left Paris for Arles in Provence in 1888. Matisse, too, suddenly felt liberated in
the south from any pressures outside his art. 'I worked only for myself,' he said

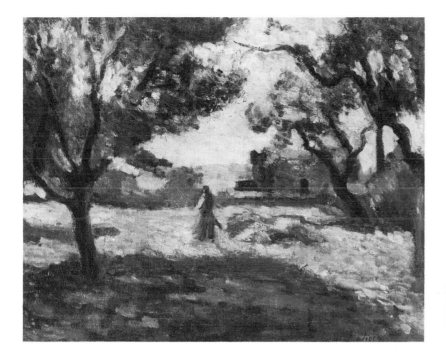

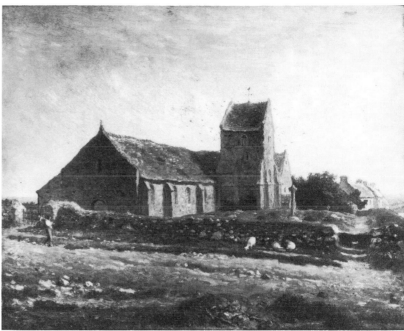

15. *Corsican Landscape.* 1898. Oil on canvas, 38 × 46 cm. St Tropez, Musée de l'Annonciade.
France was a predominantly rural country with a majority of the working population in agriculture. Jean-François Millet had popularized the subject of the peasant and the style of this painting over twenty years earlier.

16. Millet. *The Church at Greville.* 1871–4. Oil on canvas, 60 × 73.5 cm. Paris, Musée du Louvre.
The painting entered the Luxembourg Museum in 1875 and became one of the most celebrated of Millet's landscapes. Its influence can be seen in the work of Van Gogh and Cézanne as well as that of Matisse.

17. *Corsican Landscape (The Olive Tree).* 1898. Oil on canvas, 38 × 46 cm. Private collection.
The freedom of the brush-strokes, which vary in shape and density from loops describing the foliage of the tree to choppy, pigment-laden commas forming a pattern of reflected lights, is a development of the technique of Monet's Belle-Île paintings.

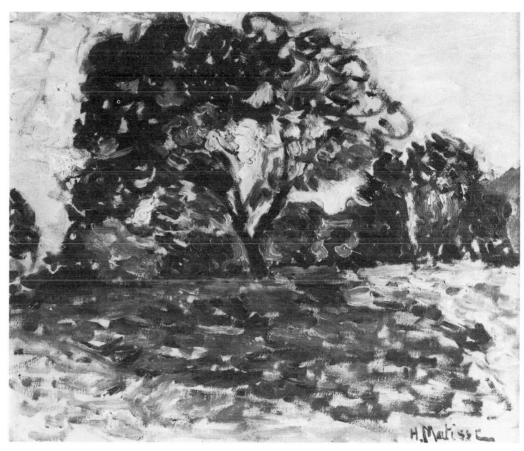

later. 'I was saved. Soon the love of materials for their own sake came to me like a revelation. I felt a passion for colour developing within me.' The Matisses stayed in Corsica from the end of January to August 1898. Corsica, like Brittany, was an ideal place for a French artist without much money. Accessible and yet different from mainland France, it offered a wide variety of picturesque motifs and, above all, it gave Matisse his first, crucial experience of Mediterranean light.

Matisse explored different approaches to landscape painting in Corsica, from conservative, well-constructed compositions to exuberant small-scale experiments in the expressive manipulation of colour, stimulated by his responses to motifs bathed in intense light. A comparison between *Corsican Landscape* (Plate 15) and *The Church at Greville* of 1871–4 (Plate 16) by Jean-François Millet (1814–75), which

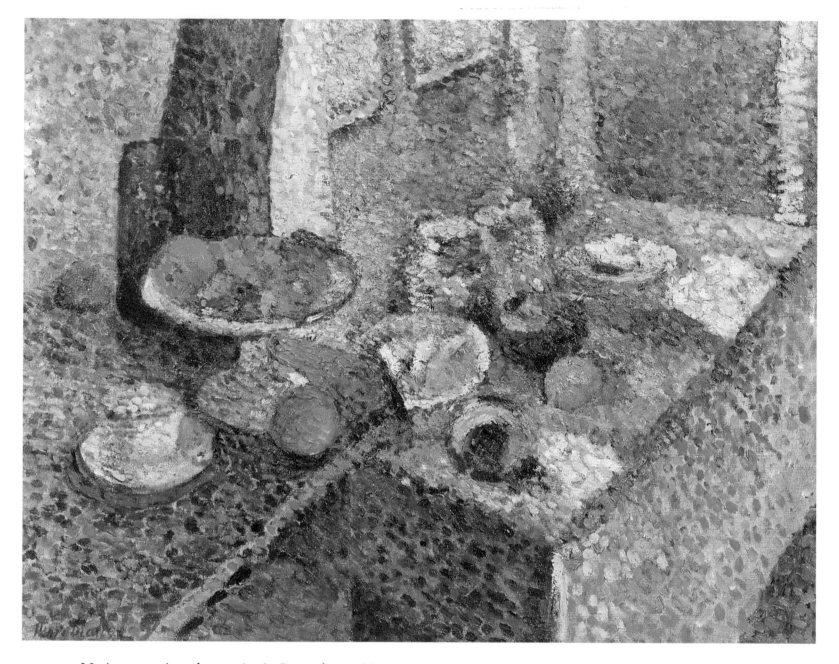

18. *Sideboard and Table.* 1899. Oil on canvas, 67.5 × 82.5 cm. Switzerland, Mr and Mrs R. Weinberg.
Matisse painted *Sideboard and Table* in response to reading Signac's essays on the Neo-Impressionist or Divisionist technique. It is doubtful if he had really looked at Neo-Impressionist paintings in Paris before leaving for Corsica and Toulouse because Signac's precepts are not applied systematically. Signac would not have condoned the bright red contour surrounding the teacup and saucer on the left.

Matisse must have known in the Luxembourg Museum, shows that his more solidly worked landscapes were dealing with the problems of a pre-Impressionist generation. In both, accents of unmixed colour are touched in without disrupting the structure of tonal values. By contrast, *Corsican Landscape (The Olive Tree)* (Plate 17) employs a technique derived from Monet's Belle-Île paintings, with an overall light ground to create atmospheric unity while allowing for experiment with different types of brushwork. Equal emphasis is given to both the olive tree and its reflection, in a way that anticipates one of his Fauve methods of structuring a composition.

In August 1898 the Matisses moved on to Toulouse, where they were based for the next six months. Outdoor working and his renewed exploration of Impressionist technique in Corsica had further opened up to Matisse the modernist syntax of semi-autonomous colours and brush-strokes as instruments of expression. His breakthrough as a painter in Toulouse stemmed from two sources: from pursuing a series of at least seven still-lifes, not landscapes; and from reading Signac's *From Eugène Delacroix to Neo-Impressionism*, which had been serialized in three instalments in *La Revue Blanche* between May and July 1898 before being published in 1899.

Still-life painting allowed Matisse to concentrate on a problem from canvas to

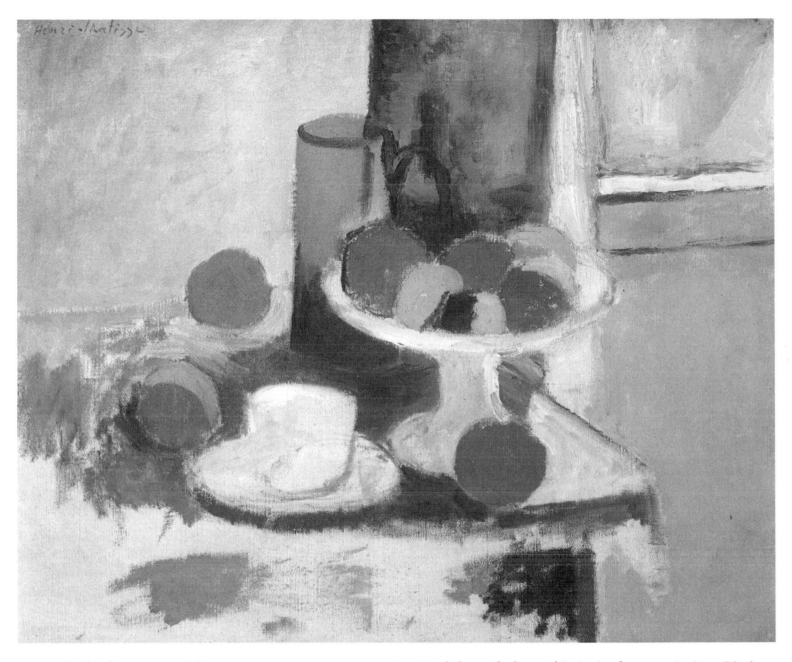

19. *Still-Life with Oranges*. 1899. Oil on canvas, 45.7 × 55.2 cm. St Louis, Washington University Gallery of Art. *Still-Life with Oranges* marks Matisse's change from construction through tonal value to construction through colour. A comparison with the earlier Chardinesque *Still-Life with Apples* shows how he returned to an earlier compositional arrangement. A glass jug is introduced in both cases to add a note of ambiguity to the formal composition. It is characteristic of his painting that the most audacious use of colour occurs in his most rehearsed and disciplined compositions wherein the separate areas of colour are clearly defined.

canvas in a manner that he did not find possible in landscape painting. He later outlined this process: 'With more involvement and regularity, I learned to push each study in a certain direction. Little by little the notion that painting is a means of expression asserted itself, and that one can express the same thing in several ways.' *First Orange Still-Life* (Plate 13), which was preceded by a more Impressionist pastel study, illustrates this transition from Impressionism to a more personal form of expression through colour. As in *The Dinner Table* the scene is set *contre-jour*. A blazing Turneresque colour scheme of hot oranges and yellows contrasts with the blues in the shadows. In addition to describing the local colour of the oranges, orange acts as the colour of light and as an emotional equivalent of interior warmth.

With the tragically early death of Georges Seurat (1859–91), Paul Signac (1863–1935) had become the self-appointed leader of Neo-Impressionism, sometimes known as Divisionism or Pointillism because of the practice of isolating bright 'prismatic' colours in small dots, which in theory would combine in the eye to produce a lively, vibrant surface. In the 1880s the Neo-Impressionists had reacted against the arbitrary, romantic naturalism of Impressionism. They first sought a more scientific understanding of reality and art, and then, by the end of the 1880s, they postulated a total theory linking not only the individual elements

of the artistic vocabulary with emotion and thought but also all the different forms of art with the grandiose goal of universal human harmony. Their interest in an autonomous language for art, like that for music, allied them to the Symbolists and the new avant-garde. In 1888, Signac exhibited twelve canvases listed by opus numbers and dates alone. He published *From Eugène Delacroix to Neo-Impressionism* to revive interest in the movement, which had lost momentum by the end of the 1890s. His text served its purpose—though not always in a way that he approved—for it provided the aspiring colourist with a historical rationale and a coherent body of theory seemingly based on scientific law.

Sideboard and Table (Plate 18) is Matisse's only essay in the Divisionist technique before *Luxe, calme et volupté* of 1904–5 (see Plate 36). The swirling, distinct blots of colour following the right-hand side of the coffee-pot in *First Orange Still-Life* are organized in more uniform dots covering the whole canvas surface: dark green dots predominate in the shadow and yellow dots in the light, while cool pink dots inform both areas to create a feeling of pictorial unity. Matisse followed Signac in seeing Neo-Impressionism as a logical development of Impressionism.

For all its novelty, *Sideboard and Table*—like *The Dinner Table*—is an awkward transitional painting, still closely related to Matisse's previous compositional methods and technique and yet full of possibilities that he was later to take up and explore. As we shall see, the discipline of Neo-Impressionism resulted in 1905 in a sudden flowering of his art as a colourist. *Still-Life with Oranges* (Plate 19), which may have been a bold study blocking in the main colour areas of the left-hand half of *Sideboard and Table*, has all the exciting qualities of a Fauve canvas of 1905 (see p. 67). Like musical notes in a scale, forms and colours are reduced to a point where they can be played significantly against each other. The circular theme, concentrated in the pile of oranges, is developed around the fruit-dish with the three oranges on the table, the cup and saucer, and glass jug. Flat areas of colour sound out in association with shape to create both light and structure. The colour orange is enhanced through contrast with its complementary blue. The thinly applied, grainy white priming of the coarse linen canvas is left exposed to describe the cup and saucer and the cloth hanging down over the edge of the table and to assert the material identity of the painting as an artificial, two-dimensional, constructed object.

Matisse did not paint another still-life quite as bold and simple as *Still-Life with Oranges* until *Pink Onions* of 1906 (see Plate 53). He had finally moved beyond Impressionism. But in saying this, we must be conscious that Fauvism was essentially a development of Impressionism, as Matisse himself acknowledged. In the 1920s, he resumed his dialogue with Impressionism, returning to the Channel coast and painting in front of the motif as Monet had done. Matisse respected the robust empiricism of the Impressionist aesthetic, but at the back of his mind there always lingered the academic prejudice, taken up by the Symbolists and the avant-garde, that Impressionism was too much like a preliminary information-gathering process, the raw material of experience that had to be synthesized further for it to be recognizable as a work of art. 'What did the Realists do, and the Impressionists?' Matisse asked rhetorically in 1909. 'They copied nature. All their art has its roots in truth, in exactitude of representation. It is a completely objective art, an art of unfeeling—one might say of recording for the pleasure of it.' This is grossly unfair to the Impressionists, although in the circumstances understandable. By this time Monet, the archetypal Impressionist, had become more interested in the structural and expressive effects of brush-marks and colour than in accurate representation. But Matisse was perhaps too close to the Impressionist generation to recognize this, and, in any case, he was anxious to distinguish his art from Impressionism.

In February 1899 the Matisses were back in Paris, living at 19 Quai Saint-Michel. A glance at contemporary exhibitions would have been enough to convince Matisse that he had successfully caught up with the avant-garde. His recent work would have looked perfectly at home in the mixed exhibition of Symbolists, Nabis, and Neo-Impressionists held in March at the Durand-Ruel gallery.

Matisse's relationship with his contemporaries the Nabis is puzzling. He may well have been aware of their work from his first days as an art student in Paris. He once told the photographer Brassaï that he did not stay at the Académie Julian under Bouguereau because Paul Sérusier (1863–1927), who accompanied Gauguin to Pont-Aven in 1888 and founded the Nabis (named after the Hebrew word for prophets) with his fellow students Bonnard, Vuillard, Denis, and Ranson, had left with his disciples. It is quite possible that Vuillard's painting of 1896 of his family at lunch prompted *The Dinner Table*. One report has Matisse and Bonnard (who was known as the Nabi *très japonais*) buying Japanese prints together on expeditions down the rue de Seine in 1896.

Matisse shared the Nabis' general anti-naturalistic, anti-Positivist stance, as well as their liking of intimate subject-matter and the decorative. Yet he appears to have deliberately held out against their influence and to have worked much the same problems out for himself later. Now that he had, as it were, drawn level, he found that his art had a strength and presence that identified him with the aspirations of the next generation—artists like Derain who were some ten years younger than he and the Nabis. *Interior with Harmonium* (Plate 20) demonstrates the point. The positioning of the harmonium along the diagonal recalls the compositional arrangement of the table in *The Dinner Table* (see Plate 10), which must have been influenced by Nabi paintings of the mid-1890s and ultimately by Japanese prints. However, *Interior with Harmonium* has a forceful, almost ruthless, simplicity which is wholly Matisse's own.

A further, very important point distinguishing Matisse from the Nabis was that he did not consider his days of apprenticeship to be over. Instead of settling down as a painter of still-lifes, varied by the occasional landscape, he decided to tackle in both painting and sculpture one of the outstanding subjects in the history of Western art since the Renaissance—the posed nude.

A persistent practical problem facing any artist painting the nude was to have regular access to models, which were an expensive item for a young artist. Artists in the provinces had the additional problem of persuading models to pose in the nude. At Aix-en-Provence, Cézanne was obliged to base his nudes for the bathers compositions (see Plate 21) on his student drawings or his studies after the Old Masters. Matisse's solution was to become a student again. In 1899 he tried to gain readmission to the École des Beaux-Arts. Unfortunately, during his absence from Paris, Moreau had died. Moreau's successor, Fernand Cormon, soon eased Matisse out of the studio on the grounds that he was too old to be a student at thirty. He enrolled at the Académie Camillo (sometimes known as the Académie Carrière because Eugène Carrière taught there), where he could work from the model for next to nothing without, he said, having to endure instruction. But Matisse was dogged by bad luck: the Académie Camillo closed within the year for lack of numbers. He then joined Marquet and Manguin, his friends from Moreau's studio, in sharing a model. Also from 1899 to 1901 he took lessons in sculpture at an evening course held at the École Communale de la Ville de Paris, rue Étienne-Marcel, and went to the sculptor Antoine Bourdelle's studio for further technical advice.

Back in a student milieu, Matisse found himself the leader of a new grouping of younger artists, including Jean Puy and André Derain. When Derain introduced

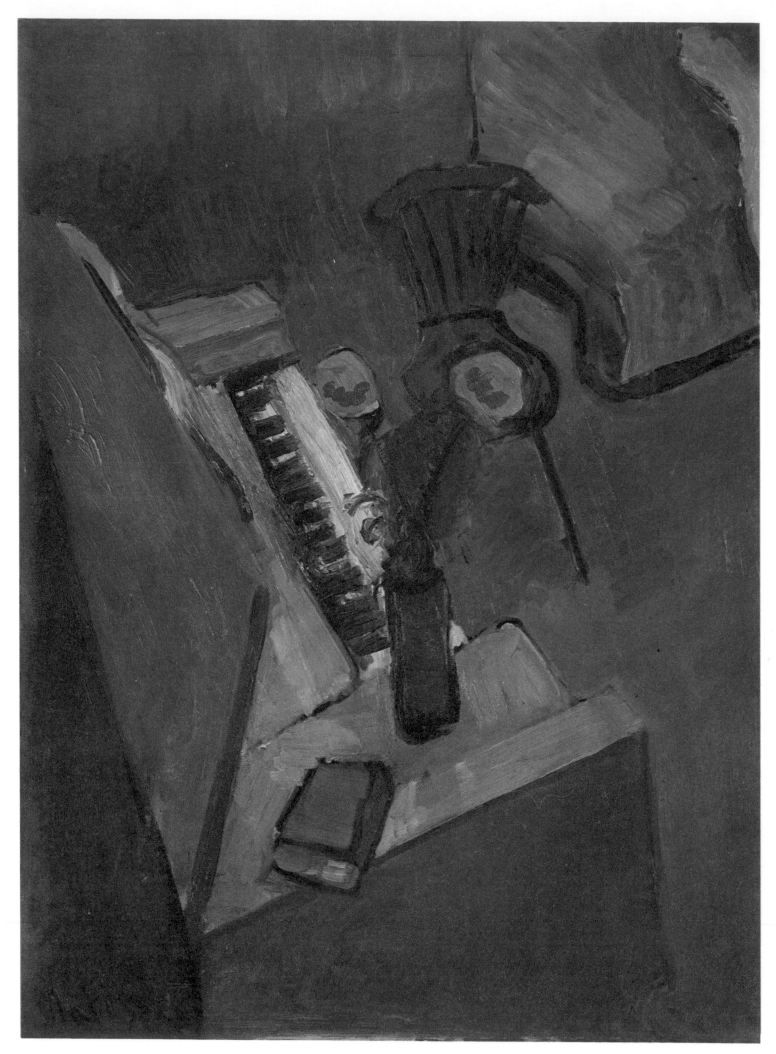

20. *Interior with Harmonium. c.*1899–1900. Oil on paper mounted on panel, 73 × 55 cm. Nice-Cimiez, Musée Matisse.
Matisse used a paper on panel support to ensure the visibility of every brush-mark. Brush-marks of green and reddish-brown shut off the spatial recession of the background on the right. The powerful perspectival drive of the harmonium along the diagonal, a device borrowed from the Nabis and ultimately from Japanese prints, is countered by the concentration of the main chromatic accents in the two vermilion-red flowers, as in certain of Odilon Redon's pastels which Matisse admired at the Durand-Ruel gallery in March 1899.

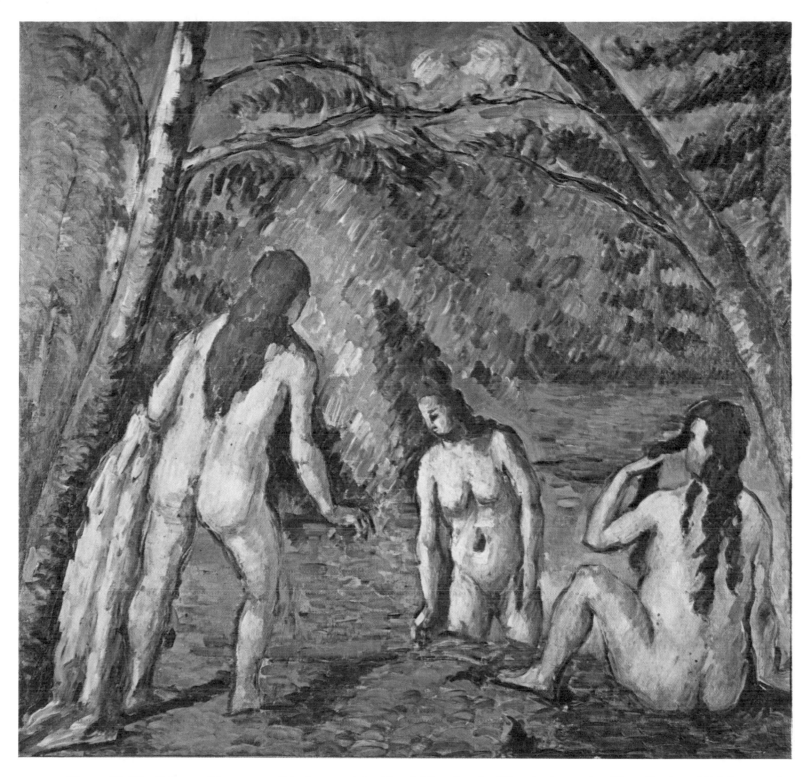

21. Cézanne. *The Three Bathers. c.*1881–4. Oil on canvas, 50 × 50 cm. Paris, Musée du Petit Palais.

Matisse bought *The Three Bathers* in 1899. The painting became a talisman for Matisse and the modern movement. Picasso based the squatting nude in his *Les Demoiselles d'Avignon* of 1907 (see Plate 59) on Cézanne's bather in the same position. *The Three Bathers* proved that modern developments in colour and construction since the early days of Impressionism could be reconciled with the enduring monumentality of the Old Masters, in one of the grandest imaginary themes in the history of art—nudes bathing, symbolizing man in harmony with nature.

Matisse to his friend Maurice de Vlaminck at the Van Gogh exhibition at the Bernheim-Jeune gallery in 1901, the principal artists associated with the development of Fauvism had come together. Matisse was the key figure in Fauvism, which was not a movement or group as such. The participants worked in knowledge of each other, from similar sources, towards an emancipation of colour as an expression in itself. A common direction and identity emerged in their art only when they were all hung together at the Salon d'Automne of October 1905. Derain is the one Fauve who has any claim to have substantially affected the course of Matisse's art; but even he was more a catalyst than a direct influence.

The origins of Fauvism lie in Impressionism. However, in studying the nude model, artificially posed in the studio, Matisse was in part reacting against the Impressionist neglect of the human figure and of solid form. The Impressionist treatment of the figure as part of an overall surface pattern of light meant that the individual elements in the pattern became the units of construction rather than the

figure as a whole. This had the effect of liberating these elements from a strictly representational framework, so that they could be considered for their structural or emotional potential, but, taken further, it eventually led to the destruction of representation and to the evolution of abstract art. Matisse did not so much want to abandon Impressionism as to integrate what he had learned from it with his new interest in the human figure.

Matisse regarded his paintings of the nude model from 1899 to 1901 as studies, known by the term *académies*. The majority of them are inspired by Cézanne. They deal with structure and the solidity of form and surface in a restricted palette. As Jean Puy pointed out, the figures are powerfully constructed in terms of light and shade; their flesh tones stand out against a shallow background of dark blues, deep violets, browns, and greens. During the winter of 1904, following his second summer in the south influenced by Neo-Impressionism, Matisse again shared a model with Marquet and Manguin and painted *académies*, as a preparation for the figures in *Luxe, calme et volupté* (see Plate 36).

In the eyes of the avant-garde of 1900, Paul Cézanne (1839–1906) and Auguste Rodin (1840–1917) had done more than any other modern artists to reinvest the human figure with its traditional significance as a subject in art. There is no doubt that Cézanne's example suggested to Matisse a way of unlocking the expressive potential of the whole picture surface without sacrificing light, structure, the integrity of the human figure, and the qualities of permanence he associated with his Louvre copies.

Recent reappraisals of Cézanne tend to place him back into the context of the Impressionist movement, where he belongs, rather than to isolate him as a Post-Impressionist. However, according to Matisse's definition of Impressionism as the recording of transient impressions of nature, Cézanne was not an Impressionist. Matisse recalled a conversation with Pissarro, who probably introduced him to the work of Cézanne, in which a distinction was made between an Impressionist who always painted a new picture and Cézanne who always painted the same one, in the sense that his sensations and personality were his real subject-matter.

Matisse was able to see Cézannes at Vollard's gallery, where the first retrospective exhibition of Cézanne's work was held in 1895. According to Simon Bussy, Vollard's gallery replaced the Louvre as Matisse's place of pilgrimage. In 1899 Matisse made a considerable financial sacrifice and bought a Cézanne, *The Three Bathers* (Plate 21). On looking at the painting he recognized, he said, for the first time 'the sheer power, the song of the arabesque in unison with the colour, the steadiness of forms'. These were the qualities he wanted to bring to his own work. But Cézanne's influence went far beyond questions of style and technique. He was for Matisse a moral exemplar, the epitome of a modern artist who had struggled in virtual isolation to achieve the highest standards. When Matisse gave *The Three Bathers* to the Petit Palais in 1936, he wrote, 'It has sustained me morally in the critical moments of my venture as an artist; I have drawn from it my faith and my perseverance.'

In 1900 Matisse showed some of his drawings to Rodin (without getting much help), and he later distinguished between what he regarded as Rodin's piecemeal assemblage of expressive parts and his own conception of the figure as a whole from the beginning. However, Matisse's first original sculpture, *The Serf* (see Plate 22), is unthinkable without Rodin's example.

Rodin had restored sculpture to its status as a major innovatory art-form after decades of dull monuments. His reputation as the most celebrated living sculptor was confirmed with the first retrospective one-man sculpture exhibition in the history of art, held at the Universal Exhibition of 1900. Rodin and Matisse had

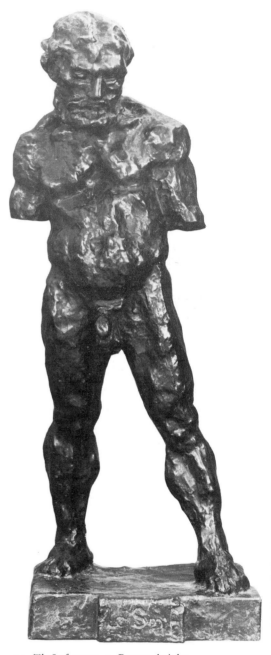

22. *The Serf.* 1900–3. Bronze, height 92.3 cm, base 33 × 30.5 cm. Nice-Cimiez, Musée Matisse.
The Serf, Matisse's first important sculpture, is clearly indebted to Rodin's *The Walking Man*. The same model posed for the legs of the Rodin and for *The Serf*. For Matisse sculpture was an exploratory activity. During a very lengthy process—calculations vary in the region of 500 to 2,000 hours—the figure was worked and reworked until it expressed the very concept of serfdom in its over-large head and overburdened limbs.

much in common. They were both obsessed with the human form, its structure, rhythm, gesture, and expression; and they elaborated numerous ways of portraying its different aspects and moods. They shared a belief in drawing as the guiding principle in art, a love of oriental art, an understanding that a pose should evolve out of a spontaneous response to a model's personality, and a view that art should proceed from a study of nature and the greatest works of the past. More particularly, Rodin studied anatomy under Antoine Barye (1795—1875); Matisse himself began by copying Barye's *Jaguar Devouring a Hare* at the École Communale de la Ville de Paris. The ape-like model Bevilaqua posed for both Rodin's *The Walking Man* (Plate 23) and Matisse's *The Serf*. Matisse paid Rodin the compliment of buying his plaster bust of Henri Rochefort from Vollard in 1898.

Rodin's public commissions are heroic and declamatory, whereas Matisse's sculpture is private, experimental, and, with the exception of *The Backs* (see Plates 119, 120, 160), small in scale. Some of Rodin's studies and variations on figures for his commissions, such as *The Walking Man*, were of more interest to Matisse because they were not statues representing people, gods, or heroes but sculpture dealing with problems which were clearly articulated in the actual work. *The Walking Man*, for example, is concerned with conveying the sensation of movement in a static form.

Matisse's growing reputation as a major sculptor rests on some seventy pieces executed during periods in his career when he was concentrating on the human figure as the main subject in his painting: from 1899 to 1901; from around 1905 to 1910, when he was working on the great decorative figure compositions culminating in *Dance* and *Music* (see Plates 83, 84); from 1910 to 1913 and in 1916 when he was trying to complete *Bathers by a River* (see Plate 112), originally intended as part of a cycle with *Dance* and *Music*; and in 1918 and from around 1924 to 1930, leading from the crisis with a renewed form of Impressionism to the Barnes murals (see Plates 161, 162). By realizing the figure in clay he felt better able to encapsulate its solidity on a two-dimensional surface and achieve a suggestive synthesis of the whole. He outlined his reasons for making sculpture: 'I took up sculpture because what interested me in painting was a clarification of my ideas . . . That is to say that it was done for the purpose of organization, to put order into my feelings, and find a style to suit me. When I found it in sculpture, it helped me in my painting.'

The *académies* and figure sculptures fall into two modes. In the first, Matisse wanted to absorb our attention within the very substance of a figure; whereas in the second, he wished to divert our attention from the physicality of form by making the arabesque or overall rhythm of the figure dominate. *The Serf* (Plate 22) and *Male Model* (Plate 24) illustrate the first mode, and *Nude Study in Blue* (Plate 25) and *Madeleine I* (Plate 26) the second.

The Serf and *Male Model* are forcefully constructed in terms of their respective media, clay and paint, to give a craggy, elemental presence—enhanced in *The Serf* by the removal of the arms some time after it was photographed in 1908. With head bowed and legs stolidly braced, *The Serf* looks resigned to bearing the burdens of the world on its shoulders. *Male Model* shows the same model, Bevilaqua. The figure looks as though it was sculpted in paint over a long work period. Repeated modifications in the pose have left an aura of violet around its back. As in *The Serf*, Matisse is uninterested in the sensual qualities of flesh. Forms are analysed and expanded in solid volumes in a style which anticipates the 'analytic' phase of Picasso's and Braque's Cubism by some nine years.

The treatment of *The Serf* and *Male Model* in this very structural mode presented a new, peculiarly modern conception of the figure, which attempted to side-step the

23. Rodin. *The Walking Man*. 1875—8. Bronze, height 85.1 cm. New York, Metropolitan Museum of Art. *The Walking Man* is one of the most influential sculptures in the evolution of modern art. It is not a statue of a mythological figure but a sculpture dealing with problems which are articulated in its own form. Matisse's wish to express in the human figure his 'almost religious awe towards life' echoes Rodin's concept of the human body as 'a temple that marches'.

43

24. *Male Model. c.*1900. Oil on canvas, 100 × 73 cm. New York, Museum of Modern Art.
Male Model parallels Matisse's intentions in *The Serf*, but this time in paint. The 'chipped' Cézannesque brush-strokes define the volumes of the model's chest like the chisel marks of a sculptor cutting a form out of a block. Matisse later reminds us that a work of art 'must carry within itself its complete significance and impose that upon the beholder even before he recognizes the subject'.

25. *Nude Study in Blue. c.* 1900. Oil on canvas, 73 × 54.3 cm. London, Tate Gallery.
The arabesque or circular rhythm unfolding through the figure became an extremely important feature of Matisse's work. He used a plumb-line to plot the movements round the vertical axis.

26. *Madeleine I.* 1901. Bronze, height 60 cm. Baltimore Museum of Art, Cone Collection.
Madeleine I is the counterpart in sculpture of *Nude Study in Blue.* It was followed by a rougher, more chunky version in 1903, as though this first version was too reminiscent of the polished smoothness of much Salon sculpture.

question of subject-matter by making the figure appear more 'real' than in real life—so that it could somehow embody meaning rather than represent it. Matisse hoped that this could be achieved without having to give titles or explanatory captions. *The Serf* marks this transition from a traditional statue to a modern piece of figurative sculpture. Its volumes are exaggerated to convey a feeling of burdened weight which makes the inscription *Le Serf* on the base an unnecessarily literal reminder of its subject-matter; though it does serve to confirm the figure's source in Rodin's studies for *The Burghers of Calais* (1884–6), who offered themselves as sacrificial victims to save their town, and it also makes the point that sculpture was still expected to represent something.

The arabesque in the second curvilinear mode arose out of Matisse's copy of Barye's *Jaguar Devouring a Hare*, with its body seen from above twisted in a tense s shape, and out of his study of the female nude. The accommodation of different directions in a pose, so that the figure appears as a smoothly unfolding arabesque, was a legacy of the High Renaissance, when a premium was placed on the solution of extreme compositional difficulties with apparent ease. The arabesque was a popular feature of late nineteenth-century academic sculpture; also it was taken up by the Nabis from the older painters associated with Symbolism, Moreau and Redon.

The model in *Nude Study in Blue* is posed with her weight pivoted on the left leg, and with her right leg bent back from the knee to introduce a curving rhythm which informs the whole figure. This rhythm is accentuated in the sculpture *Madeleine I*, which is named after the model who posed for it. Her hip is thrown out to the side, her torso is bent back to balance it, and her arms are folded across her breasts so as not to interrupt the flow. Madeleine looks soft, sinuous, and vulnerable in comparison with the masculine strength of Bevilaqua in *The Serf* and *Male Model*. Her personality is expressed through the pose; Matisse makes no attempt to define the features of her face.

The concepts behind Matisse's structural and curvilinear modes originate in Symbolist theory. The structural mode relates to the idea of the work of art as an autonomous, constructed object, and the curvilinear mode to an anti-materialistic

doctrine linked to the arabesque. This latter doctrine stressed the power of the imagination and thought, as opposed to the slavish imitation of nature. Imagination did not mean escapist fantasy; it was understood as something approaching divine insight into the hidden relationships behind visible appearances, which allowed the creation through analogy and metaphor of a state of harmony, the ultimate goal of the artist. The importance of the arabesque—which became the key organizing principle in the great decorative paintings of Matisse's maturity—was that it provided the means of uniting the different elements in a composition, so that the relationships between objects and the picture surface as a whole took precedence over the description of the objects themselves.

At the end of 1900, Matisse was still struggling. He had sent nothing to any of the Salons that year. The *académies* had opened up areas which he did not feel ready to develop. In fact he did not pursue the two modes until 1907, with *Blue Nude— Souvenir of Biskra* (see Plate 55) in the structural mode and *Le Luxe I* (see Plate 57) in the curvilinear mode. In addition, he was worried about his inability to support his family; his job painting decorations for the Universal Exhibition had put a great strain on his health. He contracted bronchitis, and in 1901 was taken by his father for a short stay at Chézières near Lake Geneva to recover. It was in these circumstances that his interest in landscape painting revived. Impressionist landscapes were now selling well, and Matisse regarded landscape painting as a way both of calming his nerves and of finding his feet by returning to the source of modern art in the study of nature.

In 1901–2 Matisse painted in the Luxembourg gardens with his friend Marquet, whom he regarded as his mentor in outdoor working, and in the neighbourhoods of Paris and his native Bohain-en-Vermandois. He continued to observe the traditional distinctions between the various stages in the artistic process. His ten entries at the Salon des Indépendants of 1901 included three *croquis*, three *études*, and a *pochade*. At first the majority of Matisse's landscapes were studies, but, as the pressure on him to produce saleable works increased from 1901, he painted fewer and more finished works.

The view from 19 Quai Saint-Michel—where Marquet also had one of the many apartments used by artists as studios—provided the ideal subject for Matisse to combine the Impressionist practice of painting in front of the motif with the traditional process of slowly building up the paint surface in the studio. It is difficult to imagine a more picturesque motif than the view of Notre-Dame and the river. There were ample precedents for painting it. Jongkind, one of the fathers of Impressionism, had painted two views of the river and Notre-Dame in 1863 and 1864 (one of which came into the collection of Signac). The success of Monet's Rouen Cathedral series of 1893–4 was partly responsible for the Neo-Impressionist painter Maximilien Luce in 1899 beginning a series of views of Notre-Dame from the very building in which the Matisses were living. Matisse himself had been painting the Seine since his move to 19 Quai Saint-Michel in 1895. He once claimed that a painting of a sunset he made from the window caused his expulsion from the École des Beaux-Arts in 1899, where such Impressionist subjects were still an anathema. The motif also uncannily fitted in with his favourite compositional structure, seen in *The Dinner Table* (see Plate 10) and *Interior with Harmonium* (see Plate 20), of a strong diagonal form balanced by a central point of focus—in this case the river cutting across the foreground balanced by the twin towers of Notre-Dame tilted towards the picture plane in the middle.

Matisse's views of Notre-Dame are not a series. The motifs seen from his window presented him with endlessly stimulating subject-matter which he reinterpreted in

the light of his changing preoccupations. Although in *Notre-Dame* (Plate 27) his interest is in light, atmosphere, and colour, the technique and structure recall his Louvre copies. A tonal-value gradation moves from a dark foreground to a light background. The barge in the foreground is modelled with brush-strokes of thick opaque paint, worked wet-in-wet into each other, over dry brown underpainting; the sky by contrast is painted comparatively thinly. The apparently Whistlerian *Notre-Dame in the Late Afternoon* (Plate 28) is in fact more indebted to Cézanne in its reduced palette biased towards blue and its surfaces described in passages of vertical brush-strokes. The blue mood, coupled with the serene presence of Notre-Dame, is not necessarily a reflection of any orthodox Christian belief. Maximilien Luce, a self-confessed anarchist with strong anti-clerical ideas, enjoyed painting Notre-Dame for the atmosphere and the crowds gathering for ceremonies.

A window and a painting share the obvious but fascinating characteristic of opening on to another world. The views from Quai Saint-Michel begin to exploit this relationship, with Notre-Dame becoming a sort of positive image conjured out of the negative space of the open window. These early views are very close up against the window, using it as a frame for the picture. Gradually Matisse came to include more of the window frame and room inside; until, eventually, it led to a new theme lying between the external view and the studio interior. Exterior space became inseparable from interior space, and the window acts more as a metaphysical divide between the artist's private and public worlds than as an actual barrier.

In 1902, Matisse painted his darkest, most deliberately structured landscape, *Path in the Bois de Boulogne* (Plate 31). The winding path leads our eye into the middle ground where it gets detained in the curtaining trees. The technique is similar to the treatment of the foreground in *Notre-Dame*: the light accents of colour are played on a dark, tonal base.

The darkening of Matisse's palette coincided with the worsening of his material circumstances. The situation had become critical. His wife's health had given way.

Worn out by bringing up the children and having to support the family, she could not continue with the shop. Matisse longed to make just enough money for them to live in the country for a year so that she could recover. There is a note of desperation about his money-making schemes. He planned to form a syndicate of a dozen collectors who would guarantee the purchase of two canvases a month. He begged his friends to introduce him to potential patrons. In a letter to Simon Bussy of July 1903 he even talked about giving up the unequal struggle in favour of a more lucrative profession. The only solace he could find was in the practice of art itself. He was forced back to his parents' home at Bohain-en-Vermandois for long periods in 1902 and 1903. *Studio under the Eaves* of 1903 (Cambridge, Fitzwilliam Museum) shows his temporary workplace there, tucked away in an attic. Matisse's nerves were on a knife-edge. He kicked the easel over when his wife, while posing for *The Guitarist* (see Plate 29), shifted from her cramped position and accidentally twanged the guitar. The painting crackles with tension.

Matisse's rejection of the bright, Impressionist palette probably suited his pocket as well as his mood. A No. 6 tube of cadmium yellow made by Lefranc cost 4 francs, whereas No. 6 tubes of ochre or sienna brown cost only 50 centimes. He therefore often restricted the expensive warm colours to telling accents on a tonal base of greys and browns. His friend Marquet was equally hard up; but Matisse felt that Marquet's lack of the expensive cadmiums suited his style. This pathetic picture of Matisse painting away in a garret, starved of money and success, can be conjured up too readily to account for his change in palette. The association of colour with an artist's psychological state is largely a matter of speculation. It is worth noting that

29. *The Guitarist.* 1903. Oil on canvas, 54.6 × 38.1 cm. New York, Mr and Mrs Ralph F. Colin.
Costume pieces gave Matisse the opportunity to paint elaborate and colourful clothes. Men's formal attire in France aped the dull uniformity of the English dark suit. Women's clothes were generally more interesting, with fashions often following trends in the theatre.

30. *Carmelina.* 1903. Oil on canvas, 80 × 62 cm. Boston, Museum of Fine Arts.
Matisse is seen in the mirror painting the model. Costume pieces and the artist and model theme became extremely important subjects in his art.

the dark palette can equally be explained in terms of a return to the colour scheme of the Louvre copies and his first original paintings, and of a renewed interest in the work of Manet.

In his published statements Matisse does not mention Manet with the same warmth as Cézanne. Perhaps Manet represented the detached, cerebral side of his own personality which he preferred to hide. Nevertheless, two of his major paintings of this period, *The Guitarist* (Plate 29) and *Carmelina* (Plate 30), demonstrate Manet's influence. Manet was able to reconcile different conventions and points of view in the same painting, combining past with present, and realism with fantasy. We look at the figures in a Manet and they often unflinchingly stare back at us, giving nothing away. Matisse's long-suffering wife is realistically painted in a fanciful Spanish costume in *The Guitarist*, one of Manet's celebrated subjects. The model in *Carmelina*, placed in a full-frontal pose, challenges us to inspect the volumes of her body in as brazen a manner as Manet's *Olympia* (see Plate 56). *Olympia* had caused a scandal when exhibited in 1865, because the audience did not know whether to see the model as a naked prostitute or a nude in the tradition sanctified by Titian. By contrast Matisse's naked models are always unambiguously 'nudes'.

Between 1901 and 1903 Matisse also made his first prints. *Self-Portrait as an*

31. *Path in the Bois de Boulogne.* 1902. Oil on canvas, 62.9 × 79.1 cm. Moscow, Pushkin Museum of Fine Arts.
Although the colour scheme is sombre, the painting is by no means without colour. Squiggles of vermilion enliven the dark areas between the trees on the left and bars of light yellow fall across the mauve path.

32. *Self-Portrait as an Etcher*. 1903. Etching and dry-point, 15.1 × 20.1 cm. New York, Museum of Modern Art.
Self-Portrait as an Etcher, perhaps begun in 1900, is Matisse's first print. The role of the artist as the creator of art was a subject which fascinated Matisse, and he returned to it time and again.

Etcher (Plate 32) shows the anxious Matisse, forehead furrowed, staring fixedly at the viewer. Two smaller self-portraits can be seen, on their sides, in the upper left-hand corner of the composition: one shows him scowling, the other peering suspiciously from under his top hat. He went on to execute some eight hundred graphic works and illustrations for twenty-nine books, which he either designed and illustrated throughout or for which he provided at least one illustration. Among these numerous prints, *Self-Portrait as an Etcher* is remarkable for its subject-matter, intense atmosphere, and stylistic exploration. The later prints were usually either relaxed variations on poses of the female nude, first established in his paintings, or portrait heads of his friends and models. By contrast, his illustrated books demanded his complete attention, and, like *Poésies de Stéphane Mallarmé* (published in 1932) which was his first such project, they were done at times when he had temporarily lost interest in easel painting.

Although there was no significant increase in his sales, Matisse was beginning to exhibit regularly and gain a growing reputation among his fellow artists. In February 1902 he had taken part with Marquet in a small group exhibition at Berthe Weill's gallery without selling anything. His first one-man exhibition, which opened at Vollard's in June 1904, included forty-six paintings: eighteen still-lifes, nineteen landscapes, seven figure-studies, and two interiors. It was something of a review of his work since the Salon du Champ-de-Mars of 1896, beginning with *The Dinner Table* of 1897 and paintings from Belle-Île. In his preface to the catalogue, the critic Roger Marx summed up Matisse's development. He defined Matisse's art as a synthesis of the teachings of Moreau and Cézanne. He drew attention to Matisse's rejection of a fashionable career after his success at the Salon du Champ-de-Mars in 1896, and described his subsequent evolution as though he was a latter-day Impressionist, inspired by colour and light, and sensitively seeking to register his sensations before nature. He likened the tranquil intimacy of Matisse's interiors to the work of Vuillard.

The one-man exhibition marked the end of an era of struggle in Matisse's life. There was neither an immediate improvement in his living standards, nor any indication that his art had settled into an established style. Nevertheless, his days of isolation, uncertainty, and extreme financial difficulty were over.

3 From Neo-Impressionism to Fauvism, 1904-1906

In 1904 Matisse was thirty-four years old. His exhibition at Vollard's in June gave him the opportunity to stand back and take stock of his work. The more-finished 'dark' paintings of 1902 and 1903 might have looked vaguely Impressionist, but in fact they constituted Matisse's temporary rejection of everything he had learned from Impressionism concerning emancipated colour and brushwork combining to evoke the play of light. Added to which, the exhibition was neither a commercial nor a critical success. This is surprising when we consider that he had not dared to include his more audacious *académies* and still-lifes of 1899. But now that he had gone so far down the road of modern art, he must have decided that he had nothing to lose. Rather than return to a more traditional form of Realism, he pressed on with what he called the 'rediscovery of expression in colour'.

His breakthrough to an art of colour came during two summers spent painting in the south of France, on the Mediterranean coast—at Saint-Tropez in 1904 and Collioure in 1905. Each summer's work was concluded with a great imaginary painting, executed back in Paris during the winter: *Luxe, calme et volupté* (*Luxury, Calm and Delight*) in 1904–5 (see Plate 36) and *Le Bonheur de vivre* (*The Joy of Life*) in 1905–6 (see Plate 51). But the event which stood out in the minds of the exhibition-going public of his day was the Salon d'Automne of October 1905; it announced the arrival of Fauvism as the first avant-garde movement of the twentieth century with Matisse as its leader.

Soon after the closure of his exhibition at the end of June 1904, Matisse and his wife travelled south to Saint-Tropez, where they stayed for four months. Saint-Tropez had become a Mecca for talented young painters, attracted by the quiet, unspoiled beauty of this small Mediterranean fishing village and—more materially for the impecunious artist—by the hospitality of Signac, the leader of the Neo-Impressionists. Since his first brief foray into Neo-Impressionism in 1899, Matisse had met Signac at the annual Salon des Indépendants, which was dominated by Neo-Impressionists.

Signac was a colourful character. For a convinced anarchist he had a conveniently large bank account, inherited from his father, a wealthy harness-maker who died in 1880. Signac's private income gave him the freedom to indulge his twin loves, painting and sailing. Although only seven years older than Matisse, he had practised and promoted modern art from 1884, when at the age of twenty-one he had helped found the Indépendants. He came to know most of the leading painters in the modern movement, including Van Gogh, Gauguin, and of course Seurat, and in 1892 he married a relative of Pissarro. It was Gustave Caillebotte who taught him to sail. His first boat, *Manet-Zola-Wagner*, bought in 1883, was named after

33. *The Terrace, Saint-Tropez*. 1904. Oil on canvas, 71.7 × 57.1 cm. Boston, Isabella Stewart Gardner Museum.
Matisse's wife, wearing a kimono, is seen sewing on the terrace of the house in which the Matisses stayed at Saint-Tropez during the summer of 1904. The couturier Paul Poiret popularized this Japanese garment when he brought out his celebrated kimono-coat.

34. *By the Sea.* 1904. Oil on canvas, 64.5 × 51.5 cm. Cantigny, Robert R. McCormick Museum.
Matisse's wife and their son Pierre posed for this painting on the beach below Signac's house, La Hune, at Saint-Tropez, with the view facing north across the bay to the hills of the mainland. It acted as a study for *Luxe, calme et volupté.*

three of his heroes before he met Seurat in 1884. A later boat, *L'Olympia* (named after Manet's painting), was responsible for his discovery of Saint-Tropez in 1892, when he had to move her there because of the lack of a safe anchorage at nearby Cabasson, where his close friends Henri-Edmond Cross (1856–1910), the Neo-Impressionist painter, and Félix Fénéon, the critic and dealer, lived. Both Cross and Fénéon became of considerable help in Matisse's career.

Signac let the Matisses stay in La Ramode (seen in Plate 33), the house in which he lived before he had La Hune (The Crow's Nest) designed and built by the Neo-Impressionist painter and architect Henri van de Velde in 1898. La Hune is well sited on the small hill just outside Saint-Tropez. From the main studio window, you look down through the pine trees to the small beach, where Matisse executed the studies for *Luxe, calme et volupté*. This idyllic view of pines overlooking water is echoed in the subject-matter of the Japanese prints still hanging on the wall there. Japanese prints and classical landscapes from Poussin to Puvis de Chavannes established the main precedents for Signac's vision of timeless beauty and harmony.

The interest in Japanese and oriental cultures was a common feature of modern art. Van Gogh and Gauguin identified themselves with a highly idealized vision of a disciplined and simple life in the Orient, which they regarded as aesthetically and morally superior to a decadent European civilization. Gauguin set out in search of this life in the South Seas; Van Gogh tried to found an ideal community in the south of France. It is likely that Signac also had such a plan in mind when he settled at Saint-Tropez.

Matisse did not remain unaffected by the cult of the Orient at Saint-Tropez in the summer of 1904. He painted his wife in her kimono on the terrace of La Ramode (see Plate 33), and he used a Japanese reed-pen and brush technique in his wonderfully expressive drawing of a fishing boat pulled up on the beach (Plate 35).

Matisse did not paint many canvases that summer. The renewed experience of Mediterranean light resulted in an immediate lightening of his palette and the abandonment of brown underpainting. He was reluctant to adopt the overtly Neo-Impressionist technique, and his first paintings at Saint-Tropez are, if anything, more indebted to Cézanne than to Signac. Signac protested, evidently feeling that Matisse had not kept faith with the Neo-Impressionist ideals of Saint-Tropez; the anonymity of the Neo-Impressionist divided touch was associated with the co-operative ideas of anarchist politics. According to Matisse's daughter, Signac actually quarrelled with her father over the broad brush-strokes of *The Terrace, Saint-Tropez* (Plate 33), which is quite understandable as the painting has little to do with Neo-Impressionism. There is nothing methodical about the way it is painted. Ravishing touches of a pale blue-grey are worked into the violet-tinted terrace; the shutters are coloured in a very pale bluish-green viridian rubbed on in dry, chalky scumbles. The main chromatic accent comes in the centrally placed vermilion geraniums.

As the summer progressed, Matisse increasingly came under the influence of Signac and Cross. At first glance, *By the Sea* (Plate 34) gives the impression of a rapidly executed outdoor study, but in fact it was planned and executed very methodically. An infra-red photograph reveals that the main features of the composition were first drawn in considerable detail on the canvas; Matisse's wife and their son Pierre were included only in the final stages of the painting. *By the Sea* has some similarity with the studies that Cross was accustomed to make for his major paintings. Cross and Signac were preparing for large exhibitions and Matisse, therefore, could have become familiar with their methods of working at first hand.

Back in Paris in the early autumn of 1904, Matisse's interest in Neo-Impressionism maintained its momentum. Before leaving Saint-Tropez, he had

35. *Fishing Boat*. 1904. Indian ink on paper, 44.5 × 31.8 cm. Chicago, Art Institute of Chicago.
The Japanese reed-pen and brush technique was employed by both Van Gogh and Signac. This drawing may well have served as a study for the lateen-rigged boat in *Luxe, calme et volupté* (see Plate 36).

evidently decided to include everything he had learned from Neo-Impressionism in a major exhibition piece, *Luxe, calme et volupté* (Plate 36). In contrast to the archetypal *plein air* Impressionist landscape, Signac's large landscapes were painted in the studio, using an academic method of proceeding from studies and sketches to a cartoon and thence to the final canvas. By this method Signac sought a harmonic balance between emotion, colour, composition, and information drawn from nature. Matisse was to follow a similar academic process for *Luxe, calme et volupté*. He rehearsed the composition in a study at Saint-Tropez; executed a cartoon in Paris; worked on the painting over the winter; and finally exhibited it at the Salon des Indépendants in March 1905.

Luxe, calme et volupté is Matisse's first great imaginary composition and his only major statement in a Neo-Impressionist style. The painter Raoul Dufy (1877–1953) was not alone in being struck by the painting at the Indépendants in 1905: 'Impressionist Realism lost its charm for me as I contemplated the miracle of imagination that ordained the drawing and colour.' Signac was so delighted that he bought *Luxe, calme et volupté* and hung it at La Hune, where it remained literally out of public sight and mind for years.

The title *Luxe, calme et volupté* is taken from the repeated refrain of Baudelaire's poem 'The Invitation to the Voyage':

> There, everything is ordered and beautiful,
> Luxury, calm and delight.

Beyond these words and the general view that the only safe haven in this world is located in the artistic imagination, the poem has nothing in common with the subject-matter of the painting. Matisse's wife, covered up with extreme propriety in a long blue dress, sits like a madame among her five naked girls, fixed in studiously relaxed poses on the beach. A boat lies ready to transport them over some imaginary horizon. The Matisses' son Pierre, surrounded by a hallucinatory aura of colour, stands behind the reclining red-haired nude. The three teacups on the cloth suggest that the refreshments are intended only for the artist—and by extension the spectator—his wife, and son.

The precise placement of every line and colour area was carefully worked out in the preliminary studies. The format of *By the Sea* was changed from vertical to horizontal to accommodate the bathers. The line of the hills was lowered to conform to the classical proportion of the Golden Section (the smaller part is to the larger part what the larger part is to the whole), which was thought to convey a feeling of harmony. Two further overlapping Golden Sections give the exact position of the tree and the boat's mast in relation to the vertical edges of the canvas. Similarly the colour of *By the Sea* was further systematized to give a more calculated harmony. Following Neo-Impressionist practice, the main areas of local colour (local colour is the true colour of objects) were mapped out and then modified: by complementary colours (complementary pairs such as red and green, orange and blue, yellow and violet are mutually enhancing) in the shadows; by yellow in the patches of sunlight; and by the reflections of adjacent colours. Strictly speaking a powerful vermilion red is not the local colour of the sandy beach below La Hune; however, as the Neo-Impressionists quite naturally associated red with psychological warmth and happiness, it must have been selected to establish a fitting correspondence with the subject-matter.

Despite the calculated harmony of colour, linear direction, and emotion, the mood of *Luxe, calme et volupté* is anything but calm. Not that Matisse felt calm in 1904; Cross described him as 'madly anxious'. As in his first large-scale exhibition piece, *The Dinner Table* of 1897, he tried to deal with too many new issues in one

36. *Luxe, calme et volupté (Luxury, Calm and Delight)*. 1904–5. Oil on canvas, 94 × 117 cm. Paris, Musée National d'Art Moderne, Centre Georges Pompidou. The first of Matisse's great imaginary compositions and his only major statement in the Neo-Impressionist style.

painting and give each equal emphasis. The result is almost unbearably active in the overall vibrato of the colour. The anarchic energy, created by the semi-autonomous mosaic-like blocks and separated colour zones, distracts attention from the linear and figurative content. In many cases, the figures appear merely as vehicles for unpleasant rashes of colour. There are also strange discrepancies in scale. The setting is far too small for the figures; our eye is inexorably drawn to the line of the hills and then down to the tightly knit group cramped on the beach.

The origin of the nude bathers in *Luxe, calme et volupté* remains unclear. It has been suggested that they evolved from studies of a model he shared with Signac, but Signac had virtually stopped making studies of the clothed model *en plein air*, let alone the nude, after *At the Time of Harmony* of 1894. The posing of nudes *en plein air* was a later Fauve practice, probably begun by Matisse at Collioure in the

37. Henri-Edmond Cross. *Landscape with Bathers*. 1893–4. Oil on canvas, 115 × 163 cm. Paris, Musée du Louvre.
Signac owned this painting by Cross which is the closest source for Matisse's *Luxe, calme et volupté*. Matisse owned Cross's *The Farm, Morning* of 1892–3, whose twisting tree-trunks reappeared in his own *Le Bonheur de vivre* of 1905–6; Cross in turn owned three paintings by Matisse.

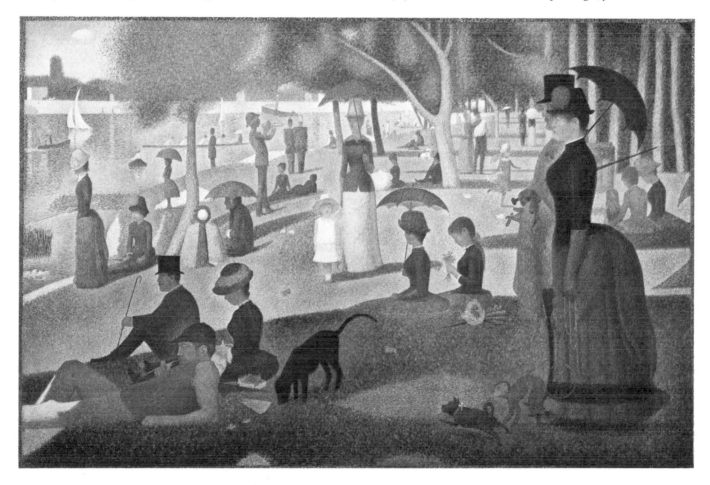

38. Seurat. *A Sunday Afternoon on the Island of La Grande Jatte*. 1884–6. Oil on canvas, 206.4 × 305.4 cm. Chicago, Art Institute of Chicago.
La Grande Jatte is a key work in the history of modern art. Its presence in the Salon des Indépendants of March 1905, along with *Luxe, calme et volupté*, must have prompted Matisse to break new ground. The compositional arrangement of land balanced by a triangle of water is common to both paintings.

summer of 1906. The most likely source for nude bathers at Saint-Tropez in 1904 is in the work of Signac's friend Henri-Edmond Cross, who had moved from Cabasson to nearby Saint-Clair.

There was an immediate rapport between Matisse and the older Cross. Both of them came from French Flanders and were the sons of businessmen who discouraged their choice of career. Cross abandoned socially relevant subjects, instead painting nudes posed as nymphs and naiads in an imaginative vision of the Mediterranean coast bathed in radiant light; and his *Landscape with Bathers* (Plate 37) is very close to *Luxe, calme et volupté* in style, subject-matter, and technique. Matisse's standing nude holding up her hair, for example, looks like a direct quotation from the Cross. In addition, Cross painted a number of canvases inspired by Symbolist poetry, which may have influenced Matisse's decision to take Baudelaire's poem as the starting-point—or at least the title—for his painting.

The imaginary compositions of Signac, Cross, and Matisse find a common source in Puvis de Chavannes's work, which was the subject of a large retrospective exhibition at the Salon d'Automne in October 1904. In general terms these compositions belong to the tradition of the Golden Age. The legend of the Golden Age, passed down by poets from antiquity, describes a period of human happiness during the reign of Saturn, who was ousted by Jupiter, after which the human condition deteriorated in successive stages. The Golden Age was followed by an Age of Silver, an Age of Bronze, and finally an Age of Iron which it was hoped would not end in the destruction of the world but in the renewal of the whole cycle. Virgil thought the occasion would be marked by the birth of a mysterious child. Could Matisse have been referring to this when he placed his son Pierre in *Luxe, calme et volupté* surrounded by a hallucinatory aura? Images of the Golden Age have been used in Western art as subject-matter for paintings of pleasure or to throw into relief an evil in society by confronting it with its opposite. The full title of Signac's *At the Time of Harmony* included the pious hope, 'The Golden Age is not in the past, it is in the future.' Signac told Cross that he found this statement in the writings of the anarchist Malato. The painting illustrates the Utopian, anarchistic idea that social harmony could only come about through a return to the soil as opposed to urban industrialization. It is ironic that anarchist thought should be expressed in such a disciplined, methodical technique as Neo-Impressionism. Matisse, on the other hand, saw harmony more as a spiritual state than a social possibility. The figures in *Luxe, calme et volupté* are self-absorbed in statuesque poses and do not communicate with each other.

Signac's Utopian vision of workers living in harmony with the earth and each other in a village environment by the sea had little to do with contemporary reality. By 1904 the optimistic mood of the *belle époque* had altered. The growing lack of faith felt by workers in the ability of radical governments to effect social change was marked by the emergence of a new phenomenon, direct industrial action. There was a wave of strikes between 1904 and 1907; in 1906 strikes forced the government to make Sunday an obligatory day of rest.

If the subject-matter of nudes relaxing on a beach and bathing in the Mediterranean looks dated, it is because what was then a vision of leisure has now become a commonplace reality. The second half of the nineteenth century saw the development of tourism on the north coast of France, a subject documented by the Impressionists, and in the twentieth century the development has shifted from the north to the Mediterranean coast. It could well be more than a coincidence that in the 1960s Saint-Tropez became the centre for alienated youth seeking sensual emancipation in the sun, with Brigitte Bardot as their lovely goddess. Bardot first came to public attention in 1957, when she starred in Roger Vadim's *Et Dieu créa la*

39. *Woman with a Parasol*. 1905. Oil on canvas, 46 × 38 cm. Nice-Cimiez, Musée Matisse.
Madame Matisse, holding a parasol, stands on the seashore at Collioure, a small port by the Spanish border. The idea for the painting may have been suggested by the elegant lady carrying a parasol in Seurat's *La Grande Jatte*.

femme, filmed at Saint-Tropez. It is but a short step from the nymphs and naiads in Cross's paintings to starlets walking along the beach. For the beautiful people— and soon for society at large—leisure was no longer synonymous with idleness, it had become one of the normal expectations of life.

Important retrospective exhibitions of two of the fathers of modern art, Seurat and Van Gogh, were shown at the Salon des Indépendants of March 1905. Their work established alternative styles which Matisse explored at Collioure that summer: the former finished Neo-Impressionism as a stylistic option for him and the latter opened up possibilities he was to explore in Fauvism. The presence of Seurat's *A Sunday Afternoon on the Island of La Grande Jatte* of 1884–6 (Plate 38) in the same exhibition as *Luxe, calme et volupté* must have made Matisse realize that he had either to take up the challenge set by the Seurat or develop the landscape of leisure in a different direction. Both these enigmatic figure paintings are derived from landscape studies, and both attempt the fusion of the temporal with the timeless, the atmospheric with architectural order; yet the Seurat is of a scale, complexity, and ambition which place it in the company of the greatest works of the past, whereas the Matisse is an exciting but unresolved transitional painting, caught between expression through the representation of the figures and expression through colour.

Matisse's work of 1905 followed a similar pattern to that of the previous year. After the Salon des Indépendants closed at the end of April, he and his wife went south again for the summer, this time to the small port of Collioure, close to the Spanish border. A landscape painting that summer (see Plate 47) became the setting for his second imaginary composition, *Le Bonheur* (or *La Joie*) *de vivre* (see Plate 51). This painting, even larger than *Luxe, calme et volupté*, was executed in Paris during the winter, in a large studio space rented in the former Couvent des Oiseaux, rue de Sèvres.

Signac had painted at Collioure in 1887, and he probably recommended it to the Matisses. Collioure has some claim to be called the birthplace of Fauvism. André Derain joined Matisse there in July, and together they worked towards the emancipation of colour as a means of expression—rather in the same way as Picasso and Braque were to work together during the development of Cubism. The picturesque motifs of Collioure—which for artists without transport had the added advantage of being within easy walking distance—have become well known through Matisse's and Derain's paintings: the mountains around the little bay, the church tower sticking out above the rhythm of the roof-tops, masts seen swaying in the heat outside the cool interiors of small seaside rooms, olive trees swept along in the movement of some imaginary brush-stroke, and the emphatic form of the lighthouse at the end of the breakwater. Collioure was close enough to Spain for it to assume an exoticism in the eyes of the two painters and yet far enough away from Saint-Tropez and Neo-Impressionism for Matisse in particular to feel free to evolve his own style. Matisse continued to spend summers at Collioure until 1914. As it was on a main railway line, he could safely send canvases to Paris for exhibition without having to stop work and take them himself.

Matisse did not make an immediate break with Neo-Impressionism at Collioure in the summer of 1905. *Woman with a Parasol* (Plate 39) may be a preliminary study for another large Neo-Impressionist composition which was never carried out. Close scrutiny of the surface reveals an underlying grid; this suggests that it was squared up ready for transfer to a larger scale, a traditional academic working method. The use of an overall white ground to convey the luminosity of Mediterranean light recalls Signac's earlier observation: 'In this region there is nothing but white. The

40. *Landscape at Collioure*. 1905. Oil on canvas, 59.4 × 73 cm. Leningrad, Hermitage Museum.
Collioure became Matisse's regular base in the sun, and he responded to it with intense colours and brush-strokes of unprecedented variety and freedom.

41. Michel Eugène Chevreul. *Chromatic Circle of Hues*. First published in 1839.
The colour circle provided painters with an abstract scale, so they could compose in colour without being bound by the local colour of objects.

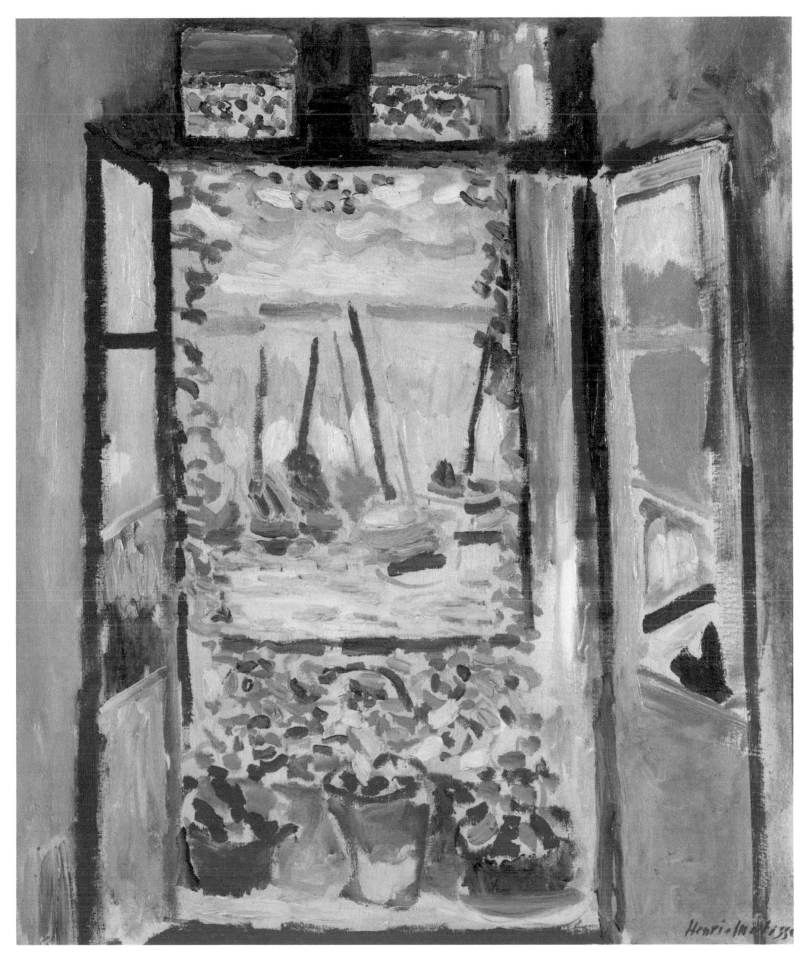

42. *The Open Window, Collioure.* 1905. Oil on canvas, 52.7 × 46 cm. New York, Mr and Mrs John Hay Whitney.
Matisse's balcony with pots of geraniums overlooks the harbour at Collioure. The architecture acts as a vehicle for light and colour. Overlapping rectangles of colour lead the eye into the composition. As much substance is given to some of the reflections in the window-panes as to solid objects. The natural transparency of viridian green and cobalt violet is exploited, allowing the ground to glow through.

light, reflected everywhere, devours all local colours and makes the shadows appear grey.' Even when Matisse had apparently abandoned Neo-Impressionism for his Fauve style, he still could paint a large Neo-Impressionist work, *Port of Abaill*, back in Paris that autumn. Perhaps he was at first unsure of his Fauve style and wanted to keep in with Signac.

Matisse's renewed involvement with Neo-Impressionism was to have a critical impact on his theory and practice as a colourist, but his relationship to it was ambivalent. He recognized in Neo-Impressionism the basis of his organization of colour, and yet his published statements invariably stress what were for him the expressive limitations of working to a system. Something of the effect it had on Matisse can be gauged by the fact that he came to characterize Fauvism as a reaction against Divisionism, the Neo-Impressionist technique:

> Fauvism overthrew the tyranny of Divisionism. One can't live in a house too well kept, a house kept by country aunts. One has to go off into the jungle to find simpler ways which won't stifle the spirit. The influence of Gauguin and Van Gogh were felt then, too. Here are the ideas of that time. Construction by coloured surfaces. Search for intensity of colour, subject-matter being unimportant. Reaction against the diffusion of local tone in light. Light is not suppressed, but is expressed by a harmony of intensely coloured surfaces.

Before discussing Matisse's Fauve paintings of the summer of 1905 at Collioure, we must be clear how Neo-Impressionism gave him the means to construct by coloured surfaces. It has become apparent that his ideas and assumptions about the nature and organization of colour derive from the writings principally of the scientists Michel Eugène Chevreul (1786–1889) and Ogden Rood (1831–1902) which were absorbed by the Neo-Impressionists. Neo-Impressionism can therefore be regarded as Matisse's major theoretical source, even though he was to put its laws to very different uses.

The main contribution of the Neo-Impressionists to an art of colour was the further systematization of the Impressionist palette to one approximating more closely to the spectral hues. Strictly speaking there are no prismatic colours on the artist's palette. The term 'prismatic colours' or 'hues' refers to particular wavelengths of the visible spectrum within the total context of electromagnetic energy. Paints, however, are substances which have the property of selectively absorbing and reflecting light waves. A so-called pure, prismatic colour such as bright cadmium orange on an artist's palette absorbs a percentage of all wavelengths of the visible spectrum except the orange, which is reflected and perceived by the eye. So there is an inherent distinction between colour as light and colour as paint, each with its own primary or fundamental colours from which all the other colours can be mixed. The primaries of paint—red, yellow, and blue—are called the subtractive primaries, because they darken towards black when mixed; whereas the light primaries—red, green, and blue—are called the additive primaries, because they lighten towards white light when their wavelengths are blended. The matter is further complicated by the existence of a third set of primaries in the brain—the psychological primaries, red, yellow, green, and blue.

Nineteenth-century writers on colour often confused the light primaries and the pigment primaries of paint; nevertheless the concept of primary colours led to the formation of the colour circle. In Chevreul's celebrated *Chromatic Circle of Hues* (Plate 41), first published in 1839, each pair of the three pigment primaries—red, yellow, and blue—was mixed to give the three secondary colours, orange, green, and violet. The six colours, when equally spaced around the *Chromatic Circle*, with the complementary pairs—red and green, orange and blue, yellow and violet—

placed opposite each other, provided the basic framework of the circle. Each adjacent pair of the six colours was then mixed to produce twelve colours in all. The precise positioning of the colours in a colour circle varies according to whether it is based on the light or pigment primaries.

Numerous investigations were carried out into the ways colours could be combined to achieve pleasing results and different moods. Chevreul's famous definition of the simultaneous contrast of colours listed the changes that occur in the tone and hue of two colours placed side by side in strips. Colour in itself came to be seen as possessing the inherent power to affect appearances and mood, and to generate light. The colour circle finally provided the artist with an abstract scale, based like the musician's scale on scientific law, with which to construct in colour.

The Neo-Impressionists planned their compositions by mapping out the dominant colours and then putting in the reactive complementaries softly so as to harmonize with the overall tonal gradation into depth. At Saint-Tropez in 1904 Matisse had attempted to follow suit, without much success—as he admitted: 'I couldn't get into the swing of it. Once I had laid in my dominant, I couldn't help putting on its reactive colour equally intense.' This served to create a two-dimensional plane rather than a feeling of pictorial recession. He particularly liked the contrasting pair of cyclamen pink and turquoise green, precisely because red and green are the closest in tone of all the complementaries and therefore could be used to evoke light while maintaining the flatness of the picture surface.

At Collioure in 1905 Matisse continued the Neo-Impressionist practice of first establishing his dominant colours, but instead of small dots he employed large, flat areas of colour which he then would chop and change intuitively until he had achieved a balance of opposing forces. He later explained this new method to his son-in-law, Georges Duthuit: 'I painted flat seeking to obtain my quality through an accord of all the flat colours. I attempted to replace the vibrato by a more expressive, more direct accord, whose simplicity and sincerity would give me more tranquil surfaces. Since I have a local form, a leg for example, I should logically have a flesh tone. I find myself obliged however to use a vermilion: my red, green, and blue harmony suffices to create the equivalent of the spectrum.' It is worth noting that Matisse followed the Neo-Impressionists in his conception of colour as light, and here selects the light primaries, red, green, and blue.

Almost as a reaction to the discipline of Neo-Impressionism, Matisse executed a number of small-scale, uninhibited landscapes, inspired by the painted sketches of Signac and Cross. The lovely *Landscape at Collioure* (Plate 40) is one of the most considered of his Collioure landscapes; an infra-red photograph reveals a detailed drawing, which acts as an armature or framework on which the planes of colour are built.

Matisse used his knowledge of the colour circle to create a new form of pictorial architecture in colour, whereby painterly passages of great beauty might be sustained in a mixed technique, without loss of atmospheric unity. This is nowhere better seen than in *The Open Window, Collioure* (Plate 42). Atmospheric unity is conveyed by the very pale beige ground, which breathes through even the large planes of flat colour to create the sensation of an overall field of light—as in a watercolour wash technique. The flat planes of turquoise green and cyclamen pink, placed either side of the open window, are linked by a passage of ultramarine blue at the top of the painting to form the triad of the light primaries, which is repeated in delicate pale tints in the seascape outside. Two colours, vermilion and ultramarine, activated by green and orange, their respective complementaries, emphasize the centre of the composition in the interior and balance the movement of the boats outside.

44. Van Gogh. *Self-Portrait with Fur Cap, Bandaged Ear, and Pipe.* 1889. Oil on canvas, 50.8 × 45.1 cm. Stavros S. Niarchos Collection.
Van Gogh was the main influence behind a series of Fauve portraits painted by Matisse and Derain in 1905.

43. *Portrait of Derain.* 1905. Oil on canvas, 39.3 × 28.8 cm. London, Tate Gallery.
Derain's head is turned nervously away from the spectator, with the main features drawn in a fluid tint of cobalt blue. The portrait radiates light, created by colour contrasts and by the white ground, which is often left exposed between the colours.

Matisse's spirited use of bold, contrasting colours was stimulated by his new interest in Van Gogh and by his friendly rivalry with Derain, who had recently arrived at Collioure. Matisse himself acknowledged the influence of Van Gogh's paintings, which 'encouraged him to strive for a freer, more spontaneous technique, for intenser, more expressive harmonies'. Significantly, Matisse had been chairman of the hanging committee of the retrospective exhibition of Van Gogh's work at the Salon des Indépendants earlier that year. Like Matisse, Van Gogh was introduced to an art of pure colour by Signac, while his colour theory derived from Charles Blanc's *Grammaire des arts du dessin*, and from Blanc's writings on Delacroix. Van Gogh was obsessed with balancing contrasting colours; what is more, he wanted to harness the expressive power of pure colour in his characterization of personality. In June 1890 he wrote, 'What impassions me most—much, much more than all the rest of my work—is the portrait, the modern portrait. I seek it in colour, and surely I am not the only one to seek it in this direction.'

Matisse responded directly to this ambitious programme set by Van Gogh in a striking series of Fauve portraits. The initial developments in freer brushwork and colour at Collioure were made in landscape painting, and it proved an extremely difficult task for him to reconcile these qualities with the discipline of portraiture. Matisse may well have had in mind Van Gogh's *Self-Portrait with Fur Cap, Bandaged Ear, and Pipe* (Plate 44), exhibited at the Indépendants, when he began his *Portrait of Derain* (Plate 43). Like Van Gogh, Matisse isolates the figure by colour contrasts from a background divided into two different colours. A triad, composed of large planes of chrome yellow, viridian green, and cobalt blue, frames Derain's head, which is further distinguished from the green and blue background by their respective complementaries, red (in the beret) and orange (in the tints of the face). In contrast to his methodical organization of the colour relationships, the actual paint is applied *alla prima* (wet-in-wet) with unprecedented freedom and variety of touch. Derain's smock is relatively sparsely painted in long brush-strokes, while the greatest weight of pigment is concentrated on the head and neck. The background, in comparison, is broadly brushed.

Derain had joined Matisse at Collioure in July. Their paintings executed from then to September established the Fauvist style first seen in public at the Salon d'Automne that autumn. Derain celebrated his twenty-fifth birthday at Collioure. Not only was he eleven years younger than Matisse but his development as an artist had been interrupted by three years' military service, from the autumn of 1901 to September 1904. Despite this handicap, he was already considered by a number of contemporaries as a more exciting prospect than Matisse; the dealer Ambroise Vollard felt sufficiently confident of his talent to sign a contract with him in February 1905. In October 1904, Derain had resumed painting with his friend Vlaminck at Chatou, one of the Impressionists' old haunts on the Seine. By the time of the Salon des Indépendants of May 1905, Derain had painted canvases in a Fauve style. Matisse visited Derain and Vlaminck at Chatou early in 1905, when he probably invited Derain to join him at Collioure.

When Derain arrived at Collioure, Matisse was going through a crisis, caused by his efforts to shake off Divisionism. From the evidence of his paintings and published correspondence with Vlaminck, Derain's understanding of colour theory was very limited. In a letter to Vlaminck of 28 July 1905, he talked about his discovery of luminosity and colour in shadow as though Impressionism had never happened. He even regarded Van Gogh's paintings as too theoretical. What he could demonstrate to Matisse, though, were the advantages of a much more spontaneous method of working (see *Portrait of Matisse*, Plate 46). In contrast to Matisse, who painted little more than twenty canvases over the summer, Derain

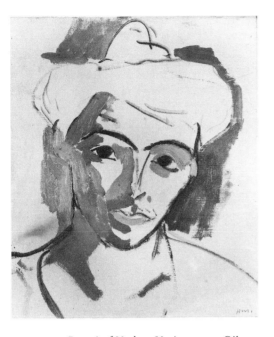

45. *Portrait of Madame Matisse*. 1905. Oil on canvas, 46 × 38 cm. Nice-Cimiez, Musée Matisse.
This is a preliminary version of *Portrait with the Green Stripe* (see Plate 49). The main features are drawn in a bluish tint of violet, and the shadows are blocked in to model the head. Rather than execute sketches, Matisse would often proceed to a definitive statement by way of such preliminary versions on canvases of a similar size.

expected to complete some thirty canvases, twenty drawings, and fifty sketches during July and August alone.

Apart from Neo-Impressionism and Van Gogh, the third great influence on Matisse's work at Collioure was Gauguin. Matisse owned a painting by Gauguin, and he surely saw the Gauguin exhibitions at the Salon d'Automne in 1903 and at Vollard's in 1904 and in 1905. In 1903 Gauguin died in the Marquesas Islands in the Pacific, and by chance the greater part of his last paintings were being looked after by his friend Daniel de Monfreid, at Corneilla de Conflent near Collioure. Thanks to Aristide Maillol, a member of the Nabis who turned to sculpture when his eyesight began to fail in the late 1890s, Matisse and Derain were able to visit de Monfreid in the summer of 1905.

In a letter of 14 July 1905 to Signac, Matisse wrote that he was unhappy about the relationship between line and colour in *Luxe, calme et volupté*. Only Gauguin, he told a friend, could help him in this situation. And undoubtedly it was Gauguin's work which suggested to him a way of resolving the conflict between line and colour by means of a more overtly decorative style, using flatter areas of colour articulated by sinuous linear arabesques. Gauguin's influence is very apparent in *Landscape at Collioure* (Plate 47), which served as a study for *Le Bonheur de vivre* (see Plate 51). But although the actual colours within the sweeping trunks and branches are laid on in much flatter areas than before, the disposition of the hues owes more to a Divisionist system of contrasts than to Gauguin. Even in his most Gauguinesque works at Collioure, Matisse continued to use colour contrasts to evoke light and create pictorial depth.

On his return to Paris in September, Matisse rounded off his summer's work with two celebrated portraits of his wife: *Woman with the Hat* (Plate 48) and *Portrait with the Green Stripe* (Plate 49). The former was exhibited at the Salon d'Automne, which opened on 18 October, while the latter was still in progress during the exhibition. They are very different. In *Woman with the Hat*, Madame Matisse glances round from under the hat, which is as much the subject of the painting as the sitter. In *Portrait with the Green Stripe*, which was preceded by a preliminary version (Plate 45), the problem of expressive characterization in colour is literally tackled head on, giving immediate access to both personality and colour. The green stripe emphasizes the vertical division of the face into two halves—yellow on the left and pink on the right.

It is all too easy to summarize Matisse's paintings of the summer of 1905 as a synthesis of the successive influences of Neo-Impressionism, Van Gogh, and Gauguin; but that is not how the general public reacted to such paintings as *The Open Window, Collioure* and *Woman with the Hat* when exhibited at the Salon d'Automne. Matisse found himself branded as a member of a bunch of wild beasts (*les fauves*, from which Fauvism gets its name), the latest artists to be accused of flinging a pot of paint in the public's face. The publicity was not entirely unwelcome, but Matisse was taken aback by the hostility of the reaction to his work.

There is some confusion as to the naming of Fauvism and when the term was first used. According to Matisse the epithet 'Fauve'—which was never accepted by the painters concerned—was coined by the critic Louis Vauxcelles. On entering the *cage centrale* (central room) of the Salon d'Automne, Vauxcelles spotted an Italianate bust by the sculptor Marque surrounded by the paintings of Matisse, Derain, Vlaminck, Manguin, Marquet, and Puy and exclaimed, '*Tiens, Donatello au milieu des fauves*' ('Look, Donatello among the wild beasts'). Whatever the truth in this, the epithet stuck.

Unlike the Salon des Indépendants, the Salon d'Automne included a much wider

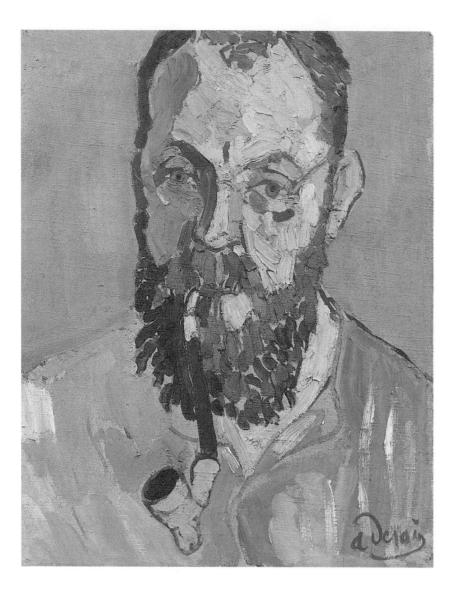

cross-section of work than just the contemporary avant-garde. To those unused to the Fauve conventions, their paintings must have appeared raw, primitive, and almost incoherent when hung alongside the smooth illusionism of academic art. Even the Fauves' most ardent supporters experienced some difficulty with their art. Leo Stein, who bought Matisse's *Woman with the Hat*, could still describe it as 'the nastiest smear of paint I had ever seen'. However, warned by the recent acceptance of Manet as a new Old Master after initial hostility, informed critics did not want to be caught out twice and were therefore on the whole guarded in their opinions.

In their efforts to make modern art acceptable, sympathetic critics neglected to bring out an important point about Fauvism which the public appreciated intuitively: Fauvism was very much a youthful Romantic rebellion against the moral strictures and values of that section of society which frequented art exhibitions. So it is not surprising that these people should have reacted adversely. The Fauves wanted to push aside all bourgeois conventions and base their art on their instinctive responses to experience and to their pictorial means. Vlaminck's description of his own working method exemplifies the Fauve approach: 'I heightened all my tone values and transposed into an orchestration of pure colour every single thing I felt. I was a tender barbarian filled with violence. I translated what I saw instinctively without any method, and conveyed truth, not so much artistically as humanely.' And Matisse, not normally given to hyperbole, expressed much the same sentiment: 'I overdid everything as a matter of course and worked by instinct with colour alone.' One of the most perceptive of contemporary critics, the Nabi painter Maurice Denis, on entering the *cage centrale* at the Salon d'Automne, felt that he was right in the middle of the 'domain of abstraction'. He did not mean

47. *Landscape at Collioure.* 1905. Oil on canvas, 46 × 55 cm. Copenhagen, Statens Museum for Kunst.
The style of this landscape, which served as a study for *Le Bonheur de vivre* (see Plate 51), is indebted to Gauguin. However, unlike Gauguin, Matisse uses colour to construct pictorial space. The vermilion tree-trunks lead the eye towards the sea, which is linked to the foreground through the repetition of blue.

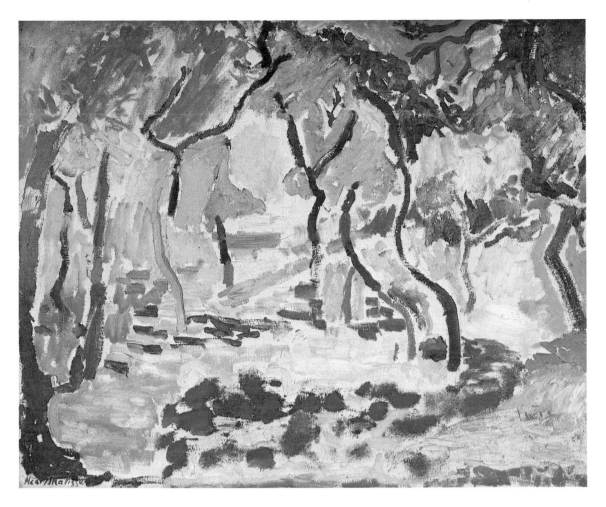

48. *Woman with the Hat.* 1905. Oil on canvas, 81 × 65 cm. San Francisco, private collection.
It conveys the freshness of colour and atmosphere characteristic of Matisse's work at Collioure. So it comes as a surprise to learn that Madame Matisse posed for it in Paris wearing a black dress and black hat against a white wall. Like the hat, the colour scheme was therefore an imaginative *tour de force*.

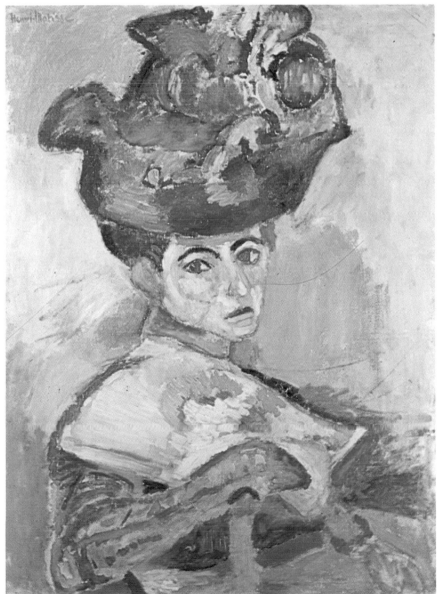

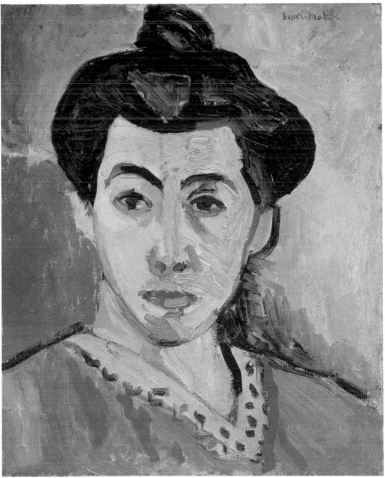

49. *Portrait with the Green Stripe.* 1905. Oil on canvas, 40.5 × 32.5 cm. Copenhagen, Statens Museum for Kunst.
The traditional technique of employing light and shadow to model form is here synthesized into a chromatic balance of flat areas of contrasting colours, calculated to unite foreground and background in a frontal portrait of hieratic stability and great psychological insight.

abstraction in our modern non-representational sense, but abstraction as operating outside all contingencies except the actual act of painting.

For Matisse Fauvism was more a period of awakening to the expressive possibilities in colour than a time when he achieved a mature style. His small-scale Fauve paintings of the summer of 1905 are comparable to his earlier Impressionistic landscapes in which he developed material later to be transformed in a large exhibition piece. Before the reaction to the Salon d'Automne had died down, Matisse was hard at work on his second great imaginary composition *Le Bonheur de vivre* (Plate 51), which was to be his only exhibit at the Salon des Indépendants in March 1906.

Le Bonheur de vivre is a key work in Matisse's evolution, and it is to be regretted that the regulations of the Barnes Foundation in Merion, Pennsylvania, do not permit the reproduction of their paintings in colour. Broad areas of pure, flat colour are articulated by sinuous arabesques to provide the setting for a harem of oriental women in the West. A ring of figures tread out a dance by the sea, emphasizing the posed immobility of the nudes in the foreground. A solitary little piping shepherdess looks back over her shoulder as she leaves them to luxuriate in the joy of life. We can well imagine Matisse as he painted them murmuring the first lines of Mallarmé's *L'Après-midi d'un faune* (*A Faun's Afternoon*):

> I desire to perpetuate these nymphs.
> So luminous,
> Their light rosy flesh, that it hovers in the air
> Drowsy with tufted slumbers.

Nothing in Matisse's *œuvre* to date prepares the viewer for the chromatic shock of *Le Bonheur*. The glazed expanses of oranges and yellows create an atmosphere of enveloping warmth. Above the blue strip of water in the background the sky is painted in pale pink. Smaller areas of green, such as the foreground bank of grass, subtly counterbalance the warm hues and set off the flesh tones of the nudes. Our attention is first focused on the two central reclining nudes; they are much larger than even the nudes in the foreground, and their bright red outlines are dramatically enhanced by the surrounding broad bands of contrasting green. The two are reversed images of the same pose; their reciprocity informs the colouring of their hair in the complementary colours orange and blue (complementary pairs, it should be remembered, are mutually enhancing colours, where the after-image of one is the colour of the other). The hair of the nude on the left is orange glazed with brown, and the hair of the nude on the right its complementary dark blue. Glazing is the technique of using transparent films of paint, rich in oil, so the colour underneath glows through.

Le Bonheur is nearly six by eight feet and demanded considerable organization to integrate all the different elements. Matisse went about it in a characteristically methodical way. As with *Luxe, calme et volupté*, the landscape setting and general colour scheme were established in a landscape painting executed the previous summer (see Plate 47). At least three small oil studies were produced to work out the placement of the nudes in the landscape setting. Numerous drawings were made of a model in all the different poses seen in the painting; for the reclining nude playing the twin-pipes in the foreground, the elbow of the model had to be propped up on a pillow in the studio. Finally, the whole composition was rehearsed in a full-scale cartoon.

The outstanding source for *Le Bonheur* lies in Gauguin's paintings and woodcuts. The general composition echoes the arrangement of such works as *Te Arii Vahine*

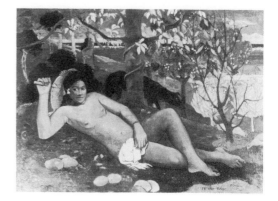

50. Gauguin. *Te Arii Vahine* (*Queen of Beauty*). 1896. Oil on canvas, 97 × 130 cm. Moscow, Pushkin Museum of Fine Arts. Gauguin was the outstanding influence on the vision and style of Matisse's *Le Bonheur de vivre*. The subject of the exotic earthly paradise was to preoccupy Matisse throughout his life.

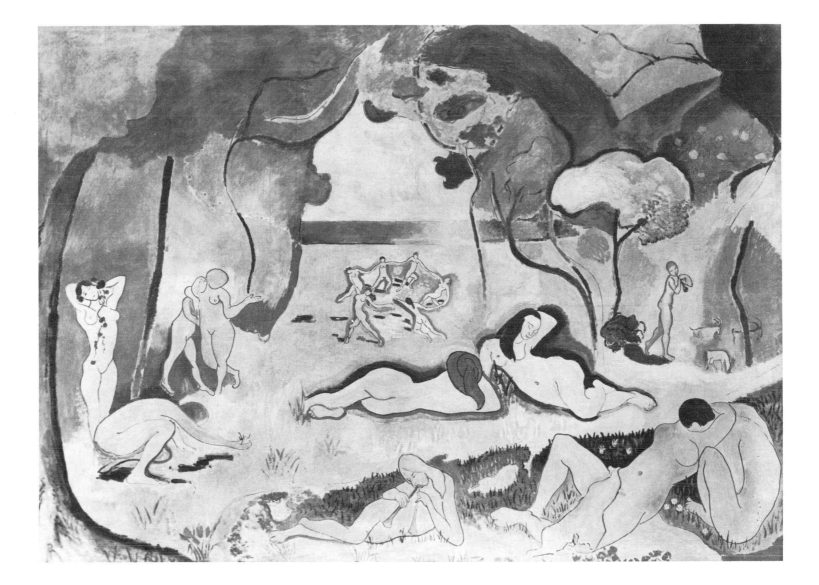

51. *Le Bonheur de vivre* or *La Joie de vivre* (*The Joy of Life*). 1905–6. Oil on canvas, 174 × 238.1 cm. Merion, Pa., Barnes Foundation.
The painting is the second of Matisse's great imaginary compositions and a seminal work in his evolution. In it are seen for the first time many of the figure groups and themes—such as the ring of dancers—which he was to develop in some of the most magnificent compositions of his maturity.

(*Queen of Beauty*) (Plate 50), described by Gauguin in a letter to Daniel de Monfreid of April 1896: 'A nude queen reclining on a green lawn, a servant girl picking fruit, two old men by the big tree arguing about the tree of knowledge, in the background the sea.' De Monfreid also owned a woodcut of this composition by Gauguin. The moralizing aspect of Gauguin's work is not present in *Le Bonheur*, where the nudes—moved by music and the rhythm of the dance—luxuriate in the warmth of light and love, and in the sheer pleasure of just being. Nevertheless, it is impossible to account for the appearance of *Le Bonheur* without the precedent of Gauguin's vision of an earthly paradise.

The visual sources for earthly-paradise paintings, or landscapes of the Golden Age, go back to the Renaissance revival of classical myths in a contemporary setting. These were intended as hedonistic celebrations of the pleasures of existence—food, wine, love, and music—rather than abstruse allegories that required learned interpretation. Most famous among these compositions were the decorations for Alfonso d'Este's study at Ferrara, commissioned between 1518 and 1525. Titian's third painting for the project, *The Andrians* of 1523–5 (now in the Prado, Madrid), has many of the features seen in Matisse's *Le Bonheur*, including the two reclining women in the centre in reversed images of the same pose. In fact, Matisse may have turned to a specific engraved source for his composition, Agostino Carracci's *Reciprico Amore* (*Love in the Golden Age*) of *c.*1589–95, which shows a circle of dancers in the background. The subject was taken up in the nineteenth century

by among others Ingres and Manet, and—as we have seen—it informed Matisse's *Luxe, calme et volupté* via the paintings of Puvis de Chavannes, Signac, and Cross. *Luxe, calme et volupté* in turn inspired Derain's *The Age of Gold*, possibly begun at Collioure that very summer of 1905.

Both Ingres and Manet were given retrospective exhibitions at the Salon d'Automne of 1905. Manet's *Le Déjeuner sur l'herbe* (1863) shows a group of figures, partially derived from a sixteenth-century engraving, in a landscape setting curtained by trees, with water in the background. Ingres is a closer source for *Le Bonheur* than Manet. The entwined lovers in the bottom right-hand corner of *Le Bonheur* are adapted from the pair similarly placed in Ingres's *The Age of Gold* (1862), which also has a circle of dancers in the centre of the painting. Ingres carefully avoided the opportunity to paint an orgy, and chose instead to illustrate a slightly anaemic Miltonic paradise, overpopulated with ideal family groupings; the atmosphere of the painting is definitely chaste. Matisse and the Fauves found far more in common with the unabashed hedonism of *The Turkish Bath* of 1863 (Plate 52), the old Ingres's defiantly erotic dream. *The Turkish Bath* set a new standard in the distortion of the nude figure to convey emotion. One reviewer of the Salon d'Automne of 1905 saw in Ingres the ancestor of the young 'deformers'. Matisse himself felt that Gauguin's treatment of the figure had developed from that of Ingres.

The subject of *Le Bonheur de vivre* may be classical in origin, but the general vision, as well as the stylization of some of the figures and other details, owes a considerable debt to oriental art. (By oriental art, Matisse meant everything from Persian miniatures to Japanese prints.) It has recently been suggested that he based the standing nude and her crouching companion in the left foreground of *Le Bonheur* on two figures in Toru Kiyonaga's woodcut print *Visitors to Enoshima*. Even if it cannot be proven, the resemblance is close enough to show his affinity with Japanese art. The treatment of the isolated tufts of grass in a few spiky brush-strokes could have been taken from Persian miniatures, or he could equally have adopted this convention from Gauguin. Gauguin had given a more primitive inflection to that fusion of the classical and oriental which occurred earlier in the nineteenth century; Matisse repeated a description of Ingres as 'a Chinese lost in Paris'; Manet based his illustrations to Mallarmé's *L'Après-midi d'un faune* on drawings in Hokusai's *Manga*. What these artists were seeking was the setting or vision for a new Golden Age, not just to refresh a stale academic vocabulary or even simply to unite line drawing with their new interest in decorative, flat colour and pattern.

To account for *Le Bonheur* in terms of its borrowings helps us to understand the complexity of its sources and content but does little to explain its novelty for viewers at that time. *Le Bonheur* created a sensation at the Salon des Indépendants because of its size and colour, not its subject-matter. Pure, flat colours had been seen before, but not on such a scale. Even Matisse's former supporters were astounded. Signac, who saw the painting two months before the opening of the Indépendants, wrote to a painter friend, Charles Angrand, 'Matisse, whose attempts I have liked up to now, seems to me to have gone to the dogs. Upon a canvas of two and a half metres he has surrounded some strange characters with a line as thick as your thumb. Then he has covered the whole thing with flat, well-defined tints, which—however pure—seem disgusting.'

Soon after the opening of the Salon des Indépendants in March 1906, Matisse followed in the footsteps of Eugène Delacroix (1798–1863) and visited North Africa 'to see the desert'. Delacroix was regarded by the Fauves as the progenitor of

52. Ingres. *The Turkish Bath.* 1859–63. Oil on canvas pasted on wood, diameter 108 cm. Paris, Musée du Louvre.
The Turkish Bath was based on an account of a visit to a harem in Adrianopolis, which gave Ingres the opportunity to paint female nudes relaxing in different poses—one of Matisse's obsessive themes. Ingres had done much to restore to the female nude its status as a monumental genre in its own right.

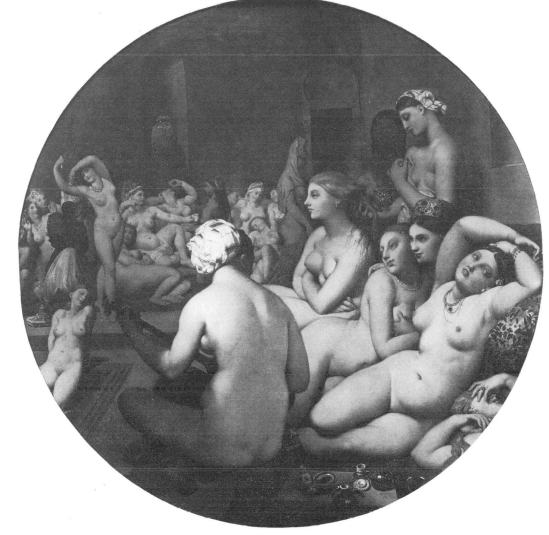

their preoccupation with light and colour. Matisse stayed at Biskra in Algeria for two weeks and then returned directly to Collioure, with some North African textiles and pottery, which appear in *Pink Onions* (see Plate 53). The only recorded painting done on the trip is the little panel *Landscape at Biskra* (Copenhagen, Statens Museum for Kunst), which is more an atmospheric study than a finished work.

At Collioure in 1906, Matisse neither tried to develop the style of *Le Bonheur*, or attempt to recapture that inventive spontaneity characteristic of his previous summer's work. Perhaps this was a time of retreat in the peace of Collioure in which he took stock of his recent rapid developments. The paintings of the summer of 1906 are marked by a greater realism than those of 1905, and his exploration of ways to combine light with structure is replaced by a renewed interest in the manipulation of colour as *matière*, the physical substance of paint itself. The evident conflict in his work between the imaginary and the real is more successfully resolved in the still-lifes than in the figure paintings, where the nudes quite understandably look ill at ease posed in the actual landscape. The portraits and figure studies of 1906 are distinguished by increasingly heavy emphasis on contours, but this is replaced in the still-lifes by a more sensitive dialogue between line and colour.

Pink Onions (Plate 53) is prophetic in its move to overtly decorative, flat colour. Matisse, apparently apprehensive about the simplicity of the solution, passed it off to Jean Puy as a work 'just painted by the Collioure postman'. He was to account for his first paper cut-outs in much the same way. Modelling is reduced to a minimum, and the background is simply split between blue and green. The matt evenness of

73

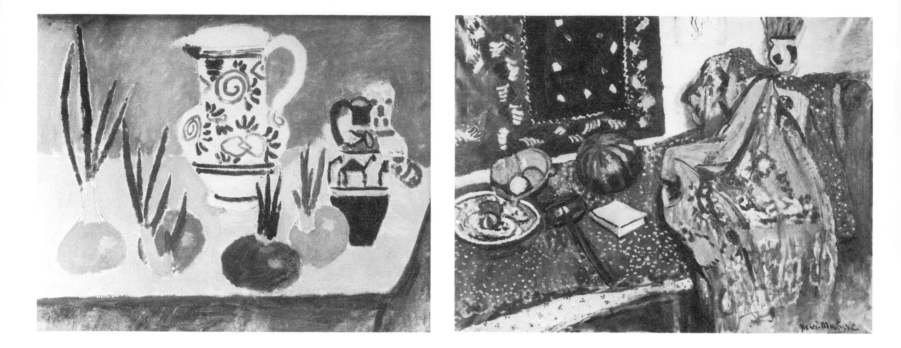

the paint surface anticipates his later technique which gives the effect of fresco. The more ambitious *Still-Life with Red Carpet* (Plate 54) has nothing of the stylistic homogeneity of *Pink Onions*. Some of the objects are modelled in thick paint, while the cream ground is revealed extensively in the green drape, tossed over the red table-cloth on the right. The inclusion of patterned fabrics and carpets enabled Matisse to reconcile an imaginary decorative art with the real world. However far fantasy might lead him, he never wanted to lose touch with reality.

The years 1904–6 were a period of exceptional progress in Matisse's art of colour. The vivacious audacity of his colouristic solutions was never really recaptured, as he himself acknowledged. In 1951 he told Tériade, 'Fauvism at first was a brief time when we thought it was necessary to exalt all colours together, sacrificing none of them.' Derain felt that it was a kind of fear of imitating life that informed the spontaneity of Fauve painting. He turned to the museums for guidance in achieving a more enduring art, but Matisse, who had only comparatively recently emerged from the museums, calling himself a 'student of the Louvre', was able to capitalize on the Fauve experience.

Matisse did not pursue several of the pictorial options opened up at Collioure until much later. It was, for example, only with the invention of the paper cut-out technique that he could resolve the conflict inherent in Neo-Impressionism between colour as idealized light and colour as *matière*. In the cut-outs, compositions were built up using paper evenly painted in gouache colours, reminiscent of his 1905–6 oil palette, and thereby leaving the expressive manipulation of *matière* to the oil paintings and large brush drawings. And it was only in the cut-outs that Matisse returned to balancing several complementary colour pairs in large flat areas within a single composition.

Matisse's Fauvism was a summation of the past as well as a portent of the future. The mixed technique was as much an attempt to come to grips with his stylistic sources as an investigation into new ways of handling primary colours. In retrospect the exuberant *tachisme* of 1905–6, that expressive manipulation of *matière*, was an episode against the grain of his art. The most lasting impulse behind his Fauve paintings was the move to a decorative ideal of timeless beauty inspired by Gauguin and by his own *Le Bonheur de vivre*, a painting which also provided an inventory of figure poses and groups that he was to develop over the next four years.

53. *Pink Onions*. 1906. Oil on canvas, 46 × 55 cm. Copenhagen, Statens Museum for Kunst.
The gourd, black pitcher, and four sprouting onions move around the composition in a rhythm set by the spiral motif on the central white jug. The creamy silhouette of Matisse's little sculpture of 1905, *Woman Leaning on her Hands*, is seen behind the black pitcher.

54. *Still-Life with Red Carpet*. 1906. Oil on canvas, 90 × 116 cm. Grenoble, Musée de Peinture et de Sculpture.
Matisse had included a carpet in his second still-life, painted in 1890. The carpet became a symbol of his lifelong wish to create a harmonious interior world out of flat colour and pattern.

4 *The Grand Decorations,*
1907-1910

Between 1907 and 1910 Matisse entered his maturity as a painter and developed a monumental decorative art culminating in *The Dinner Table (Harmony in Red)* of 1908–9 (see Plate 78), *Dance* of 1909–10 (see Plate 83), and *Music* of 1910 (see Plate 84). These three magnificent paintings were commissioned by the Russian merchant Sergei Shchukin as decorations for his baroque mansion in Moscow.

Matisse's financial situation improved dramatically. He was able to travel abroad regularly. His trip to Algeria in 1906 was followed by a visit to Italy in 1907. He made two trips to Germany in 1908, and a third in 1910 to see the enormous Islamic exhibition in Munich. In September 1909 he signed a contract with the Bernheim-Jeune gallery under the management of Félix Fénéon (who had probably been acting unofficially for him since 1906), and he moved with his family to a large house surrounded by a walled garden in the suburbs of Paris at Issy-les-Moulineaux. Although he was to lose the leadership of the Parisian avant-garde to his younger rival Picasso, his international reputation spread. His art began to be exhibited and published abroad. A growing circle of international collectors like Shchukin began to buy and commission work. The Steins—Leo, Gertrude, Michael and his wife Sarah—who were the first Americans and among the first collectors anywhere to buy Matisse, introduced him to other collectors and artists, including Picasso. Leo Stein's acquisition of three of his most difficult and challenging paintings, *Woman with the Hat* of 1905 (see Plate 48), *Le Bonheur de vivre* of 1905–6 (see Plate 51), and *Blue Nude* of 1907 (see Plate 55), must have given him enormous encouragement. Leo, however, later lost interest in Matisse; Michael and Sarah Stein—apart from Shchukin—were the most important collectors of his work up to 1914. Sarah in particular became a personal friend, founding, with the German Hans Purrmann, Matisse's school at the rue de Sèvres in the winter of 1907–8. The school not only brought in extra money but, as it was filled with foreign students, ensured him an additional network of contacts abroad.

Matisse's financial success and reputation were linked with his new status as leader of the avant-garde. At the Salon d'Automne of 1906 the term Fauve was again employed, and by 1907 it was in common usage. A large number of younger painters went through a phase of Fauvism as a way of coming to terms with developments in modern painting since Impressionism. On his way to Italy in the summer of 1907, Matisse interrupted his journey at La Ciotat, on the coast near Marseilles, to see Othon Friez (1879–1949) and Georges Braque (1882–1963), who were painting landscapes in a Fauve style—which, however, they were to abandon by the end of the summer. (Friez had one of the studios in the Couvent des Oiseaux where Matisse was working.) Variants of Fauvism soon flourished in

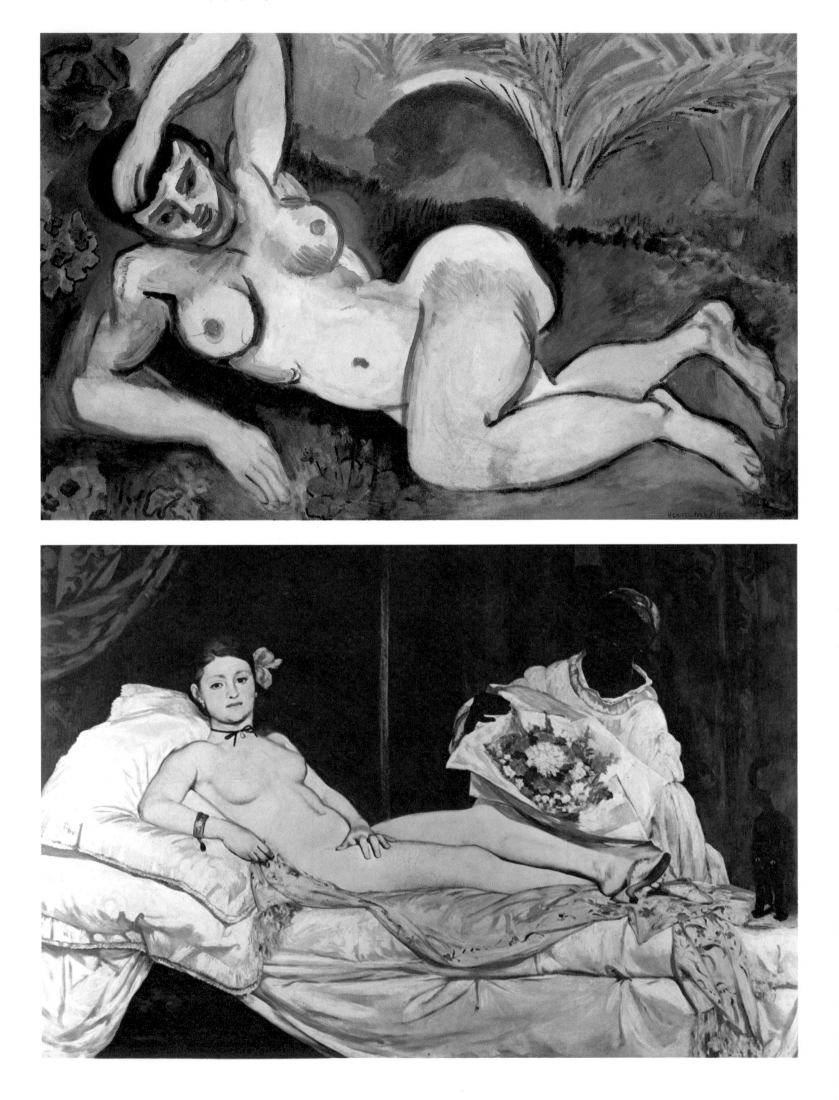

55. *Blue Nude—Souvenir of Biskra.* 1907. Oil on canvas, 92 × 140 cm. Baltimore Museum of Art, Cone Collection.
The figure is closely framed within the canvas format, and numerous different viewpoints are combined to ensure that each element is read separately. The linen-coloured ground of the canvas is left partly exposed to describe the flesh tones, and the emphatic blue contours (from which *Blue Nude* gets its name) are used to contain the expansion of the forms.

56. Manet. *Olympia.* 1863. Oil on canvas, 130 × 190 cm. Paris, Musée du Louvre.
Olympia confronted the spectators at the Paris Salon over forty years before *Blue Nude.* Its flatness, like Matisse's art later, was also remarkable—Courbet thought it looked like a playing-card.

57. *Le Luxe I.* 1907. Oil on canvas, 210 × 138 cm. Paris, Musée National d'Art Moderne, Centre Georges Pompidou.
Le Luxe was exhibited at the Salon d'Automne of 1907 as an *esquisse* or sketch, which indicates that either Matisse was hesitant about its style or he already had the second version, *Le Luxe II*, in mind. He took great care with the composition: two studies and a full-scale cartoon are now in the Centre Georges Pompidou. It has been suggested that *Le Luxe I* was completed before Matisse's trip to Italy in July.

58. Puvis de Chavannes. *The Poor Fisherman.* 1881. Oil on canvas, 157 × 191 cm. Paris, Musée du Louvre.
The Poor Fisherman established a precedent for the composition of *Le Luxe.*

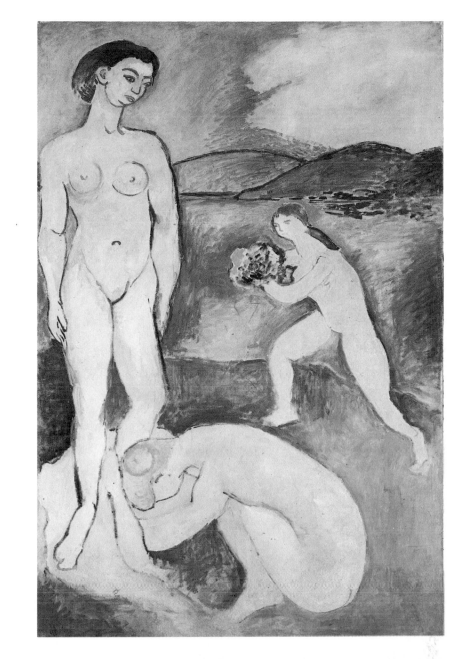

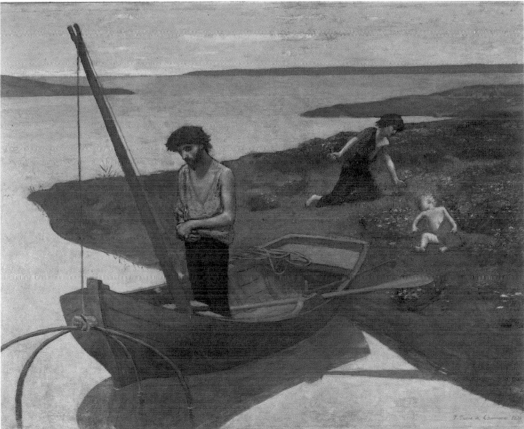

Germany, Russia, Belgium, Holland, Italy, England, and America. The German Expressionist painter Ernst Ludwig Kirchner (1880–1938), for instance, was strongly influenced by Matisse's first one-man exhibition in Germany, which opened in January 1909 at Paul Cassirer's Berlin gallery.

At the very time that Fauvism was being adopted by younger painters, Matisse himself was exploring alternatives to the archetypal Fauve style of the summer of 1905. His dissatisfaction with what he regarded as the excesses of this style should be seen in the context of a growing general disenchantment with novelty *per se* and a concomitant assertion of values sanctioned by tradition—in painting this took the form of a return to classicism. The exuberant immediacy and impact of such Fauve paintings of 1905 as *Landscape at Collioure* (see Plate 40), *The Open Window* (see Plate 42), and *Portrait of Derain* (see Plate 43) are still tremendously appealing, but for Matisse they did not have the scale and permanence of a grand decorative art. In *Le Bonheur de vivre*, as we have seen, he attempted to fuse Fauve colour with the subject-matter of the Golden Age. However, there is something nostalgic about the treatment of *Le Bonheur* which places it alongside other nineteenth-century images of the subject. The nudes tend to drift into deep space, which counteracts the immediate impact of the colour. Matisse now set out to integrate these figures from *Le Bonheur* with the flat surface of the picture in such a way that the subject-matter of an ideal state of being could be experienced as a fact. This coupling of serious intent with a highly decorative means of expression resulted in a new category of art—the decorative easel painting.

Concepts of the decorative lie at the centre of Matisse's intentions and achievements, and therefore call for definition. Broadly speaking, Matisse's ideas on decoration fall into three related areas, each of which had been anticipated in the concerns of the avant-garde in the 1890s. Firstly, by 'decorative' he meant the pictorial autonomy of a work of art, whereby a painting was considered both as representation and as a decorative object in its own right, like a tapestry on a wall. This was partly a reaction against nineteenth-century Realism, but also a return to what was thought to be an earlier, more primitive or fundamental view of art, where distinctions between painting and decoration were not clear-cut. Matisse explained his position while defending his art against the charge that it was highly decorative, in the pejorative sense of superficial:

> The decorative is an extremely precious thing for a work of art. It is an essential quality. It does not detract to say that the paintings of an artist are decorative. All the French primitives are decorative. The characteristic of modern art is to participate in our life. A painting in an interior spreads joy around it by the colours, which calm us. The colours obviously are not assembled haphazardly, but in an expressive way. A painting on a wall should be like a bouquet of flowers in an interior.

On his visit to Italy in the summer of 1907, he was attracted to the decorative 'primitives' rather than to the artists of the High Renaissance.

Secondly, Matisse included in the decorative compositional questions relating to the way in which content is communicated in a painting. The decorative entailed respect for both the painted surface and the distribution of psychological emphasis. Matisse wrote:

> Expression for me does not reside in passions glowing in a human face or manifested by violent movement. The entire arrangement of my picture is expressive: the place occupied by the figures, the empty spaces around them, the proportions, everything has its share. Composition is the art of arranging, in a

decorative manner, the diverse elements at the painter's command to express his feelings.

Thirdly, decoration concerned the scale and function of painting. According to Matisse's daughter, decoration meant any painting larger than 2 metres, implying that an artist was unlikely to embark on a painting of that size unless it had been commissioned as a decoration for a specific location. The desire to do decorations was linked with the restitution of one of the main functions of art, the decoration of walls. Throughout his life Matisse kept in mind the vision of a public mural art. In 1942, the year after he survived a near-fatal illness, he told the poet Aragon, 'Perhaps after all I have an unconscious belief in a future life . . . some paradise where I shall paint frescoes.'

To the Western mind an art of serious decoration is a contradiction in terms. In Islamic cultures decorative pattern-making is understood as having a serious purpose: the beauty and harmony of forms and colours give praise to the Creator and hint of His order in Paradise. But in Western art the highest ideals have been communicated through the human figure. Matisse was now proposing to unite these two traditions, the oriental and occidental, in a new decorative art.

Any bland apologia for an art of harmonious decoration disguises the very real problems that it entails, as well as the nature of Matisse's achievement. To flatten or make a surface pattern out of a human figure would destroy its integrity, rob it of humanity, and repeat in a different manner the Impressionist subordination of the figure to patterns of light. No artist had ever been able to communicate the highest ideals without a profound understanding of the human figure, and the art of Michelangelo, for example, showed that this was unlikely to be achieved without maintaining its sculptural integrity. There was no simple solution to this problem—perhaps Matisse was attempting the impossible; but his struggle to resolve it led to some of the most moving paintings in twentieth-century art.

In 1907, Matisse resumed the treatment of the figure in two modes that had earlier been seen in his *académies* of 1899 to 1901. In comparison with the almost brutal immediacy of *Blue Nude* (Plate 55), the style and mood of *Le Luxe I* (Plate 57) is lyrical and nostalgic. It is as though Matisse were motivated by conflicting drives: on the one hand to possess the figure and make it somehow more assertive and 'real' than in reality, and on the other to create a traditional image of timeless beauty in harmony with its setting. In fact the relationship between the two modes is closer than might be expected. The exaggerated distortions of the former, when translated into the linear contours of the latter, enabled Matisse to sustain interest in simplified figures and further relate them to a stylized background. Both *Blue Nude* and *Le Luxe* originate from *Le Bonheur de vivre*: *Blue Nude* from the two central reclining nudes and *Le Luxe* from the standing nude and her crouching companion in the left foreground.

The full title of *Blue Nude* is *Blue Nude—Souvenir of Biskra*, which shows that it was painted in memory of his trip to the oasis of Biskra in Algeria the previous summer. A nude reclining beneath a grotto of palm branches was an appropriate personification of the pleasures of the oasis. In *The Fruits of the Earth*, a youthful paean to the joys of sensual experience, the novelist André Gide, a friend of Cross's, similarly characterized Biskra in terms of shady groves where each woman seemed to be waiting for him. Colonization was presented to the French as a glorious Romantic adventure. For some Europeans, certainly for Matisse, North Africa appeared to hold the key to a more instinctual response to experience, a world of sensual being at once more immediate and yet timeless. African irrationalism or

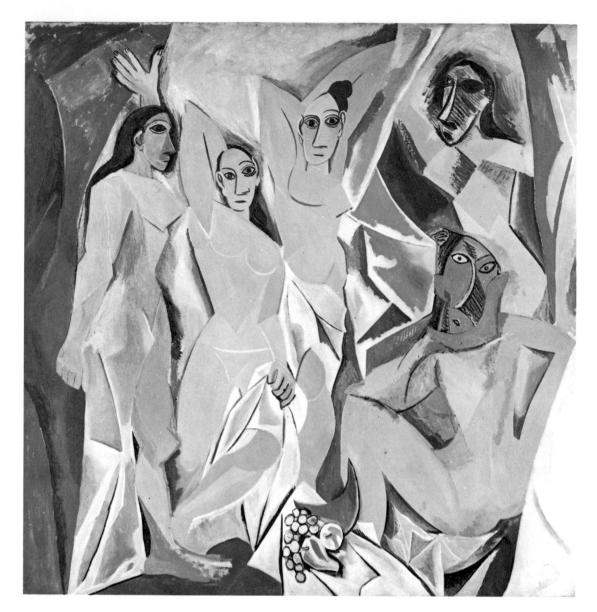

59. Picasso. *Les Demoiselles d'Avignon.* 1907. Oil on canvas, 244 × 233 cm. New York, Museum of Modern Art.
Matisse almost certainly saw this seminal painting in the autumn of 1907, although it was not exhibited until 1916, when it was given the title by which it is now known. The carrer d'Avinyo (rue d'Avignon) in Barcelona was then the site of a notorious brothel.

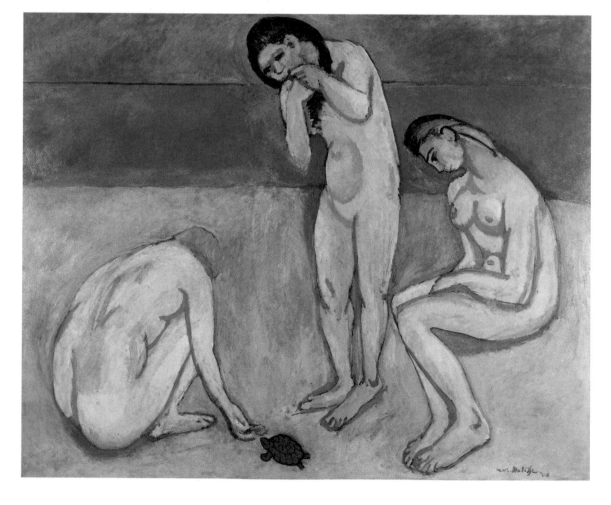

60. *Bathers with a Turtle.* 1908. Oil on canvas, 179.1 × 220.3 cm. St Louis Art Museum, gift of Mr and Mrs Joseph Pulitzer Jun.
Matisse sought to involve the spectator in the whole chromatic substance of the painting's surface. The bathers contemplate the turtle and we contemplate the bathers, taking our place in the centre of the circle left open for us.

61. *Reclining Nude I.* 1907. Bronze, 35 × 50 × 27.5 cm. Paris, Musée National d'Art Moderne, Centre Georges Pompidou. This sculpture, related to *Blue Nude*, became Matisse's personal symbol of his successful achievement of a sensual state of 'being' in solid form, and it features in several of his paintings, for example *Goldfish and Sculpture* of 1911 (see Plate 92).

emotion was contrasted with French logic. The African connection with Matisse is especially pertinent given his unstated programme to reawaken our capacity to experience—in particular, the emotive power of pure colour, and now that of the human figure, in a renewed language of artistic expression.

Blue Nude did for the figure what the Fauve paintings of the summer of 1905 had done for colour: its volumes are displayed across the canvas surface as autonomous areas of experience which link up to create the effect of the whole. In the two reclining nudes in *Le Bonheur* our eye courses over the sensual contours of the figures, whereas in *Blue Nude* every limb is exaggerated and assumes its own forceful identity. Extensive *pentimenti* around the left breast and right arm show that the forms were adjusted on the canvas itself until a visual balance was achieved.

Matisse first confronted us with the solid volumes of a nude in *Carmelina* of 1903 (see Plate 30). Manet had set a modern precedent for confronting the spectator with a reclining nude in his *Olympia* of 1863 (Plate 56). The wilful distortion of *Blue Nude* originated in Ingres's *The Turkish Bath*, but the means of achieving it in coloured volumes came from Cézanne. Matisse's *académies* of 1899 to 1901 were concerned, like Cézanne's *The Three Bathers* of *c.*1881–4, with the solid internal modelling of the figure in colour, whereas the paintings of 1907, like Cézanne's late bathers, emphasize the contours. This change enabled Matisse to reconcile the structural weight of the *académies* with a two-dimensional, decorative surface.

Blue Nude is not a harmonious painting, and it was not seen as one when exhibited at the Indépendants in March 1907. It was singled out at the Armory Show in New York in 1913, the first large exhibition of modern art ever held in America, as a symptom of everything from moral decline to madness, and when the exhibition moved to Chicago it was burnt in effigy by students in front of the Art Institute. A sympathetic defence of modern art against such hostile reactions often evades the fact that some paintings are difficult. Like Manet's *Olympia*, which suffered an equally vitriolic reception at the Paris Salon in 1865, *Blue Nude* appears to be defying, as well as exploiting, the conventions of nudity. There is no consistent reading of it. The mood of reverie conveyed by her self-absorbed gaze is broken by the harsh, staccato rhythm of her body's sculptural forms.

The transition from internal modelling to the surrounding contour in *Blue Nude* was accompanied by an exploration of the volumes of the figure in the same pose in the sculpture *Reclining Nude I* (Plate 61). The sculpture preceded the painting,

although it was completed afterwards. The painting was apparently begun as a substitute for the sculpture when it was damaged. There is a much more satisfactory relationship between style and content in the sculpture than in the painting. In the sculpture Matisse synthesized the concept of a sensual state of 'being' with a new type of dynamic harmony, expressed as a dramatic visual balance of opposing forces and forms. The upward movement of the model's raised left arm, twisted back behind the head, is balanced by her right arm, bent beneath the body as a support; the twist of the torso to the left is balanced by the hip and leg being thrown across the horizontal axis of the figure to the right. This is the equivalent in sculpture of Matisse's balancing of large flat areas of complementary colours in his Fauve paintings of 1905.

Matisse and his wife left Collioure for Italy in mid-July 1907. They visited Venice and then Padua, where Matisse studied Giotto's frescoes in the Scrovegni Chapel (c. 1306). In Florence they stayed with his new American friends, the Steins, at Fiesole, and made excursions to see Piero della Francesca's frescoes in the choir of San Francesco at Arezzo (c. 1452), and Duccio's great *Maesta* panels (1311) and other 'primitives' at Sienna.

The Matisses returned to Collioure in mid-August 1907. Inspired by the Italian trip, Matisse painted a life-size image of classical simplicity, *Le Luxe I*, in complete contrast to the muscular energy of *Blue Nude*. The principal nude figure, rising out of her discarded drapery, shy in her exposure, is a variant on the theme of Botticelli's celebrated *Birth of Venus* (1483), which Matisse would surely have seen in Florence. The crouching companion to the standing nude in the left foreground of *Le Bonheur de vivre* (see Plate 51) is turned round to attend her. A third nude runs in with a bouquet of flowers. The landscape is a schematic rendering of the view from Matisse's window at Collioure. *Le Luxe*'s mood of elegiac melancholy is anticipated in Matisse's sculpture of a small sentinel figure, *Standing Nude* of 1906 (Plate 62), for which his daughter Marguerite posed. As Marguerite was approaching womanhood, *Standing Nude* and *Le Luxe* can be interpreted as a father's touching statement on the changing status of his favourite child.

In addition to the trip to Italy, the work of Pierre Puvis de Chavannes (1824–98) now stimulated Matisse's move towards a more classical vision of timeless simplicity in a mural style and technique. (Two years before his death in 1898, Puvis had supported Matisse's membership of the Salon de la Société Nationale des Beaux-Arts.) In *Tamaris* (c. 1885) Puvis revived a classical subject, symbolizing a celebrated Mediterranean watering-place with a reclining figure; Matisse followed suit in *Blue Nude*. Puvis's *Pleasant Land* (c. 1882), 'a poem of ancient happiness', is one of the main sources for Matisse's *Luxe, calme et volupté*, and his celebrated *The Poor Fisherman* of 1881 (Plate 58) is an important source for *Le Luxe I*.

Other paintings by Puvis are obviously closer to *Le Luxe I* in subject-matter than is *The Poor Fisherman*, so that the connection between these two paintings in terms of mood, composition, and colour has never been given due attention. Both paintings include a dominant standing figure in a three-figure group, which is closely related to a background banked up behind in the alternating rhythm of land, sea, and sky. *The Poor Fisherman* has no subject in a narrative sense, and it expresses the idea of poverty in its form, just as the subject of *Le Luxe* is expressed rather than illustrated. In *Le Luxe*, Matisse abandoned the extrovert gaiety of his Fauve style for the remoteness of Puvis's figures. His colour scheme and technique similarly changed from the exuberant colour contrasts and expressive brushwork of the Fauve paintings to flat areas of bleached colour, close in effect to the colour of *The Poor Fisherman*, rudely described by the novelist Huysmans as 'an old fresco eaten up by moonbeams and washed away by rain'.

62. *Standing Nude.* 1906. Bronze, height 48 cm. Private collection.
Matisse's preoccupation with decorative figure paintings was preceded by a renewed interest in sculpture. The pose and mood of this sculpture anticipates *Le Luxe I*.

Matisse evidently wanted to achieve a fresco effect reminiscent of Italian mural decoration, for he did a second, even more simplified version of *Le Luxe*. Significantly, it is executed in monochromatic areas of evenly applied, matt distemper, a medium most commonly used in scene painting. *Le Luxe II* was probably painted in 1908, although it has been dated as late as 1911, when Matisse was again interested in a fresco effect.

Back in Paris in the autumn of 1907, Matisse sent five paintings to the Salon d'Automne, including *Le Luxe I* and *Music* (see Plate 73), discussed below, each labelled as an *esquisse* or sketch. The Salon marked the zenith of his reputation as *le roi des fauves*, king of the wild beasts. His position as leader of the avant-garde was already being challenged by Picasso, who was nearly twelve years younger. Derain moved away from Matisse and joined the circle around Picasso in 1906. Braque abandoned his La Ciotat Fauve style towards the end of the summer of 1907 at L'Estaque; his *View from the Hotel Mistral, L'Estaque*, executed in simplified masses and a restrained palette, announces the beginnings of Cubism, which he subsequently developed in close association with Picasso.

Pablo Picasso (1881–1973) first came to Paris from Barcelona in 1900 for the Universal Exhibition. He had certainly met Matisse by the spring of 1906, probably at one of the weekly Saturday evening salons held by Leo and Gertrude Stein at 27 rue de Fleurus, and he sometimes attended Matisse's Friday evening gatherings. Picasso and Matisse are reported to have discussed the Manets on exhibition at the Durand-Ruel gallery in March 1906. They went as far as to exchange paintings—a sure sign of profound mutual respect. Although their personalities and backgrounds were poles apart—Picasso literally referred to Matisse and himself as the North and South Poles—each recognized in the other from the outset his only serious competitor for the leadership of the avant-garde. Their intense rivalry acted as a powerful stimulus in their respective careers; when Matisse died in 1954, Picasso movingly said, 'Yes, he is dead, and as for me, I continue his work.'

In *Standing Nude* (Plate 63), painted in Paris in the autumn of 1907, Matisse continued the structural mode of *Blue Nude* in a harsher, more angular style. If *Blue Nude* had expressed his memories of Africa in a Cézannesque style, *Standing Nude* was now in an African style inspired by Picasso. In Matisse's first interview, published in December 1907, the poet Apollinaire discusses his art with reference to a variety of primitive sources, including 'the statues of African Negroes proportioned according to the passions which inspired them'. Passion, however, is not the word that springs to mind when describing *Standing Nude*. It is an extremely awkward structural analysis of the human figure in terms of simplified volumes, which are heavily outlined in black. The body looks like an African sculpture, in the pose of Rodin's *The Walking Man* (see Plate 23), with an over-large European head stuck on at an angle.

In 1907 African sculpture became a very important source for avant-garde artists exploring new formal and expressive figurative conventions. Apollinaire pointed to Matisse's interest in the relationship between the distortions of African sculpture and the expression of emotion. In African sculpture forms are simplified and exaggerated to convey a general concept, such as fear or fecundity, rather than the complex feelings of one human being for another. The Fauves were similarly concerned with the expression of generalized states of mind. In addition, African sculpture provided Matisse with the means to reinvest the nude with primordial significance. The fact that he knew very little about the cultures from which the sculpture originated and yet found himself profoundly moved by them was all the

more convincing proof that the human figure was a very potent medium of communication, if the message was simply and forcefully expressed.

Nothing illustrates the mutual interaction between Matisse and Picasso more graphically than a comparison between Matisse's *Standing Nude* and Picasso's seminal painting *Les Demoiselles d'Avignon* (Plate 59) in relation to their respective uses of African sculpture. Matisse apparently introduced Picasso to African sculpture early in 1907. Picasso was already at work on the studies for a large brothel scene, *Les Demoiselles d'Avignon*, inspired by Matisse's *Le Bonheur de vivre* (see Plate 51). But Picasso's serious interest in African sculpture only came after a visit to the Trocadero, the ethnographic museum in Paris, in May or June 1907. He then repainted the two figures on the right and the one on the left of *Les Demoiselles* with the brutal simplifications of some African masks. Matisse's one-off response to *Les Demoiselles* was *Standing Nude*; stylistically there is nothing else like it in Matisse's œuvre. Picasso himself produced a postscript to *Les Demoiselles* called *Nude with Drapery*, which is similar in pose to *Standing Nude*, although more extreme in the stylistic distortions of the figure.

Les Demoiselles ended the Fauve impetus to exaggerate and shock. Matisse could not compete with Picasso's wilful distortions and deliberate technical crudity, appropriate perhaps for a brothel scene but not for Matisse's aspiring 'art of balance, of purity and serenity, devoid of troubling or depressing subject-matter'. In response to the challenge of Picasso, Matisse was to develop the theme of nudes posed by the sea into a monumental decorative art stemming ultimately from Giotto. The result was *Bathers with a Turtle* of 1908 (Plate 60), the first great work of his maturity, and certainly one of the most profoundly beautiful paintings of his whole career.

63. *Standing Nude*. 1907. Oil on canvas, 91.4 × 63.5 cm. London, Tate Gallery. Matisse is interested here in structure and not colour. The figure is painted in ochre surrounded by wide black contours. The brutal simplifications of its volumes reflects Matisse's new interest in African sculpture coupled with his response to Picasso's *Les Demoiselles d'Avignon*.

64. Louis Le Nain. *The Horseman's Rest*. c. 1640. Oil on canvas, 54.6 × 67.3 cm. London, Victoria and Albert Museum. Before Matisse, Manet had based his *The Old Musician* on this work by Le Nain. The self-contained mood of Le Nain's figures was as much a factor in the painting's appeal as their sculptural treatment in a composition resembling a classical relief.

Matisse was finally able to achieve what he had been working towards since *Luxe, calme et volupté*. *Bathers with a Turtle* presents as a challenging pictorial reality an elemental image of a harmonious state of being. The turtle, like some ancient symbol of a more leisurely age, crawls in as a near complementary accent, reddish-brown against green, to focus attention and initiate the circular rhythm which unites the three bathers, who are silhouetted against the triple horizontal bands of land, sea, and sky. The crouching bather tempts the turtle into the painting, the standing bather fingers her hair like the stops of a primitive flute, and the bather on the right sits absorbed in the harmonic structure of the whole.

In describing *Bathers with a Turtle* the word 'harmony' flows from the pen with an ease which does little justice to the intense process of study and refinement that brought the pictorial elements in the painting into a decorative accord. *Bathers* conveys a feeling of harmony through simplification, but awareness of its complexity commands our attention. What is at first sight an evenly painted field of colour, such as the blue of the sea, in fact fluctuates in intensity from deep Prussian blue to scumbles of lighter cobalt blue. The *pentimenti* around the bathers record previous positions in the final paint layer, so that traces of the painting's process become part of its content. We are challenged by distortions and displacements of scale which deny observable appearances, yet look perfectly natural within the context of the picture.

The immediate source of *Bathers with a Turtle* again lies in one of Matisse's own pictures, *Three Bathers* (Plate 77), painted at Collioure during the summer of 1907, which already includes the compositional arrangement of the figures and background. Louis Le Nain's *The Horseman's Rest* of c.1640 (Plate 64), Giotto's frescoes at Padua, and Cézanne's *Bathers* of c.1898–1900 (Plate 65), all played a

65. Cézanne. *Bathers.* c.1898–1900. Oil on canvas, 27 × 46.4 cm. Baltimore Museum of Art, Cone Collection.
Cézanne was an extremely important source for Matisse's compositions with bathers. Even if Matisse missed seeing this painting at the Salon d'Automne of 1904, he would undoubtedly have known it in the Steins' collection at 27 rue de Fleurus.

part in the imaginative transformation of Matisse's *Three Bathers* from a delightful painting of nudes on a beach to a monumental decoration which possesses the dignity, simplicity, and natural nobility of a great work of art.

The redness of the sunbaked earth of the south of France, which came through in the bright vermilion red and cadmium oranges in Matisse's Fauve palette, was gradually replaced, in his figure paintings after his visit to Italy in 1907, by the bleached greens and blues of Giotto's frescoes. Giotto's influence on Matisse, like Cézanne's, went beyond questions of style or formal sources. Few, if any, of Matisse's figures can be traced back to Giotto, but his work exemplified for Matisse the power of art to communicate serious content without recourse to literal description. 'A work of art', he wrote, 'must carry within itself its complete significance and impose that upon the beholder even before he recognizes the subject-matter. When I see the Giotto frescoes at Padua, I do not trouble myself to recognize which scene of the life of Christ I have before me, but I immediately understand the sentiment which emerges from it, for it is in the lines, the composition, the colour. The title will only serve to confirm my impression.' Matisse's subsequent career can partly be seen as an attempt to reconcile the spiritual qualities he recognized in Giotto with a new art of decoration. Towards the end of his life he stressed increasingly that Giotto was really the source of modern art, and he told his friend Bonnard that the attempt to find an equivalent to the art of Giotto was 'too important for a single lifetime'.

Cézanne's work provided a link between Giotto and Matisse's treatment of the bathers theme. Cézanne had died in 1906, and in 1907 retrospective exhibitions were held in his honour at the Bernheim-Jeune gallery in June and at the Salon d'Automne in October. A new view emerged of Cézanne as a classical figure painter in the tradition of Poussin, rather than as an Impressionist. Matisse illustrated his appreciation of the formal clarity of Cézanne's figures by contrasting them in his 'Notes of a Painter' with those of Rodin, for whom a composition was nothing but the grouping of fragments. Cézanne's *Bathers* provided a source for the poses of the crouching and seated bathers in *Bathers with a Turtle*, and it demonstrated how warm figures could be placed against a cool background of greens and blues. Looking ahead, it also anticipated the disposition of figures in active and passive groupings, within a shallow, relief-like space, in the second version of Matisse's Barnes murals of 1932–3 (see Plate 161).

In 1908 Cézanne was the main inspiration behind the development of a very different style of painting from *Bathers with a Turtle*: Cubism. Matisse himself may have played a part in the naming of Cubism. In September 1908 Georges Braque submitted six Cézannesque landscapes to the Salon d'Automne, in which his L'Estaque motifs were realized in simplified volumes. Matisse, who was on the jury which rejected all six, is reported to have said that Braque was 'making little cubes'. The charge was repeated by Louis Vauxcelles, who baptized Fauvism, in his review of Braque's exhibition at Kahnweiler's gallery in November 1908. Although Matisse at first resented Cubism, nevertheless the emergence of this radical, alternative style to his own posed a fresh challenge which he increasingly found that he could not ignore.

The Salon d'Automne of 1908 signalled the gradual eclipse of Matisse's reputation as leader of the Parisian avant-garde and, paradoxically, the rise in his international reputation. In December 1908 he published his influential 'Notes of a Painter' to defend his position against any adverse criticism or challenge. The 'Notes' were translated into Russian, German, and later English. His authority as a leading figure in the modern art world was enhanced by the success of his school. When the

66. *Portrait of Sergei Shchukin*. 1912. Charcoal on paper, 49.5 × 30.5 cm. Private collection.
The Russian merchant Sergei Shchukin was the most important collector of Matisse's work up to 1914. Matisse appreciated the spirituality and refinement of educated Russians. His secretary and companion for the last two decades of his life, Lydia Delectorskaya, was Russian.

Couvent des Oiseaux was sold by the government in the spring of 1908, Matisse had moved his studio, school, and family to spacious quarters in another expropriated convent, the Couvent du Sacré-Cœur, housed in the eighteenth-century Hôtel Biron, at the corner of the rue de Varenne and boulevard des Invalides. Hans Purrmann, the co-founder of Matisse's school, and the dancer Isadora Duncan were among the other inhabitants of the Hôtel Biron at one time or another. Rodin also moved there in 1908, and when he died in 1917 part of it was made into a Rodin museum.

Teaching put Matisse in an ambiguous position. Students from abroad flocked to his school expecting to be initiated into modern art by *le roi des fauves*, whereas Matisse believed that art education should be based on traditional life-drawing in combination with the study of nature and the greatest works of the past. Also he faced the perennial problem of the artist-teacher, that the more time he devoted to his students the less he had for his own work. Therefore, as his sales increased, he spent less time teaching. By 1909 his teaching sessions had become infrequent, and by 1911 they had ceased entirely.

With the exception of Marcel Sembat, Matisse's first major collectors were foreign. It can be argued that the level of innovation in French art was a reflection of public indifference, not interest, and that foreign patronage was largely responsible for its international reputation. In the main, the French only bought Matisse's early work in well-established Realist and Impressionist styles. Matisse's Fauve paintings of 1905 to 1907 relied on the patronage of Americans, the Steins and their circle. From 1907 Matisse's Scandinavian and German friends and pupils began to promote his work in their respective countries. *Bathers with a Turtle* (1908) was bought by the German collector Karl-Ernst Osthaus, who had commissioned a ceramic triptych (see Plate 71) from Matisse for his house at Hagen the previous year. From 1908 Matisse's evolving art of decoration appealed increasingly to Russian taste, and the Russians became by far and away the largest collectors of his work up to 1914. Franco–Russian commercial and cultural links were extremely close. By 1914 one-third of France's liquid capital was invested abroad, 25 per cent in Russia and only 10 per cent in the French colonial empire. Russian magazines such as *Apollo* and *Golden Fleece* promoted avant-garde French art. In 1908 three Matisses were included in a large Post-Impressionist exhibition in Moscow. In 1909 Diaghilev's Russian Ballet took Paris by storm and started the pre-World War I oriental craze.

The works by Matisse that went to Russia were bought by two wealthy Moscow merchants, Sergei Shchukin (1854–1936) and Ivan Morozov (1871–1921). Of the two, Shchukin was the more adventurous. He began collecting Matisse some time before Morozov, perhaps as early as 1904, and he came to play an influential role in the commissioning of Matisse's work. It was not until 1912 that Morozov began to compete seriously with Shchukin; Matisse appears to have skilfully exploited their rivalry.

With his beetle brows and Mogul head (Plate 66), Sergei Shchukin looked like an Oriental from off the steppes. He was the only one of six brothers with the ability to make money as well as spend it. His notorious brother Ivan kept an extravagant salon in Paris, attended by the leading figures in the art world of his day, ran through a small fortune, and ended up by committing suicide. By contrast, Sergei prospered, and he bought the magnificent baroque mansion in the centre of Moscow built by the Princes Trubetskoy. He retained its resplendently ornate interior, which he filled with what has since been confirmed as the best in avant-garde French painting, from Monet and Degas to Cézanne, Van Gogh, and especially Gauguin. He had a love of rich decoration and a passionate interest in

Egyptian art. Thus he was well equipped to appreciate Matisse and then Picasso, much to the consternation of accepted critical opinion in Moscow, and in Paris for that matter. He contacted Matisse on one of his visits to Paris in 1906, and from then on bought directly from his studio, rather than through a dealer.

Shchukin was an outstanding collector and patron with the vision and material means to inspire an artist to new heights with a commission. Matisse produced some of his most ambitious works in response to commissions, and it is unlikely, given his financial circumstances until the 1920s, that he would ever have embarked on his series of great decorations in 1908 without having Shchukin in mind. *A Game of Boules* of 1908 (Plate 68) was probably painted in response to Shchukin's request for a painting similar to Karl-Ernst Osthaus's *Bathers with a Turtle*, and *Nymph and Satyr* of 1909 (see Plate 82) may have been commissioned by Shchukin after Osthaus's ceramic triptych by Matisse, which had a satyr in the central panel. Shchukin required no further prompting. His commissions for *Dance* (see Plate 83) and *Music* (see Plate 84) followed early in 1909. *The Dinner Table (Harmony in Red)* of 1908–9 (see Plate 78) and *Conversation* of 1909 (see Plate 81) were certainly intended for Shchukin, even if they were not actually commissioned by him.

In the period 1900 to 1914, the shift in informed critical opinion from a consideration of a painting's subject-matter to a consideration of its formal content made possible a re-evaluation of still-life as a major genre. Roger Fry was Matisse's principal publicist in England and the propagandist of 'significant form'—the idea that a work of art conveyed meaning through its formal relationships rather than through its subject-matter. In 1902 Fry linked his experience of a Chardin still-life to one of the greatest works of figurative decoration: 'Just the shapes of those bottles and their mutual relationships gave me the feeling of something immensely grand and impressive and the phrase that came into my mind was "This is just how I felt when I first saw Michel Angelo's frescoes in the Sistine Chapel".'

In 1908 Matisse began to develop the still-life in an interior into a monumental decorative genre, but by a different route from his bathers compositions. Broadly speaking the bathers were conceived in Matisse's imagination and confirmed in studies of the figure, whereas the still-lifes, which derive from seventeenth-century Dutch painting and Chardin, arose out of his experience of actual objects. During the painterly process these objects were transmuted on to an imaginative plane, through relationships of form and colour. The outcome of Matisse's development of this new decorative genre was *The Dinner Table (Harmony in Red)* (Plate 78).

The Dinner Table (Harmony in Red) is one of the chief glories of the Hermitage Museum in Leningrad. Through the dramatic reduction and intensification of form and colour, Matisse transformed the subject of his *The Dinner Table* of 1897 (see Plate 10) into a large-scale decoration. Following the precedent set by Puvis de Chavannes, whose *Young Girls by the Sea* was titled *Panneau décoratif* at the Salon of 1897, Matisse listed *The Dinner Table (Harmony in Red)* in the catalogue of the Salon d'Automne of 1908 simply as *Panneau décoratif pour salle à manger* (Decorative panel for dining-room) in the collection of Monsieur Shchukin.

In a dining-room permeated by red, a maid, wrapped in her own thoughts, places a fruit dish on the equally red table. The red interior is balanced by the predominant green of the garden, seen through the large barless window which is placed on the wall like a picture within a picture. Every shape and colour plays an integral part in the pictorial dynamics of the whole. The blue fronds of the piece of patterned *toile de Jouy* material in Matisse's studio become antler-like forms which pin the table to the wall and galvanize the interior space into sweeping rhythms repeated in the curves of the branches outside. Yellow, tinged with orange, acts

67. Vuillard. *The Piano.* 1896. Distemper on canvas, 210 × 153 cm. Paris, Musée du Petit Palais.
Like Matisse's *Le Luxe II*, Vuillard's decorative panel is executed in distemper to give a matt, fresco effect. It anticipates Matisse's use of an overall surface pattern, like wallpaper, in *The Dinner Table (Harmony in Red)*. Wallpaper became popular in the nineteenth century as a relatively inexpensive way of giving the appearance of luxury.

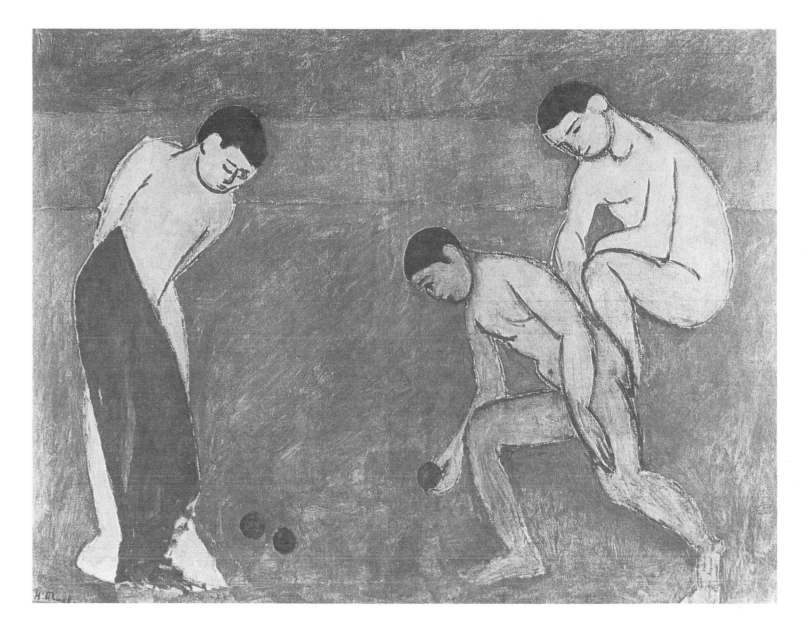

68. *A Game of Boules*. 1908. Oil on canvas, 113.5 × 145 cm. Leningrad, Hermitage Museum.

This was painted as a companion piece to *Bathers with a Turtle. Boules*, a form of bowls, which was becoming popular at that time, was accepted as having ancient origins. Thus the subject would have fitted in with Matisse's ambition to paint images of timeless harmony.

both as a barrier between the red interior and green exterior and as accents of colour and light which are played across the surfaces of the table and garden in the melodic lines of fruit and flowers. The way in which Matisse makes colour function as object, and object as colour, on an overwhelmingly decorative surface, which at the same time conjures up a heightened vision of the observed world, is surely one of his greatest achievements.

The sources of *The Dinner Table (Harmony in Red)* are a complex compendium of Matisse's previous work and his changing response to the painting itself as it evolved. Outside his own work, the only possible precedents are Vuillard's decorative panels for his patron Doctor Vaquez (Plate 67), exhibited at the famous Fauve Salon d'Automne of 1905; but, marvellous as these panels undoubtedly are, in their adherence to more circumspect conventions of realistic representation they belong to the end of the nineteenth century when they were painted. Early in 1908, Matisse began *The Dinner Table as Harmony in Green*, exhibited it at the Salon d'Automne that year coloured in blue, before he took it back from Shchukin and finally repainted it in red the following spring (see *Conversation*, Plate 81). Although it is based on his first major painting, *The Dinner Table* of 1897, Matisse avoided the former compositional arrangement of the table running along the diagonal into depth. Instead, he accepted as his starting-point the flat surface of the

canvas, across which the shapes and colours read as in the receding planes of a relief. The flatness of the new composition, with the table placed parallel to the picture plane, was anticipated in his Cézannesque *Blue Still-Life* of 1907 (Plate 69). The two unifying, decorative devices of a single, dominant colour and powerful arabesques originated in a number of smaller still-lifes he painted in 1908. In *Still-Life in Venetian Red* (Plate 70) the carpet provides both the background and the table-cover on which the still-life objects are placed, and the arabesque is introduced with the inclusion of his sculpture *Madeleine I*.

The initial green colour scheme was possibly suggested by the lawn outside his studio at the Couvent du Sacré-Cœur, where he had moved with his school in 1908. Vestiges of green, washed out with turpentine, remain as a border around the whole composition. The blue state, in which the painting was photographed at the Salon d'Automne of 1908, was a development of the colour scheme of *Blue Still-Life*. According to Matisse, the replacement of the blue in the interior with red was done to achieve 'a better balance of colour'. As red and green are near complementary colours, the interior is therefore linked to the exterior in a dynamic dialogue. The green field is much smaller than the red, but in our minds it is perceived to expand beyond the confines of the window and occupy a much larger area.

In his 'Notes' of 1908, Matisse borrows the musical term 'transposition' to account for such radical changes in the dominant colour: 'It is necessary that the various elements I use be so balanced that they do not destroy one another . . . I am forced to transpose until finally my picture may seem completely changed when, after successive modifications, the red has succeeded the green as the dominant colour.' The source of this conception of colour lies, as we have seen in the preceding chapter, in the Neo-Impressionist theory of colour as light, expressed in the abstract scale of the colour circle. However, in contrast to the Neo-Impressionists, Matisse's use of colour was unsystematic. He was always open to any fresh stimulus outside a narrowly theoretical framework. For example, the relationship between the white of the maid's pinafore in *The Dinner Table (Harmony in Red)* and the branches of blossom in the garden apparently suggested itself after a late fall of snow whitened the blossoms. For Matisse, colours were areas of energy that had to be balanced intuitively. He concluded in the 'Notes': 'When I have found the relationships of all the tones, the result must be a living harmony, a harmony not unlike that of a musical composition.'

Early in 1909, soon after repainting *The Dinner Table* as *Harmony in Red*, Matisse began work on the first of his two most celebrated figure decorations for Shchukin, *Dance* (see Plate 83) and *Music* (see Plate 84), which were exhibited at the Salon d'Automne of 1910 before being sent to their destination in Moscow. The precise details of the commission are still obscure. Matisse evidently conceived *Dance* and *Music* as part of an ambitious cycle of three decorations. In an interview published in April 1909, he described how he envisaged the cycle fitting in to its architectural setting in Shchukin's palace:

> I have to decorate a staircase. It has three floors. I imagine a visitor coming in from the outside. There is the first floor. One must summon up energy, give a feeling of lightness. My first panel represents the dance, that whirling round on top of the hill. On the second floor one is now within the house; in its silence I see a scene of music with engrossed participants; finally, the third floor is completely calm and I paint a scene of repose: some people reclining on the grass, chatting or daydreaming.

However, in his letter of 31 March 1909, confirming the commission of *Dance* and suggesting *Music* as a second subject, Shchukin makes no mention of the third

69. *Blue Still-Life.* 1907. Oil on canvas,
88.9 × 116.2 cm. Merion, Pa., Barnes
Foundation.
The table is covered in the same piece of *toile
de Jouy* patterned material which was
expanded to fill the interior of *The Dinner
Table (Harmony in Red)*.

70. *Still-Life in Venetian Red.* 1908. Oil on
canvas, 88 × 104 cm. Moscow, Pushkin
Museum of Fine Arts.
The nearest parallel to the tension of this
painting is in the still-lifes of Cézanne, where
the objects become the actors in an intensely
personal drama. But the overall effect is
highly decorative: by selecting a dominant
colour, red, Matisse was following a well-
established formula employed by decorators
for obtaining a general impression of unity in
a room.

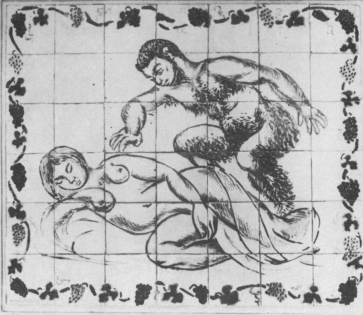

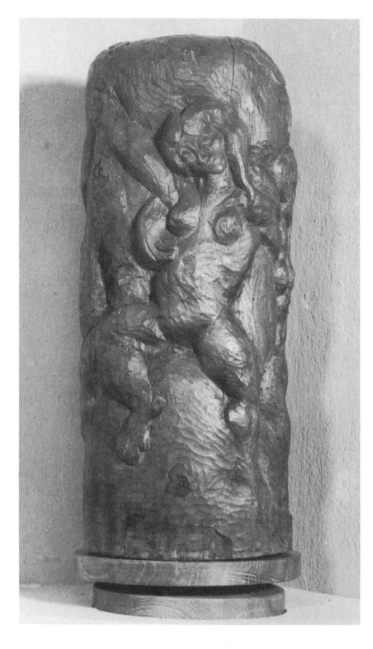

71. *The Hagen Triptych*. c.1907. Ceramic, left panel 58.5 × 39.5 cm, centre panel 56.5 × 67 cm, right panel 57 × 38 cm. Hagen, Karl-Ernst Osthaus Museum. The triptych anticipates the subjects of both *Nymph and Satyr* and *Dance*. It also represents Matisse's first attempt at ceramic tile decoration, which he was to repeat much later in the Vence Chapel (see Plates 216, 217).

72. *The Dance*. 1907. Wood, height 44 cm. Nice-Cimiez, Musée Matisse. Inspired by African sculpture and Gauguin's wood reliefs, Matisse carved this very primitive version of the circle of female dancers in his *Le Bonheur de vivre* of 1905–6. Both Picasso and Derain were also carving chunky, African-style figures at this time.

73. *Music (sketch)*. 1907. Oil on canvas, 73.4 × 60.8 cm. New York, Museum of Modern Art.
Both dance and music are depicted. The actual figures are derived from *Le Bonheur de vivre*, which Shchukin would have known in the collection of Leo and Gertrude Stein.

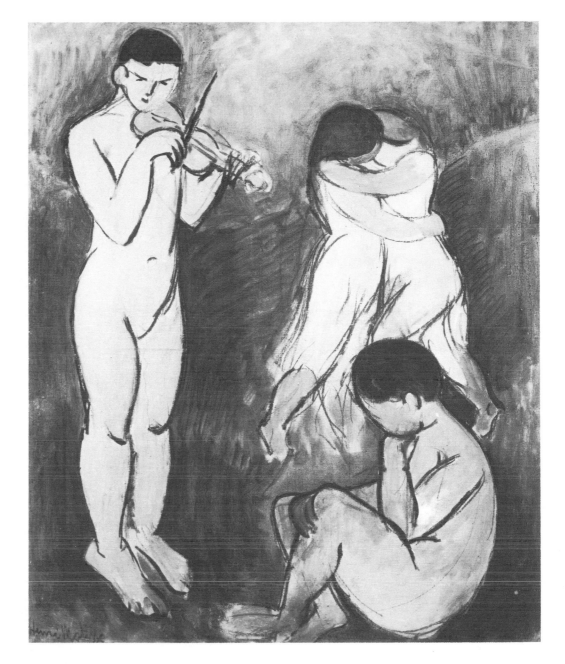

decoration. Whatever the case might be, the preparations for the third decoration were definitely under way during the summer of 1909. The painting was not sold to Shchukin. It remained in Matisse's studio and eventually, after numerous changes, ended up as the great *Bathers by a River* of 1916 (see Plate 112).

Shchukin's rival collector Morozov had commissioned eight panels of the *Story of Psyche* from Maurice Denis, and the challenge was now on for Shchukin to reply with an equally ambitious series by Matisse. Shchukin probably regarded *Nymph and Satyr* (Plate 82), completed by early February 1909, as a trial run prior to commissioning further figure decorations from Matisse. For his part, Matisse carefully groomed Shchukin into selecting the subjects of dance and music, which had preoccupied him since *Le Bonheur de vivre* in 1905–6. In 1907, he had developed the subject of dance in different media. Inspired by Gauguin and by classical line drawing, he carved three chunky dancers around a wooden cylinder (Plate 72), painted three similar dancers around a ceramic vase, and placed dancers either side of a nymph and satyr in the Hagen ceramic triptych (Plate 71). The sketch *Music* (Plate 73), which represents dance as well as music, apparently figured in Matisse's discussions with Shchukin. Finally to clinch the commission, Matisse

painted *Dance I* (Plate 74), based on the circle of dancers in the background of *Le Bonheur de vivre* (Plate 75), during Shchukin's stay in Paris in March 1909. It was painted very rapidly—in as little as one or two days, according to Hans Purrmann who lived on the floor above Matisse's studio.

Shchukin's commission of *Dance* and *Music* changed Matisse's life-style. By the time he signed his first three-year contract with the Bernheim-Jeune gallery on 18 September 1909, he and his family had moved to Issy-les-Moulineaux. The likely prospect of further commissions for decorations would have led him quite justifiably to expect a prosperous future. His decorations sold for considerably more than his easel paintings, and, as they were not included in his Bernheim-Jeune contract, he could deal directly with a potential patron and thus avoid the gallery commission. The largest paintings in his contract, Format 50 (116 × 89 cm), were priced at 1,875 francs, whereas Shchukin had agreed to pay 15,000 francs for *Dance* and 12,000 francs for *Music* (by coincidence, approximately the same figures give the equivalent sums in pounds at today's values).

Issy-les-Moulineaux was one of the new suburbs of Paris that had grown up outside the old city gates after 1870. The Matisses' house was built in a typical eighteenth-century style, with large shuttered windows on the first two floors and little *œil-de-bœuf* windows in the mansard roof. Following the advice of the American photographer Edward Steichen, Matisse had a large prefabricated wooden studio, approximately thirty metres square, constructed in his garden behind the house. He employed a gardener, enjoyed riding with his children in Clamart nearby, painted neatly dressed (sometimes with his riding-boots on), and to all appearances lived the life of a successful member of one of the middle-class professions. His withdrawal from the centre of Paris, behind the high walls of his new suburban home, reflected his loss of interest in teaching and the temporary abandonment of his challenge for the leadership of the avant-garde. For the next year, from September 1909 to September 1910, he was going to concentrate on his own wholly personal style of figurative decoration.

With *Dance* Matisse's effort went into the enlargement of the circle of dancers in the background of *Le Bonheur de vivre* on to the surface of a painting so that the concept of dance could be conveyed in its very presence. Having completed *Dance I*, he went to quite extraordinary lengths to rethink the composition in the light of experience, and to evolve a new anatomy for its figures in order to express more completely the idea of movement. He took one of his models, called Brouty, down to Cavalière near Saint-Tropez for the summer of 1909 and posed her nude before the sea, as if to confirm an initial dream in reality. He felt a strong connection between *Dance* and the Mediterranean. In an oddly literal passage in one of his letters, he describes the blue sky in *Dance* as alluding to the Mediterranean sky in August and the green to that of Mediterranean pines against the sky. The vermilion of the nudes in *Dance* resulted from the intensification of their flesh tones to balance the blue and green. So the colour scheme, like the figures, was confirmed in reality. At the same time, Matisse believed that by reducing colour to the three light primaries, red, green, and blue, he was expressing the totality of colouristic experience in essential form.

At Issy in September, Matisse executed a startling sculpture, *La Serpentine* (Plate 76), in which female anatomy is distorted and treated as a visual balance of opposing rhythms and volumes. In *The Dinner Table (Harmony in Red)* he had developed the arabesque from his sculpture *Madeleine I*, placed in *Still-Life in Venetian Red*; now he worked the swinging arabesque back from the pattern in the painting into the new sculpture. There it slowly unwinds in space, with the voids becoming almost as important as the sculpture itself.

74. *Dance I.* 1909. Oil on canvas, 261 × 390 cm. New York, Museum of Modern Art.
Dance I was painted quickly, probably to show Shchukin what the final panel would look like. The technique is that of a sketch. Large drips of blue paint ran down the surface from the sky, and were then covered by the green below. *Pentimenti*, like those round the dancer on the left, show that the figures were drawn directly on to the canvas with long, sweeping strokes of the brush, leaving parts of the white canvas exposed.

75. Detail of the circle of dancers in the background of *Le Bonheur de vivre* of 1905–6 (see Plate 51).

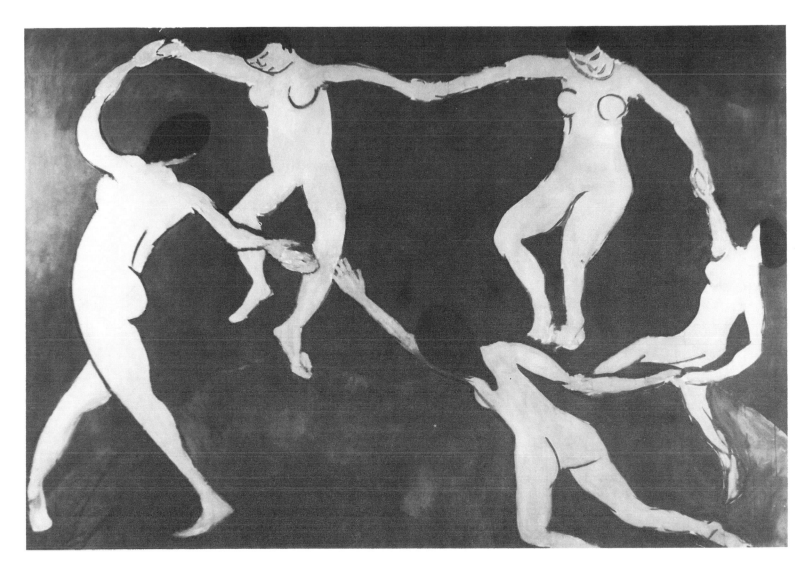

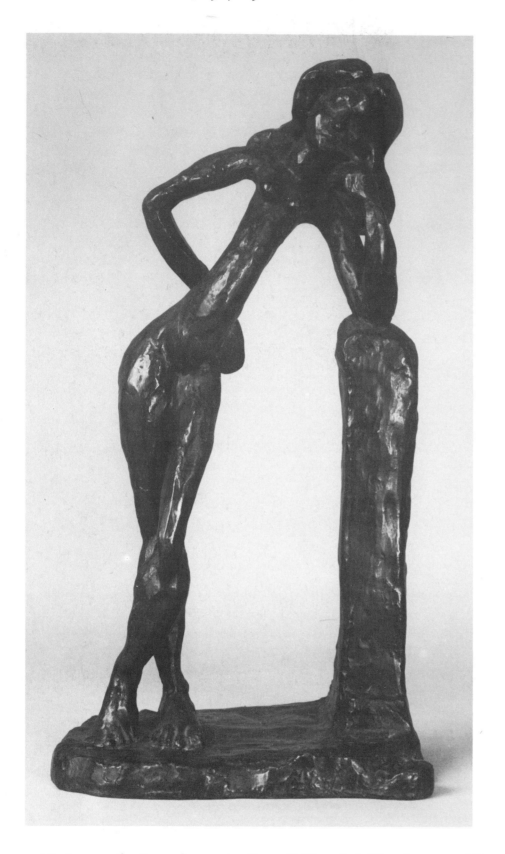

76. *La Serpentine*. 1909. Bronze, height 56.5 cm, base 28 × 19 cm. Baltimore Museum of Art, Cone Collection.
The sculpture appears so removed from the observance of female anatomy that it has been suggested Matisse based it on a photograph in a book of a model in this pose. Matisse was concerned here with the sculptural arabesque, not solid volume. He told his students, 'Arms are like rolls of clay, but the forearms are also like cords, for they can be twisted . . . The mechanics of construction is the establishment of the oppositions which create the equilibrium of the directions.'

Matisse was finally ready to paint *Dance II* (Plate 83). The character of *Dance II* is far removed from that of *Dance I*; indeed even Matisse was a little alarmed by its aggressive frenzy. The dancers are not so much willing participants in the dance as prisoners subject to the compulsive pounding force of some primordial rhythm. Matisse saw rhythm as the principal element of construction, and its effectiveness depends on the identification of the spectator with the movement of the dance. *Dance II* is like a compressed spring in comparison to *Dance I*. The emphasis which Matisse divided between the two figures on the knolls in *Dance I* is concentrated in

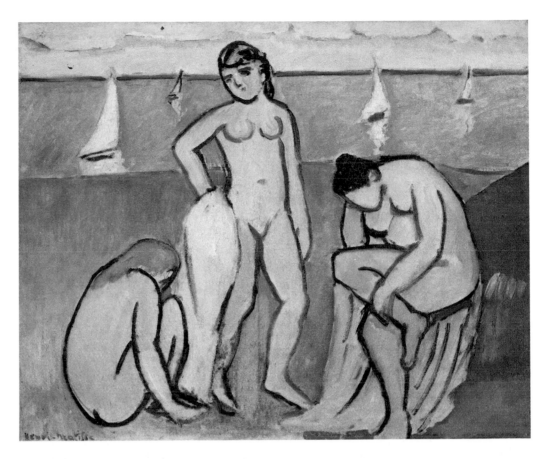

77. *Three Bathers*. 1907. Oil on canvas, 70 × 73.7 cm. Minneapolis Institute of Arts. Painted at Collioure in the summer of 1907, this acted as a preliminary study for *Bathers with a Turtle* (see Plate 60).

78. *The Dinner Table (Harmony in Red)*. 1908–9. Oil on canvas, 177.1 × 218.1 cm. Leningrad, Hermitage Museum. This painting occupied pride of place among the fifteen Gauguins in Shchukin's dining-room in Moscow. It fitted so perfectly into the space between the dado and ceiling that Matisse must have discussed the location with him, even if he did not receive a definite commission.

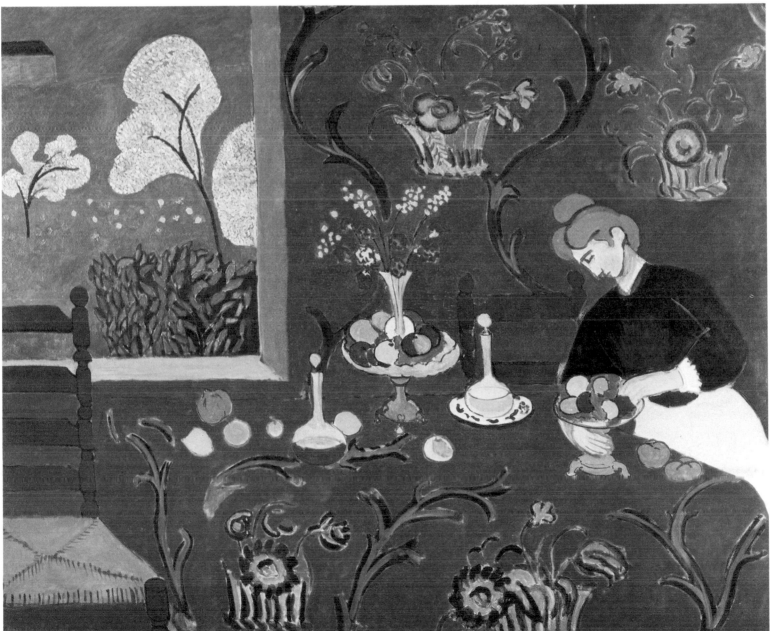

the left-hand figure with the wasp-like anatomy in *Dance II*. The right leg of this figure is brought up behind the left to connect the outstretched hands of the two dancers below. Thus two pivotal points of balance are established where the eye looks down at the foot and then up at the near-junction of the hands, giving the sensation of movement in the transition between the two points. A closer relationship is created between the figures and the background through a tightening-up of the positive–negative dialogue between the figures and the shapes of the resultant voids. The changes in colour that occur also effect a much closer correspondence between the figures and the background, causing them literally to vibrate under poor illumination. Tonal contrast is minimized between the three principal colours. The black colour of the hair is replaced by a more active reddish brown, and the flesh tones are changed from delicate pink to the raw impact of saturated vermilion.

Numerous sources have been suggested for the ring of dancers in *Le Bonheur de vivre* and for its translation into *Dance I* and *Dance II*. Goya's tapestry cartoon *Blind Man's Buff* (1789) is the most likely candidate for the right-hand half, with the figure in the foreground appearing as though dragged along by the motion of the dance. Derain set the pace with the barbaric fervour of his *Dance* of *c.*1906 (Plate 79). The compulsive rhythm and figure style of *Dance II* also have much in common with Rodin's dry-point *The Round* of 1883–4 (Plate 80). Rodin was particularly interested in dance and—as we have noted—he, like Matisse, had taken rooms in the Couvent du Sacré-Cœur where Isadora Duncan had a dance studio for a time.

Dance had taken on new impetus as a serious art-form. Diaghilev's Russian Ballet soon came to be identified with Parisian avant-garde artists. Matisse himself was to design the sets for two of their ballets, Stravinsky's *Song of the Nightingale* (1919–20) and Shostakovich's *Red and Black* (1937–8). The meaning of *Dance I* and *Dance II*, however, lay in his conception of the dance in *Le Bonheur de vivre* as a primordial ritual associated with the expression of an ideal state of being, a Golden Age. This concept of dance had more in common with Isadora Duncan's performances than with choreographed professional ballet. The distinction between performance and choreography in ballet was equated by avant-garde artists and dancers with the separation of concept and representation in painting. Like Isadora, Matisse wanted to fuse the two and make art the visual embodiment of a concept, not a representation of something but the thing itself, carrying its complete significance in its very being.

Matisse felt that this elemental concept of dance survived in folk and primitive cultures. Such personal experiences as watching the farandole at the Moulin de la Galette or fishermen dancing the sardane on the beach at Collioure played a more important role in the evolution of his *Dance* than did parallel achievements by other artists. Apparently he whistled the farandole continuously while working on *Dance*. It is somehow ironic that a highly sophisticated avant-garde artist like Matisse, whose status partly depended on his very individual ability to defy accepted conventions, should nevertheless draw his inspiration from a declining form of dance, which was very much an expression of group consciousness in closely-knit village communities.

Coming up the stairway of Shchukin's palace, newly inspired by the rhythmic tread of *Dance*, the visitor would next have been confronted by a little choir in full voice, accompanied by a violin and twin-pipes. *Music* (Plate 84) conveys the idea of a harmony fundamental since the beginning of time, which the soul can apprehend but the ear cannot hear. The subject-matter, composition, and colour are a perfect complement to *Dance*. Although the same colours are used, their proportions have been altered in accordance with the contemplative mood of the subject. The

79. Derain. *Dance. c.*1906. Oil on canvas,
185 × 228.5 cm. Switzerland, private
collection.
The outrageous colour scheme and exotic
setting of Derain's *Dance*, exhibited at the
Salon d'Automne of 1907, established a
flamboyant precedent for Matisse's *Dance*.

80. Rodin. *The Round.* 1883—4. Dry-point,
17.8 × 22.9 cm. Paris, Bibliothèque
Nationale.
The circle of dancers in the Rodin and the
Matisse originates ultimately from classical
Greek vase painting. The vermilion colour of
Matisse's dancers also stems from the red
figures of Greek vases.

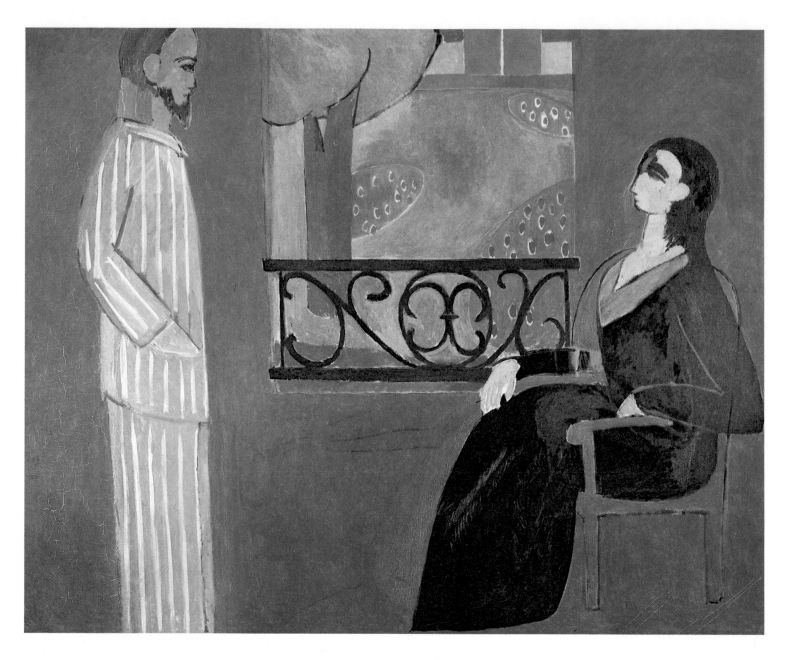

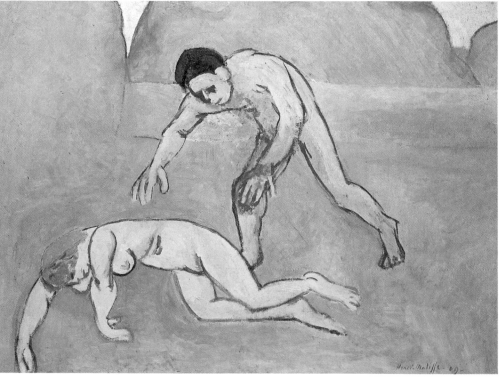

81. *Conversation*. 1909. Oil on canvas, 177 × 217 cm. Leningrad, Hermitage Museum.
As a replacement for the blue state of *The Dinner Table*, repainted in red after it was exhibited at the Salon d'Automne of 1908, Matisse produced for Shchukin this similarly proportioned decoration in blue. The mood of the painting is very tense. Matisse, like an upright, bearded seer, confronts his wife across the open divide of the window.

82. *Nymph and Satyr*. 1909. Oil on canvas, 88.9 × 117.1 cm. Leningrad, Hermitage Museum.
The subject-matter of *Nymph and Satyr*, commissioned by Shchukin, was unusual for Matisse, who preferred to leave out male figures and let the spectator play the part of the satyr about to grasp the recumbent nymph.

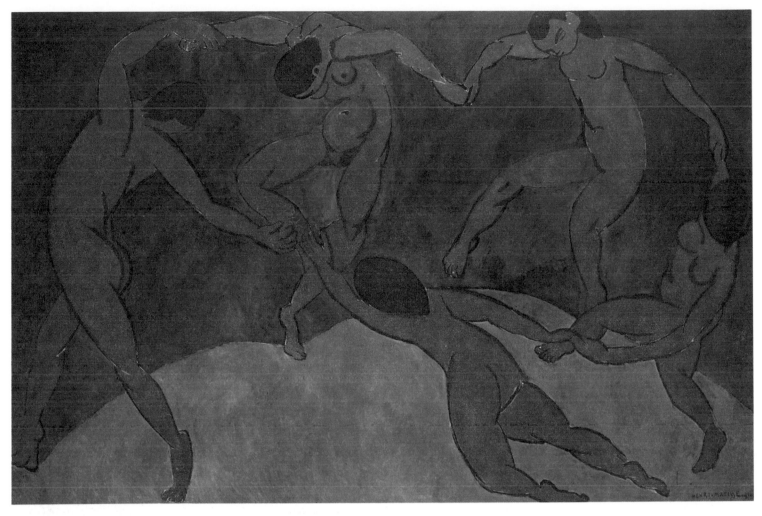

83. *Dance II*. 1909–10. Oil on canvas, 260 × 391 cm. Leningrad, Hermitage Museum.
Dance and *Music* brought to a conclusion Matisse's preoccupation with a classical form of figural decoration which he had been working on since *Le Bonheur de vivre*.

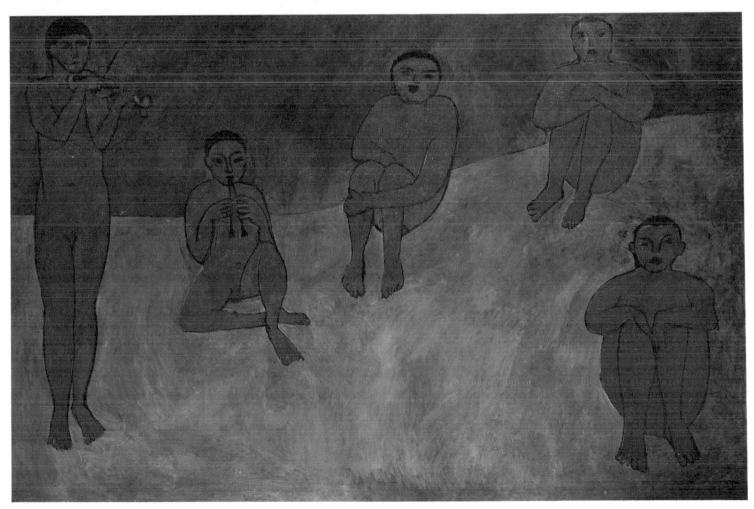

84. *Music*. 1910. Oil on canvas, 260 × 389 cm. Leningrad, Hermitage Museum.
During the process of painting, the music-makers were slowly turned round to face the spectator. Both *Dance* and *Music* were designed to be looked at from below, in the stairwell of Shchukin's palace.

emphasis in the colour scheme has shifted from the insistent rhythm of red to an expanded area of calming green. This acts as a complementary response to the vermilion figures, which are precisely positioned within black contours like musical notes on a score.

There are no published studies for the composition of *Music*. The preliminary work was done directly on the canvas, allowing the forms and colours to evolve in relation to the mood and impact of the whole. Photographs of two early states show that it was originally much closer to the style of *Le Bonheur de vivre*, with Persian flowers and a Gauguinesque dog lying at the feet of the violinist. The figures of the violinist and squatting chorister in the bottom right-hand corner were adapted from the sketch *Music* of 1907 (see Plate 73). Matisse was a keen violinist, so it is appropriate that his surrogate should lead the group. *Music* brings to a conclusion what Matisse had been working towards since *Le Bonheur*—the combination of the classical and the primitive in a new figurative art of harmonious decoration which could convey meaning by its very presence.

The distance Matisse had travelled from 1907 to 1910 was so great that critics and most other artists—let alone the gallery-going public—did not know how to look at *Dance* and *Music* when they were exhibited at the Salon d'Automne in October 1910. Matisse's subject-matter appeared archaic and distant, and his means of expression distorted and immediate. One critic, the Russian J. Tugendhold, felt that these decorations reflected a split personality: on one side 'half-dreams of a naïve primordial structure, of the lost harmony of the soul', and on the other 'the frenzied American-style life of today'. Some critics recognized Matisse's connection with a classical tradition of figural decoration revived by Puvis de Chavannes, but few could accept his reconciliation of the overtly decorative with a serious art of decoration.

Shchukin took fright. From the start of his negotiations for *Dance* and *Music*, he had been a little nervous at the prospect of displaying nudes in as public a place as his stairwell, used by a constant stream of visitors. He tried to refuse them tactfully, explaining that he had just adopted two young girls. Matisse's own gallery disloyally offered the collector a Puvis de Chavannes as an alternative. Eventually Shchukin changed his mind. The two panels arrived in Moscow in December 1910. Unfortunately, Shchukin carried out his threat and had the male sex organs of *Music* painted over before it was hung—an act of vandalism which has not been repaired.

5 Between Reality and a Dream, 1910-1917

There was a sense of impending crisis in the years leading up to 1914. In complete contrast to the ominous political scene, however, the pre-war years turned out to be one of the most glorious epochs in modern painting. In Cubism Braque and Picasso perfected a new way of representing the world which was taken up and developed by Léger and Gris. The Italian Futurists noisily challenged the Parisian avant-garde to come to terms with new ideas, subject-matter, and materials which they regarded as appropriate to the twentieth century. The period saw no slackening in Matisse's ambition. Angered rather than defeated by Shchukin's temporary refusal of *Dance* and *Music* and driven on by the new challenge of Cubism, he achieved what several critics now regard as the greatest works of his career.

While Matisse did not relinquish the ambition to paint decorations with nudes, he nevertheless found it impossible to sustain the style and subject-matter of *Dance* and *Music*. Faced with the question of what to paint, he returned to the subject-matter of his early career, which grew out of his own home, family, workplace, and surroundings, and he also sought new stimulus in travel. He made a special trip to Munich in October 1910 to see the magnificent exhibition of Islamic art. On his return in mid-November he left for Spain, and in October 1911 he visited St Petersburg and Moscow. He spent the winter months of early 1912 and 1912–13 in Morocco, finding the winters in the north increasingly depressing. The intensity of the southern light soon became a prerequisite for his art, and from 1916 he habitually passed each winter in Nice on the Riviera.

Matisse's Spanish trip lasted from mid-November 1910 to the end of January 1911. His art does not provide a record of his travels. The very Spanish-looking *Spanish Woman with Tambourine* (Moscow, Pushkin Museum of Fine Arts) was actually painted the year before he left for Spain. His vision centred on the creation of an ideal state of being, and his trips to the south were partly a search to find within the enveloping warmth of southern light confirmation of the sensations he wanted from his art. Spain also provided a cultural bridge between the Mediterranean sources of his subject-matter and his renewed interest in Islamic art. While there he concentrated on the Moorish cities of the south, basing himself at Seville and visiting Cordoba and Granada. The Alhambra, the Moorish palace in Granada, was to become an extremely important source for some of his largest paper cut-out decorations, executed in the last three years of his life. *Seville Still-Life* of 1910 or early 1911 (Plate 89) is one of the few canvases he painted in Spain.

On his return from Spain at the end of January 1911, Matisse began work on four magnificent decorations, known as the 'symphonic interiors', which were to preoccupy him for most of that year. As usual his preparations, though often

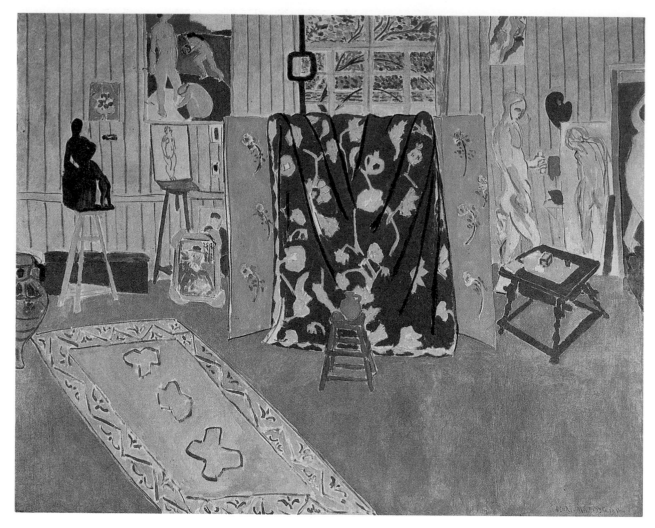

85. *The Pink Studio*. 1911. Oil on canvas, 179.5 × 221 cm. Moscow, Pushkin Museum of Fine Arts.
The Pink Studio has many of the characteristics of a sketch, and it served as a preliminary version for the more synthetic *The Red Studio* (see Plate 88). It too was bought by Shchukin.

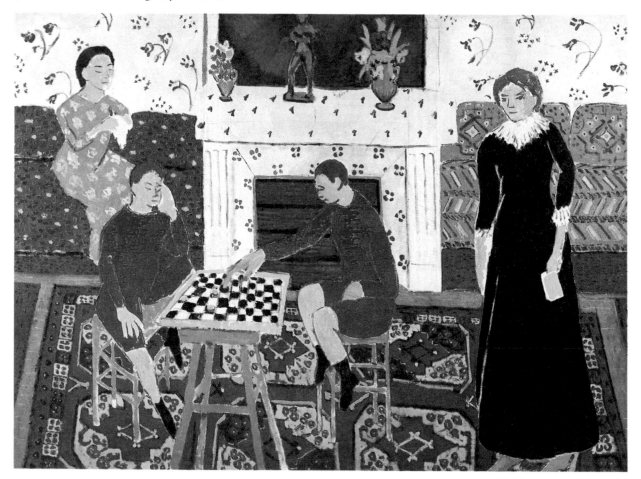

86. *The Painter's Family*. 1911. Oil on canvas, 143 × 194 cm. Leningrad, Hermitage Museum.
Colour, characterization, and pattern are woven into a complex picture of Matisse's family life. Quite understandably, he wrote on a postcard dated 26 May 1911, 'This all or nothing is very exhausting.' The painting was bought by Shchukin.

87. *Interior with Aubergines.* 1911. Mixed medium on canvas, 212 × 246 cm. Grenoble, Musée de Peinture et de Sculpture.

The original floral border would have increased the painting's connection with a hanging oriental carpet. It is still not clear why Matisse later removed the border. It could have been damaged, or perhaps he just felt that it looked over-decorative. Besides functioning as flat pattern, the floral motif suggests the presence of flowers in a luxuriant paradise garden.

88. *The Red Studio.* 1911. Oil on canvas, 181 × 219.1 cm. New York, Museum of Modern Art.

Although completely novel in its overall redness, *The Red Studio* is at the same time firmly rooted in Matisse's own art. Several of his recurring polarities are formulated afresh: intimate subject-matter and an imaginative decorative art; form and colour; and light and shade, symbolized by the juxtaposition of his two sculptures in the background on the right, the white plaster of *Jeannette IV* (1911) and the black cast of *Decorative Figure* (1908).

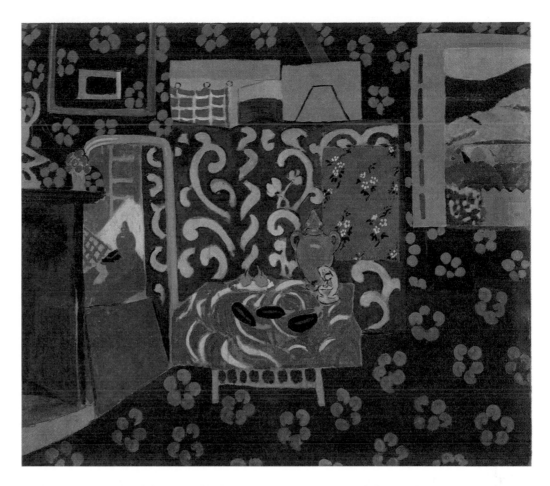

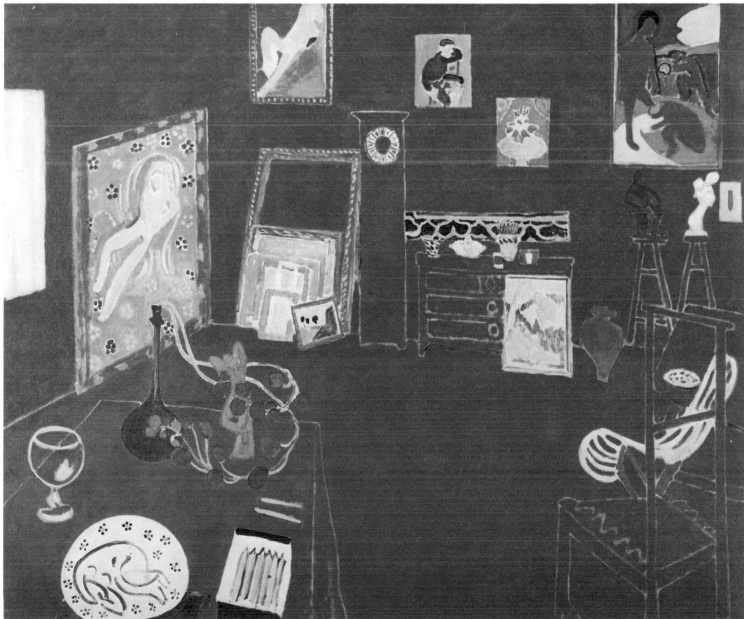

intuitive rather than consciously planned, were very thorough. The subject-matter of the interiors was so inextricably bound up with his own art and biography that he felt there was a danger of the paintings becoming too personal, intimate, and enclosed. A grand decorative art should after all convey a feeling of universality. One of his principal problems therefore in the 'symphonic interiors' was to open up this hermetic world and present it to the spectator as an earthly paradise to be enjoyed. And it was here that he sensed Islamic art could help, as he explained: 'If I instinctively admired the Primitives in the Louvre and then oriental art, in particular at the extraordinary exhibition at Munich, it's because I found in them new confirmation. Persian miniatures, for example, showed me all the possibilities of my sensations. I could find in nature what they should be. By its very properties this art suggests a larger and truly plastic space. That helped me to get away from intimate painting.'

The four 'symphonic interiors', *The Pink Studio* (Plate 85), *The Painter's Family* (Plate 86), *Interior with Aubergines* (Plate 87), and *The Red Studio* (Plate 88), represent a complete transformation of Matisse's studio, family, and his room at Collioure into monumental decorations. Although of roughly similar format, varying from 143 × 194 cm to 212 × 246 cm, they were conceived and executed separately, rather than as a series to be hung together. *The Pink Studio*, *The Painter's Family*, and *The Red Studio* were painted at Issy-les-Moulineaux and *Interior with Aubergines* at Collioure. *The Dinner Table (Harmony in Red)* is the obvious point of departure for the scale and ambition of these 'interior' decorations, which are all similarly based on the modality of red and its related pinks, browns, and violets.

The Pink Studio was painted first. Matisse's own art and other props are seen ranged along the back wall of his outdoor studio. In contrast to the degree of abstraction in *Music*, his previous major decoration, *The Pink Studio* is characterized by freshness of atmosphere, technical spontaneity, and a more realistic treatment of the subject-matter. An oriental rug is tossed across the floor, on the diagonal, to invite the spectator into the painting. The pristine white walls and floor of the studio are transformed in delicate tints of pink and violet, which counter the greenery seen through the window against the pale-blue sky. This outdoor combination of green and blue is repeated in the deep blue of the Spanish textile draped over the green screen in the interior. A green jug is then placed in front of the blue textile to complete this delightful sequential development of overlapping colours in space.

The Painter's Family, completed by the end of May 1911, is much more tense than *The Pink Studio*. Matisse's family is grouped around the fireplace in the living-room at Issy. Madame Matisse, a slightly demure seamstress, sits in the background; their two sons, Jean and Pierre, are playing draughts; his daughter Marguerite stands alone on the right, presumably watching her father at work. It was easier for Matisse to unite abstracted nudes within the unifying concepts of dance and music than to reconcile the individual characters of his wife and children in a picture of harmonious family life. The French social temperament was family orientated and unneighbourly, but this did not rule out the usual family tensions. The essence of this painting is a subtle series of conflicting formal and psychological elements, which are balanced rather than resolved: wife against daughter, son against son, and sons against father, who is invited by the perspective to take his place (along with the spectator) at the draught-board. A complex ensemble of oriental patterns competes with the figures for our attention. The central white expanse of the mantelpiece is balanced by Marguerite's long black dress. This dialogue between black and white is then literally played out on the draught-board, before being developed from the boys' boots to their mother's hair. Blue and green

89. *Seville Still-Life*. 1910 or early 1911. Oil on canvas, 90 × 117 cm. Leningrad, Hermitage Museum.
Painted in Matisse's hotel room in Seville, it was subsequently bought, along with its companion piece *Spanish Still-Life*, by Shchukin. The play of the predominantly green and blue patterns across an overall mid-tone of pink anticipates the colour scheme of *The Pink Studio* (see Plate 85).

bands of colour alternate in the fireplace to create a powerful complementary contrast to the bright vermilion red of the boys' clothes. The idea of conflict is extended to the technique: deliberate technical crudity absorbs the spectator in the relationship between forms and colours across the surface. For example, an over-large area of the white ground is left exposed to describe Marguerite's right arm and hand, whereas her left hand is comparatively tiny.

The subject-matter of *The Painter's Family* developed from *Conversation* of 1909 (see Plate 81), but its main formal source was Persian miniatures. Matisse's family is presented as occupying their places at the court of an oriental potentate. Faced with the increasing challenge of Cubism, Matisse's art went to the opposite extreme, becoming richer, larger, more exotic and colourful. In contrast to the 'analytic' Cubist breakdown of an object, Persian miniatures showed how a whole interior could be opened out across the picture surface, in a complex system of interlocking patterns, to suggest a limitless space continuing beyond the confines of the edge. 'Analytic' Cubism resulted in the nervous fragmentation of objects in a restricted tonal palette, whereas both Persian miniatures and Matisse's art at this time are paintings of praise: forms and colours are turned towards the spectator to be enjoyed to the full.

Despite the removal of a floral border (approximately 18 centimetres wide) framing the whole composition, *Interior with Aubergines* is still the largest and most

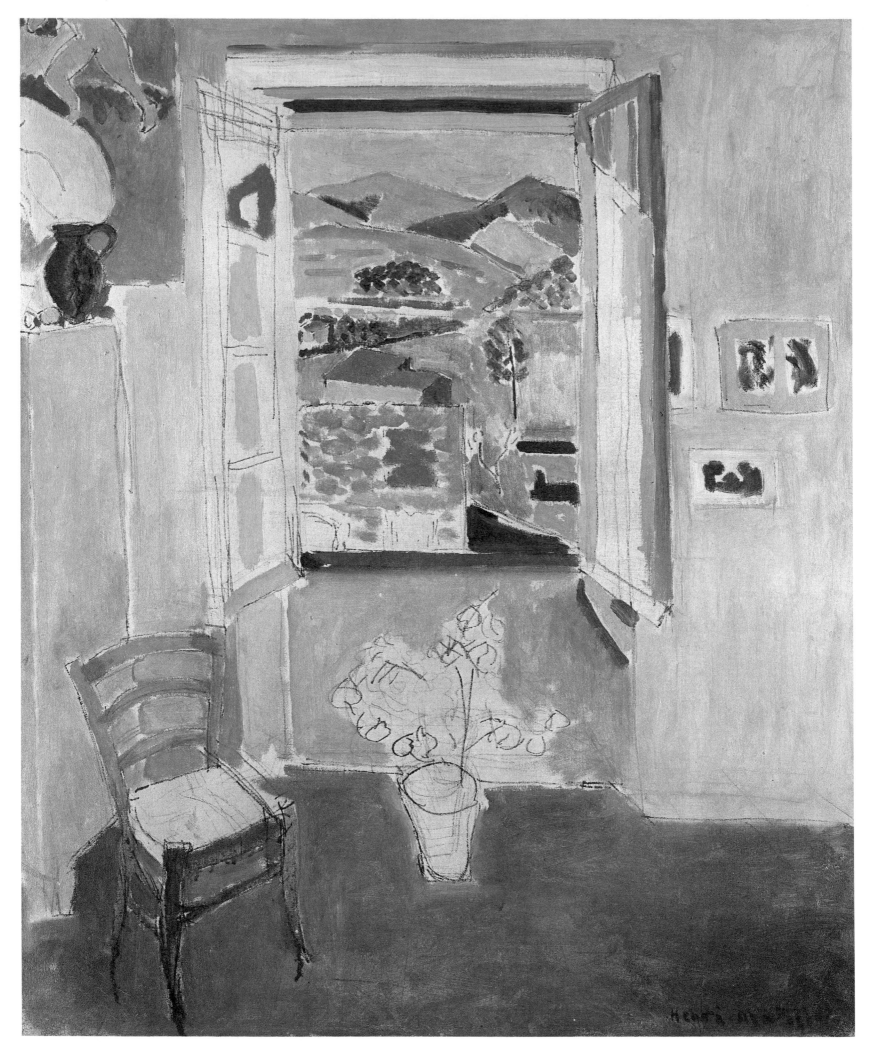

90. *Open Window.* 1911. Oil on canvas, 73.5 × 60 cm. Private collection.
The window opens on to the mountains around Collioure. Delicious tints of pink, pale violet, mauve, and green are repeated in more intense tones in the landscape. *Le Luxe II* is seen hanging on the wall.

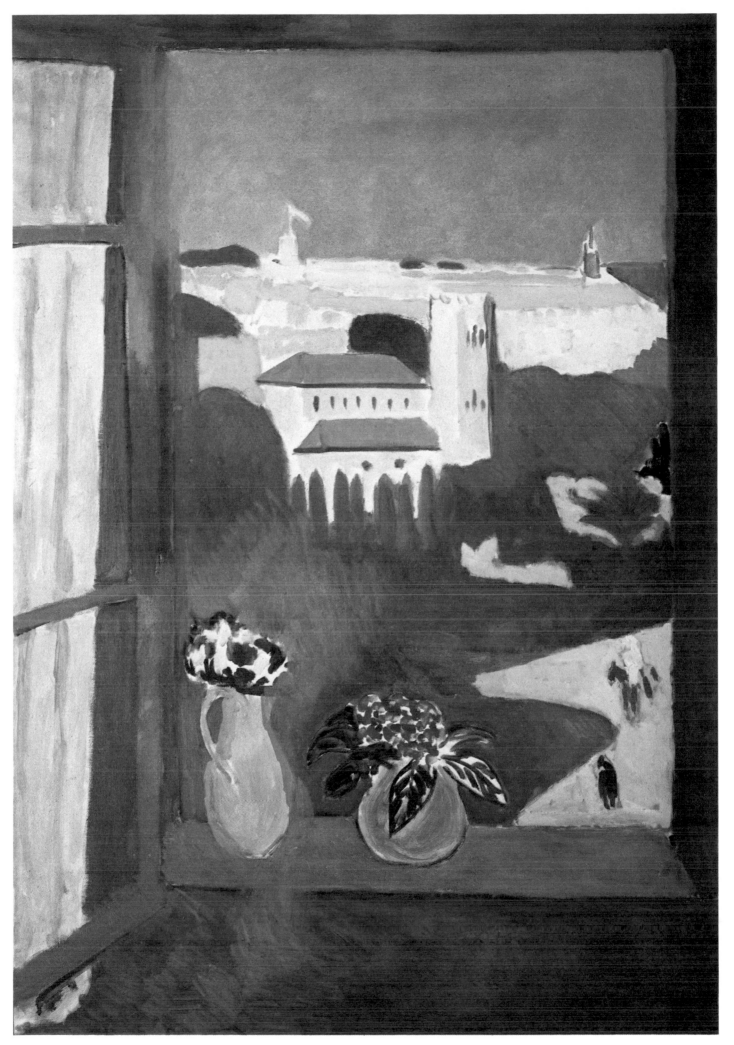

91. *Window at Tangier*. Early 1912. Oil on canvas, 115 × 80 cm. Moscow, Pushkin Museum of Fine Arts.
It shows a view from his bedroom in the Hôtel de France, Tangier, over the gardens and pink paths to the English church with its green roof and 'Tudor' tower.

decorative of the four 'symphonic interiors'. Its matt surface, in a mixed medium imitative of a fresco effect, recalls the distemper technique of *Le Luxe II*, seen hanging in *The Pink Studio*. *The Dinner Table (Harmony in Red)* had established a precedent for the dialogue across the flat surface of the canvas between interior and exterior space, but in *Interior with Aubergines* the relationships are more complex. As in *The Pink Studio*, a green screen is introduced in the centre of the composition to initiate the overlapping of a limited range of colours in association with the patterns and objects. The patterns are large and substantial enough to be read as objects and the objects sufficiently small to be read as part of the patterns. Internal frames open up on to further frames, containing patterns, reflections, or perhaps a view of the mountains behind Collioure. The imagery is so elusive that ultimately the only real subject is the painting itself. Matisse the creator, deified in the reflection of the Buddha on the left, presides over one of his greatest compositions.

As if *Interior with Aubergines* were not enough for one year, on his return to Paris in October 1911, Matisse painted another masterpiece, *The Red Studio*. It is an extraordinarily powerful painting, completely novel in its all-over redness. The right-hand third of *The Red Studio* overlaps with the left-hand third of *The Pink Studio*; the relationship between the two is similar to that between the more synthetic treatments of *Young Sailor II* (1906–7) and *Le Luxe II* (1907), seen hanging on his studio wall, and their respective first versions. An account of the redness of the interior in terms of a psychophysical response to the sensation of green in the garden outside seems completely inadequate when faced with *The Red Studio*. Conscious of being in the presence of a profoundly serious metaphysical painting, we grope for an explanation of something that really cannot be explained, only experienced. The redness is like a metaphor for light, the primary energy of life itself, within which existence is registered. Objects are indicated in an abbreviated linear language as residual images left over in the memory after a dream. Spatial depth is established through relationships dominated by a circular rhythm, introduced in the form of his white ceramic plate in the foreground and then expanded round the composition in a more measured tread than in *Dance*; the very timelessness of the movement is symbolized by the absence of hands on the white dial of the grandfather clock. Only art, Matisse's art, and nature, symbolized by the curling tendrils of the nasturtium leaves, have the substance of reality—the rest is illusion.

The four 'symphonic interiors' were accompanied by smaller paintings in a relaxed, more obviously beautiful minor mode; some of them were definitely executed as either studies or postscripts to the larger paintings. The ravishing *Open Window* of 1911 (Plate 90) is like an improvisation on a theme from *The Pink Studio*, acting as a prelude to *Interior with Aubergines*. Pale washes of pink, mauve, and violet are lightly brushed over a pencil drawing. The main accents of colour come in the chordal arrangement of the bars of crimson, deep blue, and yellow above the window, and in the landscape seen through the window. *Goldfish and Sculpture* of 1911 (Plate 92) develops the blue option which Matisse apparently first explored in a preliminary state of *The Red Studio*. A very limited number of shapes and colours are rhythmically repeated in such a way that they still conjure up the appearance of reality.

On 19 October 1911, at the invitation of Sergei Shchukin, who accompanied him, Matisse left Paris for a three-week trip to St Petersburg and Moscow. Much to his disappointment they found the Hermitage in St Petersburg closed for the winter and they moved directly on to Moscow. Matisse was received as a visiting celebrity; he attended concerts, soirées, receptions, and was shown round private collections, the Tretyakov Gallery, the main churches, cathedrals, and monasteries. In

92. *Goldfish and Sculpture.* 1911. Oil on canvas, 116.2 × 100.5 cm. New York, Museum of Modern Art.
This is the second of six paintings featuring a bowl of goldfish which were painted between 1911 and 1915. The sculpture is *Reclining Nude I* of 1906–7. A bowl of goldfish stands as a metaphor for the qualities he wanted from his art—a hermetic, internal world of calm, and powerful, affective colour.

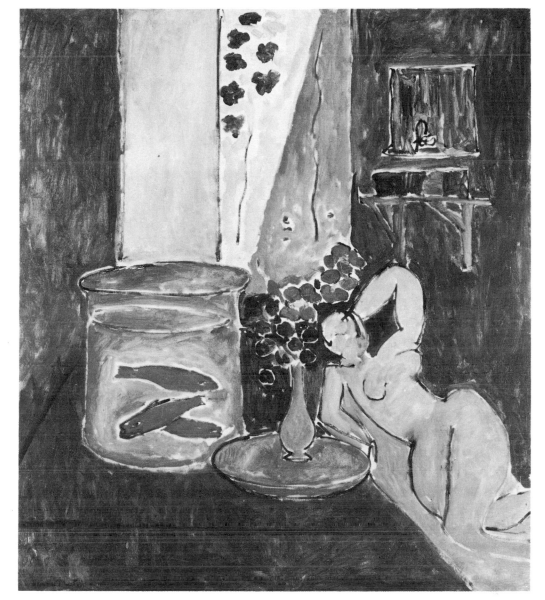

Shchukin's own collection, Matisse objected to his paintings being glazed and hung at an angle, which meant that they lost part of their effect as mural decorations. (Shchukin evidently took note: photographs taken in 1912 show them hung as Matisse intended.) Of all the things he saw in Moscow, Matisse was most impressed by Russian icons. He told a St Petersburg newspaper correspondent, 'The icon is a very interesting type of primitive painting. Nowhere have I ever seen such a wealth of colour, such purity, such immediacy of expression. It is the best thing Moscow has to offer. One should come here to learn because one should seek inspiration from the primitive.' He took back with him an album of photographs of antique icons and two original icons; the lessons he learned from them were to become especially relevant in *Portrait of Madame Matisse* of 1913 (see Plate 102).

Soon after his return to Paris in November 1911, Matisse and his wife left for their first trip to Morocco. They arrived in Tangier in January 1912 and remained there until the end of March. Following the extreme effort of his year's work, culminating in the imaginative heights of *The Red Studio*, Matisse hoped—as it in fact turned out—that Morocco would prove sufficiently exotic to bridge the gap that he felt was opening up between his art and its source in nature. He later elaborated on this point: 'The voyages to Morocco helped me to accomplish this

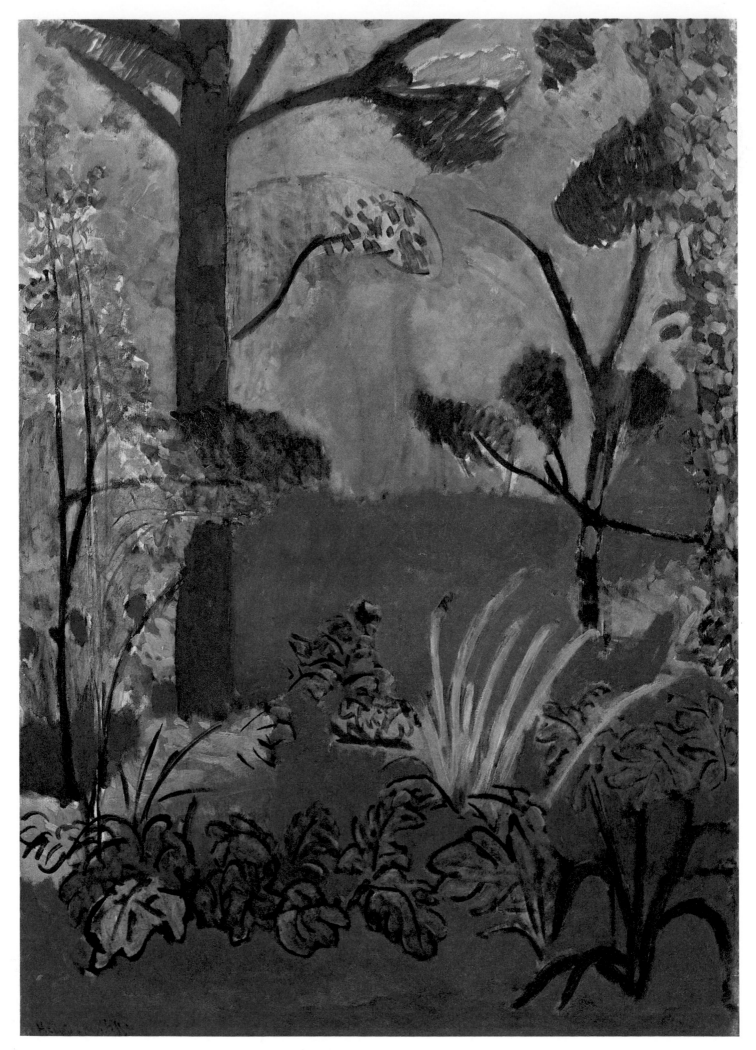

93. *Park in Tangier*. Early 1912. Oil on canvas, 115 × 80 cm. Stockholm, Moderna Museet.
Matisse was very impressed by the colour, luxuriant foliage, and magnificent trees of the gardens in Tangier, and he painted three canvases of them, all identical in size.

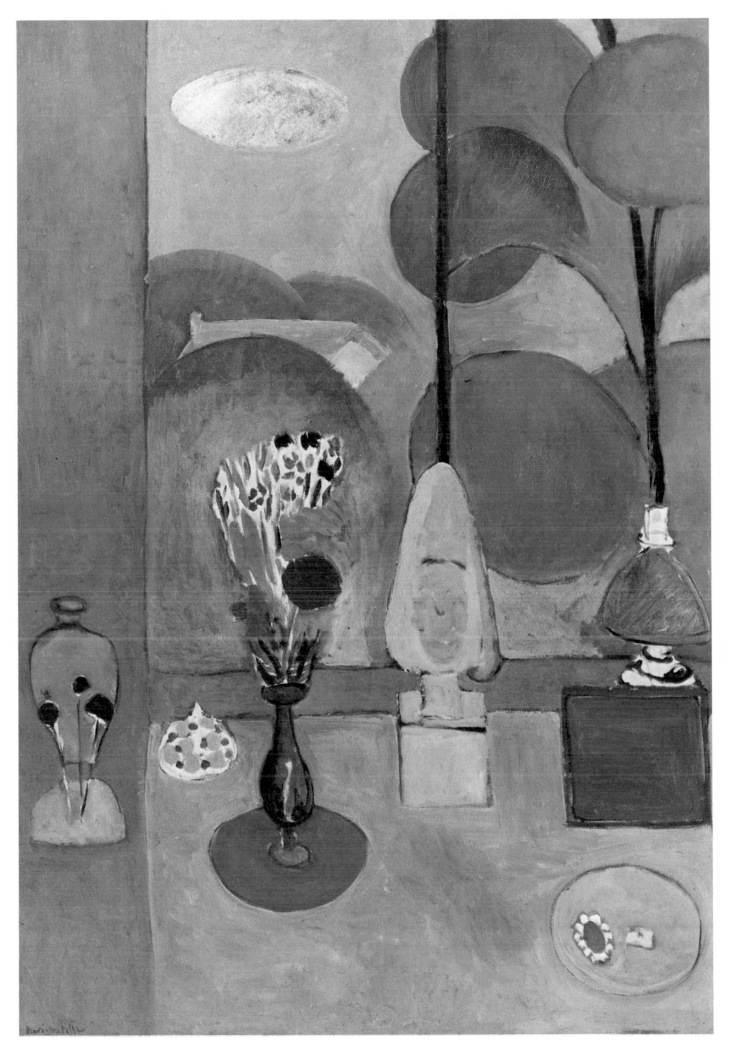

94. *The Blue Window*. 1912. Oil on canvas, 130.8 × 90.5 cm. New York, Museum of Modern Art.
Originally intended for the designer Jacques Doucet, this painting passed into the collection of Karl-Ernst Osthaus of Essen, was confiscated by the
Nazis, and ended up as one of the chief glories of the Museum of Modern Art, New York. The strange yellow-ochre head is apparently a cast of a
classical sculpture, possibly an Iberian head of a veiled woman, bought by the Louvre in 1907.

transition, and make contact with nature again ... I found the landscapes of Morocco just as they had been described in the paintings of Delacroix and in Pierre Loti's novels. One morning in Tangier I was riding in a meadow; the flowers came up to the horse's muzzle. I wondered where I had already had a similar experience— it was in reading one of Loti's descriptions in his book *Au Maroc*.'

At the beginning of the nineteenth century, the French began to supplant the Turks as overlords of North Africa. Delacroix went to Morocco in January 1832 as part of the Comte de Mornay's mission, sent by the French government to dissuade the Sultan of Morocco from supporting the Algerians in their resistance to France's occupying forces. The consolidation and expansion of France's influence in North Africa continued into the twentieth century and inevitably resulted in conflict with Germany. By appearing to compete for power in North Africa, Germany hoped to divert France's attention from Europe. The first Moroccan crisis of 1905 demonstrated the aggressiveness of Germany's ambitions. During the second Moroccan crisis of 1911, the German gunboat *Panther* arrived at Agadir and France sent an expeditionary force to Fez. Finally, Germany recognized France's protectorate of Morocco, formally ratified in 1912, in return for the secession of part of the French Congo.

Delacroix, Loti, the French Orientalists who recorded the North African scene, and Matisse all had a highly Romantic, very picturesque view of Morocco, which had more to do with what they felt contemporary European civilization lacked than with the changing reality caused by French colonization. Delacroix saw the Moroccans as the inheritors of the classical Greek and Roman virtues of dignity and simplicity; he regarded the Arab burnous as a variant of the Roman toga. In *Au Maroc*, first published in 1889, Loti, one of the most pictorial of all French novelists, conjures up a heady mixture of feelings in an exotic atmosphere. He invites the reader to experience the fleeting pleasures of life: 'Let us live in a vague dream of eternity, careless of what earth has in store for us tomorrow ... Regardless of all beside, let us grasp as they pass those things which do not deceive: beautiful women, fine horses, magnificent gardens, and the perfume of flowers.' His Moroccans are the often negligent guardians of a primal way of life, bound by timeless customs and rituals, where the men are cast as warriors and the women as pliant but mysterious sexual objects. A persistent undertone in the French Orientalist paintings of Moroccans is that, however virtuous their old customs, they are basically a backward, slightly barbaric, degenerate race overcome by inertia and incapable of coping with the modern world.

Matisse's Moroccan paintings present a compendium of these different views. His *Riffian Standing* of 1913 (Plate 100) is a colourful warrior dominating the canvas; the Moroccans lolling about in *Arab Café* of 1913 (Plate 99) are indolent figures, as incapable of action as the goldfish they are watching; and his paintings of Zorah, such as *Zorah on the Terrace* of late 1912 (Plate 97), are of a child-like figure hiding in the shadows. Matisse was uninterested in the documentary realism of the Orientalists: his *Entrance to the Casbah* of early 1912 (Plate 98), the gateway by the old Arab quarter, gives no architectural detail. His primary concern was with the flooding light and colour which absorb all figures and objects in the heady, highly perfumed atmosphere of a dream, *un rêve de bonheur*, inspired by Morocco.

Towards the end of 1911, Matisse had begun to favour the softer, more spiritual harmony of green and blue, rather than the strident complementary contrast of red and green, which is more intellectual in its clarity of colour separation. This is reflected in the paintings of his first winter in Tangier. In the beautiful *Window at Tangier* (Plate 91) a red vase of flowers floats as a chromatic accent in a mirage of blues melting into greens. The atmosphere of the lovely *Park in Tangier* (Plate 93) is

95. *Goldfish.* 1912. Oil on canvas,
116.8 × 101 cm. Merion, Pa., Barnes
Foundation.
The treatment of the still-life elements in
Goldfish is more realistic and solid than in the
earlier *Goldfish and Sculpture* (see Plate 92).

96. *Nasturtiums and the Dance I.* 1912. Oil on
canvas, 190.5 × 114 cm. Moscow, Pushkin
Museum of Fine Arts.
The unusually narrow format would suggest
that this painting was commissioned by
Shchukin for a specific location in his house.

almost too heavy and over-blown; only an unexpected patch of pale russet-brown
leaves and the energetic shapes of the acanthus plants (which reminded Matisse of
the Corinthian capitals he had drawn as a student) save the spectator from sinking,
satiated, in layers of deep blue steeped in violet. It might appear that the relaxed
atmosphere of these Moroccan paintings was the outcome of easy execution, but we
know that this was not the case. Matisse complained on a postcard to Gertrude
Stein, 'Painting is always very hard for me—always this struggle—is it natural?
Yes, but why have so much of it?'

During the summer and autumn of 1912 at Issy-les-Moulineaux, Matisse
sustained the dream-like atmosphere and blue tonality of the Moroccan paintings in
a slightly more realistic mode. Several of the paintings are variations on previous
works. In *Goldfish* (Plate 95) the arrangement of the elements in *Goldfish and
Sculpture* of 1911 (see Plate 92) is repeated, showing more of the interior of his
outdoor studio. In the first of two versions of *Nasturtiums and the Dance* (Plate 96),
the mound around which the dancers circle is changed from the green of *Dance* to a
pervasive deep ultramarine blue. But the most glorious of all the blue paintings is
without doubt *The Blue Window* (Plate 94). The barriers between his bedroom at
Issy and the view across the garden to his outdoor studio are dissolved in a simple
geometric structure filled with blue. The central window bar becomes a tree-trunk
in the garden and the tree-trunk in the garden another window bar which appears to

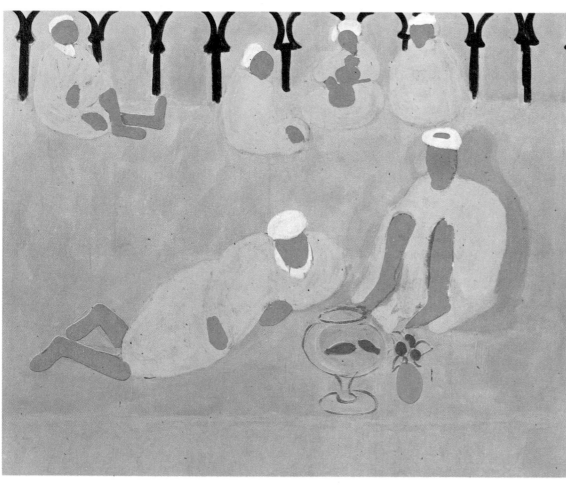

97. *Zorah on the Terrace*. Late 1912. Oil on canvas, 115 × 100 cm. Moscow, Pushkin Museum of Fine Arts.
This painting of Zorah, a model whom Matisse employed on both Moroccan trips, is the largest canvas of his so-called Moroccan triptych.

98. *Entrance to the Casbah*. Early 1912. Oil on canvas, 116 × 80 cm. Moscow, Pushkin Museum of Fine Arts.
Entrance to the Casbah and *Window at Tangier* (see Plate 91), along with the later *Zorah on the Terrace*, were intended by Matisse as a Moroccan triptych for Ivan Morozov; *Window at Tangier* was to hang on the left, *Zorah* in the middle, and *Entrance to the Casbah* on the right.

99. *Arab Café*. 1913. Casein on canvas, 176 × 210 cm. Leningrad, Hermitage Museum.
Arab Café was bought by Shchukin for 10,000 francs, after Matisse had offered it to Morozov. Shchukin wrote, 'It is the picture which I love now more than all the others and I look at it every day for at least an hour.'

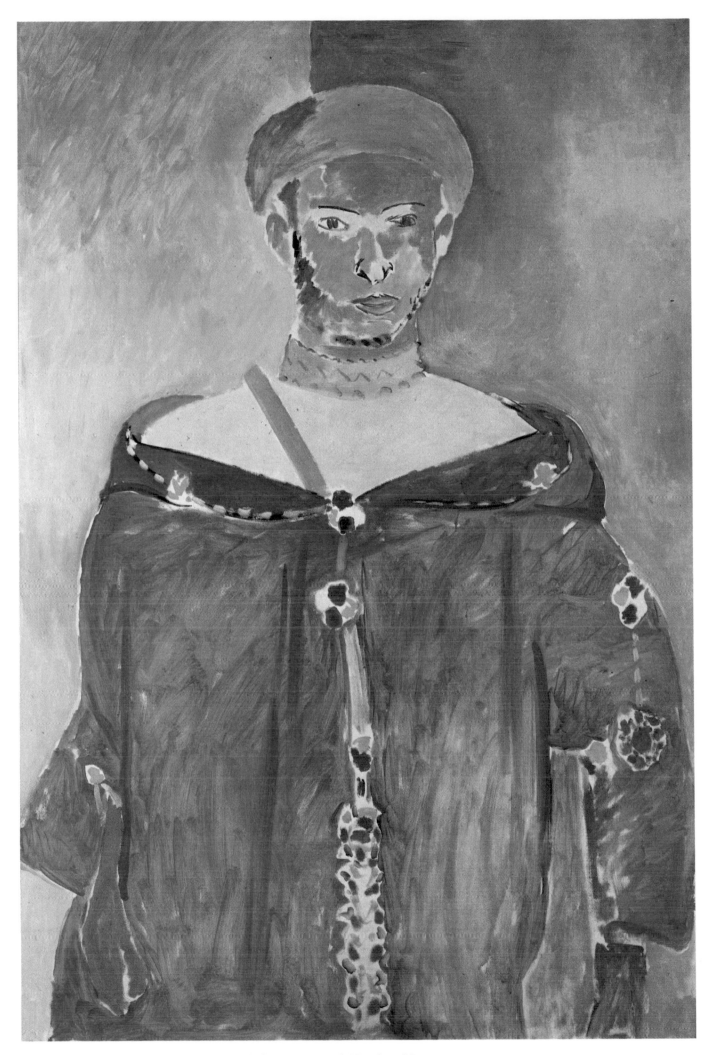

100. *Riffian Standing*. 1913. Oil on canvas, 145 × 96.5 cm. Leningrad, Hermitage Museum.
This is the second of two magnificent portraits of a Riffian painted in Tangier, probably early in 1913.

be growing out of the top of the lamp in the bedroom. Blue functions as the colour of darkness, and light is expressed as a sequence of luminous notes of colour played in association with the shapes of objects; the main chromatic accent is sounded in the two crimson flowers.

During his second winter in Tangier, Matisse came across Marquet and Camoin, his old friends from Moreau's studio. On a number of occasions in Matisse's career, Marquet led him to work from nature in a freer, more realistic style, but this did not happen in 1912–13. The paintings of his second Moroccan stay are if anything flatter and more abstract than those of the previous winter. This was perhaps a further response to Persian miniatures and Analytic Cubism. He saw the exhibition of Persian miniatures at the Musée des Arts Décoratifs in 1912, and he kept a wary eye on what Picasso and the Cubists were doing. Analytic Cubism demonstrated the extent to which a subject could be abstracted to add further formal and psychological dimensions without losing contact with reality. *Zorah on the Terrace* was painted in harmony with the colour scheme of *Entrance to the Casbah* and *Window at Tangier*, from his previous stay, to form a triptych for Shchukin's rival collector Ivan Morozov, in place of three landscapes which Matisse had promised him from Collioure in 1911. In *Zorah on the Terrace* different perspectives are combined to add interest and ambiguity to a seemingly simple composition. His favourite *repoussoir* form (taking the eye into a composition), in this case a carpet, creates the illusion of space receding behind the pair of slippers on the left, which are attached to a vertical plane of colour. Similarly in *Entrance to the Casbah* the figure on the left could be either inside or outside the arch. In both paintings light and shade compete for the possession of the figures, giving them the illusion of seeming either to blend in with or to emerge from the penumbra of the background.

With the exception of *The Moroccans* of 1916 (see Plate 116), a later imaginative synthesis of his memories of Morocco, *Arab Café* is the largest and most decorative of all the paintings executed during his two winters there. Six Arabs either squat or recline in a milky field of pale green, beneath the insistent rhythm of the arches, contemplating a bowl of goldfish and a vase of flowers. The pink border with its creamy ochre motif complements the field of green and introduces the colours of the flesh tones, the goldfish, and the vase of flowers which Matisse recalls as having inspired the painting. It is a 'fresco' decoration of a subject that had obsessed Matisse since *Le Bonheur de vivre* (1905–6)—figures suspended in a harmonious state of being. But there is a great difference between the two. *Le Bonheur* is the expression of an ideal, where *Arab Café* is—as Matisse confirmed—the consecration of an actual experience. An Arab café, described by Gide as 'a place where silence gathers and days end', became an enclosed world, like the goldfish bowl, wherein the listless figures are trapped for the lack of any alternative occupation; they are treated as mannequins, not sensual human beings—their heads look as if they could easily roll off and assume the function of some other object such as a vase.

In 1908 Rodin had planned a fresco of paradise with his beloved Cambodian dancers, and he may have given Matisse the idea of trying something similar with his Moroccans. In *Arab Café*, the fresco effect is achieved with the casein medium, made from skimmed milk; this has resulted in the surface with time becoming very brittle and fragile, its colours more chalky than Matisse must have intended. Drips in the final paint layer show that the casein was employed in a very liquid state to allow for corrections which could only be made while it was still wet.

The origins of *Arab Café* lie partly in Matisse's own work, as we have come to expect, and partly in a particular Persian miniature, *A Prince and his Tutor* (1532) by Agha Reza, exhibited at the Musée des Arts Décoratifs in the summer of 1912. The

disposition of the four Arabs along the top recalls the arrangement of the figures in *Music* (see Plate 84); the floral border and fresco effect are anticipated in *Interior with Aubergines* (see Plate 87); the goldfish and general colour scheme in *Zorah on the Terrace*. *Arab Café* changed considerably during the process of painting, each time moving towards condensation and simplicity. At one stage a row of slippers ran along the bottom of the composition, placed vertically as in *Zorah on the Terrace*.

Matisse returned to Issy in March 1913 to prepare for his April exhibition at the Bernheim-Jeune gallery, his fourth one-man exhibition in Paris, which included twelve of his Moroccan paintings, sculptures, and drawings. *Arab Café* dominated one hall, Morozov's Moroccan triptych another; it must have been one of the most beautiful exhibitions ever, with the whole room vibrating in a totally integrated atmosphere, which only Claude Monet in his various series could have rivalled in effect. In a celebrated review of the exhibition, Apollinaire likened Matisse's art to the radiant glow of an orange—the subject of one of the most beautiful of his Moroccan still-lifes (Plate 101).

The overwhelming colour and sensuality of Matisse's Moroccan paintings further distanced him from the Cubists and the Italian Futurists, the most recent arrivals in the vanguard of modern art. The decorative impact of *The Pink Studio* and *Nasturtiums and the Dance I* had caused a stir at the 1912 Salon d'Automne, but in general he had exhibited little of major importance since *Dance* and *Music* at the 1910 Salon d'Automne. By 1912 he had become a rather isolated figure in avant-garde circles. In February 1912 the first Paris exhibition of the Futurists was held at Bernheim-Jeune's, Matisse's own gallery, and during that year the painters Gleizes and Metzinger brought Cubism to the attention of a wider public with the formation of the Section d'Or (named after the Golden Section) and the publication of their book *Du cubisme*. Matisse's declining status in avant-garde circles was compensated for by the special treatment accorded him in three enormous international exhibitions of modern art—the Sonderbund exhibition organized by Karl-Ernst Osthaus at Cologne in March 1912, Roger Fry's Second Post-Impressionist Exhibition at the Grafton Galleries, London, in October 1912, and the Armory Show in New York in February 1913 (and then Chicago and Boston)—in which he vied with Picasso in terms of the number of works exhibited and attention received.

From 1913 to 1916 Matisse's painting became increasingly structural and serious, even at times severe. He spent most of 1913 working on a remarkable, grave, hieratic portrait of his wife (see Plate 102). Portraiture posed considerable problems for him. Because he was more interested in the development of his art and the expression of his own personality rather than that of a sitter, he tended to avoid portraits, especially commissions, preferring to paint his family and friends who were unlikely to try to dictate the final result. He was, nevertheless, sensitive to the mood and personality of a sitter or model, and he came to depend on them for inspiration. But in his efforts to go beyond a literal likeness, he would either bring out an aspect of the sitter's character through exaggeration, and sometimes association with forms such as flowers, or resort to his structural mode, striving for some eternal human essence beneath surface appearances.

Some of Matisse's most successful portraits are of his children when young, where a style of almost child-like simplicity and directness suited his subjects. *Young Sailor II* of 1906–7 (Plate 103), for instance, shows his son Pierre dressed up in a sailor-suit at Collioure. His portraits of adults are usually in the tradition of Renaissance three-quarter length portraits, developed by Raphael to convey a sitter's status in conjunction with his personality. Sometimes they look more like

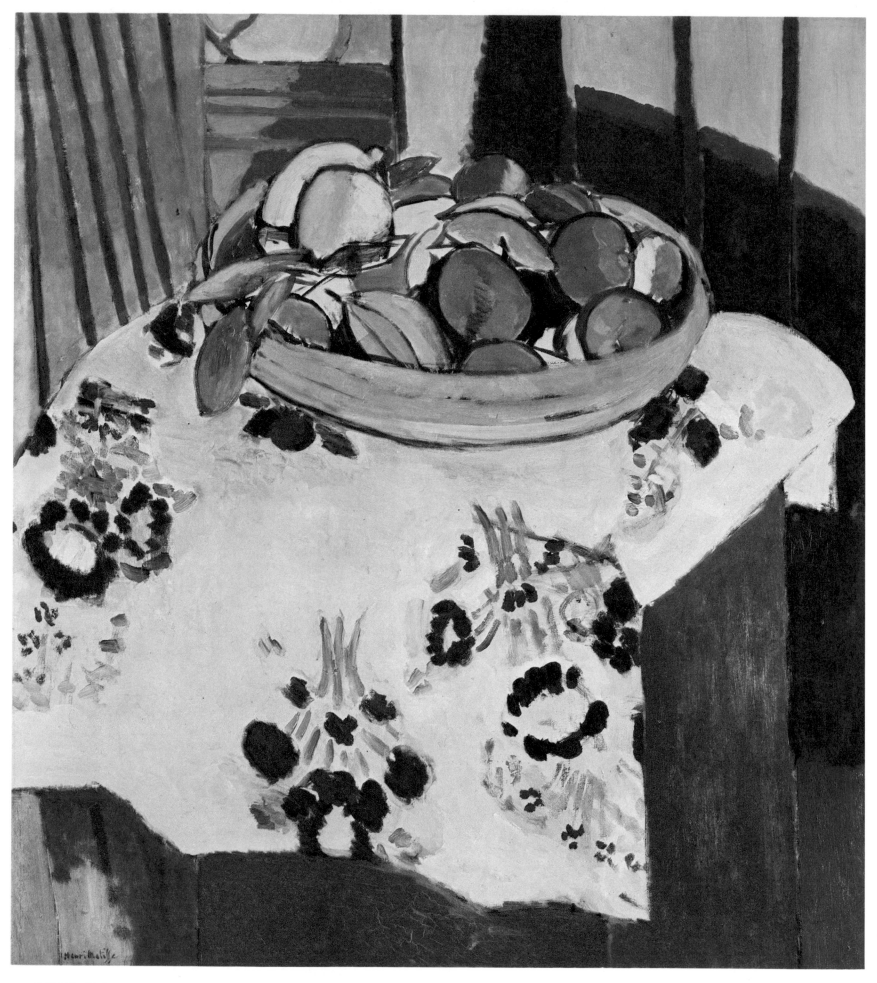

101. *Still-Life with Oranges.* 1912. Oil on canvas, 94 × 83 cm. Paris, Musée du Louvre, Donation Picasso.
Matisse was very moved when he heard that Picasso had bought this gorgeous still-life from the Berlin collection of Thea Sternheim in 1944. Picasso came to regard it as one of his favourite paintings: he felt that the radiating warmth of oranges epitomized the outstanding qualities of Matisse's art.

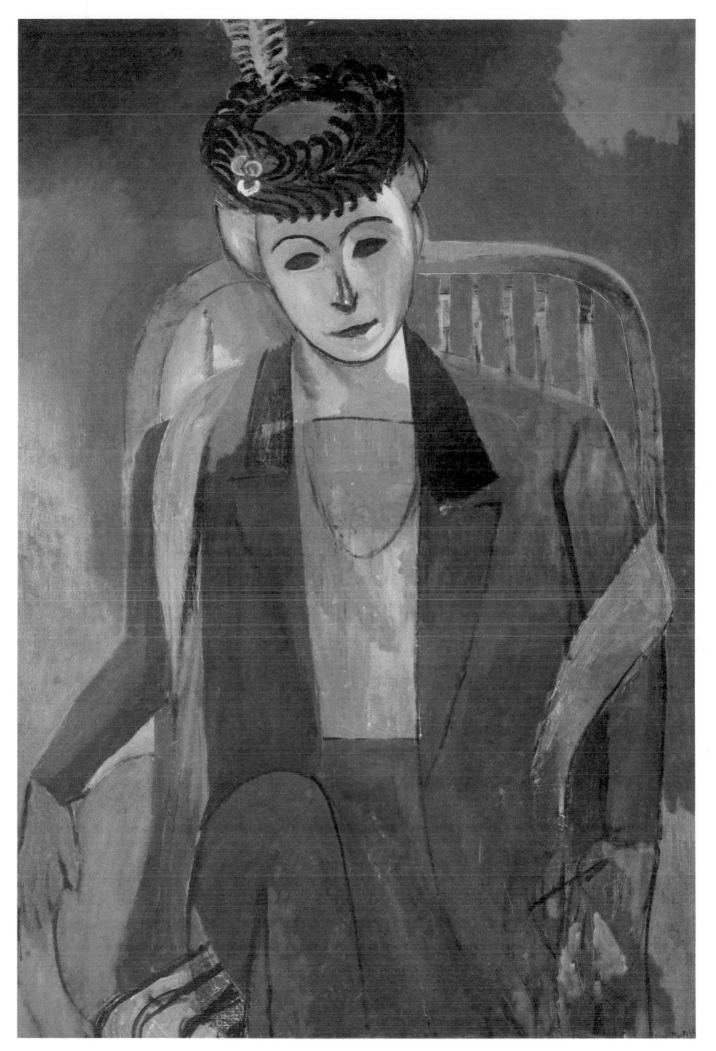

102. *Portrait of Madame Matisse.* 1913. Oil on canvas, 145 × 97 cm. Leningrad, Hermitage Museum.
The poet Apollinaire singled this portrait out as the outstanding painting in the 1913 Salon d'Automne. He thought that it would lead to a new period of sensuality, but in fact it heralded Matisse's most structural phase.

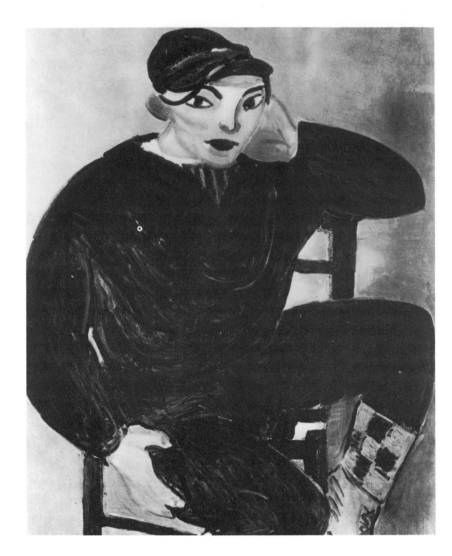
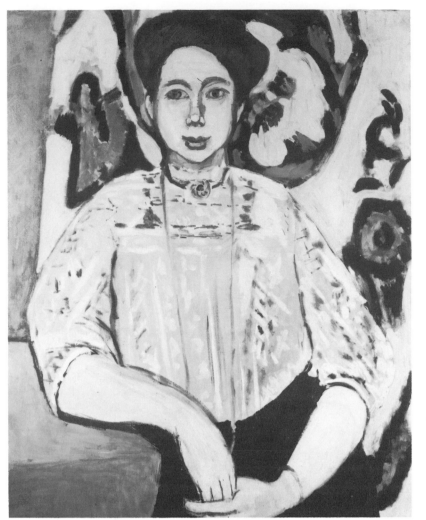

icons of saints or royalty, highly stylized images, placed frontally, filling the canvas. He probably based the celebrated Fauve portrait of his wife, *Woman with the Hat*, on Raphael's portrait of *Baldassare Castiglione* (1514–15), which he had copied as a student in the Louvre; and he turned to a portrait by Veronese in the Louvre to assist with the portrait of his friend and pupil *Greta Moll* of 1908 (Plate 104)—how appropriate then, given its strong connection with tradition, that this should be the first Matisse to enter the National Gallery in London.

The new emphasis on structure in Matisse's portraiture between 1910 and 1914 was spearheaded by a sequence of five sculptures, known as *Jeannette I* to *V* after Jeanne Vaderin, a neighbour at Issy who posed for him. A painted portrait of 1910 exploits the relationship between the sinuous grace of her figure and the shape of tulips. *Jeannette I* (Plate 105) and *II* were modelled from life, around the same time as the portrait; *Jeannette III* and *IV* were finished by October 1911 (the latter appears as if still moist in *The Red Studio* of that year; *Jeannette V* (Plate 106) was developed from a cast of *Jeannette III* during the summer of 1913, while he was struggling with *Portrait of Madame Matisse*. *Jeannette I* and *II* are more like conventional portrait heads than the last three in the series, as though to maintain contact with solid volume and realistic modelling when his paintings were flat and decorative. The progression towards abstraction from *Jeannette I* to *V* represents his effort to achieve the same state of visual autonomy in sculpture as in painting. It may also express his intuitive desire to arrive at one essential head—which is ultimately his own.

Portrait of Madame Matisse (Plate 102) carries this concern for structure from sculpture back into painting. The figure was worked and reworked so many times that its solidity emerges in a decorative form: the spectator is conscious of the numerous changes in form and colour registered in the paint surface. It apparently took over 100 sittings to complete, and despite its enthusiastic reception at the

103. *Young Sailor II*. 1906–7. Oil on canvas, 100 × 81 cm. Mexico City, collection of Mr and Mrs Jacques Gelman.
This is the second, more synthetic, version of the portrait of Matisse's son Pierre posed in his sailor-suit at Collioure.

104. *Greta Moll*. 1908. Oil on canvas, 92.7 × 73 cm. London, National Gallery.
This portrait required ten three-hour sittings. According to Greta Moll it changed considerably: 'The blouse which ended up greenish was at one time lavender white. Even the black skirt was once coloured yellow or greenish . . .'

1913 Salon d'Automne Matisse was still not entirely happy with it. The very poetic blue and green colour scheme, with a contrasting reddish-orange sash, is superficially similar to that of the magnificent *Riffian Standing* (see Plate 100), painted earlier that year in Morocco. The mood and technique, though, have changed. *Riffian* relates to Matisse's earlier, optimistic Fauve compartmentalization of the figure into separate areas of contrasting colour. The serene, slightly detached *Madame Matisse*, on the other hand, has more in common with the gravity of Russian icons than with the atmosphere of the Moroccan paintings. Absorbed in thought as in colour and structure, she is Matisse's icon and one of his most profoundly beautiful paintings.

Depressed by the weather at Issy, Matisse thought of spending the winter of 1913–14 in the south again, but on going back to his old studio at 19 Quai Saint-Michel to say goodbye to Marquet he decided instead to rent the studio on the floor below and stay in Paris. Travel, he felt, would have been a form of escapism, tantamount to putting off the task, 'the very painful endeavour', which he saw ahead. His use of structure in *Portrait of Madame Matisse* precipitated a head-on confrontation with Cubism which he could no longer avoid; his art was already moving in that direction. By contrast with Braque and Picasso, who produced much of their best Cubist work away from Paris in small provincial villages,

105. *Jeannette I.* 1910. Bronze, height 33 cm. Nice-Cimiez, Musée Matisse. The first and most conventionally realistic of a series of five heads, modelled between 1910 and 1913.

106. *Jeannette V.* 1913. Bronze, height 58.1 cm. Nice-Cimiez, Musée Matisse. In response to Cubism, Matisse pushed his increasingly extreme analysis and exaggeration of structure in the *Jeannette* series to a point he did not find possible—or even wish to achieve—in his painted portraits at the time. The features of the face assume as forceful an identity as the separate forms of head, bust, and base.

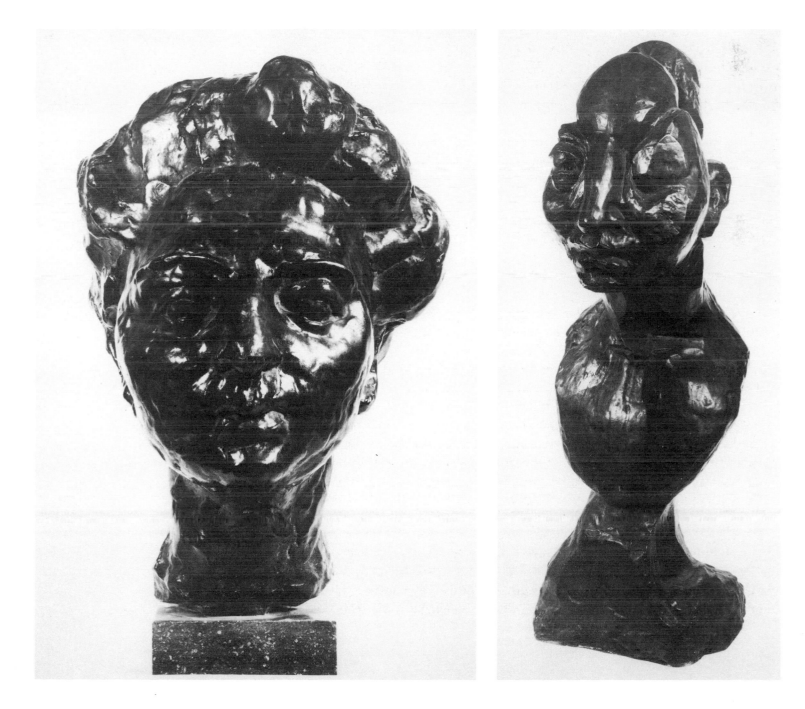

Matisse's investigation of their new pictorial language necessitated his staying in the familiar surroundings of his own studio, where he could concentrate on the same subjects over an extended period, experimenting with new ways of expressing them with greater structural force. Isolated at Issy and unable to sustain the lyrical colour and style of his Moroccan paintings, he found at 19 Quai Saint-Michel just what he required: contact with his former motifs—studio, Seine, and Notre-Dame—and the stimulus of the Parisian avant-garde milieu.

Matisse did not regret his decision to stay. He painted a succession of masterpieces during winters spent at 19 Quai Saint-Michel: *Interior with Goldfish* of 1914 (Plate 107), *Studio, Quai Saint-Michel* of 1916 (see Plate 122), and *The Painter and his Model* of 1917 (see Plate 125). *Interior with Goldfish*, painted within his first few months there, combined his recent goldfish and interior themes with his earlier interest in Seine views during his so-called 'dark period' from 1901 to 1903. The goldfish act as a central point of focus in a predominantly deep-blue and grey colour scheme. Key forms are heavily outlined in black. The circular shape of the goldfish bowl is introduced in the form of the large *repoussoir* bowl (bottom right) and repeated in the curve of the bridge outside.

Among his most severe and forcefully abstracted paintings from 1914 were once again a number of portraits. *Woman on a High Stool*, an abstract image of a woman sitting solemnly in an overall grey interior, is a painting, rather than a traditional portrait, of Germaine Raynal, wife of the Cubist critic Maurice Raynal. *Portrait of Mademoiselle Yvonne Landsberg* (Plate 108) and *Head, White and Pink* (Plate 109), based on his daughter Marguerite, both began as recognizable likenesses which were then progressively abstracted. The sweeping lines which emanate like ripples from the figure of Yvonne Landsberg were incised with the wooden end of the brush into the wet final paint layer, following several more naturalistic preliminary states. Similarly the cage-like grid imposed on Marguerite's head and torso was possibly suggested by the striped jacket she was wearing; its actual shape was based on her features in an earlier state of the painting, as opposed to a mathematical system of proportion. The incised lines, reminiscent of Futurist force lines and the cage-like Cubist grid, look completely out of character with Matisse's previous work and reflect his involvement with the new avant-garde at a time of experiment and extreme uncertainty.

The international situation had become alarming. On 1 August 1914 the order for general mobilization was given and two days later war was declared. On 11 November 1918, after four years of slaughter and destruction in France's most densely populated and richest areas, the German army accepted an armistice, and the Treaty of Versailles, formally ending the war, was signed on 28 June 1919.

The statistics of the war provide the most terrible backdrop against which French artists had to work at this time. Out of a total of some 8,570,000 men aged between eighteen and forty-six available for compulsory military services, 7,935,000 were finally mobilized; 1,322,000 were killed in battle, 3,000,000 were wounded (388,800 of them permanently), and 513,000 were captured. The war left 760,000 children without a father, about 600,000 widows, and 4,000 orphans. It is difficult to over-estimate the effects of this catastrophe. However, the cost of the war should not have come as a total surprise to those foolishly predicting a speedy French victory without Allied assistance. In a war of attrition determined by the number of men available in the field, France was doomed to come off second-best against Germany. Since 1871 France's population had slumped from second to fourth largest in Europe. What is more she had the smallest population of young people in Europe and the highest number of old people. In the last census before the

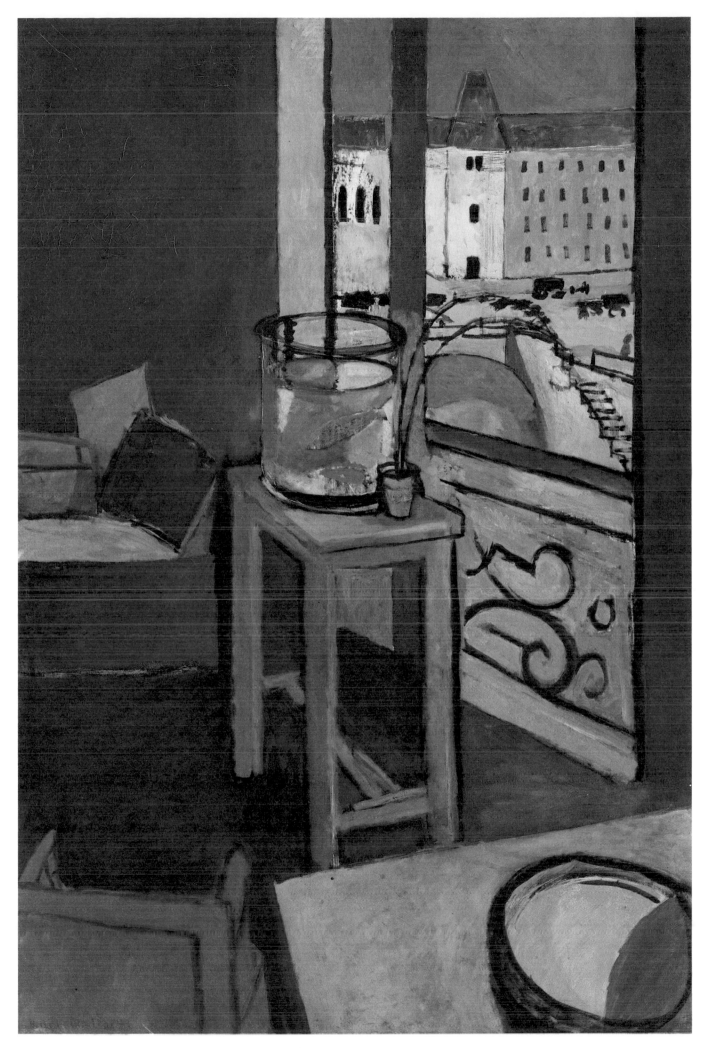

107. *Interior with Goldfish*. 1914. Oil on canvas, 147 × 97 cm. Paris, Musée National d'Art Moderne, Centre Georges Pompidou.
The intimate setting of his studio at 19 Quai Saint-Michel is opened out to balance the exterior view of the Seine, through the creation of what
Matisse called 'a larger and truly plastic space'. We are made to feel 'in' the composition, looking about us.

war, taken in March 1911, France had a total population of 39,605,000, in comparison with Germany's 64,900,000. Of the French population, 34.9 per cent were classified as young, in comparison to Germany's 43.7 per cent, and between 1890 and 1896 twenty-two Germans were born for every ten Frenchmen.

Soon after the declaration of war in August, Matisse—who at forty-five was very near the age limit for active service—volunteered but was rejected. Two of the four originators of Cubism, Braque and Léger, were less fortunate: they enlisted and were badly wounded. The other two, Picasso and Gris, as Spanish nationals were not involved—although all four lost their means of support when their dealer Kahnweiler, a German, was declared an enemy alien and had his property sequestered. With the prospect of an immediate German advance on Paris, the Matisses sent their children to Toulouse for safety. They collected them at the beginning of September and by 10 September had moved on to Collioure, where by chance Gris and Marquet were staying.

Matisse's meeting Gris at Collioure was one of those fortunate coincidences in the history of art which brought together two artists working on similar problems at a time of crisis. Both men suffered from self-doubt and found painting very difficult. Gris was torn between an almost fanatical obsession with the logic of his pictorial ideas and the desire to express the sensitive, sensuous side of his personality. Both artists wanted to convey the solid appearance of reality on a two-dimensional surface without recourse to traditional illusionism.

After attending the School of Industrial and Fine Arts in Madrid, Juan Gris (1887–1927) had established an early reputation with his drawings and illustra-

108. *Portrait of Mademoiselle Yvonne Landsberg.* 1914. Oil on canvas, 145.4 × 106.7 cm. Philadelphia Museum of Art, Louise and Walter Arensberg Collection.
Yvonne Landsberg reminded Matisse of the magnolia buds which he was drawing at the time: the constructional lines around her figure suggest buds bursting into flower.

109. *Head, White and Pink.* 1914. Oil on canvas, 75 × 45 cm. Paris, Musée National d'Art Moderne, Centre Georges Pompidou. There is a geometric framework underlying many of Matisse's paintings; here it is placed on the surface, in an overtly Cubist manner.

110. Juan Gris. *Man in the Café*. 1912. Oil on canvas, 128.3 × 90.5 cm. Philadelphia Museum of Art, Louise and Walter Arensberg Collection.
Gris pioneered the use of the grid structure in 1912.

tions for satirical magazines. On his arrival in Paris in 1906, he joined the Picasso circle and took a studio in the Bateau-Lavoir, Montmartre, where Picasso was working. He continued to earn his living as a satirical draughtsman and only began painting full-time in 1910. During 1910 and 1911 he evolved his own very personal form of Analytic Cubism, based on his intense study of Cézanne. His interest in science and mathematics drew him to the Section d'Or artists who were searching for a rational base to Cubism. In 1912 he employed a surface grid structure (see *Man in the Café*, Plate 110) to reconcile several views of his subject (rather like a plan, section, and elevation of an architect's drawing) with the flat surface of the canvas. In a series of *papiers collés* executed in 1914, Gris further simplified his forms and made them look more solid and colourful. (The *papier collé* technique was first used by Braque in September 1912; he literally glued—*collé* in French means glued—pieces of paper to a surface.) Gris did not immediately follow Picasso and Braque into the next 'synthetic' phase of Cubism: he was too interested in maintaining contact with the appearance of reality, albeit in a new pictorial vocabulary. In Synthetic Cubism, Picasso and Braque reversed their former analytic process: instead of abstracting the subject in front of them, they would begin with abstract elements and then qualify these into suggesting a realistic subject by overdrawing or shaping. Picasso's Synthetic Cubist *Harlequin* of December 1915 anticipates the flattened forms and black background of Matisse's *The Moroccans* of 1916 (see Plate 116). Matisse's later paper cut-outs are also indebted to the *papier collé* technique.

Much to Marquet's discomfort, Matisse and Gris discussed theory *ad infinitum.* Their discussions would certainly have covered such topics in vogue as theories of harmony based on mathematical proportion or Bergson's ideas on the relationship between mind, matter, and space. The philosopher Henri Bergson (1859–1941) propounded a cult of the irrational, with the emphasis on creativity and action, which was of direct appeal to the French avant-garde. While appearing to popularize the latest scientific discoveries, he undermined the Positivist position on which science and materialism were based. The inner core of human reality (*la durée*), he argued, consisted of memories, existing outside space and time, and therefore not subject to scientific analysis. Only instinct, intuition, and contemplation could guide us to a true understanding of ourselves and the movement or force uniting inert matter, which he called the movement of life. He defined the artist's duty as the breaking down of the 'barrier that space puts up between him and his model': 'Once in possession of the form of space, mind uses it like a net with meshes that can be made and unmade at will, which, thrown over matter, divides it as the needs of our action demand.' Gris and Matisse must surely have seen in such ideas a rationale for their employment of a grid structure.

On returning to Paris in October 1914, Matisse would have found that his pre-war world was rapidly changing. The battle of the Marne had saved Paris, but refugees were pouring into the city from the area of the battle; a short offensive campaign was turning into a long-drawn-out conflict. Cut off from Russia, he could no longer count on the patronage of Shchukin and Morozov. Nothing more was heard of a series of decorations he had been thinking of producing for Morozov. *Bathers by a River* (see Plate 112), which he had started in 1909—along with *Dance* and *Music*—as a third decoration for Shchukin, still remained unfinished in his studio at Issy. He also had been planning an imaginative synthesis of his Moroccan experiences which eventually became *The Moroccans* of 1916 (see Plate 116). The last Matisse bought by Shchukin, *Woman on a High Stool*, was never actually delivered. According to Matisse's daughter, *Interior with Goldfish* was also intended for Shchukin.

111. *Composition, The Yellow Curtain*. 1915. Oil on canvas, 146 × 97 cm. Brussels, Monsieur Marcel Mabille.
The rhythmic and colouristic energy concentrated in the curtain on the left is balanced by the expanded field of yellow ochre contrasted against pale blue on the right. The lower area of blue represents the small pond Matisse had built behind his house at Issy-les-Moulineaux.

112. *Bathers by a River*. Completed in 1916.
Oil on canvas, 261.6 × 393.7 cm. Chicago,
Art Institute of Chicago.
Matisse originally envisaged *Bathers by a
River* as a companion piece to *Dance* of 1909–
10, but Shchukin, who admired the sketch
Music in the Steins' collection, thought
music a more appropriate subject for his
palace where he held regular concerts.
Matisse evidently still hoped to include it as
part of a more ambitious cycle of three, not
just two, decorations. However, it remained
in his studio at Issy. He reworked it in 1913,
and completed it in 1916 in his new
architectonic Cubist style.

Unable to concentrate on painting, Matisse turned to printmaking, installed a
small hand-press in his studio at 19 Quai Saint-Michel, and executed a series of
some sixty etchings, dry-points, and monotypes, and nine transfer lithographs.
Most of the etchings are portraits of his friends, often sketched very quickly. Quite
a number of them are of other artists' wives. There are at least seven of Madame
Gris, which suggests that Matisse paid her to sit in order to help Gris in his very
precarious financial situation. The nine transfer lithographs, all of nudes, are among
Matisse's most successful prints (see *Standing Nude, Face Half-Hidden*, Plate 113). In
contrast to the scratchy resistance of the etching needle, the fluidity of the
lithographic crayon exactly suited his style of marvellously precise and sinuous line
drawing.

When he resumed oil painting in the winter of 1914, Matisse found himself
faced with the sort of crisis on which his art thrived. With characteristic clarity he
put it down to a conflict between the romantic and rationalist sides of his own
temperament. Artistically it was a choice between two very different stylistic
alternatives: the lyrical heritage of Gauguin, as expressed in *Dance*, *Music*, and the
preliminary state of *Bathers by a River*, on the one hand, and Cubism on the other.
In 1951, Matisse made a pertinent distinction between the Cubist's and the lyric
painter's approach to painting: 'The Cubists' investigation of the plane depended
upon reality. In a lyric painter, it depends upon the imagination. It is the
imagination that gives depth and space to a picture. The Cubists forced on the
spectator's imagination a rigorously defined space between each object. From
another viewpoint, Cubism is a kind of descriptive realism.' The forceful structure
and sombre palette of Cubist realism seemed the appropriate style for the times, and
it triumphed in Matisse's paintings from late 1914 to the winter of 1916; but his

efforts to reconcile the modern methods of Cubist construction with the imaginative subjects of *Bathers by a River* and *The Moroccans* resulted in two of his greatest masterpieces.

From 1914 to the end of 1915, Matisse experimented with Cubism and painted comparatively few canvases. In order to be able to concentrate his full attention on the plastic issues involved (and to preserve his own artistic identity), he based his Cubist experiments on previous paintings and familiar subjects. *Goldfish* of 1914–15 (Plate 114) is a more severely structured version of *Interior with Goldfish* of 1914 (see Plate 107); Matisse's personal signature theme of brightly coloured goldfish, fruit, and foliage is contrasted by a dramatic vertical band of black. This was a favourite Cubist device, employed by Braque, Picasso, and especially Gris, but not with the same dramatic force as Matisse. *Composition, The Yellow Curtain* (Plate 111), painted at Issy during the summer of 1915, shows a view over the garden from his living-room window. Large areas of yellow ochre, pale blue, and green are shaped—as in some Cubist *papiers collés*—to establish rhythmic correspondences across the picture surface. His student copy of the de Heem still-life (see Plate 4) served as the basis for a large-scale Cubist variation, completed by mid-November 1915 (Plate 115). The naturalistically coloured still-life objects are combined with the Cubist realization of space in geometric planes.

Having assimilated Cubism on his own terms, Matisse had gained the confidence to turn these modern methods of construction to the completion of *Bathers by a River* (Plate 112) and *The Moroccans* (Plate 116). His original conception in 1909 of *Bathers by a River* as a 'scene of repose: some people reclining on the grass, chatting or daydreaming' changed into a tense, highly abstract, architectonic composition.

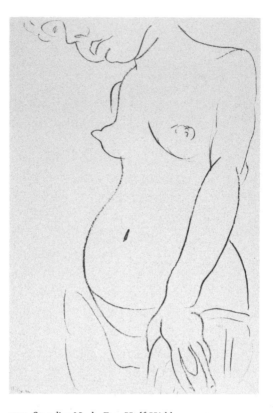

113. *Standing Nude, Face Half-Hidden*. 1914. Transfer lithograph, 50.3 × 30.5 cm. New York, Museum of Modern Art.
This beautiful lithograph is executed with the economy of the best Japanese line drawings. Significantly, Matisse included among his subjects for prints in 1914 portraits of Utamaro (the great eighteenth-century Japanese woodcut artist) and his own wife and daughter wearing kimonos.

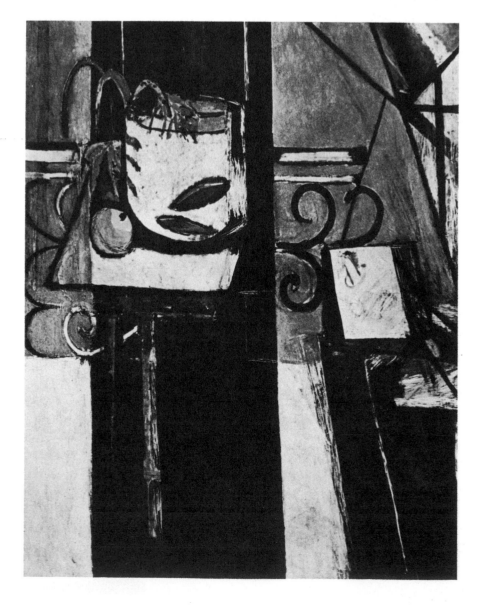

114. *Goldfish*. 1914–15. Oil on canvas, 146.5 × 112.4 cm. New York, Museum of Modern Art.
Goldfish is a more abstract variation of *Interior with Goldfish* (see Plate 107). At one stage Matisse included a self-portrait on the right, of which only his abstracted palette remains. It became a common practice of Matisse to execute two versions of the same subject—one soft and naturalistic, the other harsh and abstract.

115. *Variation on a Still-Life by de Heem.*
1915. Oil on canvas. 180.9 × 220.8 cm.
New York, Museum of Modern Art.
Matisse was fascinated by the way he could
deal with the same issues but in different
styles. Both seventeenth-century Dutch still-
life painting and Cubism were for him forms
of realism.

116. *The Moroccans.* Completed in 1916. Oil
on canvas, 181.3 × 279.4 cm. New York,
Museum of Modern Art.
After completing the deeply impressive *Arab
Café* in 1913, Matisse still hoped to paint a
souvenir of Morocco back in Paris, rather in
the same way that he had summarized his
first North African trip of 1906 in *Blue
Nude—Souvenir of Biskra.* He started the
painting in September 1913, began it again
in November 1915, and finally completed it
in the summer of 1916.

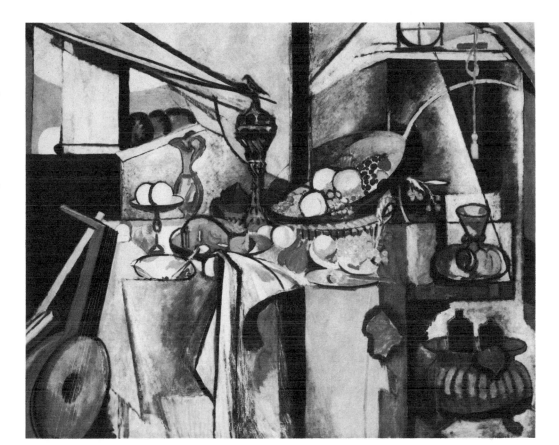

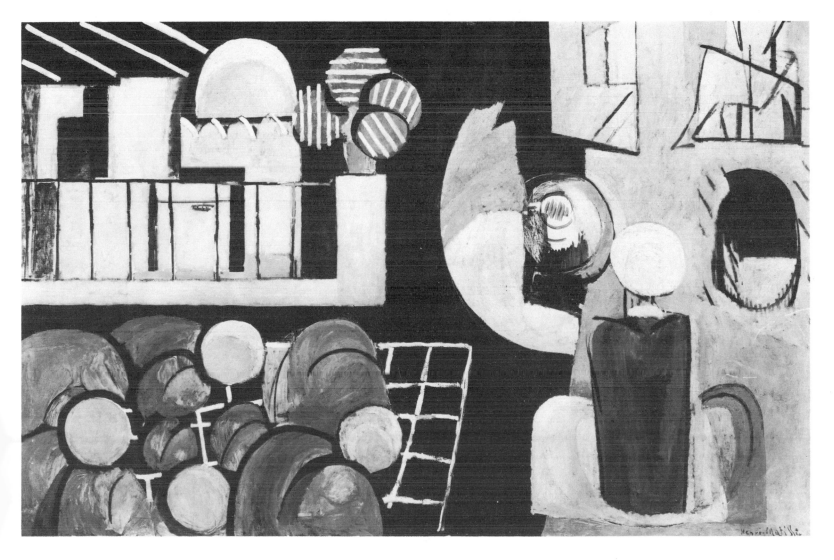

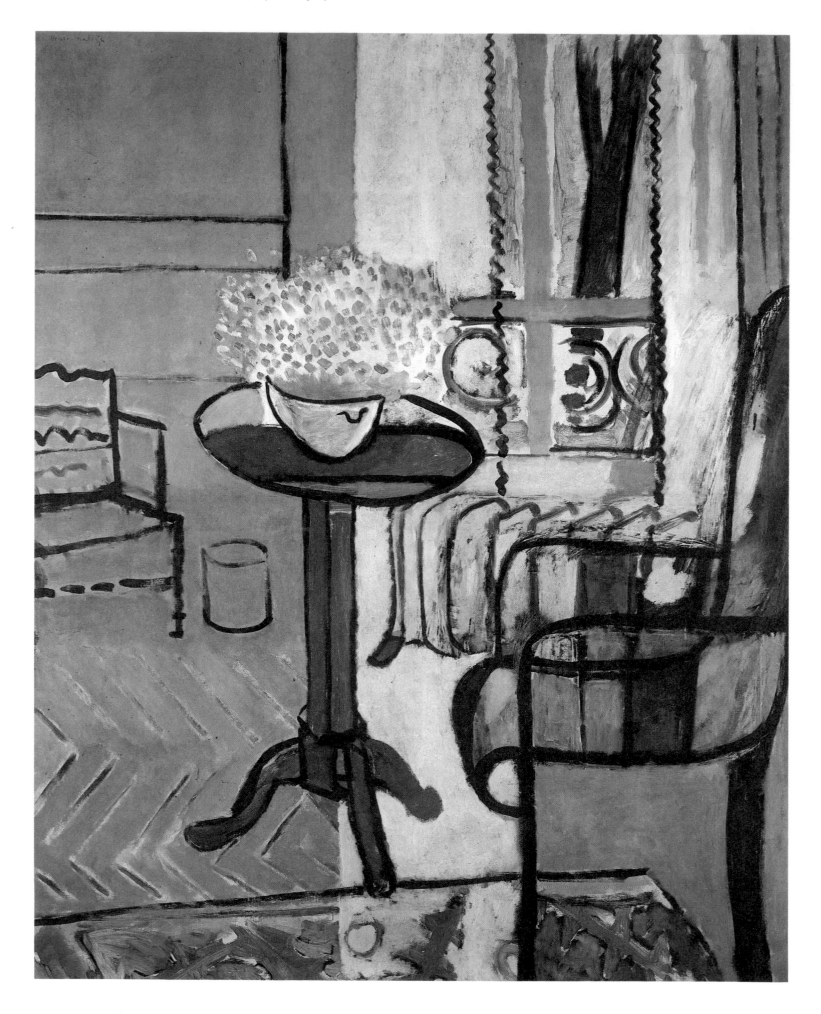

117. *The Window*. 1916. Oil on canvas, 146 × 116 cm. Detroit Institute of Arts. It is easy to imagine Matisse sitting in the chair, placed invitingly in the foreground, enjoying the scene he described in a letter of June 1916: 'Through the window of the living-room [at Issy] one sees the green of the garden and a black tree-trunk, a basket of forget-me-nots on the table, a garden chair, and a rug with a red design.'

118. *Piano Lesson*. 1916. Oil on canvas, 245.1 × 212.7 cm. New York, Museum of Modern Art.
The figure of Pierre, posed behind the piano in the living-room at Issy, has been interpreted as a surrogate self-portrait of Matisse himself. It says little for Matisse's relationship with his son that he could use him solely as a vehicle for his own temperament, but it is possible. Pierre apparently also posed for *Violinist at the Window* of 1917–18, which has been accepted as Matisse's self-portrait.

Instead of five female nudes relaxing by a waterfall, four schematic bathers, disguised by square shapes looking like ill-fitting Cubist overalls, stand depressed against a background camouflaged in vertical bands of green, black, and white. The two bathers on the right appear as the disembodied witnesses of a dreadful tragedy; the two on the left are barely recognizable as human figures. Some details apparent in a photograph taken of the painting in its transitional state in 1913 were suppressed; others were simplified and exaggerated. The waterfall was absorbed into the central black band; the leaves of the bulrushes and trees above became enlarged into scythe-like forms cutting across the field of green on the left. The snake remained, silhouetted against black, a symbol perhaps that evil had broken up a picture of paradise.

We cannot read *Bathers by a River* in a literal manner. In this respect the composition represents a new modern form of allegorical painting. Despite his later avowal that 'the war did not influence the subject-matter of painting, for we [modern artists] were no longer merely painting subjects', it is impossible to deny the vast changes in style, mood, and content that had occurred since his pre-war demand for 'an art of balance, of purity and serenity, devoid of troubling or depressing subject-matter.' In *Bathers by a River*, the formal problem of relating the figures to a flat background appears to have assumed in his mind the dimensions of a struggle for identity and survival during a very bleak period of the war. Feeling impotent and guilty at not being at the front, the painting itself became his battleground. *Bathers by a River* is certainly a grave and very difficult work, and it is understandable that Matisse was troubled by it, rather in the way that he was disturbed by the frenzy of *Dance*.

To help solve his recurring problem of relating the human figure to a flat background, without destroying the decorative effect of the whole painting, Matisse took up sculpture again and executed three life-size reliefs known as *The Backs*. These were worked on at the same time as the three stages of *Bathers by a River*: *Back I* in 1909 (Plate 119), *Back II* in 1913, and *Back III* in 1916 (Plate 120). *Back IV* (see Plate 160) dates from 1930 to 1931 when Matisse was again wrestling with this same problem during the gestation of the Barnes murals. *Back I*, like

Jeannette I, was directly inspired by the model, whereas in *Back III* the figure is abstracted into massively solid autonomous units. The extension of the model's hair into an external spine, on either side of which the masses are established, recalls his use of the vertical division down the centre of the face in *Portrait with the Green Stripe* of 1905 (see Plate 49). Reliefs share some of the formal problems of both painting and sculpture. In this case their format may have reinforced Matisse's decision to divide the background of *Bathers by a River* into broad vertical planes of colour.

Nothing appears further from the lyrical mood of the Moroccan paintings of 1911 to 1913 than Matisse's other monumental decoration of the war years, also completed in 1916, *The Moroccans*. In stark contrast to the former relaxed relationship between style, subject-matter, and content, *The Moroccans*, although less pessimistic in mood than *Bathers by a River*, is still tense, quite ruthless in its simplifications, and difficult to read. The overall atmospheric colour of his earlier Moroccan paintings is now materialized in a predominant black, balanced by a vertical band of cyclamen pink on the right—the solidified substance of a dream in which incidents and objects are recalled with varying degrees of clarity according to their formal and psychological relationships within the picture. There is no apparent continuum. The painting stands as a metaphor for a new conception of reality as a dynamic balance of seemingly disjointed parts.

The composition is divided into three self-contained areas, each firmly attached to the edges of the canvas so that the sensation of the whole surface should be greater than that of the separate parts. The architecture in the top left-hand corner includes the dome of a mosque, a balcony, and a pot with four striped cactus leaves. These establish a link with the second area, the terrace below, through the repetition of their shapes in the four yellow melons, which with their leaves also suggest prostrate Muslims at the time of prayer. The third area, on the right, is the most ambiguous. The figure at the bottom wearing a white turban is probably a priest in a minaret, viewed from above. The black form to the right of his head looks like a Cubist cross-section of the minaret's stairs; the white form to his left blending into a large arc suggests another turban and a raised arm. At the top, two further figures are reduced to small geometric frames.

The Moroccans resulted from a lengthy dialogue between Matisse's memory of a specific place and his process of making a challenging picture which has the physical presence and impact of a decorative object in its own right. In a letter to Camoin of November 1915, Matisse described the beginnings of his '*souvenir du Maroc*' and included a little sketch: 'It is the terrace of a little café with the idlers sprawled out gossiping towards the end of day. You can see the little white priest at the bottom . . . [this] bundle represents an Arab lying on his side on his burnous, the two hooks are his legs.' During the lengthy and very laboured evolution of *The Moroccans*, the anecdotal human quality of this scene was obliterated; the figures were either removed or became as object-like and structural as the architectural elements. Perhaps Matisse felt that in such dark times the human personality was submerged, overwhelmed by forces outside its control. Harrowed by his efforts, Matisse wrote to Camoin in 1916, 'I may not be in the trenches, but I am in one of my own making.'

In 1916—as in 1911 with the four 'symphonic interiors'—Matisse's intense creative commitment in these two large-scale decorations, *Bathers by a River* and *The Moroccans*, generated a wealth of pictorial ideas which he was to explore in smaller paintings. By this stage of his career Matisse could work in different styles and on several subjects, arriving at paintings in a variety of ways. In *Bathers by a River* and *The Moroccans*, Matisse had pushed oil painting to the very limits of a representational art-form. He now drew closer to reality again in two deeply

119. *Back I*. 1909. Bronze,
189.8 × 116.8 × 18.4 cm. London, Tate
Gallery.

120. *Back III*. 1916. Bronze,
187.9 × 113 × 17.1 cm. London, Tate
Gallery.
The first three versions of *The Backs* were
experimental reliefs, executed separately, not
as a series, when Matisse was wrestling with
the problem of relating figures to a flat
background in *Bathers by a River*. The
ultimate source of *The Backs* lies in the bather
on the left in Cézanne's *The Three Bathers* (see
Plate 21), owned by Matisse.

impressive paintings, *The Window* (Plate 117) and *Piano Lesson* (Plate 118).

The Window looks like a direct response to a specific motif, while *Piano Lesson* seems a more metaphysical statement on the nature of art and reality. Both were painted in the main living-room at Issy during the summer of 1916, and both convey to a quite extraordinary degree the sensation of being in the heightened presence of the visible world. In *The Window*, Matisse was evidently fascinated by the way he could adapt the techniques of his structural mode to depict atmosphere and light. The vertical band used in *Bathers by a River* is here transformed with great finesse into the left-hand white net curtain. It continues the full length of the painting to suggest light falling on the interior.

In *Piano Lesson*, the organic and the abstract, nature and art, are integrated in one of Matisse's most disciplined and gravely beautiful architectonic compositions. His

135

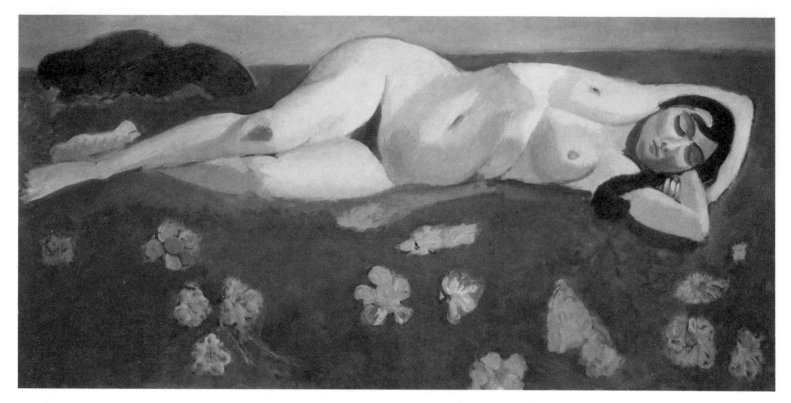

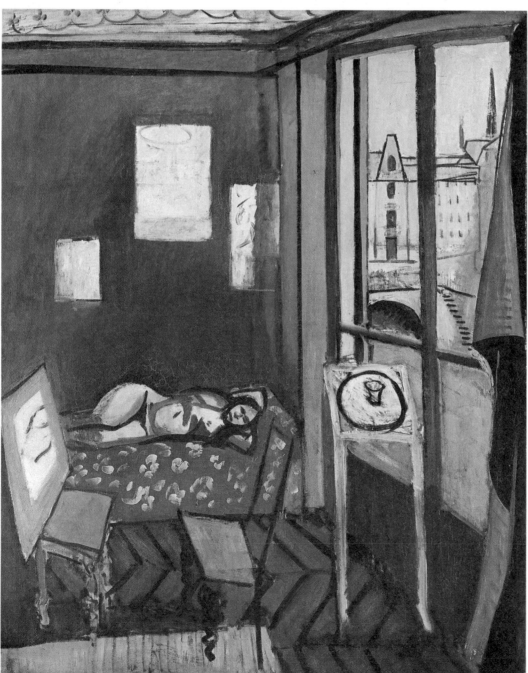

121. *Sleeping Nude.* 1916. Oil on canvas, 95 × 195.5 cm. Stavros S. Niarchos Collection.
In this painting of the Italian model Laurette, Matisse was particularly absorbed by the movement of the skin around her navel.

122. *Studio, Quai Saint-Michel.* 1916. Oil on canvas, 146 × 116 cm. Washington, DC, Phillips Collection.
Matisse may have planned this as a same-sized pendant to *The Window* (see Plate 117)—a summer and a winter interior.

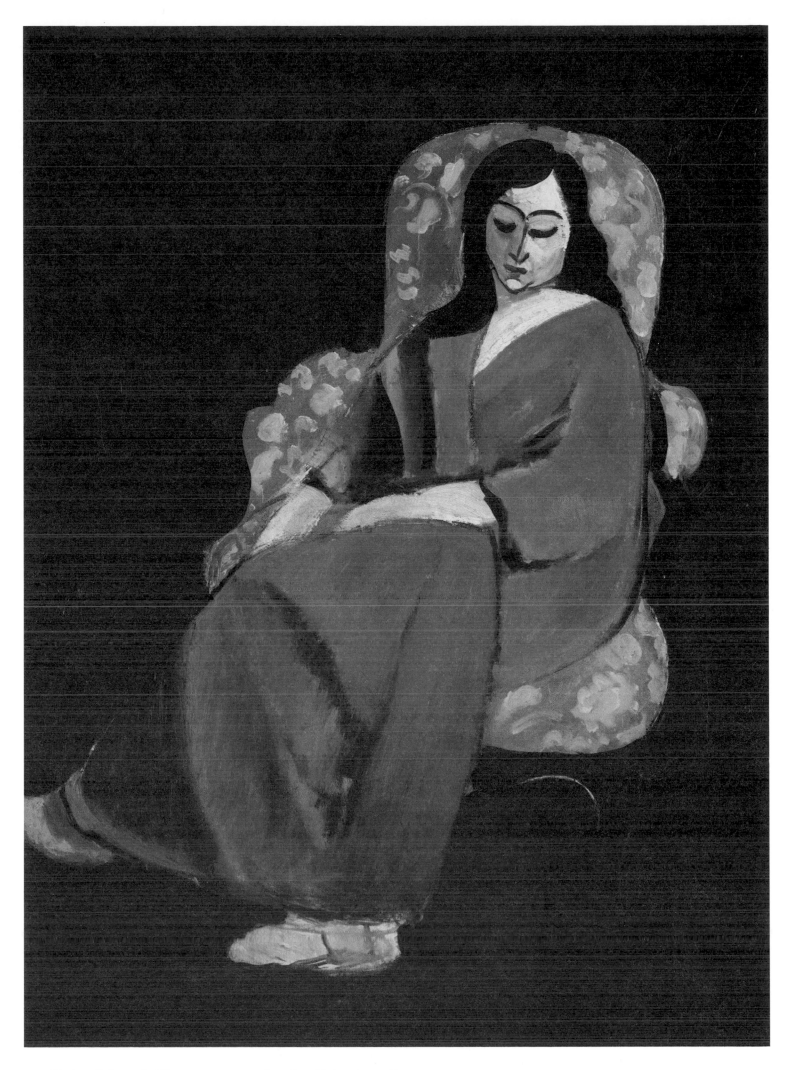

123. *The Green Robe*. 1916. Oil on canvas, 73 × 54.6 cm. New York, private collection.
The voluptuous Italian model Laurette featured in a whole series of Matisse's paintings in 1916 and 1917.

son Pierre posed at the Pleyel piano. One of Matisse's own paintings, *Woman on a High Stool*, is seen hanging on the wall behind, and his sculpture *Decorative Figure* is in the left-hand corner, its head turned attentively. The garden is synthesized in a single triangle of green, balanced on its fulcrum at the base of the balcony by the contrasting pink of the piano top. The answering expanse of grey may have been suggested by the scientific definition of complementary colours as two colours which when spun on a disc produce a neutral grey. The individual elements in the painting are realized with such strength and intensity that we really feel the impact of their relationships. The rhythm of the music-stand is echoed in the balcony, while the shape of the metronome reappears in the wedge describing Pierre's right eye. This forceful treatment of detail extends to the technique. The way the painting has been made is exposed with an exaggerated honesty to give it the appearance of being more 'real' than reality. Spatters and flecks are left on the surface, and the paint is scratched away at the base of the triangle of green to continue the pattern of the balcony.

Piano Lesson has all the ingredients of a complex personal allegory dealing with mortality, art, music, home, and family. The metronome marks the beat of recorded time, the flickering light of life during the war is symbolized by the smudgy yellow candlestick, the shadow of time falls across Pierre's face. The transience of life is juxtaposed with the permanence of art. To some extent all this may be true, but the painting method itself would argue against any too literal attempt to interpret it. Matisse transcended everyday reality by establishing relationships between objects during the actual process of painting, rather than by working to a consciously premeditated symbolism. Pierre Matisse informed the author that the painting was built up in successive states which were scraped out with a special palette-knife before reworking.

Back at 19 Quai Saint-Michel that autumn, before leaving for his first winter in Nice at the end of December 1916, Matisse continued the exploration of some of the options he had opened up since 1915 in a more realistic, less strenuous key. One of the striking features of these paintings of late 1916 and 1917 is the way elements reappear in successive paintings in completely changed contexts. *Sleeping Nude* (Plate 121), a life-size study of the Italian model Laurette seductively spread out on the studio couch, is transformed in *Studio, Quai Saint-Michel* (Plate 122) into a rather shrunken, vulnerable figure with a face reminiscent of an African tribal mask. The portrait of Laurette seated in a deliciously coloured cyclamen-pink armchair, *The Green Robe* (Plate 123), is seen in a more abstract style in *The Painter and his Model* (Plate 125). The central black vertical band in *The Painter and his Model* is derived from *Bathers by a River*, just as the colour scheme of *The Green Robe* is developed from *The Moroccans*.

The subject-matter which was to dominate the second half of Matisse's career began to take shape. Two complex relationships increasingly obsessed him: that between the artist and his model and that between the personality of the model and the style and mood of a painting. *Studio, Quai Saint-Michel* is really an artist and model subject: the artist's presence is implied in the placement of the empty chair by the drawing-board. In *The Painter and his Model* the artist is a shadowy mannequin figure painting Laurette.

Matisse was understandably fascinated by Laurette. She appears in his paintings as a ravishing sexual object, a veritable odalisque, whose charms could make the war seem a very long way away. In some cases the voluptuous curves of her body are echoed in the encircling arms of a chair, while in others her head, seen in close-up, is tossed back in a kittenish pose beside a little inlaid Arab table. Where Matisse is

more interested in colour, form, and texture than in Laurette's sensuality, she sits quite demurely, staring vacantly into space.

One of the novel features of Matisse's work in 1916 is his use of black. His feeling for black began to develop when he left his light-filled studio at Issy in the autumn of 1913 for a dark room again overlooking the Seine at 19 Quai Saint-Michel. In *Interior with Goldfish* of 1914 (see Plate 107), he conceived the darkness of the room as obscuring light, a light which at any moment might break through to define a key object in a burst of colour. Black, grey or brown gradually replaced deep blue as his colour of darkness. As black became solidified into a colour in its own right Matisse's concept changed. He claimed that in *Gourds* of 1916 he 'began to use pure black as a colour of light and not as a colour of darkness'. In *Gourds* objects and colours are isolated and contrasted with black. According to the laws of colour contrast, a light colour placed on a dark colour makes the light colour appear lighter and the dark one darker. So by manipulating this effect Matisse felt that he was creating light. However, the precedent of Manet rather than colour theory inspired Matisse's use of black. He repeated a saying of Pissarro, 'Manet is stronger than us all, he made light with black.' And in 1946, after mentioning Manet's 'blunt luminous' black in the portrait of *Zacharie Astruc* of 1866 (see Plate 145), he asked rhetorically, 'Doesn't my painting of the *Moroccans* use a grand black which is as luminous as the other colours in the painting?'

Matisse's concerns in the Laurette series are a far cry from the mood and subject-matter of *Bathers by a River* and *The Moroccans*. While the Dada movement had been founded in Zurich in February 1916 as a group response to the continuing slaughter of the war, Matisse's reaction was to shut the conflict completely out of his work. His first trip to Nice in December 1916 was an attempt to escape from the war, his studio, Cubism, and the weather, and to rediscover inspiration in Mediterranean light. He began to behave as if the war had already ended. On his return to Paris in the spring of 1917 he bought a car and made excursions around the neighbourhood with Pierre at the wheel. Evidently his financial situation had remained relatively unaffected. New collectors stepped in to replace Shchukin and Morozov. Dr Barnes, who was to assemble the largest collection of Matisses in the United States, began collecting in 1913. Matisse's first one-man exhibition in New York opened at the Montross Gallery on 20 January 1915. In his new contract with the Bernheim-Jeune gallery, signed in October 1917, the prices of his paintings were doubled and he was allowed to retain half his production.

The two major paintings of 1917, *Three Sisters Triptych* and *Music Lesson* (Plate 124), round off this period in a softer variant of the stylized form of Realism Matisse had practised the previous winter, a style reminiscent of the work of Manet. The *Triptych* is a final homage to Laurette, accompanied by her two sisters. It was begun at 19 Quai Saint-Michel in 1916 and completed there in the autumn of 1917; *The Rose Marble Table* painted in Matisse's garden at Issy that summer hangs on the wall in the right-hand panel. *Music Lesson* repeats the subject-matter of *The Painter's Family* of 1911 (see Plate 86). Marguerite sits beside Pierre at the piano, Jean stares down at a book, and Madame Matisse is seen behind the balcony. His sculpture *Reclining Nude I*, which is given the voluptuous curves of a sensual water-nymph and placed by the pond at the back of the house, anticipates the recumbent odalisques of the Nice period, 1918 to 1930; perhaps he already had in mind a picture of nudes, philodendron leaves, and southern light. Not too much, though, should be read into *Music Lesson*. It was executed in as little as two or three sittings. Matisse was probably motivated by the very natural desire to record all his family together—perhaps for the last time—before Jean left to join the army and he himself went down to Nice again for the winter.

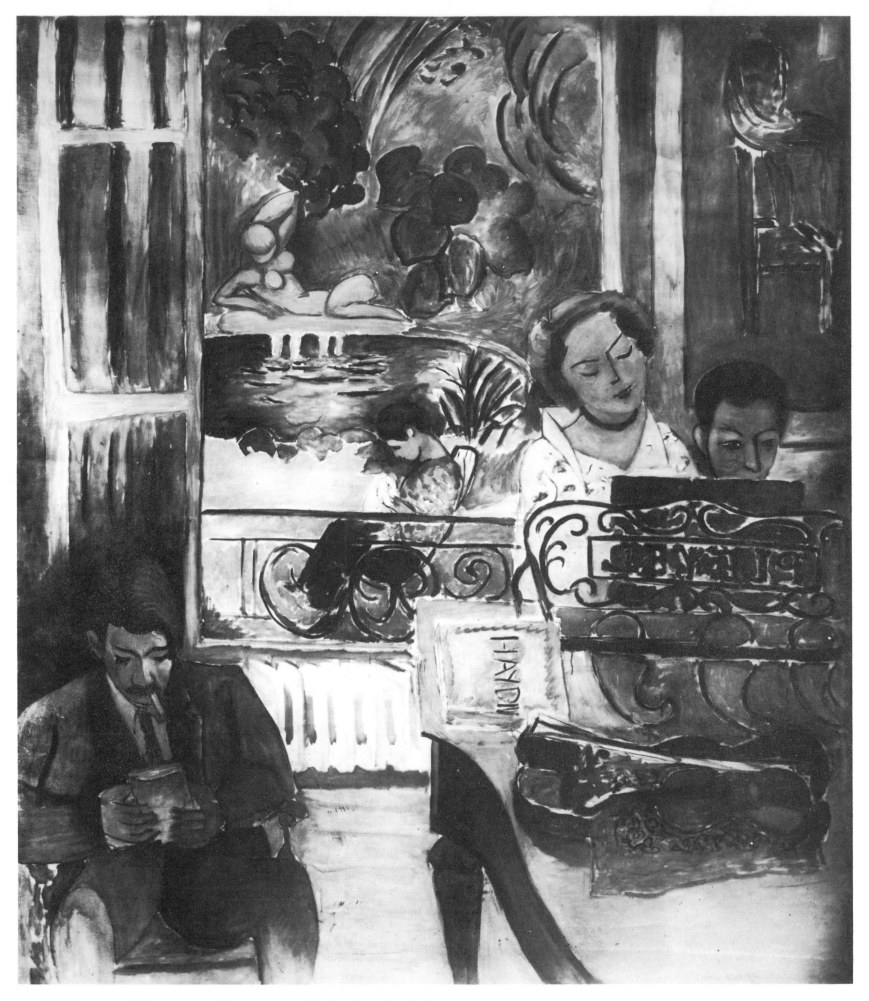

124. *Music Lesson*. 1917. Oil on canvas, 243.8 × 209.5 cm. Merion, Pa., Barnes Foundation.
Music Lesson is markedly more naturalistic, relaxed, and atmospheric than *Piano Lesson* of the previous year (see Plate 118).

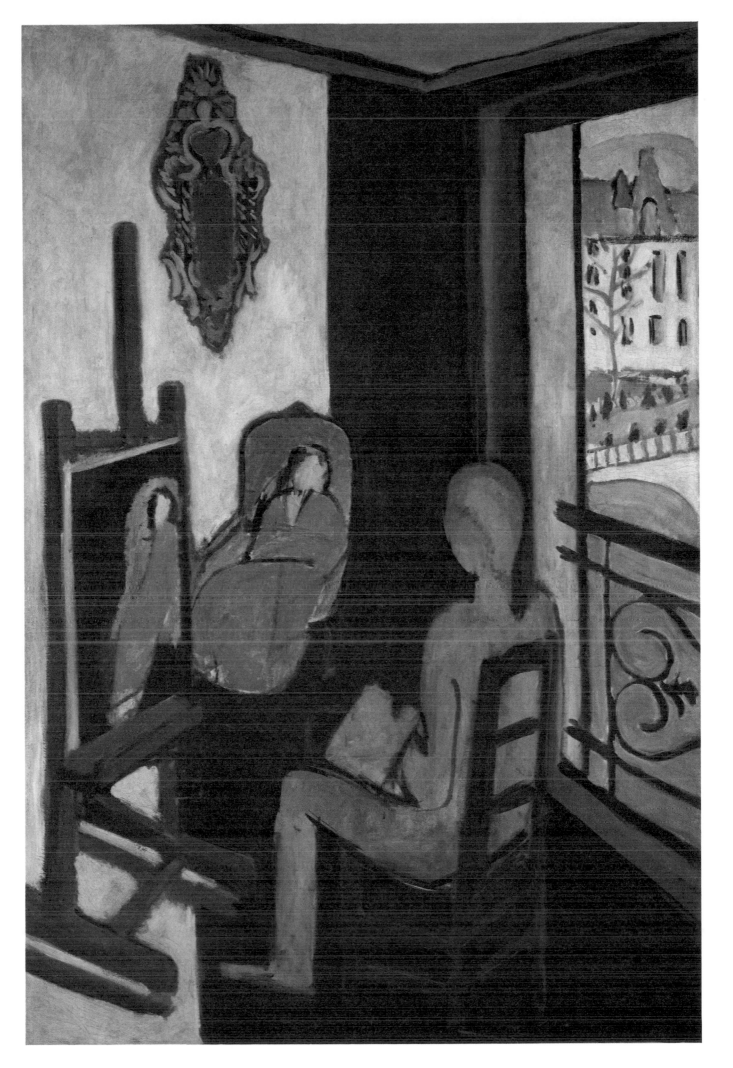

125. *The Painter and his Model*. 1917. Oil on canvas, 146.5 × 97 cm. Paris, Musée National d'Art Moderne, Centre Georges Pompidou.
Begun in 1916 and completed in 1917. *The Green Robe* is on Matisse's studio easel.

6 Nice, 1918-1929

The Great War virtually wiped out an entire generation of young Frenchmen. The epidemic of Spanish flu that followed killed almost as many people as the war itself. It was the ending of an era. Outwardly the painful process of national rehabilitation was accomplished surprisingly quickly: within eleven months of the 1918 armistice $4\frac{1}{2}$ million men returned to civilian life, and during the next seven years the ten devastated *départements* of the north-east—including Nord, Matisse's home *département*—were largely rebuilt. Relief that it was finally all over found expression in a decade of celebration—the 'gay twenties'. Life was to be lived to the full. Young ladies smoked in public, cropped their hair, wore flat-chested athletic-looking garments, and danced the night away to the tango, foxtrot, and Charleston. The energetic and optimistic influence of American popular entertainment provided an antidote to the events of the recent past. Jazz became the rage. On 18 May 1917 Matisse had attended the historic première by Diaghilev's Russian Ballet of the Satie–Cocteau–Picasso–Massine ballet *Parade*, which marked the first inclusion of jazz into French music. He was deeply impressed and later called his first major cut-out project *Jazz* (see Plates 189, 190, 206, 207).

In retrospect, however, the French designation of the decade as '*les années folles*' (the crazy years) seems more appropriate than the English 'gay twenties'. The France that emerged victorious from the war was a moribund society, dominated socially, economically, politically, and militarily by old men incapable of coming to terms with—let alone arresting—the causes of the nation's decline. At home the value of the franc, after generations of stability, fluctuated and fell. Getting the '*Boches*' to pay reparations was held out as the universal, but increasingly unlikely, solution to the economic crisis. The government resorted to printing more money. Abroad, France and her allies made half-hearted attempts at containing both communism in Russia and the rise of fascism in Italy and Germany. More immediately France had to face the growing aspirations of her colonies for independence. The period which began in the aftermath of the Great War ended with the dawning awareness that it was all going to happen again to a nation too exhausted and depleted of resources to resist.

Beneath the superficial gaiety of the 1920s, the dominant trend in all fields was towards a reassertion of traditional values, *un retour à l'ordre* (a return to order). Matisse's art marked no exception to this general pattern. He witnessed the gradual divorce of avant-garde art from everyday reality along two opposing paths. On the one hand, the desperation of Dada protest gave way to the Surrealist doctrine that true reality resided in the unconscious mind. On the other hand, the Cubist concern with an autonomous, formal language for art led to total abstraction, a nirvana of

purity, which in the case of Piet Mondrian (1872–1944) and the Dutch De Stijl movement had definite religious overtones. Matisse's reaction, his *retour à l'ordre*, on the contrary, was a return to the source of his art in the experience of nature. In 1917–18, during the second of what were to become his annual winter sojourns in Nice, he abandoned, until the Barnes murals of 1931–3, the monumental scale and innovatory audacity of his two great decorative compositions of the war years, *The Moroccans* and *Bathers by a River*. He now adopted a more popularly acceptable style which had much more in common with the subject-matter, colour, and technique of Renoir, Bonnard, and to a lesser extent Manet, than with Cubism. To have continued with the 'modern methods of construction' would, Matisse believed, have led to a mannered style.

Matisse's move to Nice, the capital of the Côte d'Azure and the *département* of Alpes-Maritimes, represented his decision to distance himself from the avant-garde and to make his art out of what stimulated him most: nudes, flowers, secluded interiors, beautiful scenery, and above all light. After a series of depressing winters in the north and the austerities of the war, Nice must have appeared to him as an earthly paradise. Its charms are still very seductive. Light is reflected off the white stucco hotels along the palm-lined Promenade des Anglais which follows the gentle curve of the Baie des Anges. Distant mountains rise up behind the city; the vista along the eastern shore is shut off by the steep slopes of the fortress, surrounded by luxuriant gardens. The winter light is so clear and invigorating that every shape and colour appears specially illuminated as something to be looked at and enjoyed. Nice was like a foreign city within France. Out of a total population in 1926 of some 200,000 people, 91,710 were foreign. The city had only been ceded to France by King Victor-Emmanuel II of Sardinia and the House of Savoy after the plebiscite of 1860. The English had started wintering in Nice at the beginning of the nineteenth century, and the custom had later been adopted by wealthy Parisians, so that Matisse was following an established pattern for the successful. He found the cosmopolitan character of Nice particularly stimulating in that it offered a wide choice of attractive models.

The magnificent *Interior with a Violin* (Plate 126) was probably begun in Matisse's room in the Hôtel Beau-Rivage on the Promenade des Anglais in 1917, then reworked on his move to a small apartment at 105 Quai du Midi in May 1918, and completed in a rented villa on the slopes of Mont Boron, behind the old port of Nice, in May or June. The painting has rightly come to be regarded as a transitional work, between the styles of the war years and the Nice period. The technique mirrors the slow build-up of the surface of *Bathers by a River* in flat layers which were repeatedly scraped out and repainted. This can be seen in the important central accent of colour between wall and floor, where the black paint is scraped away to reveal a tint of yellow, highlighted with a lighter opaque yellow. By contrast with *Bathers by a River*, the colour scheme demonstrates a new concern for light and local colour. The predominant black both draws the spectator into the interior and generates the sensation of light in the shutters through contrast with the bars of white. The light blue of the sea outside is introduced by the deep blue of the violin case in the dark interior. Matisse commented on the quality of the black 'both as contrast and as a colour in its own right'.

Light was undoubtedly a central preoccupation in Matisse's paintings of the Nice period. When in 1942 the poet Aragon asked Matisse what made him choose Nice, he replied, 'In my art I have tried to create a setting that will be crystal-clear to the mind . . . If I had gone on painting up north, as I did thirty years ago, my painting would have been different; there would have been cloudiness, greys, colours shading off in the distance.' What he was referring to here were not just differences

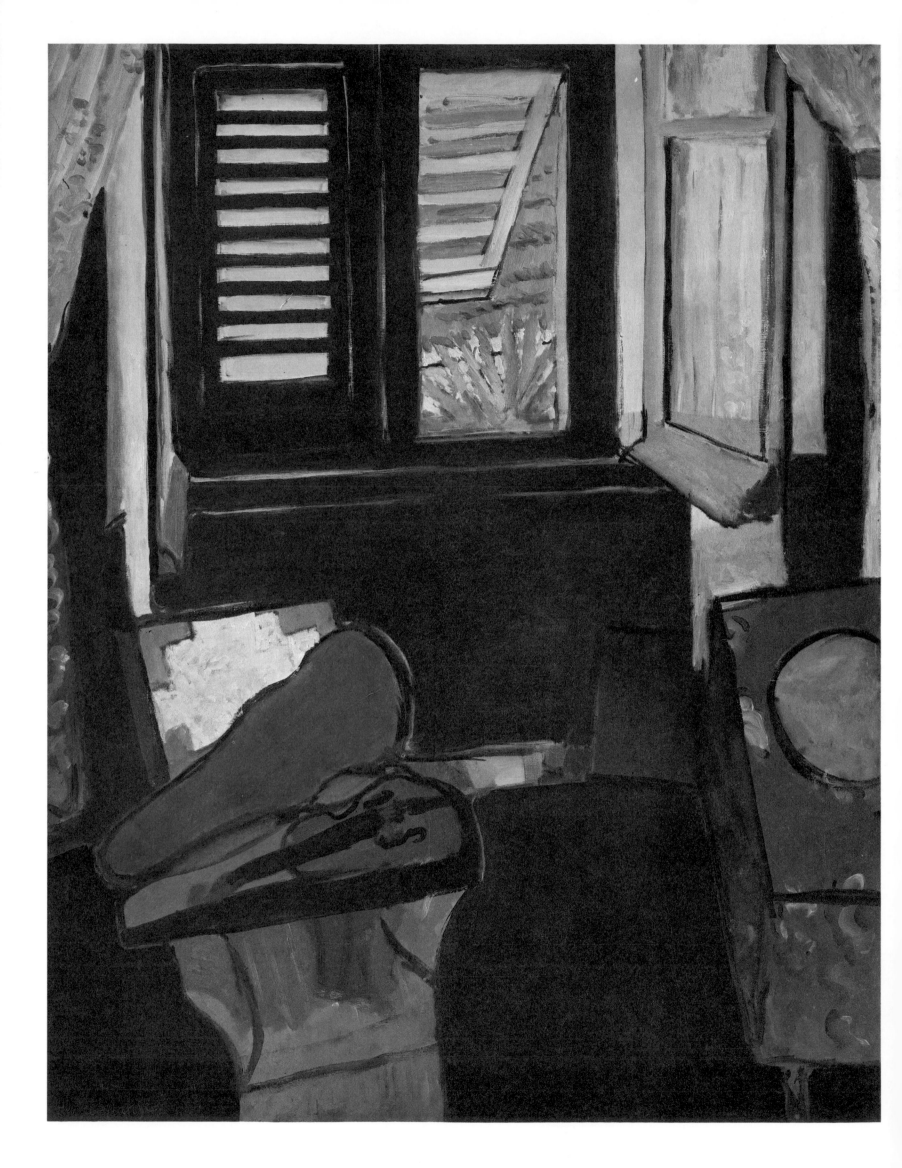

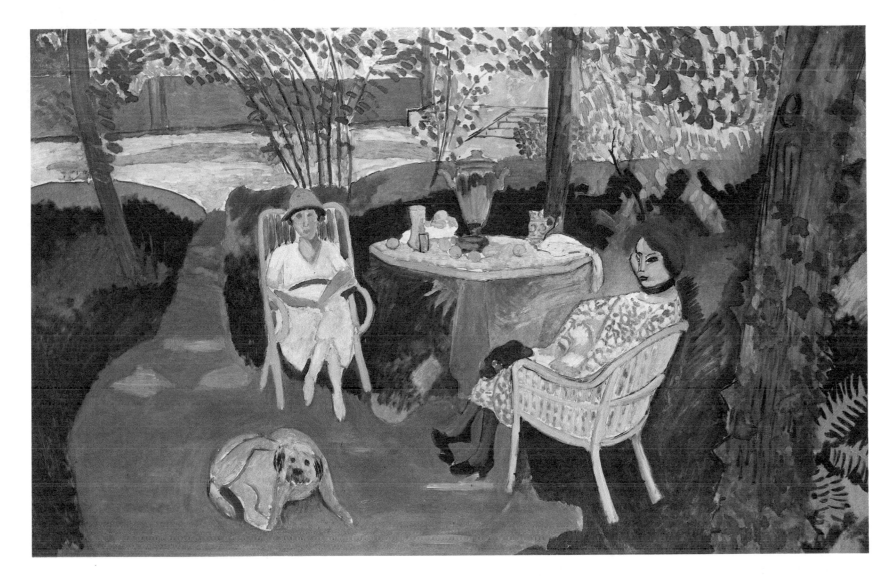

126. *Interior with a Violin.* 1917–18. Oil on canvas, 116 × 89 cm. Copenhagen, Statens Museum for Kunst.
Matisse practised the violin regularly. He apparently regarded it as some sort of insurance policy, saying that if either his eyesight failed or his paintings did not sell he could earn a living as a busker. Later he played just to keep his fingers supple.

127. *Tea.* 1919. Oil on canvas, 139.7 × 210.8 cm. Los Angeles County Museum of Art, bequest by David L. Loew in memory of his father, Marcus Loew.
Light filters down through the trees on to the path in Matisse's garden at Issy-les-Moulineaux, where his daughter and the model Antoinette are having tea. A shoe is suspended nonchalantly from his daughter's toes. A dog scratches itself. The painting celebrates the relaxed atmosphere of his domestic milieu as a subject for a large-scale art.

of tonality but two alternative ways of making a picture. Generally speaking, the first way concerned the objective representation of transient appearances and the second a subjective, more permanent reality rooted in the artist's personality. Relative as both these approaches are, they recapitulate the dialogue in the avant-garde of the late 1890s between Impressionism and Symbolism.

Matisse unequivocally credited the Impressionists with emphasizing the primary role of light in painting. In 1932 he told the Surrealist painter André Masson, 'What we owe to the Impressionists: light as the fundamental inspiration of painting. Until then it was more a question of illumination.' Then on being asked by Masson about colour he replied, 'But it is revealed by light.' However, this does not tell us much about Matisse's paintings. All too often his work of the Nice period has been described as Impressionist without a discussion as to why and in what way it marked a return to Impressionism, and whether Impressionism affected its content. If we accept the argument that Matisse was reacting to the war and Cubism, then his renewed interest in Impressionism demonstrates his nostalgia for an earlier age of peace and harmony, and his reversion to a style and range of representational techniques which he had never fully explored in the 1890s. Another point always worth bearing in mind is that paintings in an Impressionist style were more commercially successful than the art of the contemporary avant-garde. But if his art of the Nice period is really as retrogressive as is sometimes made out, we still have to account for the sudden appearance of the Barnes murals.

During the winter of 1918, Matisse visited his son Pierre, then stationed at

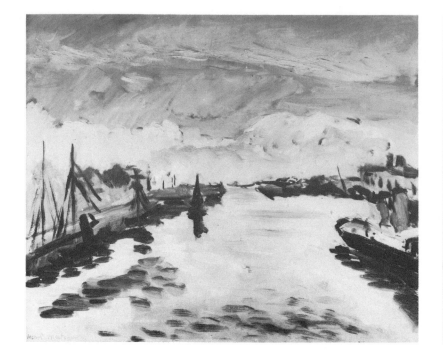

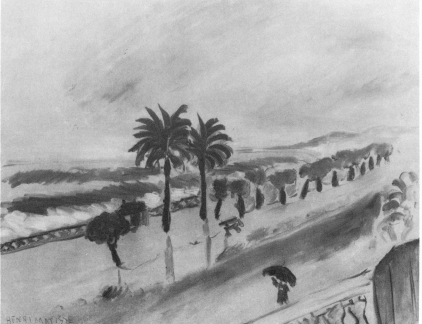

Cherbourg, and in the summers of 1920 and 1921 he painted at Étretat not far from Le Havre. According to Pierre, his father, while at Cherbourg, worked outdoors like an archetypal Impressionist landscape painter (see *Cherbourg, the Port*, Plate 128). Although Matisse apparently did not talk to his son about the Impressionists, these painting trips to the north coast, the birthplace of Impressionism, should be seen as part of his general reassessment of Impressionism at that time.

However, his little landscapes from 1918 to 1921 differ from Impressionism in their palette. Evidently their predominant colour scheme of browns and greys represented Matisse's conscious rejection of an Impressionist palette approximating to the spectral hues. In a letter of May 1918 he informed Camoin that in the small landscapes, then on show at the Bernheim-Jeune gallery, he had experimented with the earth colours, only occasionally using the bright cadmiums and vermilion. And in 1919 he described his working with black and grey, with neutral tones, as a process akin to the cleansing of his vision. There is also some uncertainty as to the status of these small landscapes in his art. Matisse, it must be remembered, had described himself as a student of the Louvre, and he continued to regard Impressionism as both a preliminary stage in the creative process leading to a finished work and a means of maintaining contact with nature. He told the art historian Gaston Diehl that he painted landscapes while in a state of anxiety during the war because 'I could finish these off in two or three sittings. And this intimacy with nature helped me to calm my nerves.' In his letter to Camoin of May 1918 he described his landscapes as 'relaxations'. He wanted, he said in 1919, to go beyond the Impressionist stage in his creative process without losing some of its qualities, such as *matière*, spatial depth, and detail. *Tea* (Plate 127), painted at Issy in the summer of 1919, is the only major, large-scale, outdoor set-piece of this period, in which Impressionist subject-matter and colour are invested with the permanence of a medieval paradise garden tapestry.

If permanence of atmosphere was a quality Matisse sought in his major paintings, then his small landscapes would have afforded him a better understanding of how this might be achieved through a refreshing exploration of its opposite. The catalogue of his Bernheim-Jeune exhibition of October 1920 lists such titles descriptive of unrest as *Stormy Afternoon, Cloudy Sky, Rough Sea*, and *A Gale*. In *Storm at Nice* of 1919–20 (Plate 129), the effect is obtained through the deft movements

128. *Cherbourg, the Port.* 1918. Oil on board, 34.5 × 43 cm. Private collection. This was evidently executed rapidly, probably in front of the motif, in a palette of pale blue, greys, and browns.

129. *Storm at Nice.* 1919–20. Oil on canvas, 50 × 73 cm. Nice-Cimiez, Musée Matisse. After a career spent trying to achieve a state of calm and serenity in his work, Matisse evidently enjoyed capturing the effect of rain lashing the famous Promenade des Anglais in Nice.

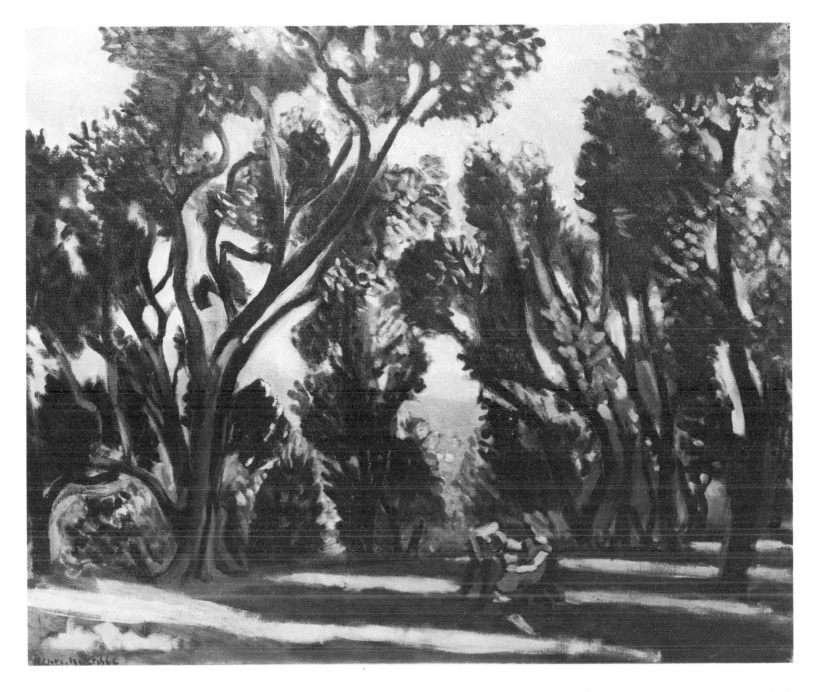

130. *Henriette painting under the Olive Trees.* 1922. Oil on canvas, 61 × 71 cm. Baltimore Museum of Art, Cone Collection.
Matisse regularly painted on the hills behind Nice, setting up his outdoor easel in front of the motif like an Impressionist. Henriette was one of his favourite models of the Nice period.

of his brush in broad, transparent washes of paint, in a style reminiscent of his friend Marquet's landscape technique. External unrest and interior calm—sometimes isolation, even boredom—were polarities he explored in a series of paintings executed in rooms overlooking the sea front at Nice, ranging from *Young Woman by the Window, Rough Sea* of 1920 to *Young Woman looking at the Sea, Stormy Day* of 1923.

Although conservative in comparison with his earlier Fauve paintings, Matisse's Nice landscapes do vary in technique. By contrast with the small canvases executed *en plein air* in front of the motif, the larger and more densely worked ones—such as *Henriette painting under the Olive Trees* of 1922 (Plate 130)—were developed from preliminary studies and completed, if not largely painted, in his studio. Painting from the security of the balcony at Place Charles-Félix, his home at Nice from 1921 to 1938, permitted the combination of studio and outdoor working methods; variations on the theme of figures watching the progress of the flower festival parade along the quay below are some of his most lively, technically inventive, and spontaneous paintings of the 1920s. In the charming *Flower Festival at Nice* of 1922

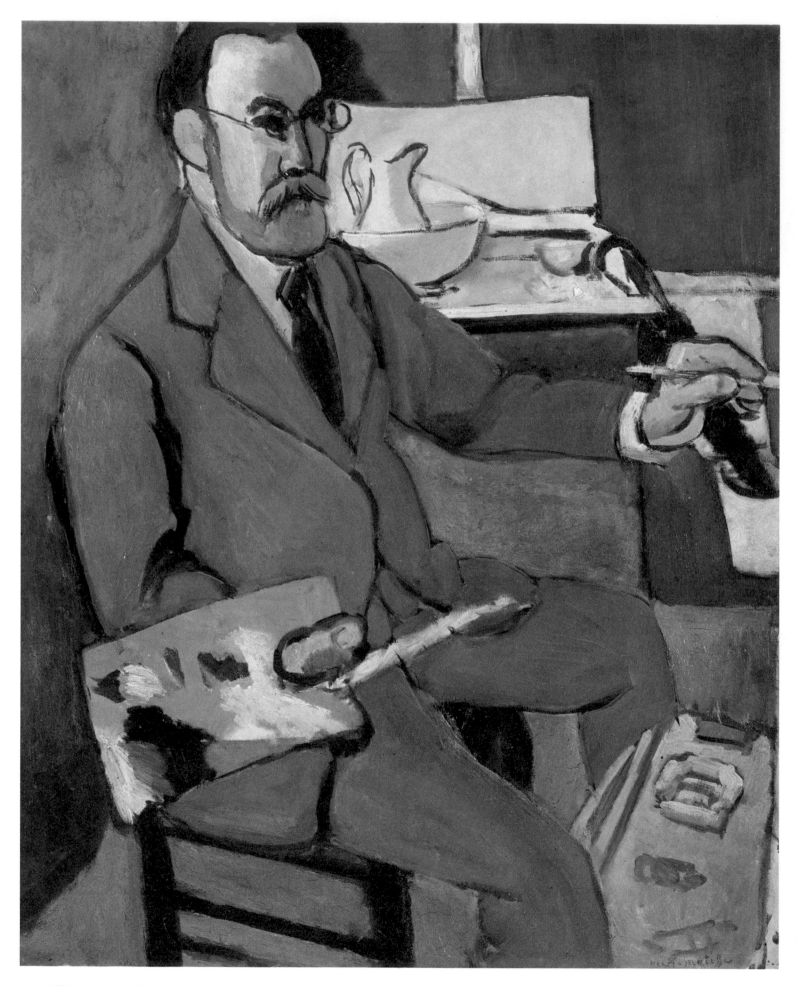

131. *Self-Portrait.* 1918. Oil on canvas, 60 × 54 cm. Private collection.
From his first winter in Nice in 1916–17 to his fifth in 1921, Matisse regarded himself as a very temporary resident. He lived out of his suitcase—which features in numerous of his hotel interiors—and was prepared to leave the moment he felt bored.

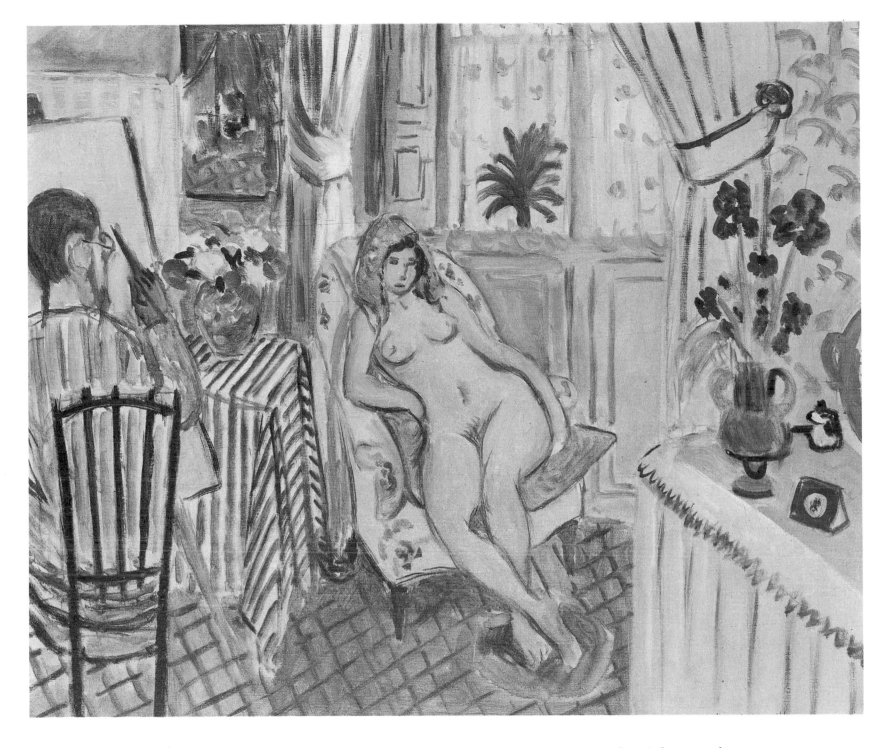

132. *Artist and Model.* 1919. Oil on canvas, 59.7 × 73 cm. New York, Dr Ruth Bakwin. In contrast to a strictly Impressionist composition, this contains repetitions of shape and colour which work together to create the quiet poetry of the interior. Through the window, lightly veiled with a net curtain accented with pale-brown flowers, is seen the crest of a fecund date-palm. A green vase echoes the shape of the model.

(Plate 133), for instance, the white canvas ground is left exposed to create an enveloping atmosphere of light; the disciplined repetition of a restricted range of colours is countered by the freedom of the calligraphic brushwork describing the forms and figures.

This return to nature was no doubt associated in Matisse's mind with the rejuvenation of his art after a strenuous period of abstraction. His landscapes came under the general category of Impressionism by their small scale, sketch-like technique, preoccupation with changing atmospheric effects, and *plein air* working. But can his figure and interior paintings be characterized in the same terms? They follow the landscapes in their greater dependence on the motif and yet their response to reality is more complex. Light as the prime vehicle in his interpretation of nature, an approach stemming from Impressionism, was opposed by another concept of Realism bound up with solidity of form and surface, in a palette

149

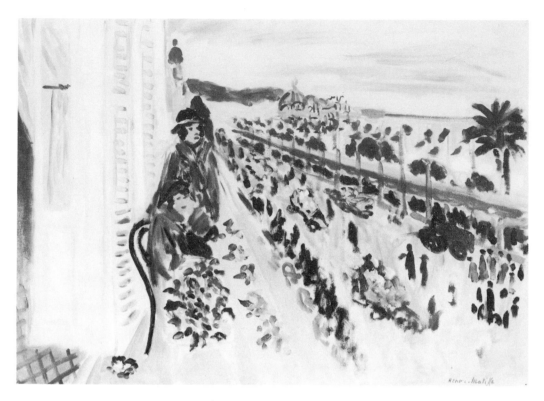

133. *Flower Festival at Nice.* 1922. Oil on canvas, 65 × 92 cm. Baltimore Museum of Art, Cone Collection.
The brightly coloured floats were one of the principal features of the festivals in the winter season at Nice, and Matisse painted them on a number of occasions. His treatment of the figures is indebted to oriental brush-drawings and to the technique of his friend Marquet, whom he regarded as his mentor in outdoor working.

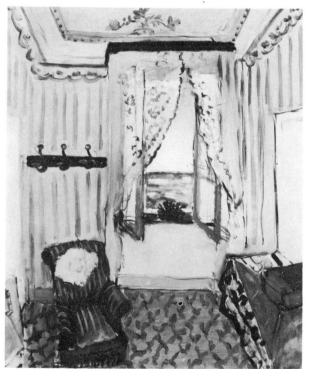

134. *Interior at Nice.* 1917–18. Oil on canvas, 73 × 61 cm. Philadelphia Museum of Art.
The extreme perspective of forms tilted towards the viewer is one of the few reminders in this painting of Matisse's modern methods of construction from his previous period of austerity.

predominantly of browns, greys, and black contrasted with pink and red. The idea that observed colour was dull in comparison with the pigmentary primaries goes back to the nineteenth century. In his letter to Camoin of May 1918, Matisse made a pertinent distinction between the *grand style*, an elevated style achieved by linear contours, and a more truthful but correspondingly more mundane style expressed by *demi-teinte*, the gradation of half-tones. Gauguin, he implied, illustrated the former and Corot the latter.

Interior at Nice of 1917–18 (Plate 134), probably showing Matisse's room at the Hôtel Beau-Rivage, is Impressionist in its treatment of light and relatively naturalistic in its attention to detail. Matisse described a similar interior, painted

135. Renoir. *The Bathers*. 1918. Oil on canvas, 109.5 × 160 cm. Paris, Musée du Louvre, Jeu de Paume.
Renoir was a major influence on Matisse's paintings of the Nice period, and Matisse visited him on a number of occasions. Matisse later told this anecdote: when he offered the opinion that *The Bathers*, in an earlier state, was finished Renoir replied, 'I find it hasn't enough of Courbet.' Gustave Courbet (1819–77) was renowned for the fullness and solidity of his nudes.

the following winter at the Hôtel de la Méditerranée, as 'a study of light—the sentimental association [established] out of the light of the interior and exterior'. By comparison *Self-Portrait* (Plate 131), also painted in the winter of 1917–18, is more densely worked. Matisse is literally holding his palette of black, white, and red against his brown suit as a key to this alternative colour scheme. It would be an exaggeration to claim that these two minor paintings illustrated Matisse's distinction between the *grand style* and the *demi-teinte*. However, he evidently wanted to achieve the *grand style* in the Nice period, without sacrificing the dominant sensation of light, and Renoir in particular showed how this might be done.

Matisse first visited the aged Pierre-Auguste Renoir (1841–1919) at his home, Les Colettes at Cagnes near Nice, on the last day of 1917, and he included both *Interior at Nice* and *Self-Portrait* in a group of paintings he took to show him in 1918. He said that Renoir expressed surprise that the darkest tone in the interior, the black of the pelmet, did not move forward to destroy the illusion of depth. Renoir often employed black specifically to establish the foreground plane. Matisse's daughter felt that her father visited Renoir 'because he wanted a break from painting and not because he was an influence on him'. Although one would not expect a painter of Matisse's stature to be influenced at the age of fifty as in his youth, it is nevertheless evident from his paintings and statements that Renoir was of comparable importance to him between 1918 and 1925 as Cézanne had been from 1899 to 1910. In 1921 Matisse told the American writer Frank Harris that his masters were Cézanne and Renoir.

Renoir's influence on Matisse is most apparent in three areas. Firstly, Renoir gave a moral example of an older painter who, right up to his death on 17 December 1919, maintained faith in art, and pleasure both in his subject-matter and in the act of painting, despite being severely crippled by arthritis. Confined to a wheelchair, with his brushes bound to his hands, Renoir triumphed over pain to create a genuine late style—just as Matisse was to do in his final paper cut-outs. Secondly, Renoir provided the precedent for a contemporary painter to concern himself with the female nude as a central theme in his art. Nobody, Matisse stated in 1921, had bettered Renoir's nudes; and he regarded *The Bathers* of 1918 (Plate 135) not only as Renoir's masterpiece but also as one of the most beautiful canvases ever painted.

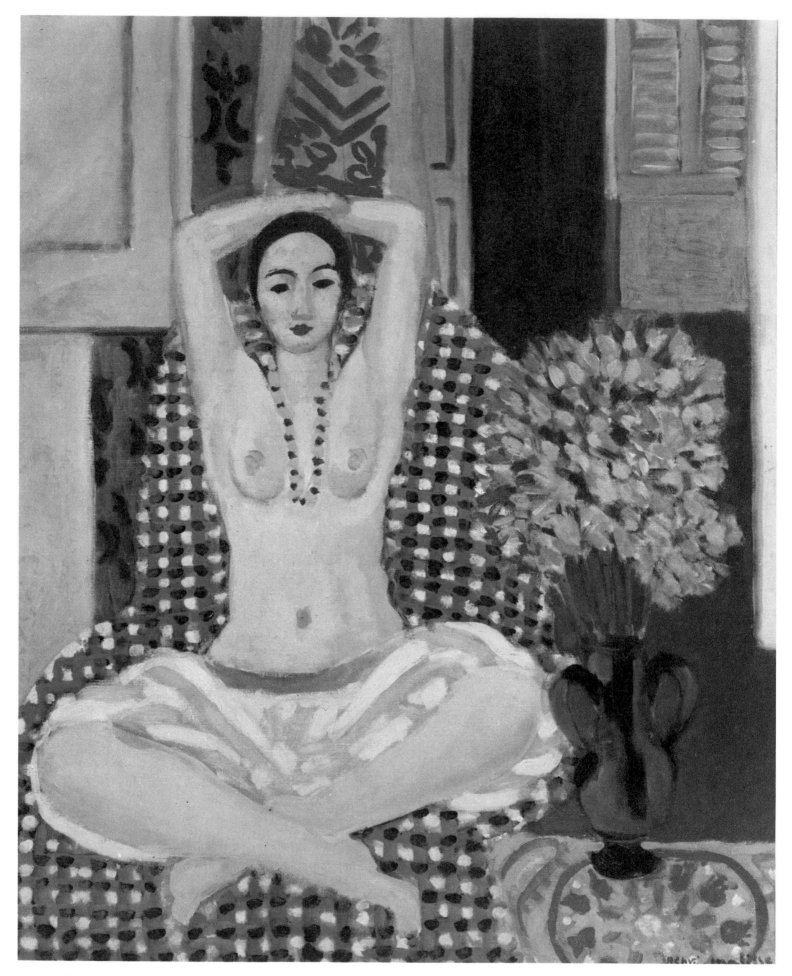

136. *The Hindu Pose.* 1923. Oil on canvas, 72.3 × 59.3 cm. New York, private collection.
Matisse loved this particular pose, which gave a sense of elevation to the form, exposed the breasts, and echoed the shape of a vase with handles.

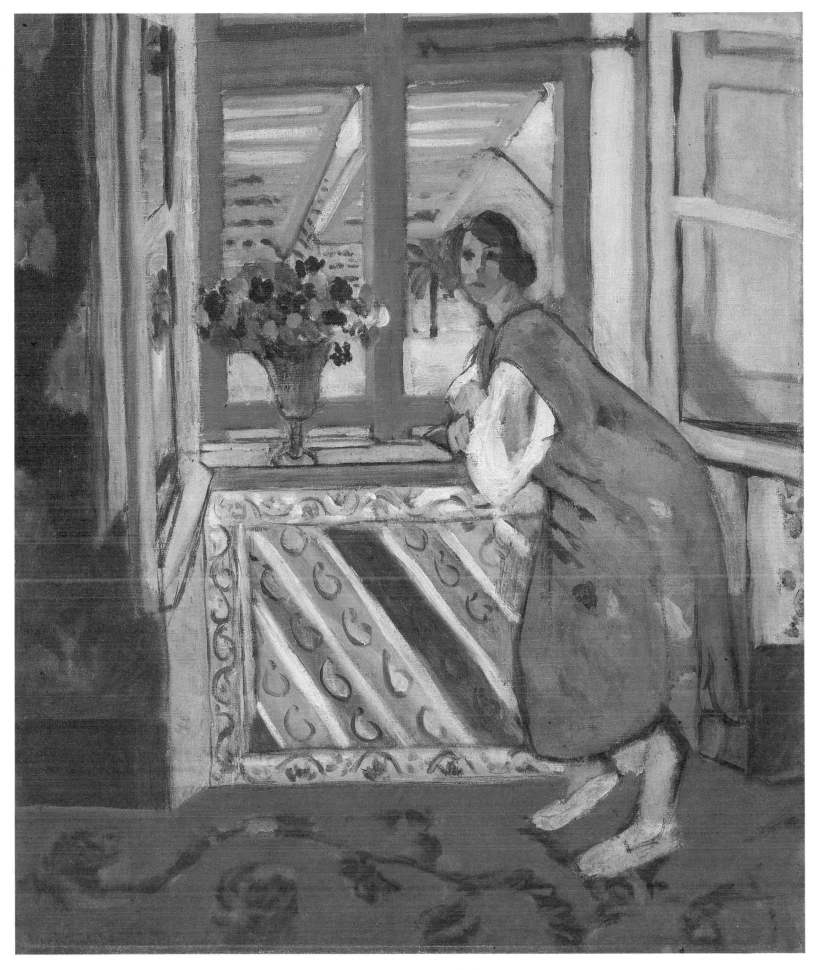

137. *Young Girl in Green.* 1921. Oil on canvas, 64.7 × 54.6 cm. New York, Mr and Mrs Ralph F. Colin.
As there always seemed to be so much going on along the Promenade des Anglais, especially during carnival time, Matisse found that the only way he could persuade some of his models to keep still was to let them lean against the window and look out.

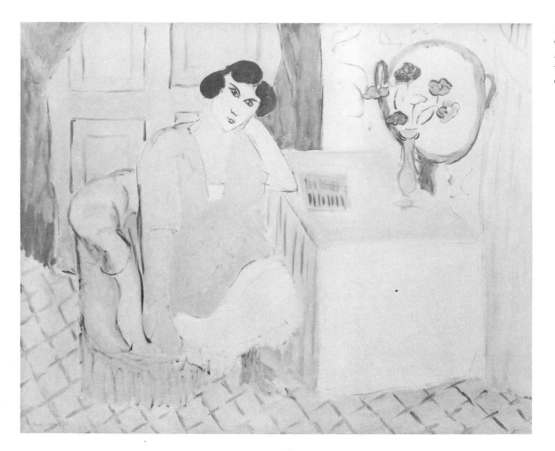

138. *The Inattentive Reader*. 1919. Oil on canvas, 73 × 92 cm. London, Tate Gallery. All is illusion and light: the paint is applied very thinly to allow the white ground of the canvas to breathe through.

And thirdly, Renoir had developed a technique of depicting the figure with linear contours, in combination with oil washes, which suggested to Matisse a method of conveying formal solidity without loss of overall luminosity. 'The painter who best used slightly thinned paint and glazes is Renoir,' Matisse explained—'he painted with liquid: oil and turpentine, quite fresh and not syrupy, oxidized by the air.'

In a typically methodical fashion, Matisse approached the problem of employing line to represent the figure in painting on two fronts. He modelled at least three little sculptures of the female nude in clay, in order to reawaken his feeling for solid form, and he studied casts of Michelangelo's Medici tombs in the local art school at Nice, run—as it turned out—by an old acquaintance from Moreau's studio. 'I hope', he informed Camoin, 'to install in myself an understanding of Michelangelo's clear but complex grasp of construction.' This was by no means an unprecedented step to have taken. Rodin, for instance, acknowledged that he had comprehended the linear rhythm of a figure by looking at Michelangelo. Renoir, too, came to appreciate Michelangelo in his last years, describing him as 'the anatomist *par excellence!*'; he worried that the nipples of his big statue *Venus* were too far apart, until he stumbled on a photograph of *Dawn* from the Medici tombs and noticed that Michelangelo had left an even bigger space between the breasts. From 1924 Matisse always kept a cast of Michelangelo's *Dying Slave* in his studio.

Now that he could express the rhythm and volume of the female figure by line, Matisse went from sculpture and drawing back to painting. In a very refined canvas, *The Inattentive Reader* of 1919 (Plate 138), form is defined in a dialogue between rhythmic outlines and pale washes of oil colour, which are subtly distorted to involve the spectator in the experience of the paint surface.

Renoir and Matisse were both obsessed with the female form, but whereas Renoir sought a classical ideal of monumental beauty, Matisse wanted to express what he called 'the ideal and the particular' in different aspects of a model's personality. In a series of paintings and drawings of the model Antoinette, wearing a plumed hat

139. *The Plumed Hat*. 1919 Pencil on paper, 53 × 36.5 cm. Detroit Institute of Arts, bequest of John S. Newberry.
One of the most ravishing drawings of Antoinette in the 'plumed hat' series. For Matisse drawing came to hold equal status with painting as an art-form in its own right.

140. *White Plumes*. 1919. Oil on canvas, 73 × 60.3 cm. Minneapolis Institute of Arts.
Matisse executed a magnificent series of paintings and drawings of the model Antoinette wearing a plumed hat which he had made himself.

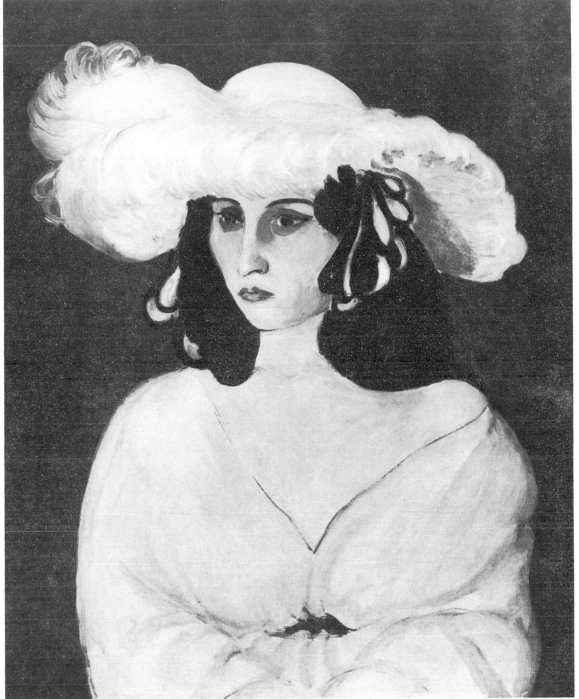

which he had actually made himself, he achieved some of the most perfect images of his entire career. Antoinette appears in a succession of guises. Her face sometimes has the podgy fullness of a young girl, at others a detached aristocratic look, accentuating her high cheek-bones. Often Matisse was more interested in forms than in her personality: the plumed hat itself, the fall of her hair, and her breasts which were of a size that Matisse likened admiringly to 'two litre bottles of Chianti'. The painting *White Plumes* (Plate 140) has the jewel-like intensity of a sixteenth-century portrait. In it Antoinette is silhouetted in a delicious colour scheme of creams against a red background. The process of refinement went from drawing into painting and from painting back into drawing. The magnificent drawing *The Plumed Hat* (Plate 139), which is as finished as the painting but even more detailed, proceeded from preliminary studies. It anticipates the subject-matter, style, and status of Matisse's independent drawings of the 1930s.

141. Delacroix. *Women of Algiers.* 1834. Oil on canvas, 180 × 228.9 cm. Paris, Musée du Louvre.
Delacroix's *Women of Algiers* had been a talisman for Matisse and the Fauves, striving for the rediscovery of colour and emotion in art, and its presence is felt behind Matisse's odalisques in sumptuous interiors of the Nice period.

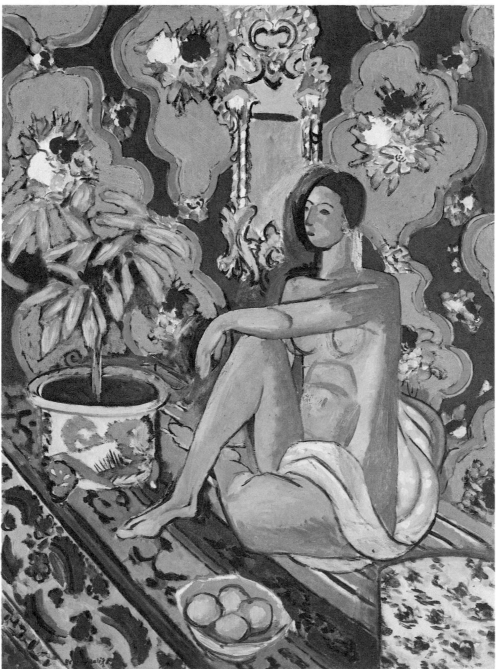

142. *Decorative Figure on an Ornamental Background.* 1925–6. Oil on canvas, 130 × 98 cm. Paris, Musée National d'Art Moderne, Centre Georges Pompidou.
Though often dated 1927, *Decorative Figure* was in fact exhibited in June 1926. It marked a renewed structural phase in Matisse's painting, and he kept it in his studio until 1938, when it was bought by the French State.

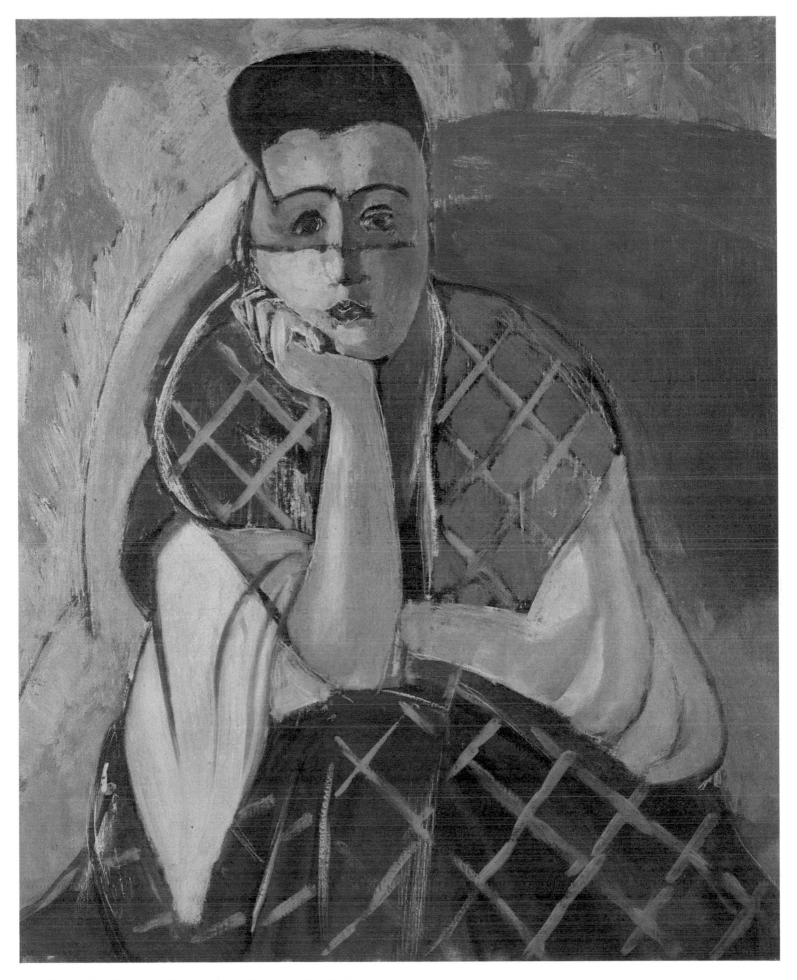

143. *Woman with a Veil.* 1927. Oil on canvas, 61 × 50.2 cm. New York, private collection.
Matisse was now more interested in the modelling potential of light and shade—symbolized in the juxtaposition of the red and green halves of the figure—than in the unifying power of light alone.

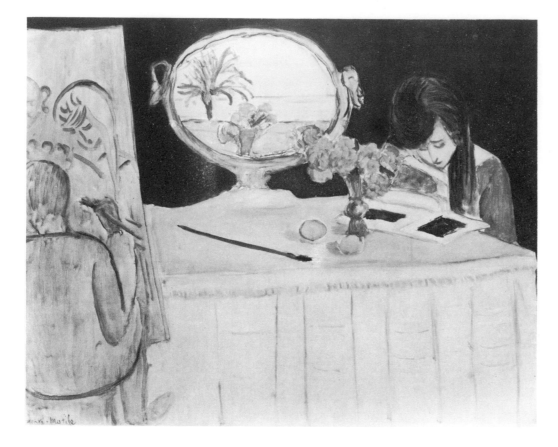

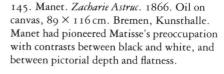

144. *The Painting Lesson.* 1919. Oil on canvas, 74 × 93 cm. Edinburgh, Scottish National Gallery of Modern Art.
The mirror, placed like a porthole in the centre of the black wall, adds ambiguity to a composition which is made to appear so simple, natural, and relaxed that we overlook its extreme artificiality.

145. Manet. *Zacharie Astruc.* 1866. Oil on canvas, 89 × 116 cm. Bremen, Kunsthalle. Manet had pioneered Matisse's preoccupation with contrasts between black and white, and between pictorial depth and flatness.

This dialogue between tradition, painting and drawing, the evocation of light, and the appearance of objects was accompanied by a parallel dialogue within Matisse's own work. His paintings continued to grow partly out of his response to his own paintings. These different strands came together in a series of paintings of the artist and model. The lovely *Artist and Model* (Plate 132), radiant with light and atmosphere, probably preceded the more synthetic *Painting Lesson* of 1919 (Plate 144), which is indebted in its composition and use of black to Manet's *Zacharie Astruc* of 1866 (Plate 145).

Matisse's principal inspiration, though, came from his models and the actual rooms in which he worked. In the autumn of 1918 he had moved to the Hôtel de la Méditerranée on the sea front, a more expensive hotel than the Beau-Rivage where he had stayed previously. Twenty years after leaving the Méditerranée, Matisse

recalled its attractions: 'I stayed there four years for the pleasure of painting nudes and figures in an old rococo salon. Do you remember the way the light came through the shutters? It came from below like footlights. Everything was fake, absurd, terrific, delicious.' He would set up his portable easel in the room like an Impressionist painter in front of a motif. In some cases he was as interested in the representation of objects and atmospheric effects as in the model. He remembered with pride the way he had achieved in *Young Girl in Green* of 1921 (Plate 137) the sensation of heat rising outside the shutters, and also the trouble he had taken painting the bunch of anemones which vies for attention with the head of the model, as in a diptych or double-portrait. There is a detailed drawing for the young girl, posed as in the painting but in the nude, which demonstrates the thoroughness of Matisse's preparatory work even in such a seemingly spontaneous interior. In others in the series he concentrated on the nude, exploring the relationships set up between her pose and the shapes of objects in the room. *Nude with Turban* of 1921 (Plate 146) exploits his favourite association of a female torso with the form of a vase.

Matisse's annual winter sojourns in Nice were akin to the temporary retreats of a harassed family man escaping the responsibilities of home, wife, and children for a place where he could build up his strength, regain inspiration, and concentrate exclusively on his art. For exercise he rowed with near fanatic regularity at the Club Nautique. His family stayed with him from time to time, but really they had no function in his dedicated life. Now that the children were grown up, they could but

146. *Nude with Turban*. 1921. Oil on canvas, 91.5 × 72.5 cm. Private collection.
This follows Renoir's technique in the juxtaposition of opaque flesh tones and thin oil washes, and in the way the background is rendered in two different browns.

147. *Reclining Nude, Back.* 1927. Oil on canvas, 66 × 92.1 cm. Paris, private collection.
Matisse selected a back view because here he was interested in the model's form rather than her personality.

148. *Odalisques.* 1928. Oil on canvas, 54.6 × 74.9 cm. New York, Mr and Mrs Ralph F. Colin.
Extensive *pentimenti* in the paint surface demonstrate the difficulty Matisse experienced: the draught-board was moved to the right, the initial outline of the clothed model was scraped out. The presence of the light source is cleverly suggested by the pale material with light-blue spots hanging on the left.

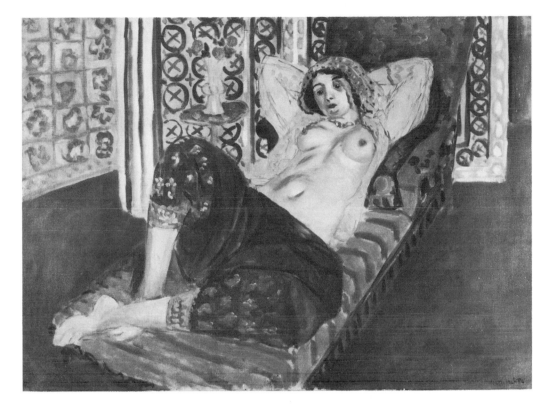

149. *Odalisque with Red Culottes*. 1921. Oil on canvas, 65 × 90 cm. Paris, Musée National d'Art Moderne, Centre Georges Pompidou.
Following its inclusion in Matisse's Bernheim-Jeune exhibition in March 1922, *Odalisque with Red Culottes* became his first painting to be bought officially for a museum in Paris.

remind their father of his own mortality. Marguerite, the child to whom he was especially close, married in 1923 the distinguished art historian Georges Duthuit. Although Amélie, Matisse's dedicated wife, was still very much in evidence, she seldom appears in his art; their relationship was probably already becoming more distant. Pretty models were readily available for him, the Hôtel de la Méditerranée attended to his daily needs, and for the stimulus of intelligent companionship he could meet friends—usually writers such as André Rouveyre or Jules Romains—at a café in the evening. However, by 1921 the temporary attraction of impersonal hotel rooms began to pall, and he felt the need for his own permanent base in Nice.

On returning to Nice from Issy in the autumn of 1921 he rented Frank Harris's former apartment at Place Charles-Félix, splendidly situated at the foot of the castle hill and gardens. This top floor apartment had all the makings of an ideal studio for Matisse: picturesque views, plenty of light, and the sensation of being part of, and yet at the same time detached from, life. The windows to the north looked out on to the church tower and the old quarter of the city, and those to the south on to a view of the sea over the low flat-roofed building called Les Ponchettes, which bordered the flower market. On market days the scent of flowers perfumed the air around the square; curiously, Matisse never seems to have painted the flower stalls.

Matisse's move from the Méditerranée to the apartment in Place Charles-Félix marks a gradual change in his figure paintings: his models, provincial girls formally posing in hotel rooms, are now cast as oriental odalisques acting out a dream of luxury, tranquillity, and delight in a theatrical setting of his own making. The more artificial the pose and setting the greater the attention paid both to the solidity of the female figure and to the physicality of colour. The increasingly complex matrix of interlocking patterns assumes the dual function of setting off the firmness of flesh and of evoking light through colour contrast, rather than by the dematerialization of local colour in luminous washes.

The model in *Odalisque with Red Culottes* of 1921 (Plate 149) lies back in a sumptuous interior world which Matisse constructed in his new studio out of screens and materials draped across wires. The setting is highly artificial, whereas

the painting is an objective exploration of relationships between the model, textures, and the illusion of light. This transient dream was made as durable as possible. The frontal nude in *The Hindu Pose* of 1923 (Plate 136) is suspended in a field of blue, activated by flickering white dots which contrast with the solidity of her form. The view out of the window has been sealed off by colour, and pictorial depth is restricted. Her expression is not allowed to detract from our observance of her nudity. Erotic pleasure is sublimated in the sensuous handling of paint and she is left looking detached—even a little bored.

In 1924 Matisse's love of rich patterns, textures, and colours resulted in a glorious series of still-lifes in interiors. Colours glowed with unprecedented radiance. Bunches of purple, pink, and red anemones, carnations, and other flowers competed for attention with objects of gold, orange, and yellow without cloying. In the outstanding *Interior at Nice* of 1924 (Plate 150), the foreground is dominated by a pineapple, a vase of carnations, oranges, apples, and lemons, all melodically arranged on a gold tray placed on a red-and-white striped table-cloth.

The richness of Matisse's paintings of 1924 owes something to his old friend and rival from the late 1890s, Pierre Bonnard. Matisse often visited Bonnard, who, after spending parts of several winters at Antibes and Cannes, bought in 1925 a small suburban villa called Le Bosquet, at Cannet above Cannes. Bonnard shared Matisse's interest in flooding a domestic interior with light and colour, but whereas Matisse required the stimulus of an actual scene, Bonnard could imaginatively transform even a cold, depressing little white-tiled bathroom into a golden setting, and his ageing companion Marthe into a youthful bather. By 1919 Bonnard had developed a method—which Matisse adopted—of using colours combined with cascades of patterns to shut off pictorial depth and evoke light. The difference between their techniques, although crucial, is one of emphasis rather than function. Bonnard tended to blend colours into each other, working wet-in-wet, while Matisse retained to a greater extent the separate identities of patterns and colours to create an overall effect through their relationships.

From 1925 Matisse's paintings once again became more concerned with the solidity of form and structure, and his dialogue with Impressionism ceased to have the same relevance in his art. The figure and interior paintings shared the Impressionists' obsession with light and with what the art historian Meyer Schapiro described as an 'apparently faithfully presented reality', but they cannot be said to have been created wholly under an Impressionist aesthetic bound up with truth to nature, or—more precisely—truth to sensation generated before nature. Part of the confusion in the interpretation of Matisse's work of this period arises out of the apparent conflict between reality and the dream. It was evidently very important to Matisse that his paintings should be based on reality. Delacroix had established a justly celebrated precedent for Matisse's subject-matter in his *Women of Algiers* of 1834 (Plate 141); however, Matisse stressed that he painted odalisques in order to paint nudes as he had *actually seen them* in Morocco. There does seem, though, something incongruous about his need to deck out a model in the popular paraphernalia of a provocatively clad odalisque.

Perhaps the key to this problem of interpretation lies in Matisse's own statements. He distinguished his own approach from Renoir's by his construction of space through relationships, rather than by directly copying nature. And in 1925 he explained that the secret of his art consisted of 'a meditation on nature, on the expression of a dream which is always inspired by reality'. For it was only by contemplation of the relationships between colours and objects that Matisse believed he could transcend everyday reality and achieve a state of harmony, a feeling of universal, abstract understanding. This idea, as discussed in Chapter 2,

150. *Interior at Nice*. 1924. Oil on canvas. 100.5 × 80 cm. Private collection. The curtain is tied back to reveal a mirror image of the artist and a view of the hills behind the old quarter of Nice. Matisse liked to have this splendidly shaped phonograph playing while he worked.

develops from the avant-garde's interest in Symbolism and the poetry of Mallarmé during the late 1890s. But to explain Matisse's glorious Nice paintings simply in terms of Symbolism would be to miss the point that they are very much expressions of pleasure, both in his subject-matter and in the manipulation of paint, and it is here that his principal debt to Renoir lies.

By 1925 a note of ennui had entered Matisse's work: he produced fewer canvases and with greater difficulty. His subject-matter no longer reflected his sensuous enjoyment of surface appearances and light. Light ceased to have the same unifying power. The atmosphere of his paintings became heavier, the patterns more dense, and the paint surface reflected his constant changes of mind. His models, who had previously been treated as a central point of focus setting the mood of an interior, were enlarged to fill the canvas format. It was as though he was taking on—without sacrificing the qualities of either—both the sculptural monumentality of Picasso's contemporary nudes in a neo-classic style and the profuse patterning seen in the majority of the pavilions at the giant Exposition des Arts Décoratifs, held in Paris in 1925. The neo-classic theme in Picasso's work had followed a trip to Italy in 1917, where he visited Naples and Pompeii. Matisse similarly went to Italy in 1925. On his return he appears to have set himself the task of resolving in both painting and sculpture a limited number of challenging poses of the female nude. The sinuous linear element in his previous figure paintings was developed separately in a magnificent series of over 200 etchings, dry-points, and lithographs. These prints were for the most part delightful variations on the poses explored in the paintings and sculpture. In a sense they represent the most complete expression of two of the principal qualities he sought in the Nice period—flooding light, as

represented by the overall whiteness of the page, and a visual equivalence for the emotion aroused in him by his models, through the treatment of their figures in linear arabesques.

The sculpture *Large Seated Nude* of *c.*1924–5 (Plate 151) incorporates three of Matisse's main preoccupations in the treatment of the female nude: the massive rounded volumes of Renoir's bathers, the poses of Michelangelo's sculptures for the Medici tombs, and Cézanne's use of figures faceted in separate planes. *Large Seated Nude* is dramatically suspended between sitting and reclining, tension and repose. Leaning right back, hands clasped behind her head, she can be seen either as the very epitome of relaxation or as coming perilously close to losing her balance and falling over.

Decorative Figure on an Ornamental Background of 1925–6 (Plate 142) is an upright variant of the pose of *Large Seated Nude.* Here Matisse set himself the problem of achieving a dynamic visual balance between the figure and the pattern, which is solidified and enlarged into architectural units. The curves belong to the pattern and the figure is by contrast harshly schematized, in a style reminiscent of his self-portrait in *The Painter and his Model* (see Plate 125), which also includes the same elaborate Venetian mirror on the wall. The technique is now structural rather than sensual. The paint on the figure's neck, for instance, has been scraped down to the white canvas ground with a palette-knife, forming an emphatic vertical edge, which acts in counterpoint to the curvilinear shapes behind.

Two separate processes are observable in the sculpture *Henriette II* of 1926–7 (Plate 152), and the painting *Woman with a Veil* of 1927 (Plate 143), both based on

151. *Large Seated Nude. c.*1924–5. Bronze, height 78.1 cm. Baltimore Museum of Art, Cone Collection.
Large Seated Nude is one of Matisse's most ambitious and successful sculptures. It evolved in at least three separate states from his exploration of the same pose in painting and printmaking.

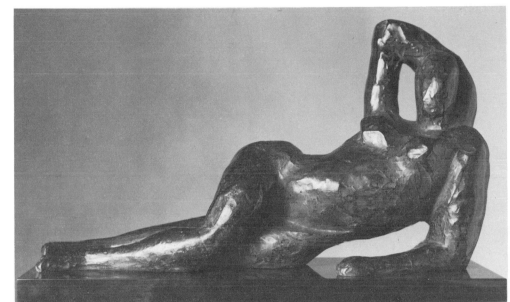

152. *Henriette II.* 1926–7. Bronze, height 32 cm. Private collection.
The head possesses an impersonal, mask-like serenity which, it has been suggested, may have been influenced by an African Baule-type mask hanging in Matisse's studio.

153. *Reclining Nude II.* 1927. Bronze, height 29 cm. Private collection.
Nothing illustrates the recurring nature of Matisse's formal problems better than the three versions of *Reclining Nude.* As with version *I* (see Plate 61), executed twenty years earlier, Matisse turned to sculpture when he was concerned with the structure and solidity of the female form. Version *III* followed soon after, in 1929.

Henriette Darricarrère, Matisse's favourite model from 1920 to 1927. He wanted in the former to build up the head into a rotund, monumental form and in the latter to break it down in a network of volumes, planes, and criss-crossing patterns which suggest form and assert the canvas surface. *Henriette II* proceeded from a more realistic preliminary version of 1925 to the smooth perfection of a detached classical style, already hinted at in *Large Seated Nude.* By contrast, in *Woman with a Veil* what may have begun as a realistic portrait of Henriette was destroyed in the struggle between the competing interests of three-dimensional form and two-dimensional pattern. Her veil (which Matisse was to depict illusionistically in two lithographs of Henriette as an odalisque in 1929) ended up looking like an angular Cubist visor.

The smooth rotundity of the surface of *Henriette II* in a sense ran counter to Matisse's previous conception of a fractured surface as a vehicle for light and as a metaphor for emotion. In the 1890s he had reacted against the polished perfection of academic finish, which he then equated with both mechanical repetition and unimaginative sterility. It was typical of Matisse that at a time of difficulty in painting he should question his own basic assumptions in this way and turn to sculpture in order to clarify his problems. His new emphasis of simplified, smooth volumes—and consequently clear, crisp outlines—enabled him to achieve a new reading of the female figure, where formal equilibrium was not necessarily the outcome of a balance of similarly shaped, opposing forces.

In the sculpture *Reclining Nude II* of 1927 (Plate 153), our eye follows the lines of the legs, in a sequence of unfolding volumes, which come to a conclusion in her raised head; her longitudinal development is balanced by the compactness and intensity of her vertical development. In the companion painting, *Reclining Nude, Back* of 1927 (Plate 147), this same device is used to lead our eye into the picture; the conclusion is reached in the swelling form of her buttocks, played off against the shape of the brass stove and the curves of the table. The transfer lithograph *Reclining*

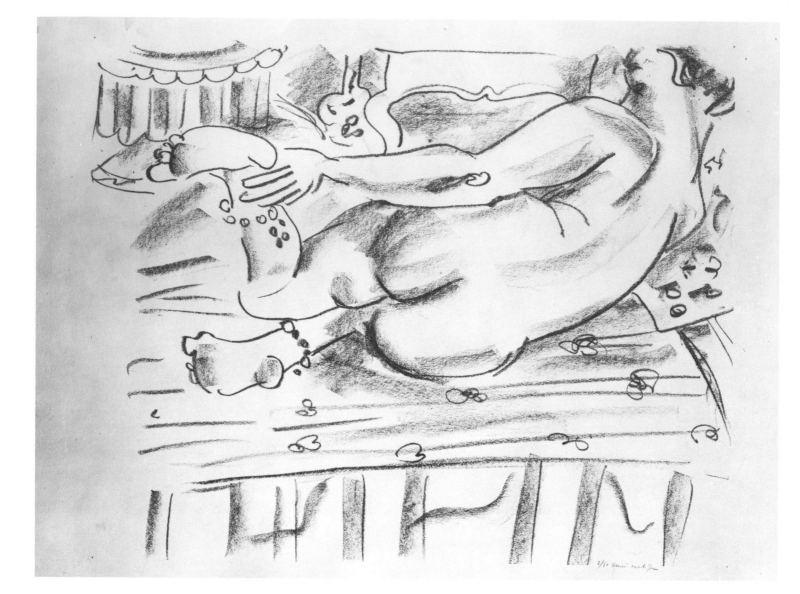

Nude from the Back of 1929 (Plate 154), like most of his lithographs of the 1920s, is a delightful linear variation on the theme of the painting. Sculpture, painting, and printmaking, therefore, each opened up a different dimension as he explored this new formal and expressive language of the human figure.

Matisse's paintings of 1928, at the end of his so-called Nice period, are like experiments: the same elements changed positions as he searched for pictorial structure. The sumptuous nature of their subject-matter often disguises his innovating drive. In *Odalisques* (Plate 148), for instance, Matisse returns to the theme of two models, first explored in his paintings of Laurette and her sister of 1917. The draught-board is placed between the upright, clothed figure on the left and the reclining nude on the right. The curvilinear patterns—which are not symmetrical—are countered by the vertical axes running through the figures: one axis connects the nude's raised elbow with the right-hand corner of the draught-board, another follows the edge of the blue-spotted material down to the point where the model's foot is cut off by the edge of the canvas. Unless we recognize the strenuous, experimental nature of such paintings, it will be difficult to appreciate that Matisse's great decorative works of the 1930s partly grew out of the issues raised in them: the relationship between figural distortion, direction, and emotion; the pristine whiteness of the page as the purest metaphor for light; and finally the rhythmic independence of line.

154. Reclining Nude from the Back. 1929.
Transfer lithograph on Arches paper,
46 × 55.9 cm. London, Victoria and Albert Museum.
Matisse's lithographs are usually much more sensual and playful than his paintings and sculptures of the same themes.

7 *The Classical Decade, 1930-1940*

Matisse emerged in the 1930s with a growing popular reputation, based mainly on his paintings from 1920 to 1925. The voluptuous *Odalisque with Red Culottes* was bought for the Musée du Luxembourg in 1922—the first purchase by the State of a Matisse painting since *The Reader* of 1895. On 10 July 1925 he was created a *chevalier* of the Légion d'honneur. In 1921 he had been paid the unusual honour for a modern artist of being invited to enter the prestigious annual Carnegie International Exhibition at Pittsburgh in the United States. In the 1927 Carnegie exhibition he was awarded the first prize for *Fruit and Flowers*, one of the glorious still-lifes of 1924, resplendent with light and colour. In his fifth and final three-year contract with the Bernheim-Jeune gallery of 1923 the price of, for instance, a size 25 figure-format canvas (81 × 65 cm) rose from the 4,800 francs of his fourth contract of 1920 to 7,250 francs. We saw in the 1920s how Matisse no longer felt obliged to paint large-scale masterpieces, and the succession of smaller easel pictures were easier to comprehend and sold well. Most of the paintings had been snapped up before his 1924 Bernheim-Jeune exhibition was officially opened.

The pattern in the collecting of Matisse's work had altered since the war. This was partly a reflection of changes in taste and circumstances, and partly, of course, due to money. Very few Matisses were now bought by Germans, but then the French themselves still did not buy in any numbers. Marcel Sembat, a socialist deputy for Paris from 1893 to his death in 1922 and minister of public works from 1914 to 1916, though never rich, had been the only major French collector of Matisse, and when he died his collection went to the Musée de Grenoble. Key paintings changed hands as new collections were formed. *Le Bonheur de vivre* passed from the collection of Leo and Gertrude Stein to that of the wealthy Danish corn-merchant Christian Tetzen Lund, the greatest collector of Matisse from 1915 to 1925; and when he was obliged to sell in 1926 it was bought by Dr Barnes, who was later to commission the murals from Matisse (see Plates 161, 162). Similarly *Blue Nude—Souvenir of Biskra* went from the Steins to John Quinn, and after his death in 1925 to Dr Claribel Cone of Baltimore. Claribel Cone died in 1925 and her collection was amalgamated with that of her sister Etta, who was to buy two of Matisse's major paintings of the 1930s, *The Magnolia Branch* of 1934 (see Plate 168) and *Pink Nude* of 1935 (see Plate 169). In 1949 the magnificent Cone collection, which included some forty paintings and eighteen sculptures by Matisse, became part of the Baltimore Museum of Art. A considerable number of Tetzen Lund's Matisses, including *Portrait with the Green Stripe*, were bought by his compatriot, the engineer Johannes Rump, who in 1938 left his collection to the State; thus Copenhagen found itself with the best public collection of works by Matisse, apart

from that of the Museum of Modern Western Art in Moscow, formed from the confiscated Shchukin and Morozov collections. From 1925 American dollar power and enthusiasm for modern art began to tell; four-fifths of Matisse's Nice paintings went to the States. By 1930 Stephen C. Clark had assembled the most representative collection of Matisse's paintings of the 1920s.

The increase in Matisse's sales and reputation was accompanied by important retrospective exhibitions of his work: in Copenhagen in 1924, Berlin in 1930, and three in 1931 alone in Paris, Basle, and the recently founded Museum of Modern Art in New York under the inspiring directorship of Alfred H. Barr Jun. MOMA, as it has come to be known, has since amassed the greatest Matisse collection, apart from the Russian Matisses, now split between Moscow and Leningrad; it is particularly strong in the period from 1911 to 1916. In 1920 the first of many monographs was published, with a preface by Marcel Sembat, assigning Matisse to the history of art. In *The Art of Painting*, published in 1925, Dr Barnes placed him below Cézanne and Renoir but above all his contemporaries. Matisse's heroic, innovative days appeared to be over, and at the age of sixty he could quite legitimately have been expected to continue in the winning style of his Nice period.

Despite this astonishing run of success, Matisse found it increasingly difficult to stick to work that demanded prolonged concentration; he virtually stopped painting in 1929. The reasons for his new crisis were again complex and open to speculation. He may have been responding to a general change of mood in the country. By 1929 the initial optimism and seeming prosperity of the post-war period were evaporating rapidly. On 24 October 1929 Wall Street crashed, and the effects of the ensuing depression began to be felt in France towards the end of 1930. France began constructing the Maginot line of defences against the possibility of yet another German invasion. Artists of the avant-garde were torn between alienation and a desperate need to be part of events which they were by definition powerless to affect. Young intellectuals became infatuated with socialism and radicalism, whilst their elders tended to remain faithful to the pre-war ideals of their youth.

Surrealism, which had started out as a literary-based, revolutionary political movement, remained the dominant force in Parisian avant-garde circles. The movement passed from anarchism to toe the Communist Party line; its review *La Révolution Surréaliste* of 1924 to 1929 became *Le Surréalisme au Service de la Révolution* of 1929 to 1933. However, as disillusion with the real world of practical politics set in, Surrealism developed into an avant-garde artistic movement. The cafés of the Left Bank—du Dome, de Flore, La Cupole—became popular meeting-places for young artists from all over the world, drawn to Paris in search of creative freedom outside the constraints of the rigid ideologies of both communism and fascism.

On a personal level, Matisse felt trapped within the hermetic environment of his own studio and isolated from the stimulus of the avant-garde. Even those young artists sympathetic to Matisse saw him as a very remote figure. His renting of an apartment on the boulevard Montparnasse was symptomatic of his desire to get back into the swim of things. However, he was in a dilemma as to what to paint. He was understandably reluctant to embark on large-scale decorations without a commission, particularly during the depression. The lure of the 'grand style' persisted, and at the back of his mind always was the challenge of Picasso and a wish to create significant paintings.

Matisse's immediate reaction was to make a complete break with the increasingly hermetic nature of his life and work: in 1930 he went to Tahiti, via New York and San Francisco, and later that year made a second journey to the United States to sit on the jury of the Carnegie International Exhibition. He categorically denied that his trip to Tahiti had anything to do with Gauguin's flight from materialist France

and return to nature in the exotic setting of a Polynesian village (a vision of leisure since institutionalized in France with the founding of the Club Méditerranée in 1950). In his interview with Tériade of October 1930, Matisse stated that he consciously set out to reassess his art in a completely different light, 'which would allow me to grasp more profoundly the space and light in which I live'. There was a note of disenchantment, though, about his comments on Tahiti. He was too preoccupied with his own problems to be anything but annoyed by what he referred to disparagingly as 'this ambience of doing nothing'; he thought constantly of ways of resolving the painting *Girl in a Yellow Dress* (Plate 155), begun in 1929 and left behind unfinished on his easel in Nice. He was far more impressed by his brief stay in New York: 'The space that I sought in Tahiti and did not find there I found in New York.' He felt full of energy there and gave rapturous descriptions of light falling on skyscrapers. And yet it is a curious fact that Matisse's experiences of Tahiti, which he was unable to deal with at the time, filtered through into his consciousness as one of the main sources of his subject-matter in the last decade of his life.

In retrospect Matisse could see that his visit to Tahiti was part of his search at the beginning of the 1930s for a larger space than that surrounding his subject: 'I was mentally aware that above me, above any motif, above the studio, even above the house, there was a cosmic space in which I was as unconscious of any walls as a fish in the sea—immediately values grow lighter and the shadows are no longer "deep as tombs"—painting becomes airy and even aerial. So at the same time that my

155. *Girl in a Yellow Dress*, 1929–31. Oil on canvas, 100 × 81.2 cm. Baltimore Museum of Art, Cone Collection.
Girl in a Yellow Dress concludes Matisse's paintings of his Nice period of the 1920s and at the same time anticipates the pose of such portraits of the 1930s as *Lady in Blue* of 1937 (see Plate 175).

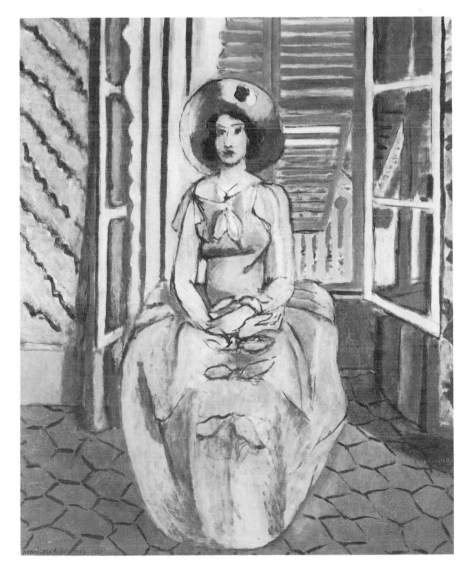

picture space was expanding I often wondered as I worked what the quality of light must be like in the tropics.' There is an obvious parallel here with 1911, when travel and the study of Persian miniatures helped him to get away from what he called 'intimate painting'. He was also, it must be said, responding to Surrealism and to the spatial freedom of Joan Miró's recent paintings, in which objects floated in a seemingly infinite, atmospheric field of colour. But Matisse's problem was how to express this new feeling for light and space without abandoning two other factors that he considered most important in art—the integrity of the human figure and 'the relationship between things'.

In 1930 Matisse received two decorative commissions which were to occupy him for the next three years and decide in the process the twin directions of his art over the decade. The first, from the publisher Albert Skira, was to illustrate an edition of the poems of Stéphane Mallarmé. The second came from Dr Barnes, during Matisse's second visit to the United States, to execute a mural in the main hall of the Barnes Foundation, Merion, Pennsylvania. Both commissions in their different ways expressed Matisse's new, expanded conception of space: the symbolic, limitless space of the white page on the one hand and the transformation of the physical confines of an existing architectural space on the other.

Apparently, Matisse was hesitant about accepting the Mallarmé commission until Skira cunningly pointed out that Picasso had agreed to illustrate the *Metamorphoses* of Ovid. Whatever the truth in this, their rivalry resulted in two of the most beautiful illustrated books in twentieth-century art. Both artists employed a very refined classical style of line drawing. The degree of Matisse's involvement with classical style and subject-matter in the 1930s reflects his disillusion and pessimism in the face of contemporary developments in both art and culture. When asked to illustrate James Joyce's *Ulysses* in 1935, he chose instead to provide drawings based on the *Odyssey* of Homer.

The *Mallarmé* is unique in Matisse's illustrated books for the closeness of correspondence between the style of the poetry and his work at that time. Mallarmé made no distinction between style and content. Like Matisse later he was so acutely aware of the means at his disposal that even the blank page became an element of construction, while each word was like a well-considered object whose shape and colour could be recombined to attain new meaning. The relationship between words rather than narrative formed the content of the poem. His efforts to achieve a diamond-like perfection found a direct equivalent in Matisse's drawing style, where forms were synthesized after long deliberation into precise outlines on the crystalline whiteness of the page. The silences in Mallarmé's poetry and the whiteness of Matisse's illustrations were influenced in their function by the oriental concept of the void, which could mean everything or nothing, a metaphor for life itself. This equivocal nature of the void is linked with the compulsive drive for perfection in the work of both poet and painter, for underlying their purity of style is a pessimism which comes from awareness that the long struggle with formal means to find an ultimate image might result in an abstraction, lacking warmth and humanity.

Matisse stated that he made no distinction 'between the construction of a book and that of a painting'. Each illustration was preceded by numerous preliminary drawings and trial proofs. Seventy-eight of the studies were bought by Etta Cone in 1932 and are now in the Cone Collection at the Baltimore Museum of Art. Some of these studies are remarkably inept in comparison with the perfection of the final illustrations. Matisse saw his main problem as one of balancing the predominantly white illustration on the right-hand page with the relatively black print on the left. He compared them to two objects taken up by a juggler: 'His white ball and black

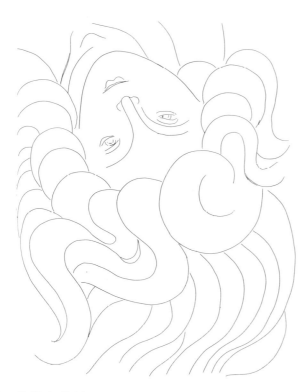

156. Page 129 from *Poésies* by Stéphane Mallarmé. Etching, 33.2 × 25.4 cm. Published by Albert Skira, Lausanne, 1932. The purity of Matisse's line exactly suits the style and content of Mallarmé's poems.

157. *Tiari*. 1930. Bronze, height 20.3 cm. Baltimore Museum of Art, Cone Collection. The *Mallarmé* illustration in Plate 156 follows on from *Tiari*. Having achieved formal perfection in the sculpture, Matisse gained the confidence, and knowledge, to encapsulate similarly shaped volumes in a single outline. His son Jean carved a beautiful marble version of *Tiari*, which made its connection with the white Tahitian gardenia more explicit.

ball are like my two pages . . . In spite of the differences between the two objects, the art of the juggler makes a harmonious whole in the eyes of the spectator.'

Matisse's twenty-nine etchings for the *Mallarmé* are not illustrations in the literal sense. Some are more closely connected with the poems than others. This is particularly true of the illustrations to the narrative poem *L'Après-midi d'un faune* (*A Faun's Afternoon*), which recall the Arcadian imagery of *Le Bonheur de vivre*. Matisse identified himself with the faun's desire to 'perpetuate these nymphs', just as he came to rely on his female models to arouse in him the emotion to make art. The relationship between most of the other poems and the illustrations is less direct. It can be argued that Matisse's nudes—his nymphs—are the real subjects of his illustrations and that the poems served to spark off associations which led to a complex rephrasing of his previous favourite poses and themes. His ravishing illustration which precedes the poem 'La Chevelure' ('The Hair') (Plate 156) was probably inspired by the words, 'The hair, flight of a flame, to the extreme Occident of desire'. At the same time its form evolved from his heads *Jeannette I* to *V* of 1910–13 (see Plates 105, 106), from the kittenish pose of his model Laurette lying back looking at the viewer of 1917, and from the rounded volumes of his recent sculptured head *Tiari* of 1930 (Plate 157)—a fusion in itself of a Tahitian girl 'with her satin skin, with her flowing, curling hair' and a *tiari* or Tahitian gardenia. The connection between the poem beginning with the line, 'What silk

with time's balms . . .', and his illustration is tenuous (Plate 158). However, the pose is a further refinement of his upright seated nudes of the 1920s, in combination with another of his recent sculptures, *Venus in a Shell I* of 1930 (Plate 159).

During his second trip to the United States in October 1930 to serve on the Carnegie jury, Matisse took the opportunity to visit two of his major collectors, Etta Cone in Baltimore and Dr Barnes at Merion. Barnes suggested then that Matisse should execute a mural for the three lunettes above the french windows in the main hall of his foundation building. It is quite understandable that Matisse did not immediately accept the commission. Barnes was a very difficult man. In the days before antibiotics, he had made a fortune from Argyrol, an antiseptic used in the treatment of infections of the eye and mucous membranes. A friend from his youth, the painter William Glackens, persuaded him to collect Impressionist and Post-Impressionist French painting, in addition to Old Masters. After a trial period, Barnes became completely absorbed and built up one of the greatest Post-Impressionist collections, including outstanding paintings by Seurat, Cézanne, Renoir, and Matisse. Deeply hurt by the very hostile reaction to his collection shown by the Philadelphia art establishment, Barnes withdrew it behind the walls of his own institution, founded in 1922, and successfully managed to keep out several generations of art critics and historians. It is only comparatively recently that the collection has been made more accessible, but even now these paintings are not catalogued, loaned, or reproduced in colour.

The site for the murals was also extremely awkward. The shapes of the three lunettes, with the two pendentives (the intervening areas between the lunettes), were very definite and dominant; the doors underneath were glazed, so the light poured in; there were the colours of the garden outside to compete with, as well as the masterpieces inside; the lunettes could be viewed either from the balcony of the mezzanine or from the floor below; lastly, the weight of the vault above the lunettes was oppressive.

Matisse finally accepted the commission for the murals in January 1931, having been assured that he could paint whatever he wanted. Barnes in any case regarded the 'plastic qualities' of a work of art as more important than its subject-matter. Without any apparent hesitation, Matisse chose the subject of the dance, seen for the first time in the background of *Le Bonheur de vivre* of 1905–6 (see Plate 51), which was now hanging in the very hall for which the murals were destined. He decided to execute the commission on canvas, back in his Nice studio.

Matisse was now faced with the daunting task of reconciling his most ambitious figure group, the circle of dancers, with the architectural setting. He was almost driven to despair by the difficulties involved. No single solution seemed to impose itself. When things became too much for him, his close friend from his days in Moreau's studio, Simon Bussy, would receive an imploring telegram: 'decoration in terrible state composition completely out of hand am in despair light suitable this afternoon for Gods sake come at once—Matisse'. One of his principal problems was how to accommodate the two pendentives into his design. At first he had the five figures from the Shchukin *Dance* of 1910 (see Plate 83) rushing around the pendentives, making it impossible to harmonize the mural with the two-dimensional surface of the architecture. The beginnings of the solution, therefore, came when he increased the number of dancers to six, enabling him to interrupt the downward movement of the pendentives with recumbent figures. He was reluctant, though, to relinquish the driving rhythm of *Dance*, and he tried adding one or two more dancers in order to preserve it.

Matisse made very little progress until he adopted a radically new and more

158. Page 147 from *Poésies* by Stéphane Mallarmé. Etching, 33.2 × 25.4 cm. Published by Albert Skira, Lausanne, 1932. This is one of the loveliest of Matisse's illustrations—supremely economical and serene. As in his *Le Luxe I* (see Plate 57), she rises up from her discarded drapery like Venus.

159. *Venus in a Shell I.* 1930. Bronze, height 31 cm. New York, Museum of Modern Art. *Venus in a Shell* relates to the illustration in Plate 158 in a similar way as *Tiari* does to Plate 156. The pose is based not only on Matisse's seated nudes of the 1920s but also probably on a Hellenistic terracotta. In 1932 Matisse made a second, more chunky, version of *Venus in a Shell*.

160. *Back IV. c.* 1930–1. Bronze, 188 × 112.4 × 15.2 cm. London, Tate Gallery.
The extreme simplification of the figure style of the Barnes murals is indebted to the fourth and final version of *The Back* series of reliefs, variously dated from 1929 to 1931, in which the figure is realized in terms of massive interlocking units, which hold their own against the format of the relief as a whole.

flexible method of working. He told Raymond Escholier, director of the museum of the city of Paris, the Petit Palais, that 'the composition of the panel arose from a struggle between the artist and 52 square metres of surface, of which the spirit of the artist had to take possession'. The techniques which made this possible came in 1931, when he rented a disused garage in Nice and set up three full-size canvases, intended for installation in the architectural setting. Instead of enlarging smaller squared-up studies, he drew directly on to the canvas with a charcoal pencil clamped to the end of a long bamboo pole. To overcome the time-consuming process of scraping out and repainting the colours every time a line was altered, he cut out pieces of coloured paper to fit the new forms and had them pinned to the surface by an assistant. Adjustments still had to be made when he replaced the paper with paint, but this technique meant that he could make quicker progress through trial and error. His work on the fourth and final version of *The Backs* series of reliefs (Plate 160) undoubtedly helped him to make the transition from the intimate scale of his Nice paintings of the 1920s to the over life-size figures of the murals.

Matisse had each state carefully photographed. Photographs, he felt, helped to distance himself from the work in progress, enabling him to assess it more objectively and, also, to return to a previous documented state for a new point of departure. This latter function may have been suggested by the printing of the various states of the *Mallarmé* etchings.

Matisse's paper cut-out technique developed from his working methods on the décor and costumes for Diaghilev's production of the Stravinsky ballet *Le Chant du*

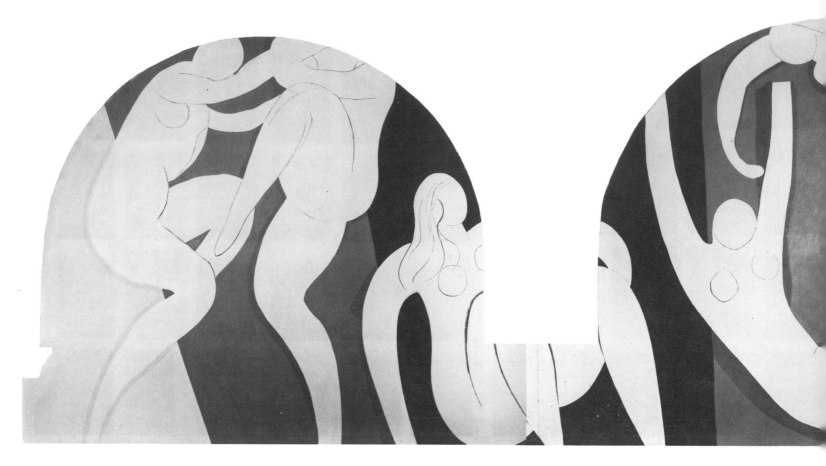

Rossignol of 1920, which was revived in 1926. This was his only previous work on a similarly large scale and, significantly, it also involved dance. Matisse had gone to London in 1919 to work on the décor with the Russian scene-painter Vladimir Polunin. He arrived without any sketches and 'set to work in the studio, scissors in hand, cutting out and piecing together a model'. Like the Barnes murals later, the décor was kept pure and simple (possibly as a reaction to the ornate profusion of earlier Russian Ballet décors). The colours of the backdrop were restricted to black, white, blue, and turquoise green; the chromatic accents came in the costumes of the dancers. This interaction between the ballet and the murals took on a new twist in 1937 when Leonide Massine, who had choreographed *Le Chant du Rossignol*, persuaded Matisse to use the Barnes *Dance* as the basis for the background to the Shostakovich ballet *Rouge et Noir.* Matisse again used cut-out paper in his maquettes for this décor.

Matisse's often agonizing labour on the Barnes murals was nearing completion in 1932 when he found that the measurements he had been given were wrong (the pendentives which had already caused him so much trouble were 1 metre wide at the base, and not 50 centimetres). Instead of adding a surrounding border to fit the lunettes, he produced a completely new variation on the same theme, with eight dancers instead of six (Plate 161); this was completed in April 1933. Nothing was wasted in Matisse's art. He returned to complete the first version (Plate 162) once he had seen the second installed in its setting at the Barnes Foundation. 'The second', Matisse explained, 'is not a simple copy of the first; because these different pendentives required me to compose with architectural masses more than twice the size, I had to change my composition. I even produced a work with a different spirit: the first is aggressive, the second Dionysiac: the colours, which are the same, are nonetheless changed; as their quantities are different, their quality also changes: the colours applied freely show that it is their quantitative relation that produces their quality.'

161. *Dance II.* 1932–3. Oil on canvas, 357 × 1,432 cm. Merion, Pa., Barnes Foundation.
Matisse adopted two of his earlier innovations to lighten the vault of the main hall in the Barnes Foundation. Firstly, the vertical bars in the background of *Bathers by a River* of 1916 (see Plate 112) were angled to suggest their extension beyond the confines of the edges of the canvas. Secondly, the device of leading the eye into a picture along a limb, developed in the painting *Reclining Nude, Back* of 1927 (see Plate 147), was reversed so that the eye was led out into space.

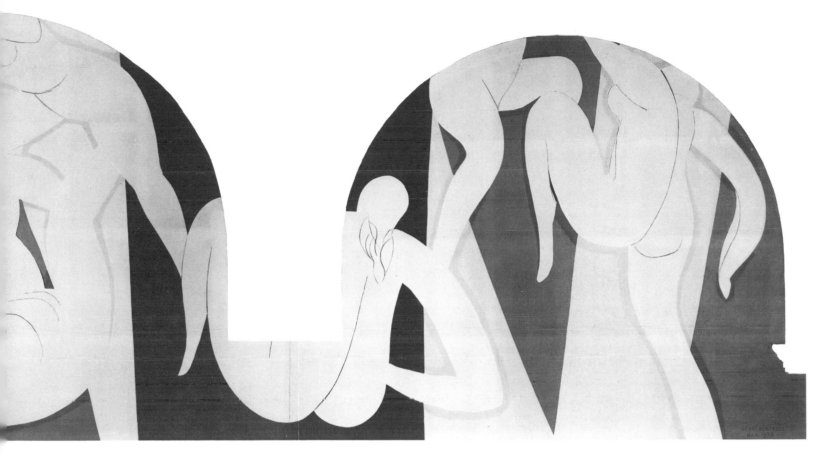

162. *Dance I.* 1931–3. Oil on canvas, left panel 340 × 387 cm, centre panel 354.9 × 498.1 cm, right panel 333 × 391.1 cm. Paris, Musée d'Art Moderne de la Ville de Paris.
The subject of the two versions of the Barnes murals is not just dance but the dialogue between the figures and the abstract shapes of the background. This discarded first version was subsequently bought by the Musée d'Art Moderne de la Ville de Paris.

There is a much more satisfactory relationship in the second version between the dancers and the format of the setting. In the first, the emphasis is concentrated to too great an extent on the two recumbent dancers beneath the pendentives, and the other three dancers look as though they are being propelled out of the setting, whereas in the second version the eight dancers rise and fall within the rhythm of the three lunettes, with their tapering limbs intertwining in sensual curvilinear patterns.

The two versions of the Barnes murals are so bold and on such a scale that they would dwarf all Matisse's previous work but for their detached style. This was intentional. Matisse wanted to differentiate the mural from the easel paintings on the walls below and make it harmonize with the architecture; as he explained in 1934: 'The expression of this painting should be associated with the severity of a volume of whitewashed stone, and an equally white, bare vault. Further, the spectator should not be arrested by this human character with which he would identify, and which by stopping him there would keep him apart from the great

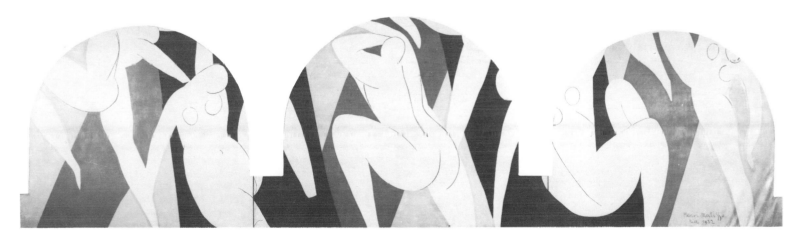

harmonious, living, and animated association of the architecture and the painting.' He made a clear distinction between his earlier Shchukin *Dance* (see Plate 83)—'a work which can hang anywhere'—and the Barnes murals—'made especially for the place. In isolation I only consider it as an architectural fragment.'

Having seen the mural installed in the Barnes Foundation in May 1933, Matisse returned exhausted to France. He went for a cure at Abano Bagni near Venice and revisited Giotto's Scrovegni Chapel at Padua, his ultimate standard in the field of mural decoration. Throughout his life Matisse tried to fight against anxiety and the coldness of his own temperament and achieve a compensatory warmth and harmony in his art. He wanted to reconcile the solidity and humanity of Giotto's frescoes with a flat, decorative surface. However, the extreme spiritual purity of his *Mallarmé* illustrations and the relative coolness of his Barnes murals accorded with his mood at the time, and he went on in the 1930s to develop a slightly detached but magnificently decorative courtly style. There is a markedly new majestic independence of the pictorial elements—figure, ground, line, and colour—which was in part facilitated by the new techniques he used to gain possession of the vast surface of the murals. Line came to dominate colour. He revived his easel painting, and regained contact with nature, by painting still-lifes (see *The Magnolia Branch*, Plate 168), but the subject which increasingly obsessed him was the female model. In 1939 Matisse explained:

> My models, human figures, are never just 'extras' in an interior. They are the principal theme in my work. I depend entirely on my model, whom I observe at liberty, and then I decide on the pose which best suits *her nature*. . . . The emotional interest aroused in me by them does not appear particularly in the representation of their bodies, but often rather in the lines or the special values distributed over the whole canvas or paper, which form its complete orchestration, its architecture. . . . It is perhaps sublimated sensual pleasure, which may not yet be perceived by everyone.

The easel paintings of 1935 are primarily concerned with drawing, and with the

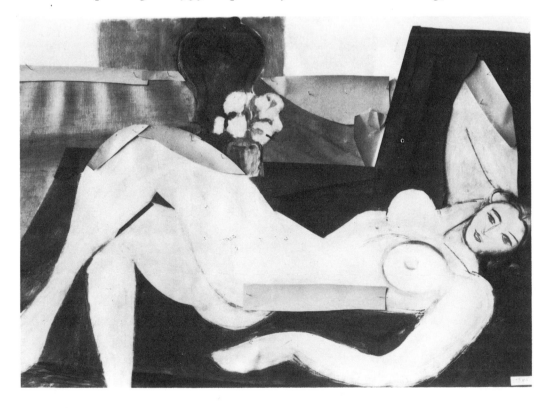

163. *Pink Nude*. Sixth photographed state, 23 May 1935.
In *Pink Nude* (see Plate 169) the striking flatness and extreme contrasts of form and colour arose out of Matisse's employment of brightly coloured, pinned cut-out paper in the process of its creation.

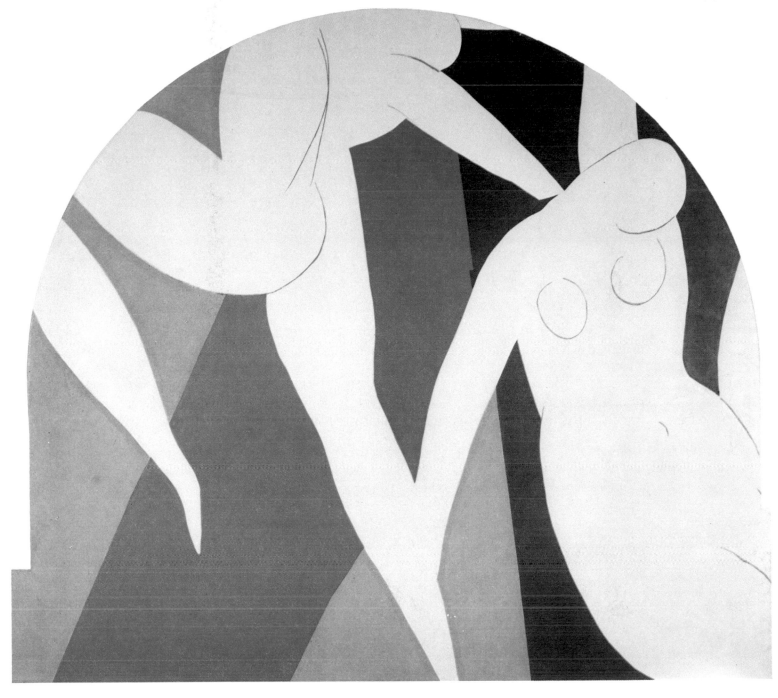

164. *Dance I*. Left panel.
The background is broken up into bars of pink, blue, and black which act in counterpoint to the soaring motion of the dancers. Perhaps its arrangement was influenced by the insistent background beat of jazz. The two black bars were intended to continue the architecture between the glazed doors and to provide a visual support for the pendentives and vault. The colour of the vault is echoed in the pearl grey of the dancers.

expressive distortion of the female form to characterize a mood in accordance with the model's personality—the length of her languid repose, for example, or the profundity of her dreaming. The subject of *Pink Nude* (Plate 169) evolved in twenty-two states (documented in black-and-white photographs) from a more naturalistic study of a nude reclining on a sofa in a large room to an enclosed hieratic image of ease. From the sixth photographed state of 23 May (Plate 163) Matisse began to expand the figure in pinned paper until the forms filled the surface with the full weight of relaxation. The role of colour, evolved in the Barnes murals, to advertise and emphasize shape in a simplified palette was continued in *Pink Nude* and other paintings from 1935 with an ever-increasing heraldic intensity and subtlety.

The Dream (Plate 170) similarly evolved in some seven states (once again documented in black-and-white photographs) from preliminary drawings of the model with her head resting on folded arms. Gradually her elbow sank, her distended fingers lost their grip, and the blue rug was picked up like a tent to funnel the full weight of the background downwards.

165. *Nude with a Necklace.* 1935. Chinese ink on Arches paper, 45 × 56 cm. Paris, Galerie Dina Vierny.
Matisse aptly described the luminous space surrounding such drawings as a 'perspective of feeling'.

The Symbolist concept of *le rêve* (the dream) had acquired new emphasis with Surrealism. Matisse's painting, though, is not so much about the model's reverie as about his own dream of ultimate harmony, expressed through the image of woman. Her arms open up ready to receive his head, like the Virgin cradling the head of Christ in Giotto's very poignant fresco of the *pietà* in the Scrovegni Chapel at Padua. In his variation of the subject of 1940, Matisse simply referred to the model as 'an angel'.

Matisse's painting was accompanied by an exquisite series of drawings. These drawings are less stylized than the paintings; much more the outcome of his response to the presence and changing moods of a model. In this respect they follow on from his independent drawings of Antoinette in 1919. The lovely *Nude with a Necklace* of 1935 (Plate 165), for example, is an abandoned variation on the pose of *Pink Nude*. Ecstatic little squiggles and criss-crossings of the pen accentuate the softness of her flesh and convey his excitement in the contemplation of her ravishing body. In a celebrated passage on his drawings Matisse wrote:

My line drawing is the purest and most direct translation of my emotion. The simplification of the medium allows that. At the same time, these drawings are more complete than they may appear to some people who confuse them with a sketch. They generate light; seen on a dull day or in indirect light they contain, in addition to the quality and sensitivity of line, light and value differences which quite clearly correspond to colour. These are also evident to many in full light. They derive from the fact that the drawings are always preceded by studies made in a less rigorous medium than pure line, such as charcoal or stump drawing, which enables me to consider simultaneously the character of the model, the human expression, the quality of surrounding light, atmosphere, and all that can only be expressed by drawing.

Lydia Delectorskaya, the young Russian who posed for *Pink Nude*, *The Dream*,

166. Picasso. *Woman with Yellow Hair.*
1931. Oil on canvas, 99.4 × 80.7 cm. New
York, Guggenheim Museum.
Picasso first met the seventeen-year-old
Marie-Thérèse Walter in 1927. He
celebrated their subsequent love-affair in an
extremely sensual series of paintings, begun
in 1931, which acted as a catalyst in
Matisse's later portrayal of Lydia.

167. *Nymph in the Forest.* 1936–42. Oil on
canvas, 234 × 191 cm. Nice-Cimiez, Musée
Matisse.
When Matisse stopped work on this
composition, he returned to a large charcoal
drawing on canvas, *Nymph and Faun with
Pipes*, which concentrated on the two
struggling figures. Struggling figures
became one of his persistent themes in the
1930s.

and the drawing *Nude with a Necklace*, was no ordinary model. Like Picasso's Marie-Thérèse Walter, she was the muse whose grace and style informed Matisse's art of the 1930s. The relationship between the two artists' respective images of the women is revealing. Matisse may have influenced Picasso's move to brighter, flatter colour and more painterly effects, while the distortions of Marie-Thérèse's head owe a lot to Matisse's heads of *Jeannette* (see Plates 105, 106). Picasso, however, completely absorbed and intensified his borrowings to the point where they constituted a new style; the seeming solidity of his planes of saturated colour and the freedom of his expressive distortions have no precedent in Matisse's art. Picasso's portraits of Marie-Thérèse of 1931–2 are some of the most personal celebrations of the erotic pleasures of a love affair in painting. Matisse's paintings of Lydia are more serene, even spiritual; but a comparison between his *The Dream* and Picasso's *Woman with Yellow Hair* of 1931 (Plate 166) illustrates the extent to which Matisse was in turn influenced by Picasso's distortions of the female figure to convey emotion. Lydia remained with Matisse to his death in 1954, as his model, confidante, secretary, and organizer of his studio. Intensely loyal, she has never published an intimate account of her life with Matisse.

During 1935–6. Matisse began two large-scale decorative paintings, *Window at Tahiti* and *Nymph in the Forest* (Plate 167). Both were based on themes from his *Mallarmé* illustrations, which had become deeply personal to him, but neither—for different reasons—was he in a position to resolve satisfactorily. In the former it was a formal problem and in the latter a psychological one.

Window at Tahiti was the cartoon for a Beauvais tapestry (Plate 174), commissioned from Matisse in 1935 by Marie Cuttoli, who was responsible for the

168. *The Magnolia Branch*. 1934. Oil on canvas, 154.3 × 167 cm. Baltimore Museum of Art, Cone Collection.
It has the dimensions of a large decorative canvas but its style looks back to *Girl in a Yellow Dress* of 1929–31 (see Plate 155) and Matisse's more realistic paintings of the 1920s, rather than forward to the flatter, more synthetic paintings of the following year.

169. *Pink Nude*. 1935. Oil on canvas, 66 × 92.7 cm. Baltimore Museum of Art, Cone Collection.
Pink Nude is a counterpart to *Blue Nude—Souvenir of Biskra* of 1907 (see Plate 55) in the same collection. The innovating character of *Pink Nude* is at first sight less easy to define because the style employed to distort the nude is almost as traditional as the pose itself. In *Blue Nude* the linear distortions of Ingres are translated into a severely structural language, derived principally from Cézanne, whereas in *Pink Nude* the distortions are in themselves an exaggeration of the graceful conventions of figural perfection which Ingres adopted from the High Renaissance and Mannerism.

170. *The Dream*. 1935. Oil on canvas, 80 × 65 cm. Paris, Musée National d'Art Moderne, Centre Georges Pompidou.
The black, blue, and pink colour scheme developed from the background colours of the Barnes murals. Black is placed in the top corners to direct our attention downwards.

attempted rehabilitation of French tapestry design. Since his Tahitian trip of 1930, Matisse had wanted to re-create somehow 'the enchanted surroundings of Oceania' in his boulevard Montparnasse apartment. He filled it with brightly coloured tropical birds, 'a living reminder of the distant isles from which they came'. This internal world of his own making was a creation complete in itself which defied translation into a work of art, until his final development of the paper cut-out technique in the last three years of his life. When faced with the commission for the Beauvais tapestry he simply enlarged the composition of his illustration of the schooner *Papeete* in the *Mallarmé* (Plate 171) and then filled it with flat, bright colour. The result is attractive and bold, but lacking in fresh inspiration. The composition worked well within the unifying whiteness of the page, whereas there is a lack of tension between the separate elements of the cartoon.

Nymph in the Forest looks like an unfinished cartoon for another tapestry. Matisse worked on it intermittently from 1936 to 1942 before abandoning it. He evidently experienced great difficulty in his efforts to reconcile the two-figure group of faun and nymph with the abstracted decorative setting, which derived from his illustration in the *Mallarmé* of a couple wandering along a path in a Tahitian landscape. The classical subject of faun or satyr and nymph, which enjoyed a long pedigree in Matisse's art, from *Le Bonheur de vivre*, the Hagen ceramic triptych, and *Nymph and Satyr*, to the illustrations for Mallarmé's *L'Après-midi d'un faune*, by 1936 had become too personal for him to resolve in a decorative manner. His relationship with Lydia had reached the point where—if only in his imagination— he himself was playing the satyr to her recumbent nymph. Their liaison lent unexpectedly new force to both his preliminary drawing and illustration of Homer's *Calypso* (she was the nymph who kept Ulysses enthralled on her island for seven years); but when it came to the long-drawn-out decorative project the consequences of his action became apparent. Like the heroine of Montherlant's *Pasiphaé* (which was to be his second fully illustrated book, published in 1944), who does not fight against her relationship with the Minotaur, Matisse found himself locked in a liaison he felt powerless to acknowledge, let alone control, even though it meant ultimately the break-up of his marriage to Amélie.

This coldly egotistical, fatalistic side to Matisse's personality is revealed in the first version of the Barnes murals, where the two dominant pendentives act like assertive male figures towering above the reclining females. Strangely enough, it found a response in the cold, stylish classicism of much French fashion and decoration of that period, and in the pessimistic mood of the country at large. When Matisse came to design the ballet *Rouge et Noir* in the winter of 1937–8, he took for his theme the hopeless struggle of man against his destiny and used the composition of the Barnes murals as the basis of his backdrop.

Ironically, Matisse was creating a classical style, with the qualities of coolness and detachment which he had reacted against in his youth. He knew that only the raw energy of pure colour could bring back a compensatory emotional warmth to his art. So in a new series of oil paintings of the posed model we find Matisse beginning with colour instead of line. He blocked in the canvas with large areas of intense primary colour. In *Nude in a White Shawl on a Green Armchair* of 1936 (Plate 172), the nude, sketched in spidery pencil lines, hardly holds her own against the forthright planes of yellow, green, and blue. Although these planes are qualified by overdrawing in black with the brush to represent armchair, philodendron leaf, flower, and wall, they still possess their own autonomous identity as colour: the nude's right leg is bent over green, rather than over the armchair. It is not surprising, therefore, that Matisse in 1936 equated this return to primary colour with Fauvism: 'Pictures which have become refinements, subtle gradations,

171. Page 23 from *Poésies* by Stéphane Mallarmé. Etching, 33.2 × 25.4 cm. Published by Albert Skira, Lausanne, 1932. The cartoon for Plate 174 was based on this illustration of the schooner *Papeete* in the *Mallarmé*, which in turn probably derived from a photograph Matisse took from his window in Tahiti in 1930. The floral embellishments on the curtain became the floral motifs on the border round the cartoon. The balcony, though, is the one that surrounded Matisse's apartment at Place Charles-Félix in Nice.

172. *Nude in a White Shawl on a Green Armchair.* 1936. Oil on canvas, 45.5 × 38 cm. Private collection.
'One is not bound to a blue, to a green or to a red. You can change the relationships by modifying the quantity of the components without changing their nature. That is, the painting will still be composed of blue, yellow and green, in altered quantities. Or you can retain the relationships which form the expression of a picture, replacing a blue with a black, as in an orchestra a trumpet may be replaced by an oboe.' (Matisse to Tériade, *Minotaure*, October 1936.)

173. Ingres. *Portrait of Madame Moitessier.* 1856. Oil on canvas, 120 × 92 cm. London, National Gallery.
The majestic pose and graceful style of Matisse's *Lady in Blue* owe a considerable debt to Ingres's *Portrait of Madame Moitessier*, which in turn was partly based on a classical mural from Herculaneum.

dissolutions without energy, call for beautiful blues, reds, yellows—matter to stir the sensual depths in men. This is the starting-point of Fauvism: the courage to return to the purity of the means.'

Matisse's models gradually assumed the grandeur of ladies at court. *Lady in Blue* of 1937 (Plate 175) is probably the most magnificent of his 'court' portraits. It is appropriately of Lydia Delectorskaya, the new queen of his domain. She is given the voluminous sleeves and waisted flowing robe of the Raphaelesque portrait of Joan of Aragon, which he knew in the Louvre; the enormous, floppy, protective hand with the rosary provocatively emphasizes her regal aloofness. The pose is clearly a reversal of Ingres's *Portrait of Madame Moitessier* of 1856 (Plate 173), with a 'reflection' of her head in the white drawing on blue, placed on the wall behind. Characteristically, Matisse began with a more naturalistic portrait, which became progressively more abstract with each successive state until a perfect balance was achieved between line and colour. Photographs of ten of these states were published in the *Magazine of Art* of July 1939. Colour was no longer used just to fill in contour, but was materialized to the point where it could take on part of the representational function, allowing line to etch out a more autonomous existence, light against dark or dark against light. Lydia's frills fascinated him, and he explored them with his pen in a number

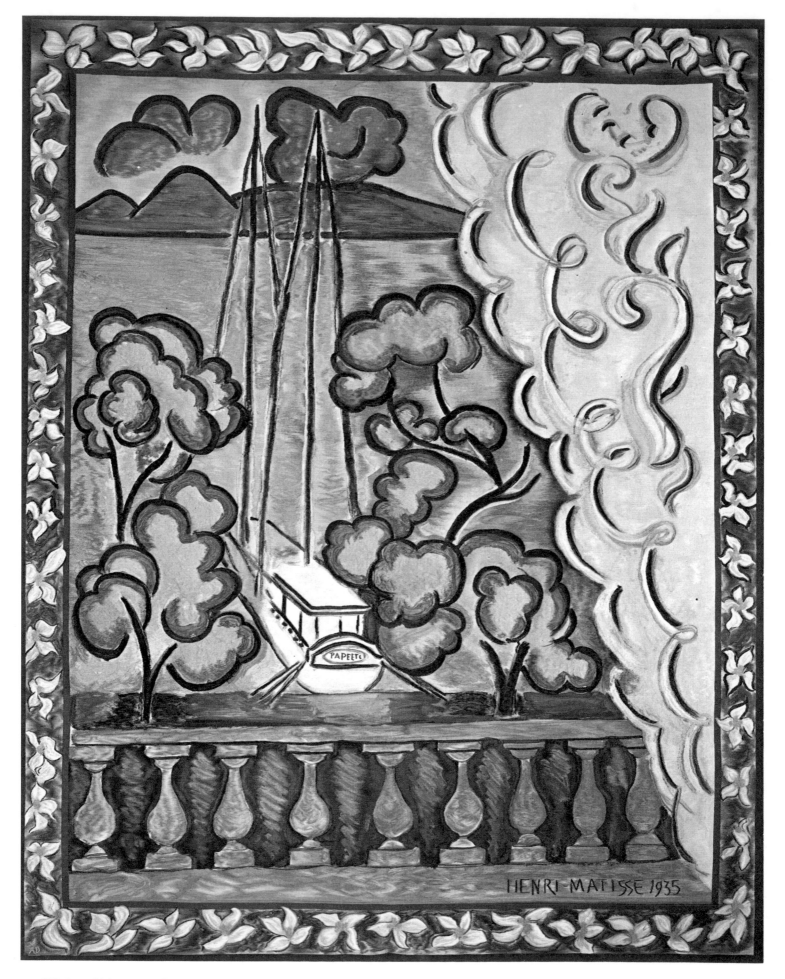

174. *Window at Tahiti*. 1935–6. Silk and wool Beauvais tapestry, 226 × 172.7 cm. New York, private collection.
This was commissioned by Marie Cuttoli, who used a number of leading artists to produce cartoons for the Aubusson and Beauvais weavers.

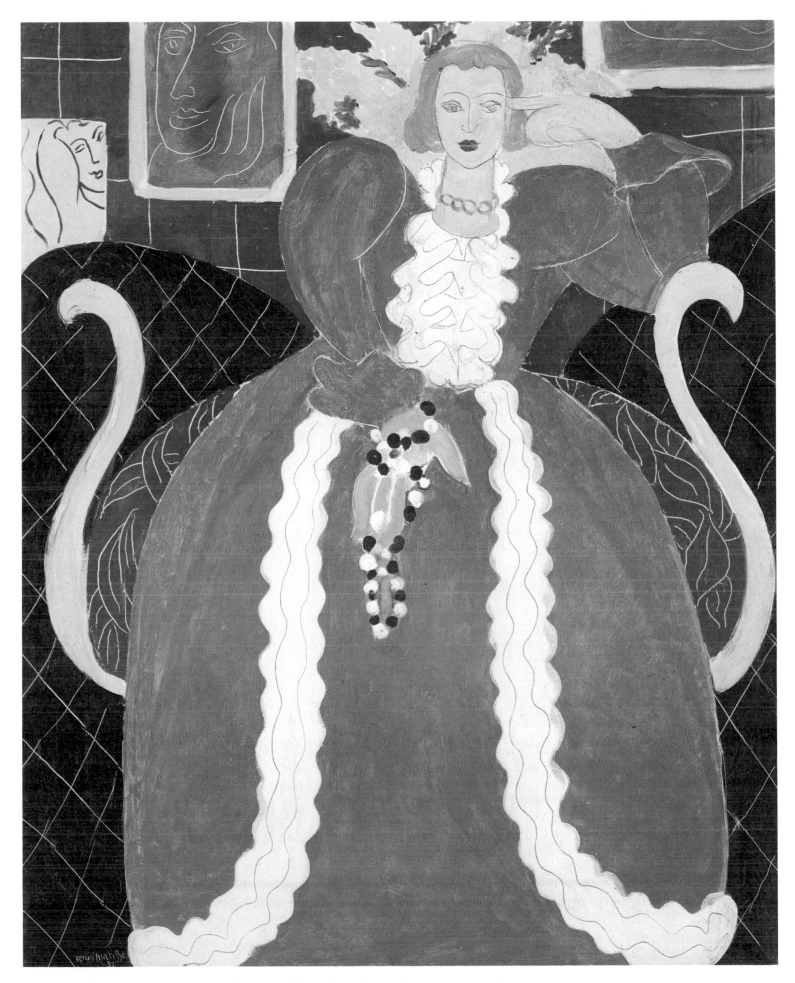

175. *Lady in Blue*. 1937. Oil on canvas, 92.7 × 73.6 cm. Philadelphia, private collection.
The blue robe worn by Lydia was the starting-point for *Lady in Blue*, which changed considerably in the process of painting. The area of black gradually expanded from describing the floor until it appeared above the couch, uniting foreground and background in a two-dimensional decorative plane. Here it was shaped to counter the downward rhythm of the robe.

of very beautiful drawings (see *The White Jabot*, Plate 176). This new independence of the pictorial elements witnessed in *Lady in Blue* was partly the outcome of his paper cut-out technique. Significantly, he made the cover maquettes for the magazines *Cahiers d'Art* in 1936 and *Verve* in 1937 out of cut-out, brightly coloured paper.

More than ever before, Matisse's art now thrived on a series of clearly articulated formal oppositions—figure against ground, object against figure, line against colour, and one figure against another—which were balanced during an often lengthy painting process. This did not make for an easy life, but it saved his work from either cloying sweetness or the frigid stylishness of fashion plates.

Towards the ends of the previous two decades Matisse had complicated his paintings of the model by adding a second and even a third figure; this took on a new significance in the winter of 1937–8 with the tensions between the women in his household. What could be more natural for Matisse than to assert domestic calm in his painting, when to do so in life would have involved him in the kind of painful decisions which he tried to avoid.

There is no hint of domestic tension in *The Conservatory* (Plate 179), the happy outcome of a long-drawn-out struggle from November 1937 to early March 1938. All is harmony and light. The surface attains the transparency and luminosity of a watercolour. On the wall a palette is left hanging as a key to the colour scheme; the five broad leaves of the philodendron similarly summarize the disposition of the principal forms—the two seated ladies, the drawing, the dog, and the palette. The back of the lady in blue takes over part of the function of the back of the chair, in the same way that the right arm of the lady in yellow partly defines the arm of her chair. The shape of the central plant pot is partly dissolved by the pale watery blue of the background, which is repeated as the colour both of the book on the lap of the lady in yellow and of the dog. Everything appears in exactly the right place; we hardly notice the subtlety of relationships between form and colour.

176. *The White Jabot*. 1936. Pen and ink on paper, 38 × 28 cm. Baltimore Museum of Art, Cone Collection.
This drawing—like his prints of the 1920s—is a variation on a theme that fascinated Matisse in one of his paintings, in this case *Lady in Blue*.

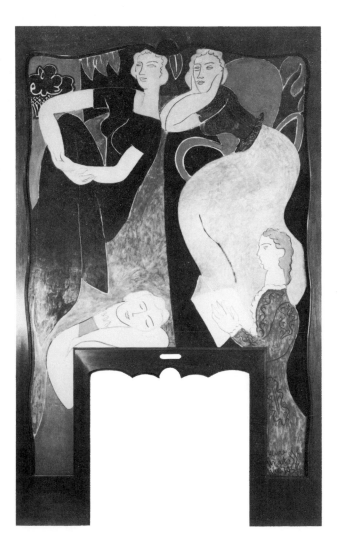

177. *The Rockefeller Overmantel Decoration*. 1938. Oil on canvas, 281.9 × 182.9 cm. New York, private collection.
Matisse completed this decoration for the peaceful seclusion of Nelson Rockefeller's home, having earlier refused the commission to do a mural on the very un-Matisse-like subject of 'New Frontiers—March of Civilization' for the vast hall of the Rockefeller Center in New York, on the grounds that the site would be too busy for his work to be appreciated.

178. *Mr Matisse paints a Picture: 3 Weeks' Work in 18 Views. Art News*, September 1941, p. 8.
The solutions to Matisse's formal problems in *Music* came right towards the end when he moved the left-hand lady's legs over to the other side of the chair. This emphasized the dynamic, circular movement in the bottom left-hand corner, which he then balanced with the aggressive yellow zigzag border to the blue robe on the right. Finally, he extended the philodendron leaves to form a frieze across the background.

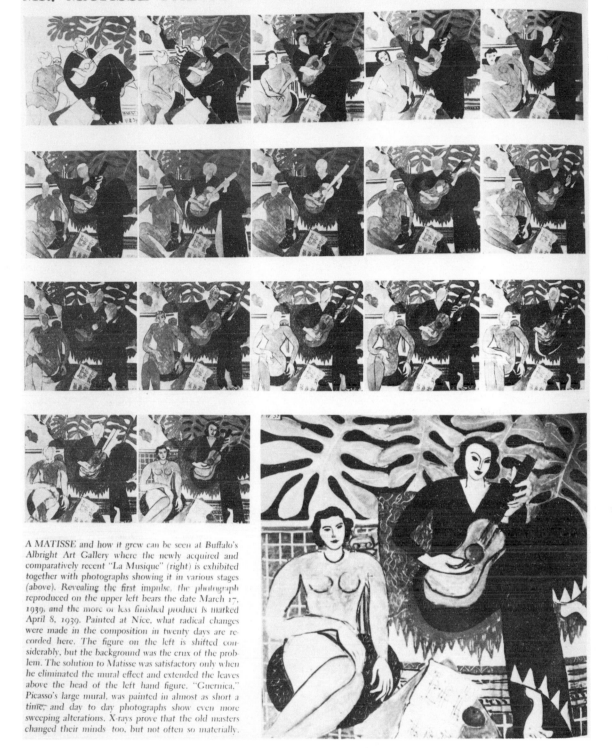

A MATISSE and how it grew can be seen at Buffalo's Albright Art Gallery where the newly acquired and comparatively recent "La Musique" (right) is exhibited together with photographs showing it in various stages (above). Revealing the first impulse, the photograph reproduced on the upper left bears the date March 17, 1939, and the more or less finished product is marked April 8, 1939. Painted at Nice, what radical changes were made in the composition in twenty days are recorded here. The figure on the left is shifted considerably, but the background was the crux of the problem. The solution to Matisse was satisfactory only when he eliminated the mural effect and extended the leaves above the head of the left hand figure. "Guernica," Picasso's large mural, was painted in almost as short a time, and day to day photographs show even more sweeping alterations. X-rays prove that the old masters changed their minds too, but not often so materially.

As his series of women in interiors progressed, Matisse came to see himself in the role of a composer rephrasing well-established themes in new variations. His overmantel decoration for Nelson A. Rockefeller's apartment in New York (Plate 177), painted during November and December 1938, includes the two ladies from *The Conservatory* and an adaptation of Lydia's pose in *The Dream* (see Plate 170); *Music* of 1939 (Plate 181) combines the same two ladies with the structural overlapping of red and black colour planes from *Lady in Blue*. In both paintings the musical analogy is explicit: in the Rockefeller decoration, the girl's singing sends the women into a trance; in *Music*, the guitarist awaits the moment to begin, with the music open in front of her. Art, like music, brings the conflicting formal and psychological elements into harmony. Photographs of eighteen states of *Music* were published in *Art News* of September 1941 (Plate 178).

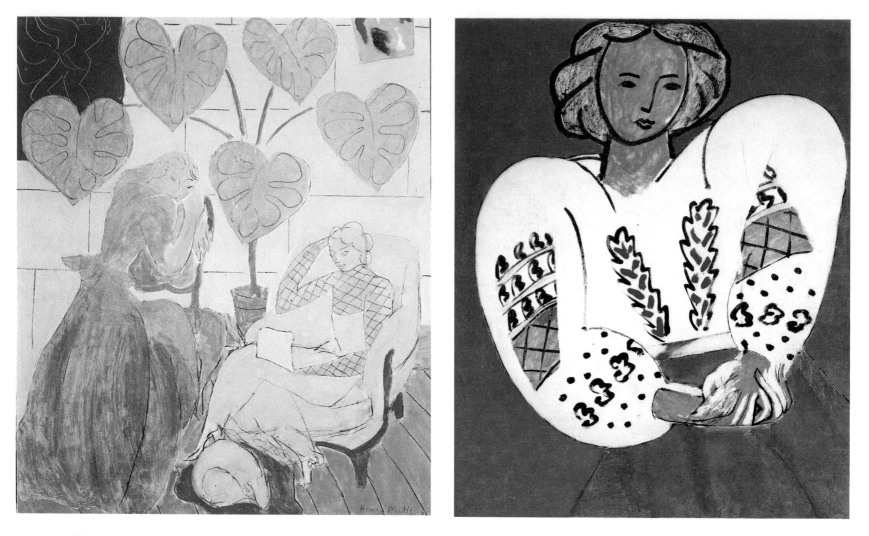

Matisse's reputation as one of the greatest contemporary painters was firmly established and remained unchallenged. But the classic qualities of his recent painting—attenuated linear grace, beauty, and an exquisitely balanced harmony of parts—were hardly designed to excite public comment or admiration. In some quarters his paintings of the 1930s were seen to reflect his fashionable maturity; even to resemble stylish drawings in *Harper's Bazaar*. The crusading rhetoric of contemporary modernism was evolved to promote what was considered new and relevant; it could not cope with a lasting and profound involvement in an artist's career. The Spanish Surrealist painter Salvador Dali had come to realize that he sold his work by promoting his own curious image and life-style. Picasso's frequent changes of style were—although not necessarily consciously planned as such—an effective strategy to remain newsworthy and part of a modernist debate. While Picasso painted his mural *Guernica* for the Spanish Pavilion at the Paris World's Fair, in protest against the bombing of the Basque town on 26 April 1937 during the Spanish Civil War, Matisse continued to paint women in his interior world.

To be appreciated, Matisse's art of the 1930s requires the attention of a connoisseur, rather than a journalist looking for a story. Joseph Pulitzer Jun., who owns *The Conservatory*, sees no loss of quality in these paintings when compared with the monumental grandeur of *Bathers with a Turtle* of 1908 (see Plate 60), which he gave to the St Louis Art Museum: 'I contend that the paintings of Matisse in 1938, while more relaxed and smaller in size and more intimate in subject than the earlier works such as the 1908 *Bathers*, are nonetheless possessed of extraordinary refinement and concentration ... Our picture has never ceased to interest me because of its composure and its luminous delicacy.'

179. *The Conservatory.* 1937–8. Oil on canvas, 71 × 59 cm. St Louis, private collection.
The subject-matter recalls that of *Tea* (see Plate 127), with a dog placed between two seated female figures.

180. *The Romanian Blouse.* 1939–40. Oil on canvas, 92 × 73 cm. Paris, Musée National d'Art Moderne, Centre Georges Pompidou. This ornately patterned blouse, which apparently belonged to a princess, first featured in a Matisse drawing of 1936, and he drew it on numerous subsequent occasions.

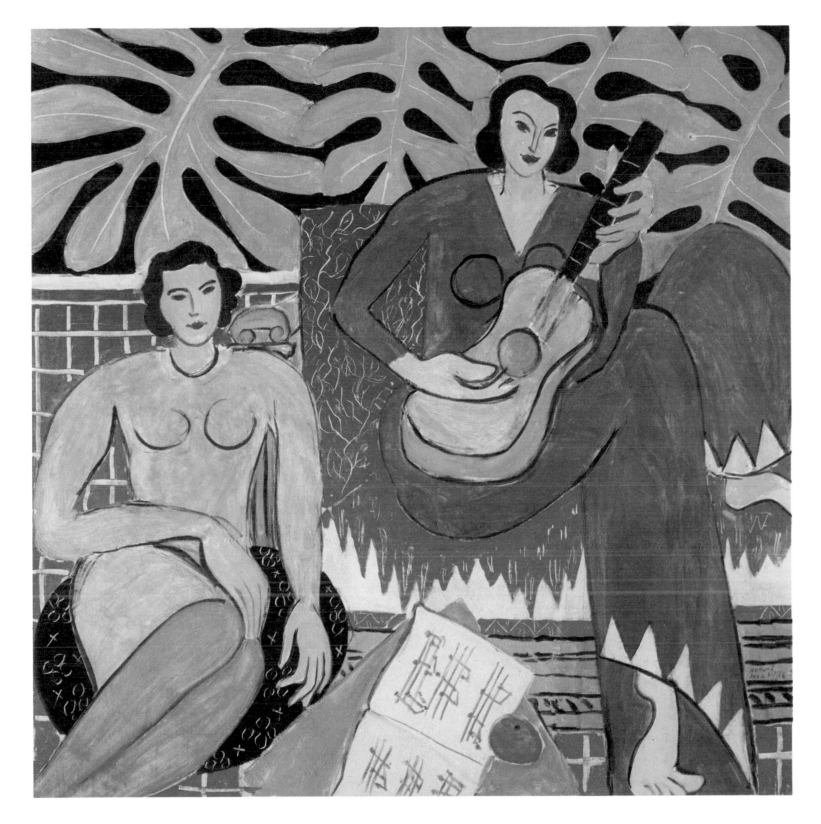

181. *Music.* 1939. Oil on canvas, 115.2 × 115.2 cm. Buffalo, Albright-Knox Art Gallery.
Music is the last and in many ways the most ambitious of Matisse's figure paintings of the late 1930s. In company with his greatest paintings, it has a serious, structural dimension belied by the overtly decorative subject-matter and style.

On the face of it, Matisse's practice, followed since the Barnes murals, of publishing progress photographs appears to contradict his stated intention to disguise his often laborious preliminary work and convey a feeling of relaxed spontaneity in the final act, like a juggler or an acrobat. Perhaps he did it both to keep his work in the public eye, and to demonstrate that his creative process was complex and difficult and his art therefore worthy of serious consideration. It may also reflect a slight shift in critical attention since the advent of Surrealism from the finished work of art to the creative process.

Paul Rosenberg had become Matisse's official dealer in 1935 and held exhibitions

of his work in 1936, 1937, and 1938. Matisse's son Pierre, by now well-established as a dealer in New York, ensured that some of his father's best paintings went straight from his studio into American collections, even during the Second World War. For example, *Music* of 1939 was bought from Pierre Matisse by the Albright-Knox Art Gallery, Buffalo, in May 1940.

In 1938 Matisse had moved into a palatial apartment in the Hôtel Régina, the enormous white building with domed corner towers which dominates the hill above Nice in the suburb of Cimiez. The Régina had been built at the turn of the century for Queen Victoria, when it was expected that she would have to winter there because of her health. The royal crowns embellish its ornate metalwork. Great palms, like sentries, line the steps up to the grand central entrance from the garden. The french windows of Matisse's apartment on the third floor opened on to the sky, with the town of Nice below. The scale and exaggerated stylishness of the Rockefeller overmantel decoration may well have been as much a response to these new surroundings as to the nature of the commission.

Matisse did not remain in the Régina long before returning to Paris. War-clouds were gathering over Europe. A repetition of the nightmare of the Great War seemed unavoidable. France's population was numerically much inferior to that of Germany (about 41.9 million compared to over 70 million), depleted of men of military age, and catastrophically led by incompetent old men, sustained in their posts only by the memory of victory some twenty years earlier. The nation had made its heroic sacrifice in what was thought to be the war to end all wars and was in no mood to go through it all again.

By May 1939 Matisse was back in Paris working in the Villa Alésia, a studio lent to him by the American sculptress Mary Callery. For convenience's sake he stayed at the Hôtel Lutétia nearby, rather than in his boulevard Montparnasse apartment. The atmosphere of Matisse at work there was captured in a remarkable series of photographs by Brassaï (Plate 182). Matisse, dressed like a surgeon in a pristine white coat, would begin the day by drawing. For him this was not a question of maintaining manual dexterity but of getting to understand his subject, even if it was a simple branch and leaves. 'The important thing', he told Brassaï, 'is the attention one gives to it, examining the way a leaf is formed, how the leaflets attach to the petiole, the rhythm with which they occur. The Orientals pay as much attention to the intervals between the leaves as they do to the leaves themselves. Each plant is its own universe, holding the secret of its formation, a secret that can be understood only through study.'

Matisse frequently drew a Hungarian model whom Brassaï had found for him, and who posed for the painting *Reader against a Black Background* (Plate 183). As the painting progressed, Brassaï was amazed to see how all the elements changed and the light background suddenly became black. It was as though the tragic atmosphere of impending war had blacked out the interior, leaving only the essential forms and colours. Black became a formal necessity in the Barnes murals, but its appearance in the backgrounds of *Music* (see Plate 181) and now *Reader* may well have reflected Matisse's deep anxiety at both the prospect of war and his own separation from Amélie, which, although never legalized, was by 1939 a *fait accompli*. Moreover, in the ballet *Rouge et Noir*, first performed in May 1939, he employed black specifically to symbolize evil destiny. Manet had introduced black into his art from Spanish painting. As if to emphasize his links with this tradition, on 3 September, the day that France and Britain declared war on Germany, Matisse made a hurried trip to Geneva to see the Spanish paintings on loan from the Prado in Madrid.

Uncertain and anxious like everybody else in the first month of the 'phoney war',

182. *Matisse drawing the nude.* Villa Alésia, Paris, summer 1939. Photograph by Brassaï. On the eve of the Second World War Brassaï took a memorable series of photographs of Matisse, dressed in a white coat like an eminent surgeon, painting *Reader against a Black Background* and drawing the same model in the nude. Matisse's obsessions for drawing and the female nude remained with him throughout his life. Here the model's pose recalls that of *The Guitarist* of 1903 (see Plate 29) in combination with those of his nudes of the 1920s with their hands clasped behind their heads.

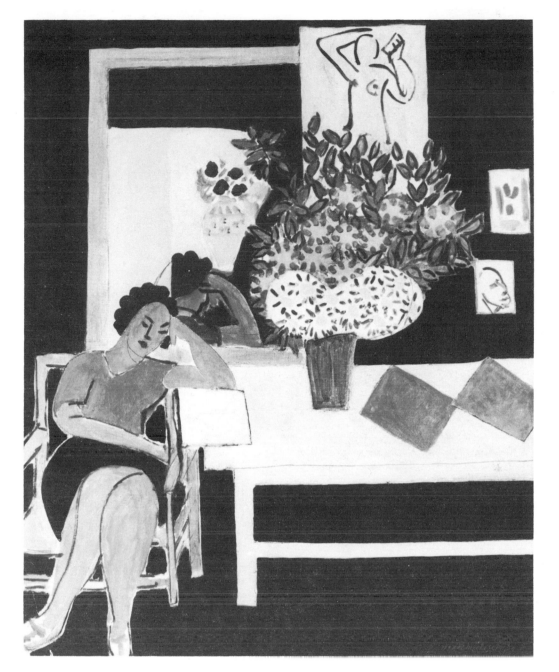

183. *Reader against a Black Background.* 1939. Oil on canvas, 92 × 73.5 cm. Paris, Musée National d'Art Moderne, Centre Georges Pompidou.
Matisse placed his easel to the right of his subject, because he wanted to make our eye move across the surface rather than concentrate on the central vase of flowers. This effect is conveyed in the painting by the placement of the forms and colours so as to act like stepping-stones around the canvas.

Matisse and Lydia moved to a hotel at Rochefort-en-Yveline, about 45 kilometres from Paris, and then went down to Nice in October. Despite his worry and increasingly severe abdominal pains, Matisse did not stop painting. On the contrary, it was only while at his easel that he could overcome his disquiet. He worked on *The Romanian Blouse* (Plate 180) from November 1939 to the following April. Thirteen progress photographs were exhibited along with the painting at the Maeght gallery in December 1945. In the first states the canvas was covered in patterns: the model wore a patterned skirt as well as the patterned blouse, the background was patterned, and so was the cover of the seat she was sitting on. Gradually, the patterns were reduced and the model's pose was expanded to fill the format. Sometimes the features of her face were painted out, so as not to interfere with the evolving expression of the whole picture. It was not until the very end of the process that the chair and all the patterns, except those on the blouse, were replaced by a monochrome red background. The final simplified image has the directness of a Russian icon.

Not all his paintings of this period have the purist simplicity of *The Romanian Blouse*; even at his most disciplined, Matisse would produce paintings in a diametrically opposite mode. *Still-Life with a Sleeper* (Plate 188) is a gloriously melodic variation on the pose of the sleeper in the Rockefeller overmantel

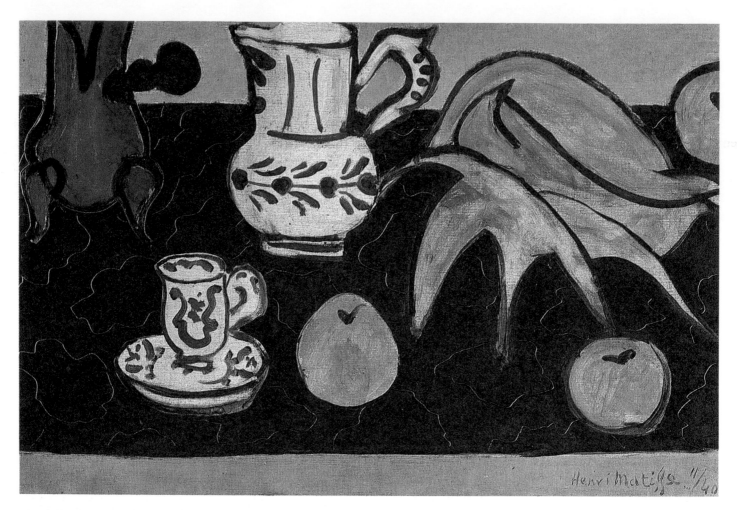

184. *Still-Life with a Seashell on Black Marble.* November 1940. Oil on canvas, 54 × 82 cm. Moscow, Pushkin Museum of Fine Arts.
There is definitely something menacing about the pink-tinged spiky seashell, which looks as though it is crawling across the black marble.

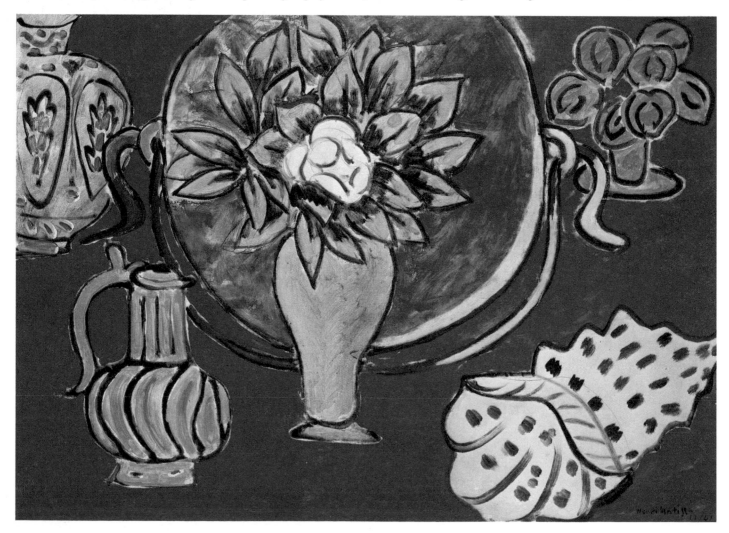

185. *Still-Life with Magnolia.* 1941. Oil on canvas, 74 × 101 cm. Paris, Musée National d'Art Moderne, Centre Georges Pompidou.
This was photographed in at least five states between September and December 1941. When Matisse was asked, just after the war, which of his paintings then on show at the Salon he liked best, he replied that for several years this one had been his favourite because he had endowed it 'with his maximum strength'.

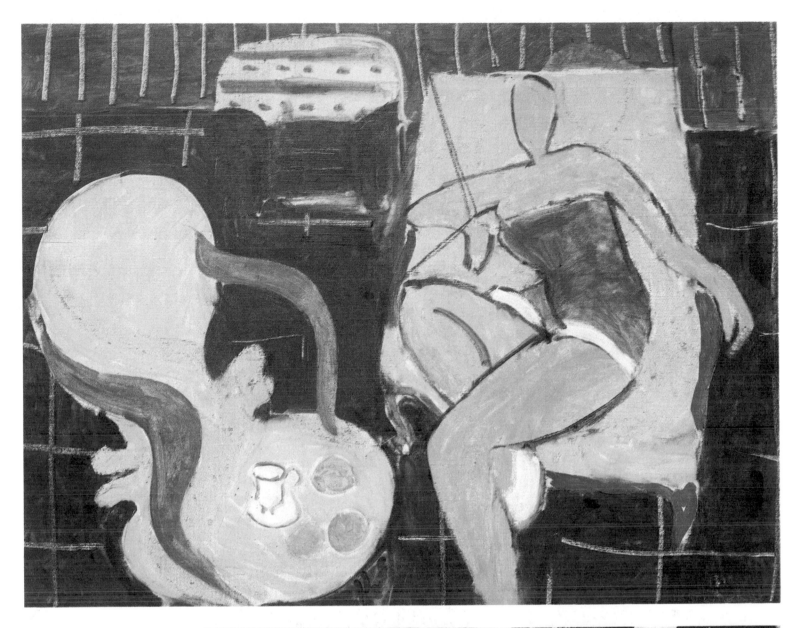

186. *Dancer and Armchair, Black Background.*
1942. Oil on canvas, 50.2 × 65.1 cm. New
York, private collection.
Progress photographs of this painting (Plate
199) show that both the chair and the model
were placed parallel with the canvas to
Matisse's right. The artist—and by
extension the spectator—is invited to join
the dancer for tea.

187. *Tulips and Oysters, Black Background.*
1943. Oil on canvas, 61 × 73 cm. Paris,
Musée du Louvre, Donation Picasso.
This was exhibited at the 1943 Salon
d'Automne before being the subject of an
exchange of paintings between Matisse and
Picasso. Picasso appreciated it for the balance
of its colour relationships.

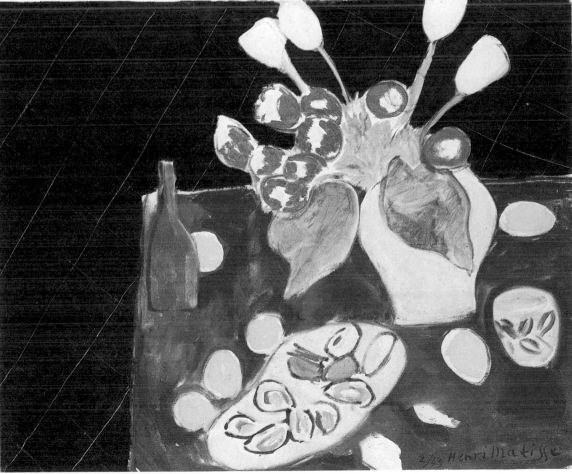

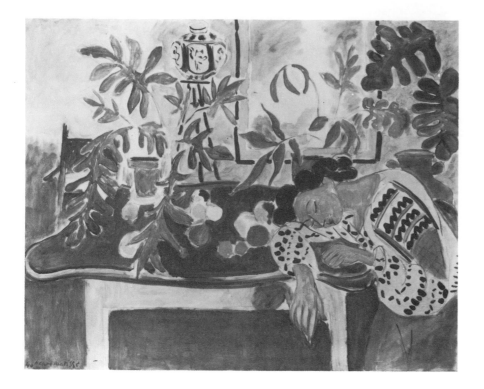

188. *Still-Life with a Sleeper*. 1940. Oil on canvas, 81 × 100 cm. Private collection. This is one of Matisse's most successful variations on the theme of *The Dream*.

decoration (see Plate 177). The intensity of her sleep finds a sympathetic sounding-board in the softly painted still-life arrangement, which emerges from a background of pale watery blues and violets. Matisse went on to develop this pose in a second, highly synthetic version of *The Dream*, which was completed in October 1940.

Matisse returned to Paris in April 1940. He did not intend to stay there long. Since his trip to Tahiti in 1930 he had dreamed of revisiting the tropics. He obtained a visa to visit Brazil and booked a passage to Rio de Janeiro on a ship leaving Genoa on 8 June. The invasion of France and Italy's entry into the war put an end to his plans. Despite the entreaties of his son Pierre and the offer of an American visa, Matisse decided to stay in France. Perhaps the example of Picasso, whom he met by chance in the street on 15 May, influenced his decision to stay.

With the rapid advance of the German army, Matisse and Lydia—like the French government—made a series of moves. On 19 May they left Paris for Bordeaux. Finding it full they moved on to Ciboure, by Saint-Jean-de-Luz on the Nivelle estuary. On 30 July they went to Saint-Gaudens. On 8 August they moved on again. They stopped briefly at Carcassonne and reached Marseilles on 17 August. On 27 August they were back at the Régina in Nice. By October Matisse decided definitely to stay in Nice for the duration of the war.

In November 1940 he once again began a new series of still-lifes in an effort to return to reality after a period of stylish abstraction. He selected oysters for his first subject, in order to entice himself back into a consideration of the distinct flavour of material things. Oil paint he felt was the only medium for these paintings. In a letter of 7 December 1940 to the Romanian painter Théodore Pallady, he wrote that for a long time he had been concerned only with the expressive relationship between line and differently proportioned coloured surfaces, and that the actual medium employed did not really matter. He regarded *Still-Life with a Seashell on Black Marble* (Plate 184) as a breakthrough in colour, and he executed a paper cut-out version of it in 1941. The contrast of the black marble against the surrounding bright yellow is remarkably bold.

Matisse's return to still-life painting was—like his return to Impressionism in the 1920s—his means of re-establishing contact with the source of his art in the sensation of reality, and he still hoped to live long enough to develop colour in another grand decorative style.

8 *An Internal Paradise,*
1941-1954

In January 1941 the abdominal pains which had been troubling Matisse for the last year worsened and he was transferred critically ill to a clinic in Lyons, where he was operated on for a tumour. Complications ensued, and it was almost three months before he could return to Nice. Even then, he was left a virtual invalid for the rest of his life. Having prepared for death, he felt that he had been given a second life. Instead of slowing down and adopting a less rigorous attitude to art, he worked on courageously to conquer pain and prepare for a new development in his life as a painter. Seventy-two years of age, and ill, he regarded every second as infinitely precious.

The circumstances could not have been less propitious for painting. In retrospect we can see that the Second World War marked the swansong of an era of visionary idealism in Europe. Adolf Hitler appeared set to fulfil his nightmarish dream of an Aryan world Reich, which was the complete antithesis of Matisse's vision. A cursory reading of Hitler's *Mein Kampf* would have left the French in no doubt where they stood in his scheme of things; he clearly identified them as belonging to an alien, non-Aryan, Mediterranean culture. The classical Mediterranean landscape of the Golden Age, which found expression in Matisse's *Luxe, calme et volupté,* was going to be crushed under the heel of the jackboot. To resist seemed heroic but futile.

Faced with the German occupation Matisse, like most Frenchmen, shut himself away and tried to live as normal a life as possible. Unable now to travel to the tropics, he constructed his own tropical environment, his internal paradise in the Hôtel Régina. One room became filled with cages, containing over three hundred tropical birds; another, his 'farm', with tropical vegetation, ingeniously watered by automatic sprinklers; a third was devoted exclusively to drawing. Pigeons flew free in the rooms. African and Oceanic masks, gourds, giant pumpkins, a plaster cast of Michelangelo's *Dying Slave* and of his own relief *Back IV,* together with other works of art, his favourite jugs and vases, his 'palette of objects', all played their allotted roles in this convalescent world of calm. He pottered about in his 'farm' for several hours a day. 'These plants', he complained, 'are a frightful bother to keep. You have no idea! But as I take care of them, I learn their types, their weight, their flexibility, and that helps me in my drawings.'

It may seem reprehensible that Matisse did nothing to help his wife and daughter who engaged in the resistance. But then there was little an old invalid could have done. To have become involved in any capacity would have jeopardized the only thing that really mattered to him and that he could contribute to France—his art. It is one of those recurring historical ironies that an artist so totally egocentric

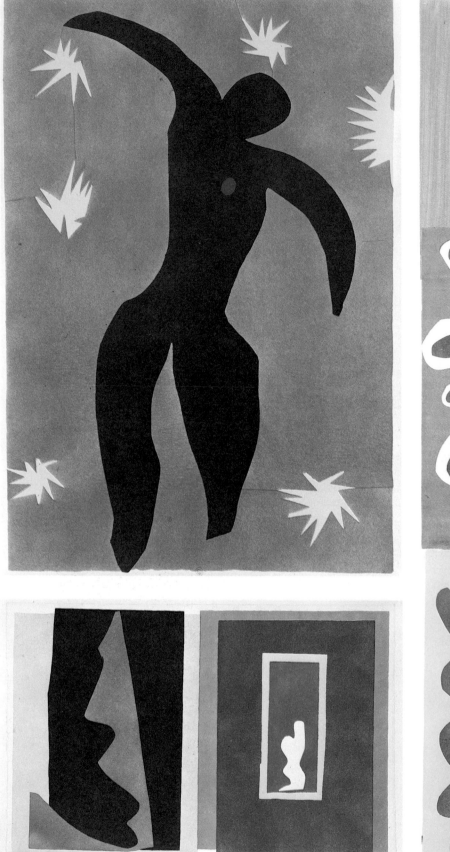

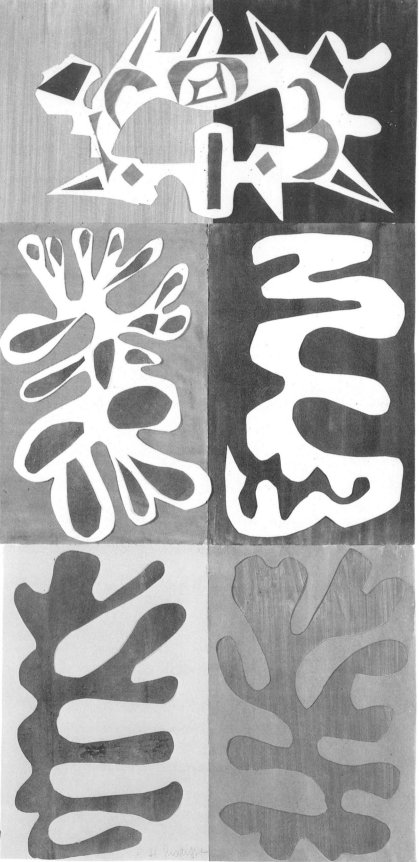

189. *Icarus* (1943) from *Jazz*. Stencil print after a paper cut-out maquette, *c*.40.5 × 27 cm. Tériade, Paris, 1947.
Matisse was well aware that the flights of his imagination, like those of Icarus, could rudely be brought down to earth. According to Aragon, the flashes of yellow represent bursting shells.

190. *Destiny* (1943–4) from *Jazz*. Stencil print after a paper cut-out maquette, *c*.42.2 × 65.5 cm. Tériade, Paris, 1947.
As in the final movement of the ballet *Rouge et Noir* of 1939, which Matisse designed, human aspirations are overcome by destiny. The contrast of black and violet in the mask of destiny on the left strikes a sombre, funereal note.

191. *The Panel with Mask*. 1947. Paper cut-out, 110 × 53 cm. Copenhagen, Danske Kunstindustrimuseum.
The paper cut-outs are by no means brash and unfeeling in their use of materials. The shapes of the forms have a distinctly 'hand-made' look about them; even the direction of the grain in the paper plays its structural and expressive part.

192. *The Lived-in Silence of Houses.* 1947. Oil on canvas, 54.9 × 46 cm. Paris, private collection.
A mood of melancholy prevails. Light is running out. The figures are almost absorbed in the surrounding black. A summary indication of the artist's presence is scratched like a graffito into the black wall in the top left-hand corner.

and detached from the dreadful realities of what was happening about him could at the same time, by obstinately pursuing his vision, provide those who were resisting Nazi tyranny with a picture of the values they were fighting for.

There is something almost biblical about the relationship between Matisse's two periods of prolonged convalescence. The first in 1890 had brought him into painting; the second led to his late style, the grand interior paintings of 1946–8, the Vence Chapel of 1948–51, and the final paper cut-out decorations of 1950–4. His art in the 1940s also follows a sequence of developments similar to his early career. He began with drawing. His first paintings were still-lifes, followed by figures in an interior, interiors, and then the decorations. His problems were again similar: to reconcile line with colour, and intimate subject-matter with an abstract art of imaginative colour. But whereas formerly he was working within established precedents, in the cut-outs he was to break completely new ground. It is debatable whether he lived long enough to gain complete control of this new medium and achieve the same quality in his last decorations as in his greatest easel paintings. However, the two are not necessarily comparable. Many of these paper cut-outs were maquettes for ceramic murals and stained glass, and were therefore partly determined by their respective functions, like the Barnes murals.

In January 1940 Matisse informed Bonnard that his drawing had begun to separate from his painting; so much so, in fact, that in 1941 and 1942 he concentrated almost exclusively on a long series of 158 drawings, divided into seventeen groups, called *Themes and Variations* (Plate 193). By April 1942 he could write to his son Pierre in New York, 'For a year now I've been making an enormous effort in drawing. I say effort, but that's a mistake, because what has occurred is a flowering after fifty years of effort.'

Drawing was an ideal medium for Matisse now that he was confined either to bed or to a wheelchair for most of the day. In the separate room reserved for his drawings (christened by the poet Aragon the *camera lucida*) everything was kept light and airy, as if he were trying to reproduce in this environment the whiteness and symbolic, limitless space of his drawing paper. Tropical birds and vegetation— in fact any form of bright colour—were excluded. Mirrors directed the light from the great windows into the interior. His series of drawings were arranged in rows on the walls, like frames from a celestial film. It must have seemed that his every line was cutting into, and circumscribing, the idealized whiteness of light and space.

Themes and Variations was published in 1943, with a lengthy introductory essay by Aragon entitled 'Matisse-en-France'. Aragon began visiting Matisse regularly in 1942, and his essay (subsequently republished in his monograph on Matisse) offers a unique insight into Matisse's life and the atmosphere in which he worked in the Régina.

The intriguing question is why Matisse did so many variations on the subject-matter of each theme, always either a still-life or a model. He may have had in mind the example of Rodin, one of the greatest masters of line drawing. Rodin had also kept a separate room for drawing, at the Hôtel Biron (where Matisse had his studio before moving to Issy-les-Moulineaux in 1909), and in 1907 he had executed a series of masks showing the changing expressions on the face of the Japanese actress Hanako. Lydia Delectorskaya mentioned that Matisse, too, had been studying physiognomy in 1939. In addition, Rodin had employed cut-out paper figures both to help plan a work and to act as stencils in the transfer of a design, practices which may well have influenced Matisse's techniques in the Barnes murals and later *Jazz* (see Plates 189, 190, 206, 207). However, Matisse's *Themes and Variations* are not simply concerned to register the gradual changes in either a model's expression or his own feelings before a still-life. Stylistically they are more self-conscious and

193. *Themes and Variations*. Series H1, *dessin du thème*, 1941. Charcoal on paper, 48 × 37 cm. Grenoble, Musée de Peinture et de Sculpture.
In 1948 Matisse gave his series of drawings on the theme of ivy trailing out of his favourite Chinese vase to the Musée de Grenoble.

complex. As is so often the case with Matisse, the answer to this question must lie in an examination of his work process.

We know that he began each theme with a detailed charcoal drawing; his purpose was to arrive at a definitive method or schema for representing the subject, what he called a 'sign'. For it was only after establishing a 'sign' that he could proceed with his variations. The variations are therefore about relationships: relationships between 'signs' and the linear rhythms imposed by his hand, between style and image, between the subject and his responses to it, as well as changing expressions and moods. They are extraordinarily sophisticated and at the same time very simple.

His absorption with drawing also found an outlet in a succession of books which he designed and illustrated throughout, like the *Mallarmé*: *Pasiphaé* by Henry de Montherlant, published in 1944; *Visages* by Pierre Reverdy, *Lettres portugaises* by Marianna Alcaforado, and *Les Fleurs du mal* by Charles Baudelaire all in 1946; *Repli* by André Rouveyre and his own book *Jazz* in 1947; *Florilège des amours de Ronsard* by Pierre de Ronsard in 1948; *Poèmes* by Charles d'Orléans in 1950; *Échos*, with texts by Jacques Prévert, André Verdet, and Nazim Hikmet, and *Apollinaire* by André Rouveyre in 1952. *Une fête en Cimmérie* by his son-in-law Georges Duthuit and *Poésies antillaises* by John-Antoine Nau were published posthumously, in 1963 and 1972 respectively. A second edition of *Pasiphaé* has been published as recently as 1981. In addition, he contributed at least one original print to a dozen other publications.

Matisse's illustrated books were by no means a form of convalescent relaxation. Like his earlier *Mallarmé*, they cost him enormous effort. In 1946 he described the principles involved in their illustration in very general terms: '1. Rapport with the literary character of the work. 2. Composition conditioned by the elements employed, as well as their decorative values: black, white, colour, style of engraving, typography. These elements are determined by the demands of harmony for the book as a whole and arise during the actual progress of the work.' He chose lino cuts for *Pasiphaé*; white lines incised in a black page, with red initial letters to relieve its slightly funereal character. He compared this simple medium to the violin with its bow: 'a surface, a gouge—four taut strings and a swatch of hair.' *Florilège des amours de Ronsard* is another of Matisse's successful illustrated books; the softness of the lithographic line was ideally suited to the subject-matter of his illustrations. There is a close correspondence between Matisse's and Ronsard's favourite themes, their love of women, their adherence to—and variations on—established conventions, their pursuit of pleasure and perfection in the face of civil strife and war. One of the tenderest of Matisse's illustrations is to the poem 'Élégie à Janet, Peintre du Roy' (Plate 194), written by Ronsard in 1555. Both poet and painter were obsessed with certain shapes, lips like rose-buds, foreheads swelling out in relief, and curling hair.

The extent of Matisse's preoccupation with drawing and book illustration is indicative of a lack of fresh inspiration in his paintings. Evidently painting was awkward for an invalid. But, equally, he was clearly experiencing stylistic and psychological difficulties in this area which concerned not just the question of reconciling drawing with colour but also that of reflecting his gradual change in mood since his near death in 1941. In comparison with the intellectual precision of the 1930s, the execution of his paintings became broader and softer. What they lose in crispness of definition they make up in warmth, something that Matisse equated with a new philosophical understanding, even tolerance. However, this caused him considerable formal problems, because his paintings of the 1930s were controlled by drawing. Moreover, his whole concept and employment of 'signs' in his recent

194. Page 31, 'Élégie à Janet, Peintre du Roy', from *Florilège des amours de Ronsard* by Pierre de Ronsard. Lithograph, 38.1 × 28.1 cm. Published by Albert Skira, Lausanne, 1948.
Ronsard gave Matisse the opportunity to draw on his obsessive themes, women observed in close-up, entwined lovers, and the circle of dancers from *Le Bonheur de vivre*.

195. *Plum Blossoms, Green Background.* 1948. Oil on canvas, 116.2 × 88.9 cm. Private collection.
The energetic rhythm of the plum blossoms is taken up in the pattern on the green background.

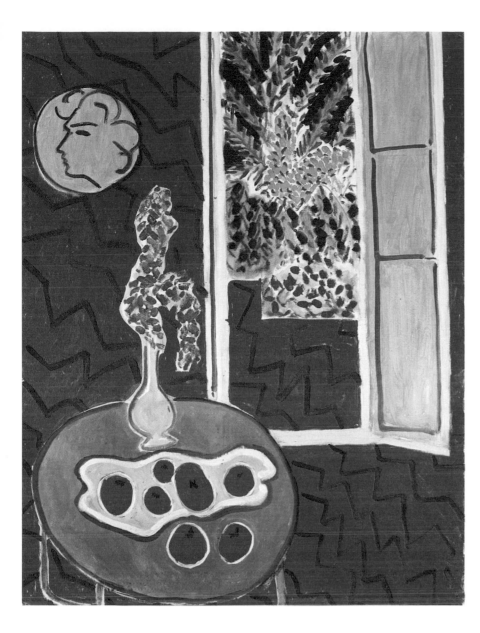

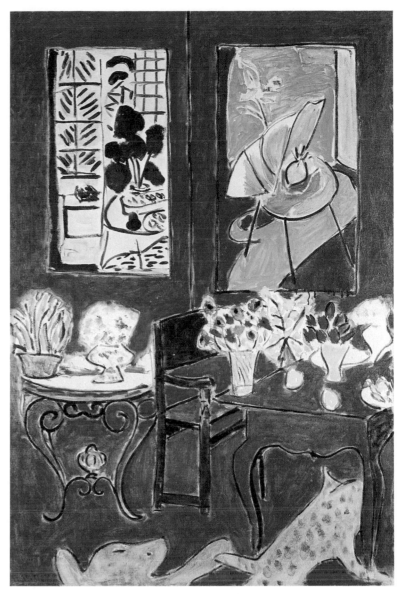

196. *Red Interior with a Blue Table*. 1947. Oil
on canvas, 116 × 89 cm. Düsseldorf,
Kunstsammlung Nordrhein-Westfalen.
A painting or drawing on a wall can act as a
window; a window or door can open on to
colour. All is illusion. As in Matisse's four
'symphonic interiors' of 1911, only art itself
has the permanence of reality.

197. *Large Red Interior*. 1948. Oil on canvas,
146 × 97.1 cm. Paris, Musée National d'Art
Moderne, Centre Georges Pompidou.
The monochromatic expanse of red does not
convey excitement or joy. On the contrary,
Matisse's serious mood prevails.

198. *Ivy in Flower*. 1941. Oil on canvas,
72.4 × 92.7 cm. Private collection.
It surely can be no coincidence that after
coming close to death in 1941 Matisse
painted ivy, a traditional symbol of
everlasting life. In 1953 he again employed
ivy, as the motif in his paper cut-out
maquette (see Plate 205) for a stained-glass
window for the mausoleum of Albert Lasker
(who once owned this painting).

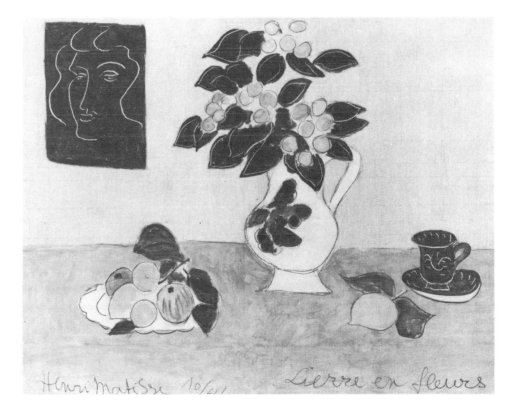

drawings had evolved from these paintings. He had come to regard the use of 'signs' as essential for any painter composing on a decorative scale. The enormous flowing hands in, for example, *The Dream* of 1935 (see Plate 170), *Lady in Blue* of 1937 (see Plate 175), and *Music* of 1939 (see Plate 181), maintain overall pictorial rhythm, assert the flatness of the surface, and challenge a too facile reading of the figures. So to shift the emphasis from the linear element to the affective glowing warmth of colour was going to involve him in a complete re-evaluation of his painting.

The very subtle and delicate *Ivy in Flower* (Plate 198), dated October 1941, is still conceived in terms of line rather than colour; even his signature and the title of the painting are written out in full along the bottom. A witty correspondence is established between the drawing of the woman's head, the suggestion of the shape of her body in the jug, and the cup and saucer. The outlines of the forms are either drawn or incised into wet paint with the point of the brush handle. By contrast, the forms in *Still-Life with Magnolia* (Plate 185), dated December 1941, are outlined in thick black paint. The central vase is surrounded by the golden aura of the copper cauldron, and the four other still-life elements are stationed around it with the symbolic finality of sacramental furniture on an altar. The monochrome red background is dense and heavy, the general mood sombre.

On 1 September 1942, Matisse wrote to Aragon, 'I have at last begun to grapple seriously with painting.' He concentrated on two themes: the female model either posed in an armchair before the great shuttered windows of the Régina or dressed as a dancer. Neither theme was treated in the same serial manner as the drawings; his way of painting meant that each work was treated as a separate entity. Their size was necessarily restricted, as he worked with the canvas propped up on a table placed across the bed in front of him.

Dancer and Armchair, Black Background (Plate 186) is a variation of the second theme. The personality of the model, probably Nezy, is played down to enhance the formal juxtaposition of the female figure and the Venetian baroque chair, which he had bought that April. There is, though, something distinctly uncomfortable about the relationships between figure, yellow chairs, and black background; perhaps this painting reflects his struggle to conquer pain and continue working.

The Idol (Plate 200), dated December 1942, is a much more harmonious painting—flatter and also more colourful. The dialogue between the model and the artist, who was positioned just in front of her to the right, is reinforced by the abutting planes of red and blue in the background. The repetition of a similar pattern across the background, to give unity to these contrasting colour planes, was to become a feature of his sumptuous paintings of figures in interiors the following year.

By the end of March 1943, Matisse at last felt that he was beginning to make the same sort of progress in colour as he had achieved in drawing the previous year. *Tulips and Oysters, Black Background* (Plate 187), dated February 1943, heralds this new departure. Here the composition is established through the relationships between larger, more autonomous areas of flat colour, rather than by drawing. The deep black background, lightly criss-crossed with incised white lines, is psychologically balanced by the red table-top. The still-life elements, which act as notes of colour and light, have that blurred glow of objects caught at the end of the day before they disappear into darkness. It looks very simple and easy to do, but we know that Matisse took immense trouble with each composition. He would often wipe out and repaint a canvas in order to ensure both the rightness of the relationships and the required feeling of spontaneity.

In 1942 the so-called free zone of France, extending from the Swiss border by

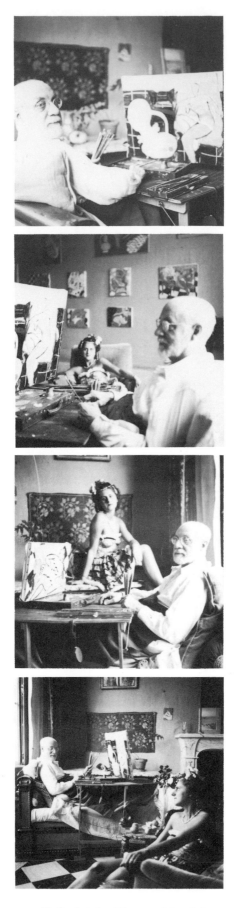

199. *Matisse painting 'Dancer and Armchair, Black Background'*. Hôtel Régina, Nice, September 1942. (See Plate 186.)

200. *The Idol.* 1942. Oil on canvas, 50.8 × 60.9 cm. Private collection. Matisse's nurse, Monique, who posed for this painting, was to become the nun Sister Jacques-Marie who first involved him in a project for the Vence Chapel.

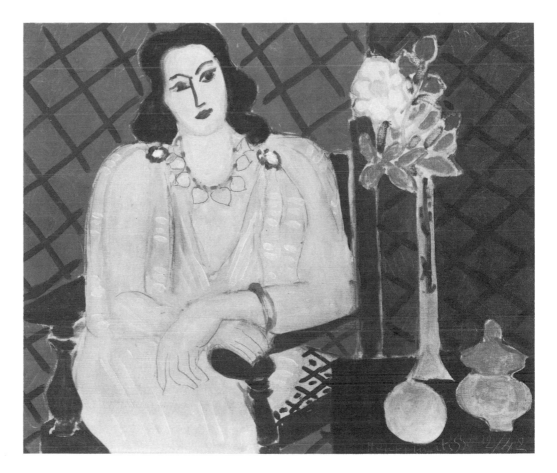

Geneva to below Tours and then down to Mont-de-Marsan in the south-west, had been annexed by the Germans. Towards the end of that year the Italians occupied Nice and camouflaged the buildings around the castle, including Matisse's old studio at Place Charles-Félix. Fearing an Allied bombardment and a possible invasion, Matisse left Nice in July 1943 for the small hill-town of Vence nearby; he was not to return to the Hôtel Régina until 1949, when he needed its space for his Vence Chapel project. The villa he rented at Vence, appropriately called Le Rêve (The Dream), the title of his painting of Lydia of 1935, lies outside the town on the road to Saint-Jeannet, just above the Foyer Lacordaire, the small Dominican sanatorium for which he was to design the chapel. Matisse described Le Rêve in a letter to Aragon, dated 22 August 1943:

A beautiful villa, I mean with nothing fanciful or fussy about it. Thick walls and glazed doors and windows up to the ceiling—so there is plenty of light—this villa was built by a British admiral in his country's colonial style.

A fine terrace with a balustrade abundantly covered with variegated ivy and beautiful geraniums of a warm colour that I didn't know—my windows full of fine palm fronds—the whole thing seems to me so far from Nice, a long journey which I did in less than an hour, that I can put all my memories of Tahiti in this setting. This morning, as I walk about in front of my house and see all the girls and men and women hurrying towards the market place on their bicycles, I can fancy myself at Tahiti at market time. When the breeze brings me a smell of burnt wood I can smell the wood of the islands—and then, I am an elephant, feeling, in my present frame of mind, that I am the master of my fate, and capable of thinking that nothing matters for me except the conclusion of all these years of work, for which I feel myself so well equipped.

The withdrawal to Vence had a quite astonishing effect on Matisse's art. Nothing

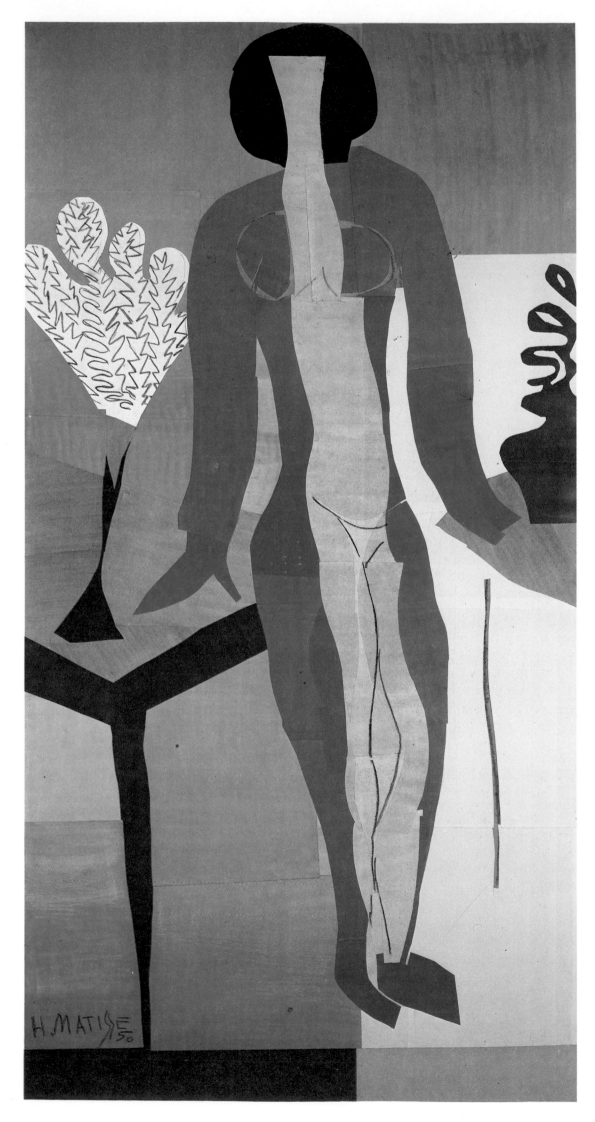

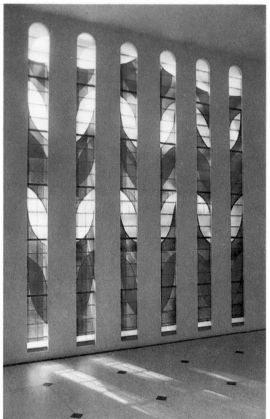

202. *The Chapel of the Rosary of the Dominicans at Vence.* 1948–51. The stained-glass windows.
The chapel was designed to convey a feeling of harmonious quietness. The great stained-glass windows on the theme of the *Tree of Life* orchestrate the colour of the light pouring into the interior, rather in the same way that the light was filtered through the palm branches in front of the windows of Matisse's villa Le Rêve at Vence.

201. *Zulma.* 1950. Gouache on cut and pasted paper and crayon, 238 × 133 cm. Copenhagen, Statens Museum for Kunst. *Zulma*, one of Matisse's favourite compositions, was bought soon after its completion in the spring of 1950 by the Statens Museum, Copenhagen, which already possessed such outstanding paintings from his Fauve period as *Portrait with a Green Stripe*.

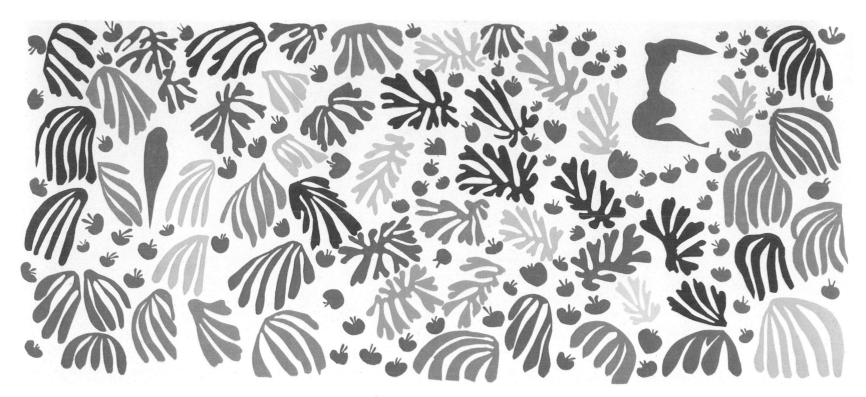

203. *The Parakeet and the Mermaid.* 1952. Gouache on cut and pasted paper, 337 × 773 cm. Amsterdam, Stedelijk Museum.
This environmental mural evolved round the walls of his main studio in the Régina, creating an exotic tropical garden. The repetitions of shape and colour are arranged with the serial character of wallpaper, punctuated by the parakeet and the mermaid which provide an animal and a human presence.

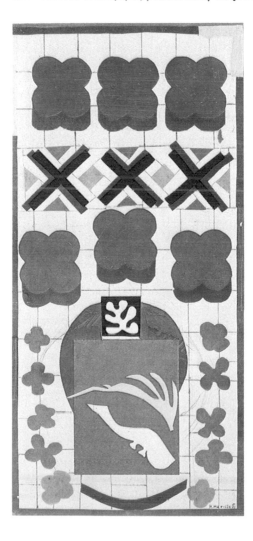

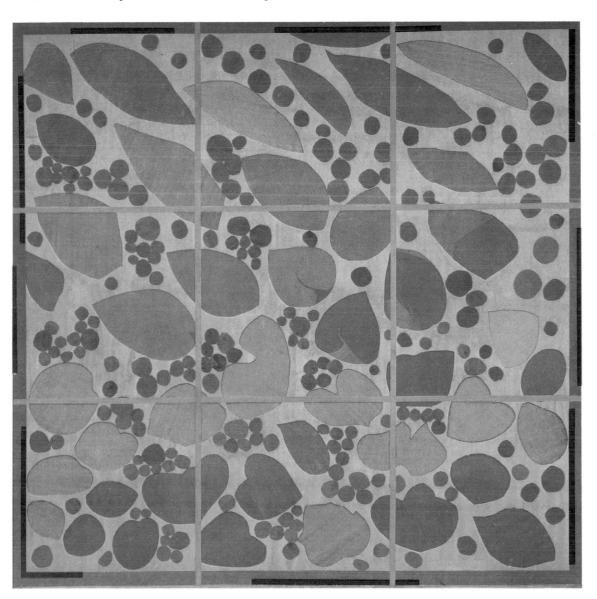

204. *Chinese Fish.* 1951. Paper cut-out maquette for a stained-glass window, 192.2 × 91 cm. Private collection.
In this maquette for a stained glass window for Tériade's villa at Saint-Jean-Cap-Ferrat, the coloured forms are placed within a grid of white light. The so-called 'fish' is a large aquatic mammal called a dugong, which Matisse took from the pages of the Larousse encyclopaedia.

205. *Ivy in Flower.* 1953. Gouache on cut and pasted paper, maquette for a stained-glass window, 284.2 × 286.1 cm. Dallas Museum of Fine Arts.

at first seemed further off than the possibility that the distinguished old man, nurturing his memories in Le Rêve, would find the creative drive and the technical means to transcend the limitations of working in bed and achieve a radically new decorative art-form. The breakthrough when it came was totally unexpected, yet, at the same time, it seemed as though he had been preparing for it all his life. Too ill and worried by events to paint, he took up a suggestion made by the publisher Tériade and Angèle Lamotte in 1942 that he should do an illustrated album in colour. This eventually resulted in *Jazz*, his first major cut-out project. He did not, as before, use cut-out paper just as an aid in the gestation of a work. Instead, as with the covers of Tériade's magazine *Verve* and the two independent compositions *The Clown* and *The Toboggan*, which he included in *Jazz*, he decided to make it the medium out of which the designs for the stencil prints were created.

The solution at first seemed so simple that Matisse dismissed it as 'this penny plaything', but it was to change completely the character of his art. The conflict between line and colour in the making of a work, which had been a problem as well as a constant source of inspiration, was now finally resolved. 'The paper cut-out', Matisse explained in 1951, 'allows me to draw in colour. It is for me a matter of simplification. Instead of drawing the contour and filling in the colour—one modifying the other—I draw directly into the colour, which is all the more controlled in that it is not transposed. This simplification guarantees a precision in the reunion of the two means which brings them together as one.'

The often laborious method of moving the elements about on the surface of a painting was replaced by a more spontaneous approach. This led to an entirely new range of subject-matter. Dream imagery came to predominate because Matisse felt that the paper cut-out medium possessed a concrete reality all of its own. 'Cutting directly into colour', he wrote in his text to *Jazz*, 'reminds me of a sculptor's carving into stone. This book was conceived in that spirit.' There is a connection in this respect with Jean Arp's wood reliefs, which function as both imaginative images and objects. It can also be seen as a final reconciliation of Matisse's curvilinear and structural modes.

There is no set programme linking the twenty stencil plates of *Jazz* and the hand-written text. The project proceeded slowly. Neither title nor format was decided until the spring of 1944, and it was not published until September 1947. The dynamism and striking contrasts of the plates recall the Satie–Cocteau–Picasso–Massine ballet *Parade* of 1917, which included the first orchestration of American jazz in European music. (A *parade* was an arresting short performance at the entrance to a circus or music-hall to attract an audience; Matisse's first title for *Jazz* was *The Circus*.)

The subject-matter of the twenty plates presents a mixture of memories, references to earlier works, and current preoccupations, coupled with an intense excitement in the chromatic power and freedom of the new medium. 'These images, in vivid and violent tones,' Matisse writes in the text, 'have resulted from crystallizations of memories of the circus, popular tales, or travel. I have written these pages to calm the simultaneous oppositions of my chromatic and rhythmic improvisations, to provide a kind of "resonant background" which carries them, surrounds them, and thus protects their distinctiveness.'

Although he described the role of the text as 'purely visual', it does relate to the images; he also provides in it a justification for his sudden change in style: 'An artist must never be a prisoner of himself, prisoner of a style, prisoner of a reputation, prisoner of success, etc. Did not the Goncourt brothers write that Japanese artists of the great period changed their names several times during their lives? This pleases me: they wanted to protect their freedom.'

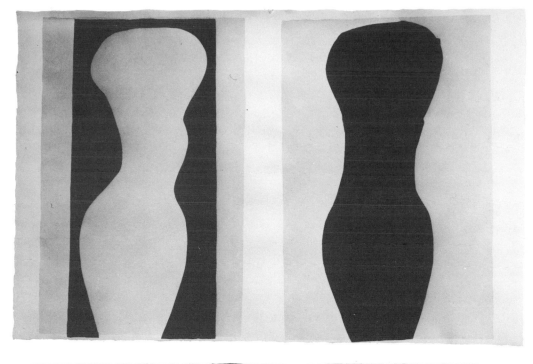

206. *Forms* (1943–4) from *Jazz*. Stencil print after a paper cut-out maquette, *c*.42.2 × 65.5 cm. Tériade, Paris, 1947. The formal clarity of the two torsos conveys their content: one light, the other dark.

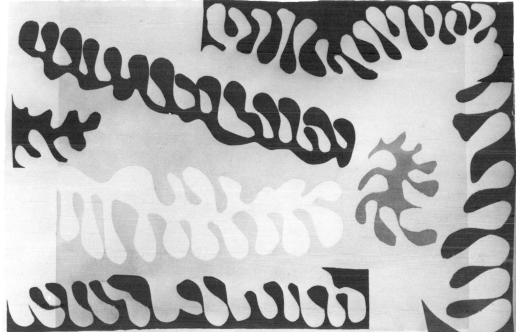

207. *The Lagoon* (1944) from *Jazz*. Stencil print after a paper cut-out maquette, *c*.42.2 × 65.5 cm. Tériade, Paris, 1947. 'Lagoons: wouldn't you be one of the seven wonders of the paradise of painters?' Matisse asked rhetorically in his hand-written text to *Jazz*.

The plates can be divided into four categories, which persist in the later cut-outs: single figures, narratives, formal compositions, and decorations. The single figure *Icarus* (Plate 189) is closely connected with Matisse's biography and his ambitions as an artist. Icarus tried to fly up to the sun and fell back to earth. His passionate red heart became a very personal symbol of life and love for Matisse after his near-fatal operation in 1941; it appears again in *Jazz*, within the horse-drawn hearse of *Pierrot's Funeral*. After the gift of life he felt that only love mattered in this world— and art. The symbolism and explanations of the narratives are strangely literal in relation to the abstract nature of their style. The little form on the right in *Destiny* (Plate 190) apparently represents a human couple clinging together, faced by the mask of destiny on the left. Matisse's wife and daughter had been imprisoned, briefly, by the Gestapo in the spring of 1944; this dreadful shock may well be reflected in the poignant image. *Forms* (Plate 206)—as its title implies—concerns a dialogue between the positive and negative shapes resulting from the process of cutting forms out of a sheet of paper. The decorations, the three *Lagoon* plates (Plate 207), relate to the formal compositions in the way they were made, but they differ

in their objective to evoke an alternative environment. Not surprisingly, therefore, these *Lagoon* decorations provided the subject-matter for his first mural-size paper cut-out maquettes of 1946, *Oceania, the Sea* (Plate 209) and *Oceania, the Sky* (Plate 211), and *Polynesia, the Sky* (Plate 210) and *Polynesia, the Sea* (Plate 212). Both these pairs of maquettes were prompted by commissions; the first from Zika Ascher for silkscreen hangings, to be printed in a limited edition on linen, the second—like *Window at Tahiti*—from Beauvais for tapestries.

On 26 August 1944 General de Gaulle entered Paris and headed the provisional government. On 30 April 1945 Hitler committed suicide in his bunker. On 8 May the war ended in Europe. In the October referendum the French population rejected, by the massive majority of 96 per cent, the revival of the Third Republic. Both socially and economically—but not politically—it was the beginning of a new era which saw the literal rebirth of the nation. The census of 1946 showed that

208. *The Snail.* 1952–3. Gouache on cut and pasted paper, 286 × 287 cm. London, Tate Gallery.
The colours are placed within a field of white, as though the composition was intended as a maquette for a stained-glass window. The black rectangle at the top weighs the movement in the composition downwards, so the other colours are felt to rotate jerkily around the central patch of green, thus creating an abstract equivalent of the form and motion of a snail.

209. *Oceania, the Sea.* 1946. Silk-screen printed on linen after a paper cut out maquette, 166 × 380 cm. Paris, Musée National d'Art Moderne, Centre Georges Pompidou.
Both *Oceania* and *Polynesia* found their inspiration in Matisse's experience of swimming in the Tahitian lagoons in 1930.

210. *Polynesia, the Sky.* 1946. Paper cut-out on canvas, cartoon for a Beauvais tapestry (woven in 1947), 200 × 314 cm. Paris, Musée National d'Art Moderne, Centre Georges Pompidou.
The birds fly around in a circle, like the dancers in the *Shchukin Dance* (see Plate 83), whereas the fishes in the companion cartoon move up and down in the undulating rhythm of the ocean. Far from being cut out in one stroke from a single piece of paper, the birds are made up of several pieces pasted together; the one in the bottom left-hand corner, for example, is composed of at least twelve little pieces of paper.

211. *Oceania, the Sky.* 177 × 370 cm.

212. *Polynesia, the Sea.* 196 × 314 cm.

the population had fallen by 1.5 million over the previous decade, to just above 40.5 million. In 1945 de Gaulle optimistically asked for 12 million 'beautiful babies' in ten years; the final figure of 8,352,700 was in itself quite exceptional.

Early in the summer of 1945 Matisse returned to Paris to find himself honoured, along with Picasso, as part of the promotion of a new independent image for France. Like Picasso the previous year, Matisse was given a one-man exhibition at the Salon d'Automne of 1945, and he and Picasso were the subject of a major exhibition at the Victoria and Albert Museum, London, that year. The new Musée d'Art Moderne in Paris, under the directorship of Jean Cassou, belatedly began to try and form a representative collection of Matisse's work, buying in 1945 both *Le Luxe I* of 1907 and *The Painter and his Model* of 1917. In 1947 Matisse was elevated from *chevalier* to *commandeur* of the Légion d'honneur; he had become a national monument, appreciated for his position rather than his art.

Matisse's art was going through a difficult transitional phase. He was still uncertain if he could make a significant new decorative art-form out of the paper cut-out technique. For the painted door, commissioned by the Argentine diplomat Señor Enchorrena in 1944, Matisse reverted to his neo-classical style of figure decoration of the 1930s and chose as his subject first the nymph and faun and then Leda and the swan; this was not completed until 1946 or 1947. It took the overtly decorative commissions from Zika Ascher and Beauvais for Matisse to develop the lagoon imagery from *Jazz* into mural-scale paper cut-outs.

During the summer of 1946 the many cut-out images for *Oceania, the Sky* and *Oceania, the Sea* were pinned directly to adjacent walls in his boulevard Montparnasse apartment, forming an alternative environment for his mind to wander in now that his body was too frail to travel abroad. 'I've always told you', he reminded Brassaï, 'that I couldn't do without a model. However, this new path has totally freed me from that. It's as though my memory had suddenly taken the place of the outside world. Sixteen years after my trip to Tahiti, my memories are finally coming back to me. There, swimming every day in the lagoon, I took such intense pleasure in contemplating the submarine world.'

There are no boundaries between sea and sky in the *Oceania* pair; birds and fish are suspended at different levels amongst algae, jellyfish, and other aquatic forms in an overall dream space, reminiscent of Joan Miró's Surrealist paintings. The linen background of the silk-screen hangings duplicates the colour of Matisse's walls, which reminded him of the golden light of the Pacific. Zika Ascher solved the problem of transferring the designs by suggesting that they should be traced, unpinned, and then packed away to be reassembled by his printers in London. This was the procedure Matisse adopted in his final environmental paper cut-outs at Nice, which were reassembled and glued to supports by specialists in Paris.

Matisse did not pursue this open-type composition, because it meant the abandonment of one of the linchpins of his art—the creation of light, space, and emotion through relationships. So in the *Polynesia* pair he took up the arrangement first seen in *Bathers by a River* of 1916 (see Plate 112) and then in the Barnes murals of 1931–3 (see Plates 161, 162, 164) of playing the organic foreground figures against the geometric planes of the background, here divided in a grid of alternating pale-blue and dark-blue rectangles. This grid was an extremely useful way of structuring the composition, in order both to assert the two-dimensional surface of the decoration and to act as a metaphor for a universal, perfectly harmonious, metaphysical reality existing behind surface appearances. During the previous year, he had made at least one completely abstract, geometric paper cut-out in the spirit of Mondrian, who had died in New York in 1944 after spending part of the war in Paris.

Matisse was smarting at his reception at the joint Matisse–Picasso exhibition at the Victoria and Albert Museum. He kept a folder of English press clippings. 'It's Picasso who receives the critics' broadsides, not Matisse!' he complained to Brassaï. 'I'm treated with respect. Obviously, next to him, I'm like a proper young lady.' The colours of both the *Oceania* and *Polynesia* pairs are muted. However, having confirmed his capacity to work with paper cut-outs on a large scale, he now pressed on determined to recapture that inventive spontaneity, audacity, and intense colour of his Fauve period. At this point Matisse re-enters the history of the avant-garde. From now on nobody was going to accuse him of having the reticence of a young lady.

In the very striking *Panel with Mask* of 1947 (Plate 191), the sensation of light is generated by the architectural balancing of brilliant Fauve contrasts of analogous (red against yellow) and complementary colours (red against green, blue against orange, and violet against yellow) within the structure of a vertical grid. The small fragmented shapes within the outlines of the three superimposed white forms add a near-explosive energy, which is barely restrained by the dignified stability of the grid structure.

Matisse's renewed consideration of colour as contrast opened up the earlier conflict in his art between colour as light and colour as *matière*, where emotion is conveyed by the expressive brush-marks and changing textures in the paint surface. The paper cut-outs are much more interesting than the works for which they often served as maquettes. In 1947 Matisse became very aware of this dichotomy on observing the difference in quality—despite the great care taken in the printing—between the maquettes and the resulting illustrations of *Jazz*. He therefore informed the director of the Decorative Arts Museum, Copenhagen, which had just bought *The Panel with Mask*, 'These works cannot be reproduced in multiple copies because, as with a tracing, they would lose the sensibility that my hand brought to them.'

As with his Fauve experiments of 1905, the paper cut-outs released a new-found feeling for the autonomy and expressive power of his pictorial elements, within a pervasive field of light. This led to the final flowering of his oil painting and to a series of large independent brush-drawings. Matisse, though, was at first nervous about the reception of his cut-outs and uncertain as to their status. In his published statements, he tended to assert the continuity of intention behind his changes in style and medium, rather than to point out the differences. 'There is no separation between my old pictures and my cut-outs,' he told an interviewer in 1951, 'except that with greater completeness and abstraction, I have attained a form filtered to its essentials, and of the object, which I used to present in the complexity of its space, I have preserved the sign which suffices and which is necessary to make the object exist in its own form and in the totality for which I conceived it.'

It is to be expected that an artist of Matisse's great intelligence and experience should see the various strands of his art coming together in his last years. But it is equally true to say that the old polarity, between the observed and the imagined, persisted. Generally speaking, the cut-outs were created in the imaginary tradition of his grand decorations, *Luxe, calme et volupté*, *Le Bonheur de vivre*, *Dance*, *Music*, and the Barnes murals. In his imagination, the views from Le Rêve at Vence led him down paths of mythological awakening, where he discovered a wealth of new images—or ready-made signs. These arresting images—often in fact drawn from natural history and ethnographic sources—accorded with his primitivized vision of a Golden Age, first set out in *Le Bonheur de vivre* of 1905–6; they were at the same time sufficiently outside his own everyday cultural experience for him to be able to

adapt them to his work. *The Panel with Mask* includes: at the top, a spiky, primitive mask (perhaps based on a New Ireland *Uli* figure in his studio); below it on the left, an image based on the shape of reindeer or caribou antlers; and to its right, a skull with open jaws and rounded teeth. Often these cut-outs were given mythological titles—*Amphitrite* (the Greek Queen of the Sea), for instance, or the Arabian *Thousand and One Nights*. However, by far his most important source of imagery was the landscape of Tahiti. (Both *Luxe, calme et volupté* and *Le Bonheur de vivre*, we may recall, also grew out of his experiences of particular landscapes.) Some of his most frequent images are variations on lagoon vegetation. The bottom two rectangles of *The Panel with Mask* contain typical examples of his variations on lagoon algae.

By contrast, his final oil paintings stem from the tradition of the domestic interior. Whereas the paper cut-out was for Matisse an audacious, imaginative medium with a concrete reality of its own, oil paint remained his favoured medium for registering his responses to the light and atmosphere of his own studio—home. The boundaries between the two are never as clear-cut as might be supposed because the interior of Le Rêve itself—like the interiors of his boulevard Montparnasse and Régina studios—became an imaginary construct, inspired by the *riad*, the internal world of the Arab house. Matisse the venerable patriach, attended by faithful females, took his place among the flowers, plants, cages of cooing doves, and multi-coloured birds, with works of his own creation on the walls. Light filtered through the palm branches and perforated screens, filling the objects of his contemplation with colour. Therefore, the still waters of the lagoon and the calm interior of the *riad* formed alternative images of spiritual peace and harmony in his art.

Yellow and Blue Interior of 1946 (Plate 213) is the first in this final series of oil paintings. This was without doubt one of the most glorious periods of painting in Matisse's entire career. Although bolder and more simplified, these paintings are comparable to the interiors of 1911–12 in both colour and atmosphere. *Yellow and Blue Interior* is indebted to the cut-outs in the way the background is built up with two rectangles of blue surrounded by a contrasting yellow ochre; but the overall atmosphere of light is conveyed more by the white ground showing through the thinly applied, flat layers of paint than by colour contrast.

Light became the key element in Matisse's art. In *The Lived-in Silence of Houses* of 1947 (Plate 192), light is expressed as a haunting atmosphere which permeates the interior, draining the figures and objects of substance and colour, leaving a residual yellow glow around their outlines. In the magnificently sonorous *Red Interior with a Blue Table* of 1947 (Plate 196), light is materialized in a scale of separate colours which are played in association with shape, like notes in a musical composition. The vibrant energy of the flickering green palm branches, framed against the blue sky, is balanced by the weight of the blue table placed at the bottom of the red field. This red is then repeated in the still-life arrangement on the blue table to give one of the most perfectly harmonious colour combinations in the history of art. *Interior with Egyptian Curtain* of 1948 (Plate 214) combines features from both these paintings; the marvellous, ornate pattern in the dark interior is juxtaposed against the palm branches, which appear as though attached to the radiating yellow spokes of light itself. *Plum Blossoms, Green Background* of 1948 (Plate 195) continues the theme from *The Lived-in Silence of Houses* of a featureless human presence behind a table, but in a higher key. The red table-top is balanced by the green background. Light appears to be coming from the intense yellow of the mimosa blossom and fruit, rather than from a window.

Large Red Interior of 1948 (Plate 197) brings to a conclusion both this series and his earlier preoccupation with red in the magnificent *The Dinner Table (Harmony in Red)* of 1908–9 (see Plate 78) and *The Red Studio* of 1911 (see Plate 88). Matisse was

213. *Yellow and Blue Interior*. 1946. Oil on canvas, 116 × 81 cm. Paris, Musée National d'Art Moderne, Centre Georges Pompidou. Matisse had treated the same subject in a previous painting (*Still-Life in Venetian Red*, Brussels, Musée Royal des Beaux-Arts); the colours and composition have changed but the objects on the circular marble-topped table have remained largely the same. The floral motif in the upper blue rectangle is yet another variation on the same piece of *toile de Jouy* patterned material that appeared in *The Dinner Table (Harmony in Red)* of 1908–9.

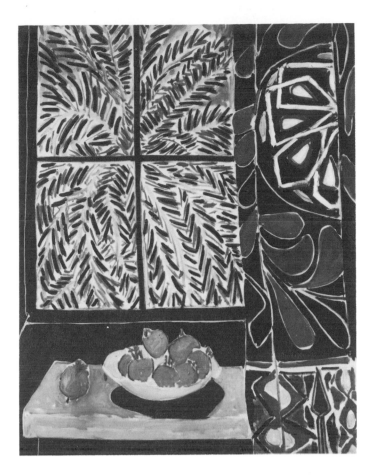

214. *Interior with Egyptian Curtain*. 1948. Oil on canvas, 116.2 × 88.9 cm. Washington, DC, Phillips Collection.
Darkness is descending on Matisse's interior world. The pattern on the Egyptian curtain wells out in stylized tears, like those wept by Picasso's *Weeping Woman* of 1937. A heavy black shadow gathers underneath the fruit-bowl; a thick blob of red looks like a drop of blood. The pomegranates and palm branches, as symbols of eternal life, offer the only hope.

215. *Interior with Window and Palm*. 1948. Brush and black ink on white paper, 105 × 75 cm. Private collection.
Brush-drawing was an ideal technique for Matisse now that his hands were afflicted, like Renoir's before him, with arthritis. The broad-lined style is anticipated in a series of aquatint prints of heads and masks which he began in 1945 and continued up to 1952. As with oriental brush-drawings, the placement, weight, and rhythm of each brush-stroke was carefully considered and then executed spontaneously.

extremely conscious of the self-generating quality of his own art, where elements are transposed from one painting to the next. An animated skin, perhaps of a bear, pursues a leopard across the floor of *Large Red Interior* and ends up lying underneath the table in his painting *The Pineapple* (1948), seen hanging on the wall above, opposite his large brush-drawing *Interior with Window and Palm* of 1948 (Plate 215). Everything exists between the poles of light and dark. The overall white ground of the canvas expresses the concept of light in its purest form. The red of the interior is felt to warm the cold purity of white light; the black forms in the drawing on the wall are blocked in with the brush against the light of the white ground. The white ground is again left exposed around the still-life elements in its triple role, to evoke atmospheric light, to describe white objects, and to assert the two-dimensional decorative surface of the canvas. Despite its extreme flatness, *Large Red Interior* still conjures up the glorious sensation of being in the heightened presence of the seen world.

Matisse had begun this new series of very large brush-drawings in 1947. He regarded them as having 'through reduced means all the qualities of a painting or mural'. He successfully demonstrated this point in *Large Red Interior* through the juxtaposition of *Interior with Window and Palm* against *The Pineapple*. The drawing conveyed more light than the brightly coloured painting-within-the-painting, so he employed it as the principal light source, like a window on the wall. Also, as his paint surface became thinner and flatter, drawing enabled him to develop a wide variety of expressive marks which enhanced colour. The black lines zigzagging across *Red Interior with a Blue Table* (see Plate 196), for instance, electrify an otherwise too sombre red, so that it holds its own against, and draws into the interior, the intensely energetic rhythms of the palm branches outside. Lastly, the purity of the independent brush-drawings acted as a necessary complement to flat, bright colour; the stained-glass windows of the Vence Chapel were to be balanced by large brush-drawings on white ceramic tiles (see Plates 216, 217), just as the cut-out images in *Jazz* had been balanced by his hand-written text. It was one of Matisse's maxims that 'An avalanche of colour has no force.'

The Chapel of the Rosary at Vence (see Plates 202, 216, 217) gave Matisse the opportunity to culminate his life's work with a total work of art, which would unite light, colour, drawing, and sculpture within architecture. It was therefore for Matisse his 'masterpiece', in the sense that he had finally given proof of his ability to master the different media at an artist's disposal, like one of the great masters of the Renaissance.

The details of Matisse's involvement in the Vence Chapel are confusing, because there were two similarly named Dominican nuns who had nursed him, Sister Marie-Ange and Sister Jacques-Marie. He first thought of doing a chapel for the Dominicans as a way of thanking Sister Marie-Ange for everything that she had done for him after his operation in 1941. Plan followed plan in their subsequent correspondence, but nothing was finalized. Then in August 1947, his second nurse Monique Bourgeois, the model in *The Idol* of 1942 (see Plate 200), who had subsequently taken the veil as Sister Jacques-Marie and was now working at the Foyer Lacordaire at Vence, began a window design for a new chapel to commemorate one of the old Sisters who had just died; this she showed to Matisse. Matisse was fond of Sister Jacques-Marie; he also felt extremely sorry for her. She had contracted tuberculosis. Although cured, she could no longer have any children, and for this reason, Matisse felt, she had opted for the religious life. At this point Brother Rayssiguier, a Dominican novice with an interest in architecture, who was recuperating at Vence, enters the story. He suggested that Matisse himself should take on the design.

Before long, Matisse had not only taken on the window design but had also agreed to underwrite the costs of a complete new chapel. Brother Rayssiguier and Matisse collaborated on the architecture, with technical assistance from the distinguished architect, Auguste Perret, and with liturgical advice from Father Couturier, who had played an active part in getting leading artists to work for the Church. At the suggestion of Father Couturier, Matisse had been invited in 1946 or 1947 to contribute to the decoration of the church of Notre-Dame-de-Toute-Grâce at Assy, Haute-Savoie. His three-quarter-length St Dominic for Assy, executed in 1948, in thick black lines on yellow-glazed tiles, was something of a trial run for his full-length St Dominic for Vence, for which Father Couturier posed. Precise details of the collaboration between Matisse, Rayssiguier, and Perret on the architecture of Vence have not yet been published.

Matisse worked on the chapel almost exclusively for four years, designing everything from the great curly-based cross on the roof to the magnificent chasubles. He was already engaged on the designs in 1948. Early in 1949 he moved back into the enormous rooms of the Régina, so that he could work on the same scale as the chapel. He employed the paper cut-out technique for the stained-glass window maquettes, and a long bamboo pole, his extended pencil, for the drawings for the ceramic tiles. The foundation stone was laid by the Bishop of Nice on 12 December 1949. A year later the windows were placed in position and Matisse began designing the chasubles. The chapel was dedicated on 25 June 1951, although some details were not completed until 1952.

The chapel was a daunting undertaking, particularly for an eighty-year-old invalid. Naturally it had to function spiritually and liturgically as a chapel for the Dominican Sisters. The site below the road to Saint-Jeannet, beneath Matisse's villa Le Rêve, was also restricting. On the east side the chapel had to be joined to the main building of the Foyer Lacordaire, whilst the position of the road above precluded windows on the north side.

Matisse's art had always flourished under constraints, coupled with the stimulus of an ambitious commission. As with the Barnes murals of 1931–3, the restrictions

of the site caused him to evolve a set of solutions which ideally suited the developments of his style. Unable to open up the north wall, he was obliged to place his stained-glass windows on the south side. It seemed inevitable then that he would balance the stained-glass windows on the south by black line drawings on white-glazed ceramic tiles on the north, as in the juxtaposition of painting against drawing in the background of *Large Red Interior*. So in his final solution the chapel would act as a celestial prism, with light from the south filling the simple white interior and flooding the ceramic drawings on the north side with colour. Lastly, he would have to switch the altar from the east to the west end, which left the east wall free for *The Stations of the Cross* (see Plate 217) and allowed him to complete his design with an apse window.

This may sound straightforward, but in fact it cost him considerable effort, not to say money. His insistence on having the walls of the nave and choir on the south side filled with fifteen, full-height, stained-glass windows caused grave structural problems. It has also resulted in the architecture looking a little too thin. This does not matter when light is pouring through the windows, seemingly supporting the weight of the building, but when the light fades the chapel loses its total effect and feels cold and insubstantial. Thus coloured light is not just decoration but a major constructional element in the architecture.

Matisse's paper cut-out maquettes for the stained-glass windows changed during the design process from the abstract to the organic, from red to green. His first maquettes for the paired apse windows, called *The Heavenly Jerusalem*, were built up in predominantly red and yellow interlocking rectangles of flat colour, with a few contrasting panels of blue and green. The only curvilinear elements occur towards the top, in order to reconcile the design with the rounded tops of the two windows. In his second maquettes, algae-like forms from *The Panel with Mask* (see Plate 191) are played against a background of smaller rectangles. However, in a rather similar way to the Barnes mural pendentives, he had not taken into account the size of the lead braces to hold the glass, so he went on to produce the third and final series of apse window maquettes, now called *The Tree of Life*. Here, as in the actual apse windows, the yellow algae forms are played against the broad, deep-blue leaves, inspired by cacti, with a more transparent green between them. The yellow reoccurs in places along the outside edges and in the glowing orb which unites the tops of both windows.

Similarly, the maquettes for the choir and nave windows on the south side began as an abstract design called *The Bees*, realized in little squares of yellow, red, and blue radiating from a central point, like bees from a hive. The larger bees, with black almond-shaped bodies and white rectangular wings, were arranged in two great arcs reaching from one side of the design to the other. The beehive symbolizes an integrated, harmonious community and honey, perhaps the yellow squares, the virginity of Mary. This rejected design was translated into glass and placed in the school at Le Cateau, Matisse's birthplace. The final choir and nave windows (Plate 202) take up the theme and colour scheme of *The Tree of Life*. The yellow algae forms and cactus leaves assume the shapes of tapering branches, growing from the vertical architectural divisions between the windows. In addition, they are all visually linked in undulating yellow and blue horizontal lines, like the arms of the dancers in the Shchukin *Dance* (see Plate 83).

The windows, which could so easily have looked over-simplified in colour and laboriously repetitive, are one of the triumphs of the chapel. Not only are the changes in rhythm extremely subtle but also our visual expectations are reversed. The green is the most transparent of the three colours, rather than the yellow which is the most opaque. 'This lack of transparency in the yellow', Matisse explained,

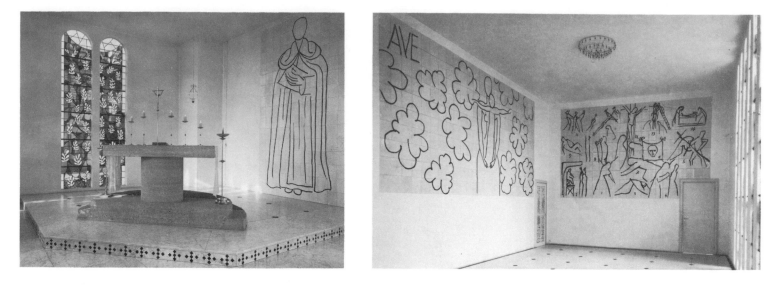

'arrests the spirit of the spectator and keeps it in the interior of the chapel, thus forming the foreground of a space which begins in the chapel and then passes through the blue and green to lose itself in the surrounding gardens.' He consciously avoided the disquieting energy of red, the only one of the four psychological primaries missing from the windows, because he felt that red would be generated in the mind as a psychophysical response to the green.

Equal care was taken with the ceramic murals. Numerous studies were executed for each of the final brush-drawings. In a sense the iconography of *The Tree of Life* extends to all three murals. St Dominic (Plate 216) is given the formal solidity of a great tree-trunk. In the preliminary studies, the Virgin began looking very much like *Lady in Blue* (see Plate 175), with a long flowing robe, and she held a particularly active Christ Child, whereas in the final version, the simplified Christ Child, with outstretched arms, grows from his mother like a branch. In the Crucifixion, the central image of the fourteen *Stations of the Cross* on the east wall (Plate 217), Christ is nailed to the cross in this same pose. Matisse concluded that the function of these ceramic murals was similar to his hand-written text for *Jazz*:

> They are the visual equivalent of a large open book where the white pages carry the signs explaining the musical part composed by the stained-glass windows. In sum, the ceramic tiles are the spiritual essential and explain the meaning of the monument. Thus they become, despite their apparent simplicity, the focal point which should underline the peaceful contemplation that we should experience; and I believe this is a point that should be stressed.

The Vence Chapel could be seen as evidence of Matisse's final *rapprochement* with Christianity. It was as though he had come to accept that the spiritual peace he had struggled to achieve through his work could only result from faith in God. He had always understood the cultural importance of the continuity of faith in the West embodied in the Catholic Church, and he saw no reason to discontinue his family tradition of being married in church and having his children baptized. But his own preoccupation was not with sin and guilt but with life and the disciplined near-oriental understanding of the pleasures that make it worth living. It is significant that he saw Chartres and the Orient coming together in the stained-glass windows of the chapel. 'My only religion', he stated quite categorically in 1952, 'is the love of the work to be created, the love of creation, and great sincerity.' The chapel is therefore to be seen as a votive offering for the gift of life given him by the doctors and nurses after his operation in 1941, and ultimately as a temple of light, a monument to his creative ego.

216. *The Chapel of the Rosary of the Dominicans at Vence*. 1948–51. The ceramic murals. Despite its extreme stylization, the image of St Dominic, for which Father Couturier posed in 1948, provides a commanding spiritual presence. Every line was thoroughly rehearsed in preliminary drawings to ensure that it conveyed both form and content. 'There I tried my very best,' Matisse told an interviewer in 1952.

217. *The Chapel of the Rosary of the Dominicans at Vence*. 1948–51. *The Stations of the Cross*. The story of *The Stations of the Cross*, like that of some awful truth scratched into a prison wall, was intentionally depicted in a very different style from the rest of the chapel. However, the final images seem too schematic to convey the mood of intense pathos that Matisse wanted.

218. Henri Matisse at work in the Hôtel Régina. Nice, 15 April 1950. Photograph by Walter Caron.

Matisse must have had wrists of steel to retain control of his long bamboo pencil with which he drew on the surrounding walls, even when lying in bed. Portions of what were to become three different cut-outs can be seen pinned to the wall, *The Beasts of the Sea*, *The Thousand and One Nights*, and *The Japanese Mask*.

Easel painting could no longer satisfy Matisse's artistic needs once he had developed the techniques of working to mural scale in the chapel. He painted his last two very loosely brushed canvases of the model Katia in 1951 and from then on, to his death in 1954, cut-out paper became his principal medium of artistic expression. His mural techniques gave him enormous flexibility. He could even continue working on a large-scale from his bed, using his long bamboo pencil. The compositions literally evolved on the walls around him. Images could be unpinned and transferred from one paper cut-out to another by an assistant. He can truly be said to have been living in a harmonious environment of his own creation.

The chromatic power and freedom of the paper cut-out medium rekindled his vision of an imaginary Orient, an earthly paradise of the senses. The beginnings of the large frieze called *The Thousand and One Nights* can be seen on the wall in the bottom right-hand corner of the photograph of his studio (Plate 218), taken in April 1950. *Zulma* (Plate 201), completed by May 1950, is of an oriental odalisque. As in his Fauve paintings of 1905, a preliminary drawing provided a linear framework on which the planes of contrasting colours were built. He began with the orange of her body and then surrounded it in a clothing of the complementary blue, so that the odalisque radiates light, not sexuality.

Zulma proved to Matisse that he could adapt the paper cut-out medium to the subject-matter of an easel painting. However, he could not sustain its all-over chromatic impact on a large scale without introducing a note of sadness. This ideally suited the subject-matter of *The Sorrow of the King* (see Plate 222) and *Ivy in Flower* (see Plate 205), his maquette for a mausoleum window, but when he required a more detached atmosphere of classical calm, in such decorative compositions as *Chinese Fish* (Plate 204), *The Parakeet and the Mermaid* (Plate 203), and *Apollo* (Plate 219), he placed his colours against a white background. 'The white intermediary', Matisse explained, 'is determined by the arabesque of the cut-out coloured paper which gives this *white atmosphere* a rare and impalpable quality. This quality is that of contrast. Each particular group of colours has a particular atmosphere. It is what I call the *expressive atmosphere*.' His employment of white as a vehicle for colour, separating and quietening the intense hues, relates both to his use of white in the Vence Chapel and to the Islamic tradition of tile decoration, epitomized by the Alhambra, which he had visited in the winter of 1910–11.

Like the 'signs' in his paintings and drawings, the organic images in his cut-outs developed from intense study and an almost pantheistic approach to his subject. 'An

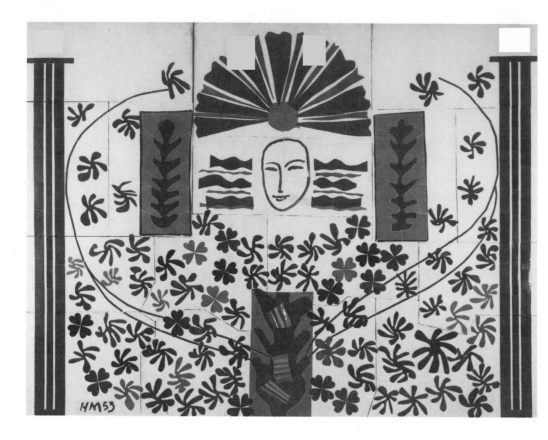

artist must possess Nature,' he advised young artists in 1948. 'He must identify himself with her rhythm, by efforts that prepare for the mastery by which he will later be able to express himself in his own language.' Having penetrated to the essence of a form and expressed it as a 'sign', he then proceeded with a composition, conscious that he was somehow duplicating nature's mode of operation in producing variations, like the myriad shapes of fig leaves he drew in his garden which were always 'unmistakably fig leaves'. In old age, he had come to identify with the organic rhythm of trees. The theme of *The Tree of Life* in the Vence Chapel led in 1951–2 to a magnificent series of large brush-drawings of trees. Through the soaring expansion of a tree's trunk and the changing rhythms of its branches and leaves, he expressed not only his wonder at nature's infinite variety but also his continuing fascination with his own undimmed creative drive.

The emphasis in his drawings had changed. He now placed a premium on the spontaneous end result, after profound contemplation, in contrast to the often laborious processes of his earlier drawings. He compared his method of working to that of an acrobat. 'The acrobat executes his number with ease and an apparent facility. Let's not lose sight of the long preparatory work which permitted him to attain this result.' Like a Zen master, he wanted to find a perfect accord between style, medium, and content. This he finally attained in a series of six brush-drawings of 1952, appropriately called the *Acrobats* (Plate 220).

220. *Acrobat.* 1952. Brush and ink on paper, 105 × 75 cm. Private collection.
The weight and rhythm of each brush-stroke perfectly accords with the form and motion of the figure bending over backwards in an arch of related parts.

219. *Apollo.* 1953. Ceramic after a paper cut-out maquette, 327 × 423 cm. Paris, private collection.
The white of his paper cut-out background became a ceramic wall, in which the glazed coloured forms were embedded. The three crinkly forms in high relief on the pruned stem apparently represent bunches of grapes.

221. *The Swimming Pool.* 1952. Gouache on cut and pasted paper, two-part mural 230.1 × 847.8 cm and 230.1 × 796.1 cm. New York, Museum of Modern Art.
This was a companion piece to the environmental mural of *The Parakeet and the Mermaid.* The subject-matter of female bathers had its origin in *The Three Bathers* by Cézanne (see Plate 21). The strip of white paper was attached to the beige fabric on Matisse's wall, now duplicated in its present installation at MOMA.

Matisse still sought a monumental decorative art, and that meant— in the last
years of his life as in 1907–10—an art based on the human figure. It was perhaps
for this reason that he preferred *Zulma* and *The Sorrow of the King* (Plate 222) to his
other cut-out compositions. Spontaneity was more easily achieved in drawing or in
cutting out a small 'sign' with scissors than in a paper cut-out realization of a
human figure, which required conscious organization if it were to convey a feeling
of solidity and significance. So in his series of four *Blue Nudes* (Plate 223) he set out
to reconcile the sculptural integrity of the human figure with the paper cut-out
medium, without sacrificing its arabesque or overall linear rhythm.

However, he experienced great difficulty when he tried fitting each *Blue Nude* in
turn into *The Parakeet and the Mermaid*. As he had found in the Barnes murals, the
human element interfered with the decorative nature of the composition. The final
mermaid, apparently only added at the last moment, is a more ambiguous form
which fits in much better with both the pomegranates and the trailing arms of the
algae.

Matisse's solution to the problem of integrating the paper cut-out human figure
into an overwhelmingly decorative composition came in *The Swimming Pool* of 1952
(Plate 221)—an aquatic companion piece to his environmental garden mural *The
Parakeet and the Mermaid*—in which he exploits the positive–negative relationships
resulting from his cut-out process. Some of the bathers plunging in and out of the

white water are positive forms, whilst others are created from the relationship between their negative shapes and the background. This related the bathers more closely both to each other and to their background.

However, when concentrating on the human figure in the cut-outs, Matisse temporarily shelved the problem of colour and usually kept to a monochrome blue. The parallel drive in his art, since his first involvement with the avant-garde in the 1890s, was the quest for an autonomous art of colour, and this received its final, most abstract formulation in *The Snail* of 1952–3 (Plate 208). The coloured panels of his earlier paper cut-out grids were released from their background role to function as the elements from which *The Snail* was created. Colour now existed as both form and structure within an overall atmosphere of white, the apotheosis of light. Matisse described it variously as *Abstract Panel rooted in Reality*, *The Chromatic Composition*, as well as *The Snail*. The circular movement had informed his other great imaginative decorations, *Le Bonheur de vivre*, the Shchukin *Dance*, and the Barnes murals. Here it is used as a symbol of his identification with the spiral growth of organic form. Quite characteristically for Matisse, it had evolved from drawings of an actual snail.

Memory of Oceania of 1952–3 (Plate 224), perhaps Matisse's last masterpiece, is a more complex mingling of 'signs', of autonomous areas of colour, and of line in the light of his journey to Tahiti in 1930. Colour creates levels of existence in space and time. In one sense *Memory of Oceania* was nostalgic, and in another it opened up new directions in the relationship between colour, form, and subject-matter which Matisse did not live long enough to develop.

Two of his last paper cut-out decorations, *Ivy in Flower* of 1953 (Plate 205) and *Rose* of 1954, were maquettes for commissions for stained-glass memorial windows. In the former, the leaves and flowers float like lagoon fauna in a sea of golden light. In the latter, the rosette contained eight green pomegranates. Like the flowering ivy and the pomegranates, light for Matisse had become a symbol of everlasting life.

223. *Blue Nude IV*. 1952. Gouache on cut and pasted paper and charcoal, 102.9 × 76.8 cm. Private collection. The remarkable continuity in Matisse's concerns throughout his career is exemplified by his four *Blue Nudes*. From his *académies* of 1899–1901 (see Plates 24, 25), to *Blue Nude—Souvenir of Biskra* of 1907 (see Plate 55), and then to these paper cut-out *Blue Nudes* he was obsessed with the problem of conveying in colour the sculptural solidity of the figure.

224. *Memory of Oceania*. 1952–3. Gouache on cut and pasted paper and crayon, 286.4 × 286.4 cm. New York, Museum of Modern Art. The forms relate to Matisse's Tahitian trip in 1930, as recalled in *Window at Tahiti* of 1935–6 (see Plate 174) and his earlier *Mallarmé* illustration (see Plate 171). The large green rectangle apparently represents the schooner *Papeete* and the magenta bar its mast.

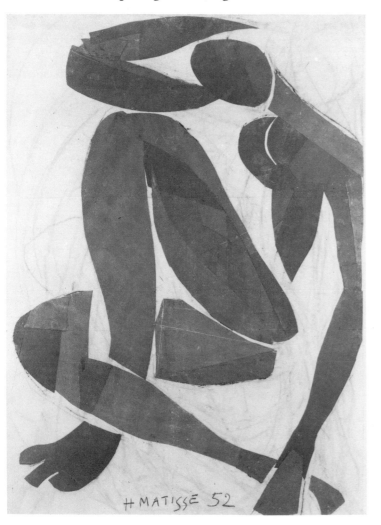

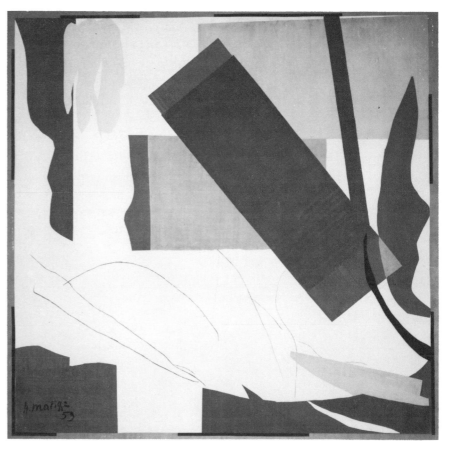

Postscript

Matisse died on 3 November 1954 at Nice and was buried in the cemetery at Cimiez, not far from the Roman arena where the Musée Matisse is now situated. His critical reputation has steadily increased both in France and abroad, and he is currently regarded as the painter *par excellence* who has done most to develop the language of painting in the twentieth century. In 1949 the Musée National d'Art Moderne, Paris, had organized the first exhibition of his paper cut-outs, and followed this with a major retrospective of his work in 1956. The Musée bought *Large Red Interior* (1948) in 1949 and *The Sorrow of the King* (1952) three years later. A new wave of important acquisitions followed the re-evaluation of his work after the Exposition du Centenaire at the Grand Palais in 1970.

However, America rather than France has been responsible for the rise in Matisse's reputation, and it is American artists, rather than their European counterparts, who have on the whole inherited his innovatory drive and ambition. A major Matisse retrospective was held at the Philadelphia Museum of Art in 1948. After the exhibition in 1949 at the Pierre Matisse gallery in New York, Clement Greenberg, the leading apologist of Abstract Expressionism, acclaimed Matisse as 'the greatest living painter'. The Matisse retrospective at the Museum of Modern Art, New York, in 1951–2, coupled with the publication of Alfred Barr Jun.'s outstanding monograph *Matisse: His Art and His Public* that same year, put the final seal of approval on his reputation.

Each generation forms its own view of Matisse, and we should bear in mind that our knowledge of his total *œuvre* is still incomplete. The long-awaited *catalogue raisonné* is not yet published. The most important holdings of his paintings before 1914 are in Russia, and until recently have rarely been seen in the West. The major exhibition of his paper cut-outs, organized by the Detroit Institute of Arts and the St Louis Art Museum in 1977, unfortunately did not come to Europe. Matisse was a prolific draughtsman, yet comparatively few of his drawings have been seen in recent exhibitions (although the comprehensive exhibition of his drawings and sculptures at the Museum of Modern Art, New York, and the Hayward Gallery, London, in 1984 goes a long way towards redressing this neglect). Even acknowledged masterpieces drop out of sight for one reason and another. Some are either too fragile to travel, like *Interior with Aubergines* and *Arab Café*, or are in comparatively inaccessible collections which do not allow their works to be loaned. Others, like the Barnes murals and the Vence Chapel, obviously have to be experienced *in situ*.

Matisse's work of the period from 1910 to 1917 has proved consistently popular with both critics and painters; this may partly be due to the magnificent collection

formed by the Museum of Modern Art, New York, in this area. The final series of oil paintings and the paper cut-outs have also always been well received, though not, it must be said, with great insight or critical understanding. Neither have the cut-outs served as the basis for a modern mural art. Despite the inability of our age to come to terms with art overtly concerned with pleasure, beauty, and style, the time is surely ripe for a reassessment of Matisse's easel painting from between the wars. Matisse as a colourist has received most attention in the many studies that have been devoted to him. However, with the revival of interest in figurative art, his treatment of the human figure in drawing, painting, and sculpture is now receiving more serious consideration.

Matisse's art will no doubt retain its high status because it has such a powerful impact, and because it is so firmly rooted in reality and in the history of art. Equally, his work should be acknowledged for the new contribution it makes to the art of painting, for which he was prepared to struggle, to force the pace. Matisse himself saw his main contribution to lie in the creation of space through colour. He was such a source of intelligent pictorial thought that subsequent artists have developed whole careers out of but a few of his ideas. However, in the final analysis it is an artist's vision that counts, and it is difficult to contemplate a world in which the beauty of a Matisse would be held any less valuable.

Notes

Abbreviations

Barr: Alfred H. Barr Jun., *Matisse: His Art and His Public* (New York, 1951). This remains the standard work on the artist.

Flam: Jack D. Flam, *Matisse on Art* (London, 1973). This is the most comprehensive collection of Matisse's writings and statements so far published in English.

Fourcade: Dominique Fourcade, *Henri Matisse, écrits et propos sur l'art* (Paris, 1972). This is the most comprehensive collection of Matisse's writings and statements published in any language, with an excellent index.

Chapter 1: The Early Years, 1869–1896

p. 10 Matisse's message to the American people: Clara T. MacChesney, 'A Talk with Matisse, Leader of post-Impressionists', *New York Times Magazine*, 9 March 1913, reprinted in *Flam*, pp. 49–53.
Leo Stein on Matisse's public image: Leo Stein, *Appreciation: Painting, Poetry and Prose* (New York, 1947), p. 170.
Matisse and his spectacles: Fernande Olivier, *Picasso and his Friends* (London, 1964), p. 88.
Matisse as a Persian lord: Martin Fabiani, *Quand j'étais marchand de tableaux* (Paris, 1976), p. 121.
Alexander Liberman on Matisse keeping his distance: Alexander Liberman, *The Artist in his Studio* (London, 1969), p. 56.

p. 11 Matisse on 'an art of balance': Henri Matisse, 'Notes d'un peintre', *La Grande Revue*, December 1908, in *Flam*, p. 38.
Matisse on copying nature: *ibid.* p. 37.
Matisse's biography: no biography of Matisse has yet been published. Alfred Barr Jun.'s *Matisse: His Art and His Public* (New York, 1951) is still the standard work on the artist. Further details of Matisse's early biography are included in the extensive literature, particularly John Russell's *The World of Matisse, 1869–1954* (New York, 1969).
Matisse's parents and their employment in Paris: Pierre Schneider, '"The Figure in the Carpet", Matisse und das Dekorative' in *Henri Matisse* (Kunsthaus Zurich, 1982), p. 13.

p. 12 Provincials in French Society: see Theodore Zeldin, *France 1848–1945*, vol. II (Oxford, 1977), pp. 29–85.

p. 13 Henri Matisse on the decision to become an artist: quoted in Raymond Escholier, *Matisse from the Life* (London, 1960), p. 26.
Pierre Bonnard on the decision to become an artist: quoted in Raymond Cogniat, *Bonnard* (Milan, 1968), p. 16.

p. 14 F. A. Goupil: *Manuel général de la peinture à l'huile* (Paris, 1877), p. 31.
Paris in the *belle époque*: see Roger Shattuck, *The Banquet Years* (London, 1969), pp. 3–28.
Subject-matter of *Jazz*: see *Henri Matisse: Paper Cut-Outs* (St Louis Art Museum and Detroit Institute of Arts, 1977), pp. 103–15.

p. 15 Entrance examination results: from the Matisse dossier at the École des Beaux-Arts.

p. 16 Matisse on drawing: letter from Matisse to Henry Clifford, 1948, in *Flam*, p. 121.
Academic drawing instruction: see Albert Boime, *The Academy and French Painting in the Nineteenth Century* (London, 1971), pp. 24–36.
Drawing instruction received by Matisse: see William John Cowart, 'Écoliers to fauves, Matisse, Marquet, and Manguin drawings: 1890–1906' (Ph.D. dissertation, Johns Hopkins University, Baltimore, 1972).

p. 17 Henri Matisse: 'Notes d'un peintre', *La Grande Revue*, December 1908, *Flam*, p. 38.

p. 18 Roger Marx: 'Le Salon du Champ-de-Mars', in *La Revue Encyclopédique*, 25 April 1896, quoted in Pierre-Louis Mathieu, *Gustave Moreau* (Oxford, 1977), p. 226.
Moreau on colour and the imagination: quoted in Francis E. Hyslop (ed.), *Henri Evenepoel à Paris Lettres Choisies, 1892–1899* (Brussels, 1971), p. 53.

p. 19 Moreau to Rouault: see Georges Rouault, *Sur l'art et sur la vie* (Paris, 1971), p. 80.

p. 20 Matisse's copy of de Heem's *The Dinner Table* not bought by the State: see John Elderfield, *Matisse in the Collection of The Museum of Modern Art* (New York, 1978), p. 106.

p. 21 Courthion on Matisse's copy of Chardin's *The Ray*: see Pierre Courthion, 'Rencontre avec Matisse', *Les Nouvelles Littéraires*, 27 June 1931, in *Flam*, p. 65.

p. 22 Matisse on the relative temperatures of black: see Henri Matisse, 'Notes sur la couleur' published in the exhibition catalogue *Henri Matisse, Aquarelles, Dessins*, (Galerie Jacques Dubours, Paris, 1962), reprinted in *Fourcade*, pp. 205–7.
Apollinaire interview with Matisse: *La Phalange*, December 1907, in *Flam*, p. 32.

p. 26 Matisse on his introduction to pure colour: see Jacques Guenne, 'Entretien avec Henri Matisse', *L'Art Vivant*, September 1925, in *Flam*, p. 54.

Chapter 2: A Time of Experiment, 1897–1904

p. 27 The emergence of the political and social avant-gardes: see Madeleine Rebérioux, *La République radicale? 1898–1914* (Paris, 1975), pp. 157–75.
The growth of radicalism: *ibid.* pp. 42–82; R. D. Anderson, *France 1870–1914* (London, 1977), pp. 5–29.
Positivism and science: see Gordon Wright, *France in Modern Times* (Chicago, 1974), pp. 287–90.
The Universal Exhibition of 1900: W. O. Henderson, *The Industrialization of Europe, 1780–1914* (London, 1969), p. 67.

p. 28 Photography and film: Zeldin, *France 1848–1945*, vol. II, pp. 388, 390, 455, 457.
The reaction to Positivism and science: Rebérioux, *La République radicale? 1898–1914*, p. 30; Zeldin, *France 1848–1945*, vol. II, p. 403.
Denis on the objectives of Symbolist painting: see Maurice Denis, *Théories* (Paris, 1904). Quotation translated by the author.
Mallarmé and modern art: L. Bailey Van Hook, 'Robert Motherwell's Mallarmé's Swan', *Arts Magazine*, January 1983, p. 103.
The avant-garde in the 1890s: see Shattuck, *The Banquet Years*, pp. 29–42.

p. 29 Fauvism and anarchism: see Marcel Giry, *Fauvism, Origins and Developments* (New York, 1981), pp. 13, 14.

p. 30 John Peter Russell's gift to Matisse of two Van Gogh drawings: Gaston Diehl, *Henri Matisse* (Paris, 1954), p. 11.
The reception of Impressionism in the 1890s and the opening of the Caillebotte bequest: see Germain Bazin, *Impressionist Paintings in the Louvre* (London, 1958), pp. 39–48.

p. 31 Domestic servants in the 1890s: Zeldin, *France 1848–1943*, vol. II, p. 943.
The reception of *The Dinner Table* (1897): *Barr*, p. 35.
Moreau on *The Dinner Table* (1897): Jacques Guenne, 'Entretien avec Henri Matisse', *L'Art Vivant*, September 1925, in *Flam*, p. 55.

Evenepoel on Matisse and Monet: quoted in Mathieu, *Gustave Moreau*, p. 238.
John Peter Russell and Belle-Île: see Elizabeth Salter, *The Lost Impressionist: A Biography of John Peter Russell* (London, 1976).

p. 33 Monet's colour, technique, and working methods at Belle-Île: J. P. H. House, *Claude Monet: His Aims and Methods c.1877–1895*, (Ph.D. thesis, Courtauld Institute of Art, University of London, 1976), p. 74.
Moreau's objection to Matisse's Belle-Île canvases: Mathieu, *Gustave Moreau*, p. 238.
The status of the outdoor sketch in the nineteenth century: Richard Allen Shiff, *Impressionist Criticism, Impressionist Color, and Cézanne* (Ph.D. dissertation, Yale University, 1973), p. 27.
Camille Pissarro's artistic objectives: see Camille Pissarro, *Letters to his Son Lucien* (London, 1943), pp. 32, 131–2, 139–40.
Camille Pissarro's advice to Matisse: *Barr*, p. 37.

p. 34 Matisse's meeting with Amélie Parayre: information supplied by Marguerite Duthuit in a letter to Sotheby & Co., dated Paris, 13 March 1978.
Amélie's shop: see Catherine C. Bock, *Henri Matisse and Neo-Impressionism* (Los Angeles, 1977), p. 33.
Matisse on Turner and Monet: Raymond Escholier, *Matisse, ce vivant* (Paris, 1956), p. 41. Passage translated by the author.

p. 35 Matisse on his passion for colour developing in the south: Jacques Guenne, 'Entretien avec Henri Matisse', *L'Art Vivant*, September 1925, in *Flam*, p. 55.
Millet's *The Church at Greville* (1871–4) and the subject of the peasant: see Griselda Pollock, *Millet* (London, 1977), pp. 5–21, 63.

p. 37 Matisse on pushing each study in a certain direction: Jacques Guenne, 'Entretien avec Henri Matisse', *L'Art Vivant*, September 1925, in *Flam*, p. 55.
The pastel study for *First Orange Still-Life*: for an illustration see Isabelle Monod-Fontaine, *Oeuvres de Henri Matisse (1869–1954)* (Musée National d'Art Moderne, Centre Georges Pompidou, Paris, 1979), p. 26.
Neo-Impressionist theory and technique: for summaries see Anthea Callen, *Techniques of the Impressionists* (London, 1982), pp. 134–7; J. C. Webster, 'The Technique of Impressionism, a Reappraisal', *College Art Journal*, vol. IV, no. 4, November 1944; Bock, *Henri Matisse and Neo-Impressionism*, pp. 14–26.

p. 38 Matisse on Neo-Impressionism as a development of Impressionism: E. Tériade, 'Visite à Henri Matisse', *L'Intransigeant*, January 1929, in *Flam*, p. 58.
Matisse on Impressionism as exact representation: Charles Estienne, 'Entretien avec M. Henri-Matisse', *Les Nouvelles*, April 1909, in *Flam*, p. 48.

p. 39 Matisse to Brassaï on the Académie Julian and the Nabis: Brassaï, *The Artists of My Life* (London 1982), p. 222.
Matisse and the Nabis in 1896–7: Diehl, *Henri Matisse*, p. 11.
Matisse's expulsion by Cormon and enrolment at the Académie Camillo: Escholier, *Matisse ce vivant*, p. 43.
Matisse's sculpture course at the École Communale de la Ville de Paris: *ibid.* p. 48.

p. 41 The formation of Fauvism: see John Elderfield, *The 'Wild Beasts': Fauvism and its Affinities* (New York, 1976), pp. 17–31.

p. 42 Matisse on Cézanne not being an Impressionist: *Barr*, p. 38.
Simon Bussy on Matisse frequenting Vollard's in place of the Louvre: Jane Simone Bussy in an unpublished memoir of Matisse.
Matisse on the qualities he appreciated in Cézanne's *The Three Bathers*: Diehl, *Henri Matisse*, p. 18.
Matisse to the director of the Petit Palais on Cézanne's *The Three Bathers*: Escholier, *Matisse ce vivant*, p. 50; reprinted and translated in *Flam*, p. 75.
Matisse on Rodin's assemblage of expressive parts: Henri Matisse, 'Notes d'un peintre', *La Grande Revue*, December 1908, in *Flam*, p. 37.

p. 43 Matisse's sculpture: for the most complete account to date see Albert E. Elsen, *The Sculpture of Henri Matisse* (New York, 1972).
Matisse on why he took up sculpture: Jean Guichard-Meili, *Matisse* (London, 1967), p. 168.
Matisse's graphic work: for the most complete publication see *Henri Matisse 1869–1954: Gravures et Lithographies* (Musée d'Art et d'Histoire, Fribourg, 1982).

The removal of the arms of *The Serf*: Elsen, *The Sculpture of Henri Matisse*, p. 39.
A comparison of *The Serf* and *Male Model*: see Elderfield, *Matisse in MOMA*, pp. 28–34.

p. 45 *Madeleine I* and the curvilinear mode: Elsen, *The Sculpture of Henri Matisse*, pp. 48–58.

p. 46 Maximilien Luce's treatment of Notre-Dame: see Beatrice de Verneilh, 'Maximilien Luce et Notre-Dame-de-Paris', *L'Oeil*, March 1983, pp. 24–31.
Matisse on being expelled from the École des Beaux-Arts in 1899: Escholier, *Matisse ce vivant*, p. 43.

p. 48 The closure of Madame Matisse's shop: Bock, *Henri Matisse and Neo-Impressionism*, p. 33.
Matisse's letter to Simon Bussy of 15 July 1903: *Fourcade*, pp. 86–7.
Matisse kicking over the easel: Matisse to Mr and Mrs Ralph Colin, who passed on the anecdote to the author.
Matisse on Marquet's palette: Jacques Guenne, 'Entretien avec Henri Matisse', *L'Art Vivant*, September 1925, in *Flam*, p. 56.

p. 50 Matisse's first one-man exhibition in June 1904: *Barr*, pp. 44–5; Bock, *Henri Matisse and Neo-Impressionism*, p. 34.

Chapter 3: From Neo-Impressionism to Fauvism, 1904–1906

p. 51 Matisse and Signac: for a discussion of when they met see Bock, *Henri Matisse and Neo-Impressionism*, p. 63.
Signac: for biographical details see Françoise Cachin, *Paul Signac* (Milan, 1970); M. T. Lemoyne de Forges, *Signac* (Musée du Louvre, Paris, 1963–4).

p. 54 The Matisses at Saint-Tropez: information about where they stayed provided by Françoise Cachin, letter to the author, February 1981.
La Hune: details provided by Ginette Signac in conversation with the author, La Hune, 1975.
The Neo-Impressionist divided touch and anarchism: Callen, *Techniques of the Impressionists*, p. 138.
Matisse's daughter on Signac's quarrel with Matisse: Elderfield, *Matisse in MOMA*, p. 36.
The Neo-Impressionists' working methods: see W. I. Homer, *Seurat and the Science of Painting* (Cambridge, Mass., 1964); Robert L. Herbert, *Neo-Impressionism* (New York, 1968); Jean Sutter, *Les Néo-Impressionistes* (Neuchâtel, 1970).

p. 55 Signac's use of cartoons: Françoise Cachin, letter to the author, February 1977.
Matisse's use of a cartoon for *Luxe, calme et volupté*: Pierre Schneider, letter to the author, December 1977.
Dufy on *Luxe, calme et volupté*: quoted in Jean-Paul Crespelle, *The Fauves* (London, 1962), p. 159.
The reception of *Luxe, calme et volupté*: see E. C. Oppler, 'Fauvism Re-examined' (Ph.D. dissertation, Columbia University, New York, 1969), p. 103.
Seurat on the relationship between the warm colours, linear direction, and emotion: Seurat, letter to Beaubourg, 1890, quoted in Homer, *Seurat and the Science of Painting*, p. 187.
Cross on wanting 'to submit everything to a harmony of colours and linear directions': Cross, letter to Van Rysselberghe, 1904, quoted in Herbert, *Neo-Impressionism*, p. 217.
Cross on Matisse's anxious state in 1904: quoted in *Barr*, p. 53.

p. 56 Matisse sharing a model with Signac: Elderfield, *Matisse in MOMA*, p. 36.
Signac's use of the model: Françoise Cachin, letter to the author, February 1977.

p. 58 Cross: for biographical details see Isabelle Compin, *Henri-Edmond Cross* (Paris, 1964).
Cross and Symbolist poetry: Bock, *Henri Matisse and Neo-Impressionism*, p. 72.
Signac and the Golden Age: Lemoyne de Forges, *Signac*, p. 57.
Matisse and the Golden Age: for a lengthy discussion see *Henri Matisse, Das Goldene Zeitalter* (Kunsthalle Bielefeld, 1981); Schneider, '"The Figure in the Carpet", Matisse und das Dekorative' in *Henri Matisse*, pp. 10–19.

The changed industrial mood 1904–7: Rebérioux, *La République radicale? 1898–1914*, p. 92.

The development of leisure on the north coast: Robert L. Herbert, Slade Lectures, Oxford (March 1978).

La Jeunesse and Saint-Tropez in the 1960s: John Ardagh, *The New France* (London, 1981), p. 522.

p. 59 Collioure and the main railway line: John Hallmark Neff, 'Matisse and Decoration, 1906–1914' (Ph.D. dessertation, Harvard University, 1974), p. 27.

Signac on Mediterranean light being white: entry from Signac's diary, Saint-Tropez, September 1894, quoted in John Rewald, *The History of Post-Impressionism* (New York, 1962), p. 244.

p. 62 Matisse on Fauvism as a reaction to Neo-Impressionism: E. Tériade, 'Visite à Henri Matisse', *L'Intransigeant*, January 1929, in *Flam*, p. 58.

Chevreul on the simultaneous contrast of colours: M. E. Chevreul, *The Principles of Harmony and Contrast of Colours and their Application to the Arts* (first published in 1839; New York, 1967), p. 78.

p. 63 Matisse on his inability to follow the Neo-Impressionist method: Diehl, *Henri Matisse*, p. 22.

Matisse on his reasons for painting in flat planes of colour: Georges Duthuit, *The Fauvist Painters* (New York, 1950), p. 62.

The infra-red photograph of *Landscape at Collioure* (1905 — Leningrad): see A. Izerghina, *Henri Matisse: Painting and Sculptures in Soviet Museums* (Leningrad, 1978), p. 127.

p. 66 The influence of Van Gogh on Matisse's paintings at Collioure in 1905: Deihl, *Henri Matisse*, p. 24.

Van Gogh's colour theory: Bogomila Welsh-Ovcharov, *Vincent van Gogh: His Paris Period 1886–1888* (The Hague, 1976), p. 64.

Van Gogh on the modern portrait in colour: *The Complete Letters of Vincent van Gogh*, vol. III (London, 1959), p. 418.

Derain: for biographical details see Denys Sutton, *André Derain* (London, 1959).

Matisse's relationship with Derain in 1905: for a summary see Giry, *Fauvism, Origins and Development*, pp. 112–26.

Derain's letter to Vlaminck of 28 July 1905: Derain, *Lettres à Vlaminck* (Paris, 1955), p. 116.

p. 67 Matisse's and Derain's visit to Daniel de Monfreid: Giry, *Fauvism, Origins and Development*, pp. 102–3.

Matisse's letter to Signac of 14 July 1905: quoted in Pierre Schneider, *Henri Matisse: Exposition du Centenaire* (Grand Palais, Paris, 1970), p. 68.

Matisse on the naming of Fauvism: E. Tériade, 'Matisse Speaks', *Art News Annual*, 1952, in *Flam*, p. 132.

The reception of the Fauves at the Salon d'Automne of 1905: Ian Dunlop, *The Shock of the New* (London, 1972), pp. 88–119; Elderfield, *The 'Wild Beasts'*, pp. 43–4.

p. 68 Leo Stein on *Woman with the Hat*: Stein, *Appreciation*, pp. 158–9.

Vlaminck on his Fauve method of working: Maurice Vlaminck, *Dangerous Corner* (London, 1961), p. 74.

Matisse on his Fauve method of working: Diehl, *Henri Matisse*, p. 25.

Maurice Denis on Fauvism as abstraction: *L'Ermitage*, 15 November 1905, republished in his *Théories* (Paris, 1964), p. 110.

p. 70 The sources of *Le Bonheur de vivre* in Gauguin: Christopher Rawlence, *Matisse and Oriental Art* (MA report, Courtauld Institute of Art, University of London, 1969), p. 10.

p. 71 The source of *Le Bonheur de vivre* in Agostino Carracci's *Reciprico Amore*: James B. Cuno, 'Matisse and Agostino Carracci', *The Burlington Magazine*, July 1980, pp. 503–4.

p. 72 Ingres as the ancestor of the young 'deformers': Dunlop, *The Shock of the New*, p. 114.

Matisse on Gauguin and Ingres: Henri Matisse, *Verve*, December 1945, in *Flam*, p. 102.

Matisse and Torii Kiyonaga: Robert Reiff, 'Matisse and Torii Kiyonaga', *Art News*, February 1981, pp. 164–7.

Manet and Hokusai's *Manga*: Anne Coffin Hanson, *Manet and the Modern Tradition* (Yale, 1977), p. 185.

Signac's letter to Angrand of 14 January 1906: quoted in *Barr*, p. 82.

p. 73 Matisse to Jean Puy on *Pink Onions*: quoted in *Barr*, p. 77.

p. 74 Matisse to Tériade on Fauvism: E. Tériade, 'Matisse Speaks', *Art News Annual*, 1952, in *Flam*, p. 132.

Derain on Fauvism: Duthuit, *The Fauvist Painters*, p. 49.

Chapter 4: The Grand Decorations, 1907–1910

p. 75 The evolution of the word Fauvism: Elderfield, *The 'Wild Beasts'*, p. 110.

The influence of Fauvism: *ibid.* pp. 141–7; Giry, *Fauvism, Origins and Development*, pp. 247–52.

p. 78 Matisse on the decorative as an essential quality: Léon Degand, 'Matisse à Paris', *Les Lettres Françaises*, October 1945, in *Flam*, p. 106.

Matisse on composition and decoration: Henri Matisse, 'Notes d'un peintre', *La Grande Revue*, December 1908, in *Flam*, p. 36.

p. 79 Matisse on his wish to paint frescos: Aragon, *Henri Matisse: a novel* (London, 1972), vol. I, p. 111.

French attitudes to their colonies: Zeldin, *France 1848–1943*, vol. II, pp. 923–43.

Gide on Biskra: André Gide, *The Fruits of the Earth* (London, 1949), pp. 135–6.

p. 82 The Matisses' Italian journey in 1907: *Barr*, p. 83.

The landscape setting of *Le Luxe* at Collioure: Madame Duthuit, letter to Robert Reiff, 25 July 1978, *Art News*, February 1981, p. 166.

Puvis de Chavannes and the modern tradition: see Richard J. Wattenmaker, *Puvis de Chavannes and the Modern Tradition* (Art Gallery of Ontario, Toronto, 1975), Jacques Foucart, introduction to catalogue *Puvis de Chavannes* (National Gallery of Canada, 1977).

p. 83 The distemper medium of *Le Luxe II*: information supplied to the author by Henrik Bjerre of the Statens Museum for Kunst, Copenhagen.

Matisse's meeting with Picasso: *Barr*, pp. 84–5.

Picasso on Matisse's death: quoted by Reinhold Hohl, 'Matisse und Picasso' in *Henri Matisse* (Kunsthaus Zurich, 1983), p. 38.

Apollinaire's interview with Matisse: *La Phalange*, 15 December 1907, in *Barr*, p. 101.

The Fauves and African sculpture: Robert Goldwater, *Primitivism in Modern Art* (New York, 1938; revised 1967), pp. 86–103.

p. 84 Picasso's chronology and his discovery of African sculpture: William Rubin (ed.), *Pablo Picasso, a Retrospective* (Museum of Modern Art, New York, 1980), pp. 86–8.

Matisse's *Standing Nude* (1907) and *Les Demoiselles d'Avignon*: John Golding, *Matisse and Cubism* (W. A. Cargill Memorial Lectures in Fine Art, University of Glasgow Press, 1978), p. 5.

p. 86 Matisse on Giotto: Henri Matisse, 'Notes d'un peintre', *La Grande Revue*, December 1908, in *Flam*, p. 38.

Matisse to Bonnard on Giotto: Jean Clair (ed.), 'Correspondance Matisse–Bonnard, June 1946', *La Nouvelle Revue Française*, July 1970, p. 70.

Matisse's comparison between Cézanne and Rodin: Henri Matisse, 'Notes d'un peintre', *Le Grande Revue*, December 1908, in *Flam*, pp. 37–8.

The origins and development of Cubism: see John Golding, *Cubism, a History and an Analysis* (London, 1968), pp. 19–46.

p. 87 Matisse's move to the Hôtel Biron: *Barr*, p. 103.

Matisse's school and his teaching: see *Barr*, pp. 116–18; 'Matisse Speaks to His Students', notes by Sarah Stein 1908, in *Barr*, pp. 550–2; Jacques Guenne, 'Entretien avec Henri Matisse', *L'Art Vivant*, September 1925, in *Flam*, p. 56.

Franco-Russian commercial and cultural links: Wright, *France in Modern Times*, p. 273; Musée National d'Art Moderne, Centre Georges Pompidou, *Paris–Moscou 1900–1930* (Paris, 1979), pp. 24–32.

Shchukin and Morozov: Michael Ginsburg, 'Art Collectors of Old Russia: the Morosovs and Shchukins', *Apollo*, December 1973, pp. 470–85.

p. 88 Roger Fry on Chardin: Frances Spalding, *Roger Fry: Art and Life* (London, 1980), p. 109.

Puvis de Chavannes and the *panneau décoratif*: *Puvis de Chavannes* (National Gallery of Canada, 1977), p. 25.

p. 89 Matisse on the changing colour scheme of *The Dinner Table (Harmony in Red)*: quoted in *Barr*, p. 125.

p. 90 Matisse on the transposition of colour: Henri Matisse, 'Notes d'un peintre', *La Grande Revue*, December 1908, in *Flam*, p. 37.

Matisse on his proposed cycle for Shchukin: Charles Estienne, 'Des tendances de la peinture moderne: Entretien avec M. Henri-Matisse', *Les Nouvelles*, 12 April 1909, in *Flam*, p. 49.

Shchukin's commission of *Dance* and *Music*: for a detailed discussion see *Barr*, pp. 132–4; John Hallmark Neff, 'Matisse and Decoration: The Shchukin Panels', *Art in America*, July–August 1975, pp. 42–4; Elderfield, *Matisse in MOMA*, pp. 54–8.

p. 94 Matisse's first contract with the Bernheim-Jeune gallery: *Barr*, p. 133.

Shchukin's letter to Matisse of 31 March 1909: *Barr*, p. 133.

Matisse's prefabricated studio at Issy: *Barr*, p. 104; Elderfield, *Matisse in MOMA*, p. 198.

Matisse's association of the colours of *Dance* with the Mediterranean: Henri Matisse, 'Lettre à Alexandre Romm', October 1934, in *Fourcade*, p. 149.

p. 98 Dance and the Parisian avant-garde: Frank Kermode, *Romantic Image* (London, 1957; 4th impression, 1972), pp. 49–91.

Matisse whistling the farandole while working on *Dance*: Matisse's daughter, Madame Duthuit, in conversation with the author April 1976.

La ronde (the round) as an expression of group consciousness, that 'compulsory neighbourliness of village life': Zeldin, *France 1848–1945*, vol. II, p. 656.

p. 102 The preliminary states of *Music*: for photographs of two of them see Izerghina, *Henri Matisse in Soviet Museums*, p. 153.

J. Tugendhold on the Salon d'Automne of 1910: *Apollon*, no. 12, 1910, quoted in Albert Kostenevich, 'La Danse and La Musique', *Apollo*, December 1974, p. 512.

Shchukin's rejection of *Dance* and *Music*: *Barr*, p. 134.

The date of the arrival of *Dance* and *Music* in Moscow: Y. A. Rusakov, 'Matisse in Russia in the Autumn of 1911', *The Burlington Magazine*, May 1975, p. 288.

Chapter 5: Between Reality and a Dream, 1910–1917

p. 103 Matisse's two Moroccan trips: for further information see Jack D. Flam, 'Matisse in Morocco', *Connoisseur*, vol. CCXI, 1982, pp. 74–86.

p. 106 Matisse on oriental art: Henri Matisse, 'Le Chemin de la couleur', *Art Présent*, 1947, in *Flam*, p. 116.

Matisse's art in 1911: for an illuminating discussion see Jack D. Flam, 'Matisse in 1911: At the Cross-Roads of Modern Painting' in *Actes du 22ᵉ Congrès International d'Histoire de l'Art* (Budapest, 1972), pp. 421–30.

French social attitudes to the family: Ardagh, *The New France*, p. 336.

p. 110 *Interior with Aubergines*: for seminal studies of this painting see Dominique Fourcade, 'Rêver à trois aubergines', *Critique*, vol. XXX, May 1974, pp. 467–89, and his *Matisse au Musée de Grenoble* (1975), p. 18.

The Red Studio: for an excellent summary of the literature on this painting see Elderfield, *Matisse in MOMA*, pp. 86–9.

Goldfish and Sculpture: for a separate study of this painting, *ibid.* pp. 84–6.

Matisse's Russian trip: see Rusakov, 'Matisse in Russia in the Autumn of 1911', pp. 284–91.

p. 111 Matisse on Morocco: E. Tériade, 'Matisse Speaks', *Art News Annual*, 1952, in *Flam*, p. 133.

p. 114 French colonial ambitions in Morocco: Anderson, *France 1870–1914*, pp. 150–1.

Delacroix's attitudes to Morocco: for a recent discussion see Jo Ann Wein, 'Delacroix's Street in Meknes and the Ideology of Orientalism', *Arts Magazine*, June 1983, pp. 106–9.

The links between French Orientalist painting and colonialism: see Linda Nochlin, 'The Imaginary Orient', *Art in America*, May 1983, pp. 119–91.

Pierre Loti: *Au Maroc* (Paris, 1889; trans. E. P. Robins, London, 1892), pp. 7, 8.

French Orientalist painting: Donald A. Rosenthal, *Orientalism: The Near East in French Painting 1800–1880* (Rochester, 1982).

p. 115 Matisse to Maurice Raynal on acanthus plants: quoted in *Barr*, p. 155.

Matisse's postcard to Gertrude Stein of 16 March 1912: quoted in *Barr*, p. 144.

The Blue Window: for detailed analyses of this painting see *Barr*, p. 166, and Elderfield, *Matisse in MOMA*, pp. 90–2.

p. 118 Morozov's wish to have a triptych from Matisse: Izerghina, *Henri Matisse in Soviet Museums*, p. 177.

Gide's description of an Arab café: Gide, *The Fruits of the Earth*, p. 125.

A Persian miniature by Agha Reza and *Arab Café*: *Barr*, p. 160.

p. 119 Marcel Sembat on the different states of *Arab Café*: *Barr*, p. 160.

Apollinaire on Matisse's Bernheim-Jeune exhibition in 1913: *L'Intransigeant*, 28 April 1913, quoted in *Barr*, p. 148.

p. 122 Greta Moll and the Veronese: *Barr*, p. 129.

The chronology of *Jeannette I* to V: Elderfield, *Matisse in MOMA*, pp. 64–71.

The painted portrait of Jeannette: *Girl with Tulips*. 1910. Oil on canvas, 92 × 73.5 cm. Leningrad, Hermitage Museum.

p. 124 *Woman on a High Stool*: 1914. Oil on canvas, 147 × 95.5 cm. New York, Museum of Modern Art. Discussed in Elderfield, *Matisse in MOMA*, pp. 92–4.

The preliminary states of *Portrait of Mademoiselle Yvonne Landsberg*: *Barr*, pp. 184–5.

The preliminary states of *Head, White and Pink*: Monod-Fontaine, *Oeuvres de Henri Matisse*, pp. 38–41.

The statistics of the First World War: Colin Dyer, *Population and Society in Twentieth-Century France* (London, 1978), pp. 29–56; Philippe Bernard, *La Fin d'un monde 1914–1929* (Paris, 1975), pp. 108–10.

p. 126 The census of March 1911: Dyer, *Twentieth-Century France*, pp. 5–28.

Matisse and Gris at Collioure in 1914: *Barr*, p. 178.

Gris's life and work: for further details see Daniel-Henry Kahnweiler, *Juan Gris, sa vie, son oeuvre, ses écrits* (Paris, 1946; London, 1969); Douglas Cooper and Margaret Potter, *Juan Gris, catalogue raisonné de l'oeuvre peint* (Paris, 1977).

p. 127 Henri Bergson and the cult of the irrational: Zeldin, *France 1848–1945*, vol. II, pp. 1142–4.

Bergson on the possession of space: Henri Bergson, *Creative Evolution* (London, 1911; reprinted 1964), p. 213.

p. 129 Matisse's etchings in 1914: for illustrations see *Henri Matisse 1869–1954: Gravures et Lithographies* (Musée d'Art et d'Histoire, Fribourg, 1982), pp. 20–34; William S. Lieberman, *Matisse: Fifty Years of his Graphic Art* (New York, 1956), pp. 36–51.

Matisse on his romantic and rationalist sides: letter dated to autumn 1914, in Danièle Giraudy (ed.), 'Correspondance Henri Matisse–Charles Camoin', *Revue de l'Art*, no. 12, 1971, p. 17.

Matisse on Cubism as realism: E. Tériade, 'Matisse Speaks', *Art News Annual*, 1952, in *Flam*, p. 134.

p. 130 *Goldfish* (1914–15) and *Variation on a Still-Life by de Heem*: for lengthy discussions of these paintings see Elderfield, *Matisse in MOMA*, pp. 100–2, 105–8.

Matisse on his original conception of *Bathers by a River*: Charles Estienne, 'Entretien avec M. Henri-Matisse', *Les Nouvelles*, 12 April 1909, in *Flam*, p. 49.

The transitional state of *Bathers by a River* photographed in 1913: Neff, 'Matisse and Decoration: The Shchukin Panels', p. 46.

p. 133 The symbol of the snake in *Bathers by a River*: Frank Trapp, 'Form and Symbol in the Art of Matisse', *Arts Magazine*, May 1975, p. 58.

The preliminary states of *Bathers by a River*: Inge Fielder, unpublished conservation report (Art Institute of Chicago).

Matisse on the war not influencing his subject-matter: E. Tériade, 'Matisse Speaks', *Art News Annual*, 1952, in *Flam*, p. 134.

Matisse on his feelings at not being at the front: letter to Hans Purrmann, 1 June 1916, published in *Barr*, pp. 181–2.

The Backs: for a fuller discussion see Jack D. Flam, 'Matisse's Backs and the Development of his Painting', *Art Journal*, vol. XXX, summer 1971, pp. 352–61; Elsen, *The Sculpture of Henri Matisse*, pp. 174–97; Elderfield, *Matisse in MOMA*, pp. 72–80.

p. 134 The genesis of *The Moroccans*: for a recent X-ray photograph and a detailed analysis see Elderfield, *Matisse in MOMA*, pp. 110–13.

Matisse's letter to Camoin of 22 November 1915: Giraudy, 'Matisse–Camoin', p. 18.

Matisse's letter to Camoin of 19 January 1916: Giraudy, 'Matisse–Camoin',

p. 19. According to John Elderfield this date is erroneous and should read as 19 July 1916 (*Matisse in MOMA*, p. 211).

p. 135 The source of *The Window*: Barr, p. 190.

p. 138 *Piano Lesson*: for a summary of the literature on this painting see Elderfield, *Matisse in MOMA*, pp. 114–16.
A surrogate self-portrait in *Piano Lesson*: Jack D. Flam, 'Matisse in Two Keys', *Art in America*, July–August 1975, pp. 83–6.
Pierre Matisse on *Piano Lesson*: letter to the author, November 1976.

p. 139 Matisse on *Gourds* and black: Barr, p. 190.
Matisse quotes Pissarro on Manet: André Marchand, 'L'Oeil' in Jacques Kober (ed.), *Henri Matisse* (Paris, 1947), in *Flam*, p. 114.
Matisse's collectors and exhibitions 1915–17: Barr, p. 180.
Pierre Matisse on the rapidity of *Music Lesson*'s execution: Barr, p. 194.

Chapter 6: Nice, 1918–1929

p. 142 France between the wars: see Dyer, *Twentieth-Century France*, pp. 57–86; Bernard, *La Fin d'un monde 1914–1929*, pp. 131–237; Alfred Cobban, *A History of Modern France*, vol. 3 (London, 1965; reprinted 1981), pp. 121–57.
Matisse and *Parade*: see Jack D. Flam, '*Jazz*', in *Henri Matisse: Paper Cut-Outs* (St Louis–Detroit, 1977), pp. 37–47.

p. 143 Matisse on modern methods leading to Mannerism: Ragnar Hoppe, 'På visit hos Matisse' (1919), in Dominique Fourcade, 'Autres propos de Henri Matisse', *Macula*, no. 1, 1976, p. 94.
The foreign population of Nice: Dyer, *Twentieth-Century France*, p. 77.
Matisse on the black of *Interior with a Violin*: Ragnar Hoppe, 'På visit hos Matisse' (1919), in Fourcade, 'Autres propos', p. 94.
Matisse to Aragon on Nice: Aragon, *Henri Matisse: a novel*, vol. I, p. 120.

p. 145 Matisse to Masson on light and Impressionism: André Masson, 'Conversations avec Henri Matisse', *Critique*, May 1974, pp. 394–5.

p. 146 Matisse painting *en plein air* at Cherbourg: Pierre Matisse, letter to the author, November 1976.
Matisse's letter to Camoin of May 1918: Giraudy, 'Matisse–Camoin', p. 21.
Matisse on working with neutral tones: Ragnar Hoppe, 'På visit hos Matisse' (1919), in Fourcade, 'Autres propos', p. 93.
Matisse to Gaston Diehl on the war landscapes: Diehl, *Henri Matisse*, p. 57.
Matisse on wanting to go beyond the Impressionist stage: Ragnar Hoppe, 'På visit hos Matisse' (1919), in Fourcade, 'Autres propos', p. 94.

p. 150 Matisse on the *grand style* and the *demi-teinte*: letter to Camoin, May 1918, in Giraudy, 'Matisse–Camoin', p. 21.

p. 151 Matisse on the light of the interior and exterior: quoted in Elderfield, *Matisse in MOMA*, p. 118.
Renoir's comment to Matisse on black: Matisse to Pierre Courthion, 1941, in Fourcade, 'Autres propos', p. 102.
Matisse's daughter, Marguerite Duthuit, on her father and Renoir: in conversation with the author, April 1976.
Matisse to Frank Harris on Cézanne and Renoir: Fourcade, 'Autres propos', p. 96.
Matisse on Renoir's *The Bathers*: ibid. p. 97.

p. 154 Matisse on Renoir's technique: letter to Alexandre Romm, October 1934, in *Flam*, p. 70.
Matisse on Michelangelo: letter to Camoin, May 1918, in Giraudy, 'Matisse–Camoin', p. 21.
Renoir on Michelangelo: Walter Pach, *Renoir* (New York, 1960), p. 21.

p. 155 Matisse making the plumed hat: Barr, p. 206.

p. 159 Matisse on the Hôtel de la Méditerranée: Francis Carco, 'Conversation avec Matisse' (1941) in *L'Ami des peintres* (Paris, 1953), in *Flam*, pp. 85–6.
Matisse on *Young Girl in Green*: Mr and Mrs Ralph Colin in conversation with the author, September 1980.

p. 160 Matisse's life in Nice: Barr, p. 195.

p. 162 Bonnard: for the most complete list of his paintings see J. and H. Dauberville, *Pierre Bonnard, catalogue raisonné de l'oeuvre*, 3 vols. and supplement (Paris, 1965–75).

Bonnard's painting technique in 1920: for an analysis see Nicholas Watkins, 'Pierre Bonnard's *Interior at Antibes*', in Waldemar Januszczak (ed.), *Techniques of the World's Great Painters* (Oxford, 1980), pp. 142–5.
Meyer Shapiro on Matisse and Impressionism: *Androcles*, February 1932, p. 21.
Matisse on why he painted odalisques: E. Tériade, 'Visite à Henri Matisse', *L'Intransigeant*, January 1929, in *Flam*, p. 59.
Matisse distinguishing his art from Renoir's: Fourcade, 'Autres propos', p. 102.
Matisse on the secret of his art: Jacques Guenne, 'Entretien avec Henri Matisse', *L'Art Vivant*, 15 September 1925, in *Flam*, p. 55.

p. 164 The different states of *Large Seated Nude*: see Elsen, *The Sculpture of Henri Matisse*, pp. 144–53.
The dating of *Decorative Figure on an Ornamental Background*: Monod-Fontaine, *Oeuvres de Henri Matisse*, pp. 57–61.

Chapter 7: The Classical Decade, 1930–1940

p. 167 Matisse's reputation by 1930: see Barr, pp. 198–203, 221–2.
Contracts between Matisse and Bernheim-Jeune: Barr, pp. 553–5.
Marcel Sembat's Matisse collection: Fourcade, *Matisse au Musée de Grenoble*, pp. 3–20.
Matisse's collectors: see Margrit Hahnloser-Ingold, 'Matisse und seiner Sammler' in *Henri Matisse* (Kunsthaus Zurich, 1982), pp. 41–63.
The Cones' collection: Baltimore Museum of Art, *Paintings, Sculpture and Drawings in the Cone Collection* (Baltimore, 1955; revised 1967), pp. 7–15.

p. 168 The formation of the Matisse collection in the Museum of Modern Art: Elderfield, *Matisse in MOMA*, pp. 9–10.
Young intellectuals and the 1930s: Henri Dubief, *Le Déclin de la Troisième République 1929–1938* (Paris, 1976), p. 60.
Matisse's position in the eyes of young artists in the 1930s: Sir Roland Penrose in conversation with the author, September 1982.

p. 169 The Club Méditerranée and the perpetuation of the Polynesian vision of leisure: Ardagh, *The New France*, p. 433.
Matisse's interview with Tériade: *L'Intransigeant*, October 1930, in *Flam*, p. 60.

p. 170 Matisse on his search for a larger space and Tahiti: Aragon, *Henri Matisse: a novel*, vol. I, p. 208.
Matisse's rivalry with Picasso and the Mallarmé commission: Brassaï, *Picasso & Co.* (London, 1967), p. 8.
Matisse on his construction of a book: 'Comment j'ai fait mes livres' in *Anthologie du livre illustré par les peintres et sculpteurs de l'école de Paris* (Geneva, 1946), pp. 21–4, in *Flam*, pp. 107–9.

p. 171 Matisse on the sources of *Tiari*: Aragon, *Henri Matisse: a novel*, vol. I, p. 9.

p. 172 The commission for the Barnes murals: Barr, p. 220.
Dr Barnes and his Foundation: Lois G. Forer, 'No Place for the Rabble', *Horizon*, spring 1964, pp. 4–7, 90–5.
Matisse to Simon Bussy: Jane Simone Bussy in an unpublished memoir of Matisse.

p. 173 Matisse's studies for the Barnes murals: these are now in the Musée Matisse, Nice-Cimiez.
Matisse to Raymond Escholier on the Barnes murals: Escholier, *Matisse from the Life*, p. 113.

p. 174 Matisse's décor for *Le Chant du Rossignol*: Melissa McQuillan, 'An Aspect of the Relationship between Art and Theatre' (Ph.D. dissertation, Institute of Fine Art, New York University, October 1979), pp. 484–5.
Matisse at work on the ballet in London in 1919: Vladimir Polunin, *The Continental Method of Scene Painting* (London, 1927), p. 61.
Matisse on returning to the first version of the Barnes murals in 1933: Henri Matisse, 'Lettre à Bussy', 16 October 1933, in *Fourcade*, p. 143.
Matisse on the differences between the two versions of the Barnes murals: letter to Alexandre Romm, 19 January 1934, in *Flam*, p. 68.

p. 175 Matisse on his intention to harmonize the mural with the architecture: *ibid.* pp. 68–9.
Joseph Pulitzer Jun. on the qualities of *The Conservatory*: letter to the author, 18 November 1980.

p. 176 Matisse on the importance of his models: Henri Matisse, 'Notes d'un peintre sur son dessin', *Le Point*, no. 21, July 1939, in *Flam*, pp. 81–2.

p. 177 Photographs of the seven states of *The Dream* and Matisse's quotation: Monod-Fontaine, *Oeuvres de Henri Matisse*, pp. 64–9.

p. 178 Matisse on drawing as the most direct translation of his emotion: Henri Matisse, 'Notes d'un peintre sur son dessin', *Le Point*, no. 21, July 1939, in *Flam*, p. 81.

p. 179 The commission for the Beauvais tapestry: *Barr*, p. 250.

p. 182 Matisse on his wish to re-create Oceania in Montparnasse: Brassaï, *The Artists of My Life*, p. 124.
Matisse's study for *Calypso*: for an illustration see Victor I. Carlson, *Matisse as a Draughtsman* (Baltimore Museum of Art, 1971), p. 133.
Montherlant's Pasiphaé and the Minotaur: Paul Ginestier, *Montherlant* (Paris, 1973), p. 14.
Matisse's programme for *Rouge et Noir*: *Barr*, p. 254.
Matisse on his return to Fauvism: E. Tériade, 'Constance du fauvisme', *Minotaure*, October 1936, in *Flam*, p. 74.

p. 183 Progress photographs of ten states of *Lady in Blue*: see *Magazine of Art*, July 1939, p. 414.

p. 187 Rockefeller's proposed commission of a mural for the Rockefeller Center in 1932 and his commission of the overmantel: see *Barr*, pp. 220–1, 252.

p. 188 Matisse's art of the 1930s compared to illustrations in *Harper's Bazaar*: *Magazine of Art*, July 1939, p. 415.

p. 190 The acquisition of *Music* (1939): Pierre Matisse, letter to the then director of the Albright-Knox Art Gallery, Gordon Washburn, 28 May 1940.
France in 1939: Dyer, *Twentieth-Century France*, pp. 87–104.
Brassaï on Matisse at work in Villa Alésia: Brassaï, *The Artists of My Life*, p. 128.

p. 191 Matisse at Rochefort-en-Yveline and Geneva: Aragon, *Henri Matisse: a novel*, vol. I, p. 27; Izerghina, *Henri Matisse in Soviet Museums*, p. 184.
Progress photographs of *The Romanian Blouse*: see Monod-Fontaine, *Oeuvres de Henri Matisse*, pp. 76–9; Diehl, *Henri Matisse*, pp. 49–50.

p. 194 Matisse's journeys in 1940: *Barr*, p. 225; Aragon, *Henri Matisse: a novel*, vol. I, p. 136; Brassaï, *The Artists of My Life*, p. 136.
Matisse to Pallady: *Fourcade*, p. 187.

Chapter 8: An Internal Paradise, 1941–1954

p. 195 Matisse on being given a second life: letter to Albert Marquet, 16 January 1942, in *Fourcade*, p. 288.
French attitudes to the occupation: Dyer, *Twentieth-Century France*, pp. 104–16.
Matisse on his 'farm' in the Hôtel Régina: Francis Carco, 'Conversation avec Matisse' (1941) in *L'Ami des peintres* (Paris, 1953), in *Flam*, p. 85.

p. 198 Matisse to Bonnard on his drawing separating from his painting: letter, 13 January 1940, in Clair, *Matisse–Bonnard*, p. 92.
Matisse to his son Pierre on drawing in 1942: quoted in *Barr*, p. 268.
Aragon on the *camera lucida*: Aragon, *Henri Matisse: a novel*, vol. I, p. 58.

p. 199 Matisse on his illustrated books: Henri Matisse, 'Comment j'ai fait mes livres' in *Anthologie du livre illustré par les peintres et sculpteurs de l'école de Paris* (Geneva, 1946), in *Flam*, pp. 107–9.

p. 202 Matisse to Aragon on 1 September 1942: Aragon, *Henri Matisse: a novel*, vol. I, p. 178.
Matisse on making progress with colour: letter to André Rouveyre, 31 March 1943, in *Fourcade*, p. 192.

p. 203 Matisse's letter to Aragon of 22 August 1943: Aragon, *Henri Matisse: a novel*, vol. I, pp. 187–8.

p. 206 Matisse on 'this penny, plaything': Matisse to Tériade, 7 March 1944, in *Henri Matisse: Paper Cut-Outs* (St Louis–Detroit, 1977), p. 278.
Matisse on the paper cut-out medium in 1951: André Lejard, 'Propos de Henri Matisse', *Amis de l'Art*, October 1951, in *Fourcade*, p. 243.

Matisse on 'cutting directly into colour . . .': Henri Matisse, *Jazz* (Paris, 1947), in *Flam*, p. 112.
Jazz once called *The Circus*: Jack D. Flam, '*Jazz*' in *Henri Matisse: Paper Cut-Outs* (St Louis–Detroit, 1977), p. 101.
Quotations from Matisse's *Jazz* text: *Flam*, pp. 111–13.

p. 207 The symbolism of the red heart: *Henri Matisse: Paper Cut-Outs* (St Louis–Detroit, 1977), p. 108.
The meaning of *Destiny*: *ibid.* p. 112.

p. 208 The rebirth of a nation: Dyer, *Twentieth-Century France*, pp. 133–74.

p. 210 Matisse's reputation in 1945: *Barr*, p. 259.
Leda: 1944–6/7. Oil on wood, 183 × 160 cm. Now in the collection of Monsieur and Madame Adrien Maeght.
Matisse on *Oceania* in 1946: Brassaï, *The Artists of My Life*.
Matisse on the golden light of the Pacific: Henri Matisse, 'Océanie, teinture murale', *Labyrinthe*, December 1946, in *Flam*, p. 110.
Zika Ascher's solution: *Henri Matisse: Paper Cut-Outs* (St Louis–Detroit, 1977), p. 125.

p. 211 Matisse on the joint Matisse–Picasso exhibition: Brassaï, *The Artists of My Life*, p. 138.
Matisse on the difference between the *Jazz* maquettes and illustrations: letter to André Rouveyre, 25 December 1947, in *Fourcade*, p. 240.
Matisse on the sensibility of his hand: letter to Erik Zahle, 15 February 1950, in *Henri Matisse: Paper Cut-Outs* (St Louis–Detroit, 1977), p. 138.
Matisse on there being no separation between his pictures and cut-outs: Maria Luz, 'Témoignages: Henri Matisse', *XXᵉ Siècle*, January 1952, in *Flam*, p. 137.

p. 212 The sources of the images of *The Panel with Mask*: *Henri Matisse: Paper Cut-Outs* (St Louis–Detroit, 1977), p. 139.

p. 213 Matisse on the qualities of his large brush-drawings: quoted in Monod-Fontaine, *Oeuvres de Henri Matisse*, p. 100.
Matisse on 'An avalanche of colour. . .': Henri Matisse, 'Rôle et modalités de la couleur' in Gaston Diehl, *Problèmes de la peinture* (Lyons, 1945), in *Flam*, p. 99.

p. 214 The correspondence between Matisse and Sister Marie-Ange: for extracts see Norbet Calmels, *Matisse: La Chapelle du Rosaire des Dominicaines de Vence et de l'Espoir* (Digne, 1975).
How Matisse became involved in the Chapel: see Lydia Delectorskaya, 'The True Story of the Vence Chapel' in Aragon, *Henri Matisse: a novel*, vol. II, pp. 183–5.

p. 215 *The Bees* and its symbolism: see *Henri Matisse: Paper Cut-Outs* (St Louis–Detroit, 1977), p. 151.

p. 216 Matisse on the qualities of the stained-glass windows and the ceramic murals: Henri Matisse, 'Chapelle du Rosaire des Dominicaines de Vence', *France Illustration*, 1 December 1951, in *Flam*, pp. 129–30.
Matisse on his religion: André Verdet, 'Entretiens avec Henri Matisse' in *Prestiges de Matisse* (Paris, 1952), in *Flam*, p. 144.
Matisse on his efforts for the image of St Dominic: Gotthard Jedlicka, *Die Henri-Matisse-Kapelle in Vence* (Frankfurt, 1955), p. 78.

p. 217 Matisse on the white background of his cut-outs: *ibid.* p. 144.

p. 218 Matisse's advice to young artists: letter to Henry Clifford, 1948, in *Flam*, p. 121.
Matisse compares his drawing to an acrobat's performance: Léon Degand, 'Matisse à Paris', *Les Lettres Françaises*, October 1945, in *Flam*, p. 103.

p. 219 The different states of *The Parakeet and the Mermaid*: see *Henri Matisse: Paper Cut-Outs* (St Louis–Detroit, 1977), pp. 232–5.

Postscript

p. 221 Matisse and the Musée National d'Art Moderne, Paris: Monod-Fontaine, *Oeuvres de Henri Matisse*, pp. 9–12.
Clement Greenberg on Matisse: 'Art Chronicle', *Partisan Review*, 1952; *Barr*, p. 265.
Matisse and America: Franz Meyer, 'Matisse und die Amerikaner', in *Henri Matisse* (Kunsthaus Zurich, 1982), pp. 64–75.

Bibliography

Alfred Barr, Jun.'s *Matisse: His Art and His Public* (1951) is still, after over thirty years, the standard work on the artist, and the omission from it of the final flowering of the paper cut-outs has recently been more than adequately rectified by the important exhibition catalogue *Henri Matisse: Paper Cut-Outs* (1977) compiled by Jack Cowart, Jack D. Flam, Dominique Fourcade, and John Hallmark Neff. Matisse's published statements are gathered together in two extremely useful books, Dominique Fourcade's *Henri Matisse, écrits et propos sur l'art* (1972), supplemented by his 'Autres propos de Henri Matisse', *Macula*, no. 1 (1976), and Jack D. Flam's *Matisse on Art* (1973). Matisse's published correspondence with his painter friends Pallady (Barbu Brezianu, ed., *Secolul 20*, no. 6, 1965), Bonnard (Jean Clair, ed., *La Nouvelle Revue Française*, no. 211, July 1970, and no. 212, August 1970), and in particular Camoin (Danièle Giraudy, ed., *Revue de l'Art*, no. 12, 1971) provide fascinating first-hand commentaries on his life and work. Albert E. Elsen's *The Sculpture of Henri Matisse* (1972) is the definitive book on the subject. In the absence of the long-awaited *catalogue raisonné* of Matisse's art the most comprehensive source of reference for his graphic work is the exhibition catalogue *Henri Matisse: Gravures et Lithographies* (1982) compiled by Margrit Hahnloser-Ingold and Roger Marcel Mayou. Matisse's drawings have been published in a number of exhibition catalogues, notably *Matisse as a Draughtsman* (1971) by Victor I. Carlson and *Henri Matisse: Dessins et Sculpture* (1975) selected by Dominique Fourcade. The catalogues of the Matisse collections in the Museum of Modern Art, New York, by John Elderfield (with additional texts by William S. Lieberman and Riva Castleman), in Soviet Museums, introduced by A. Izerghina, and in the Musée National d'Art Moderne, Centre Georges Pompidou, Paris, by Isabelle Monod-Fontaine, provide essential documentation on their respective holdings. Pierre Schneider's seminal catalogue *Henri Matisse: Exposition du Centenaire* (1970) is an important source of reference for the paintings. His substantial study of Matisse's art is published this year (1984). *L'opera di Matisse, 1904–1928* (1971), presented by Mario Luzi, is another useful source of reference for the paintings, even though it is neither totally comprehensive nor entirely accurate. Louis Aragon's two highly personal volumes *Henri Matisse: a novel* (1972) contain an excellent body of colour plates and much first-hand material. Sir Lawrence Gowing's essay, first published in 1966 and enlarged into a book in 1979, remains one of the most inspiring short introductions to Matisse. Matisse's involvement with Fauvism has been the subject of several books and studies: Georges Duthuit's *The Fauvist Painters* (1950), Jean-Paul Crespelle's *The Fauves* (1962), Gaston Diehl's *The Fauves* (1975), Ellen C. Oppler's 'Fauvism Re-examined' (Ph.D. dissertation, Columbia University, New York, 1969), Jean Leymarie's *Fauvism* (1959), W. J. Cowart's 'Ecoliers to Fauves, Matisse, Marquet, and Manguin Drawings: 1890–1906' (Ph.D. dissertation, Johns Hopkins University, Baltimore, 1972), Richard J. Wattenmaker's *The Fauves* (1975), John Elderfield's *The 'Wild Beasts': Fauvism and its Affinities* (1976), and Marcel Giry's *Fauvism, Origins and Developments* (1981). Catherine C. Bock's *Henri Matisse and Neo-Impressionism* (1977) shows how his Fauve paintings partly grew out of Neo-Impressionism. John Hallmark Neff's 'Matisse and Decoration, 1906–1914' (Ph.D. dissertation, Harvard University, 1974) investigates this crucial issue in Matisse's art; John Golding's perceptive lecture *Matisse and Cubism* (1978) introduces another important aspect of his work; and in two recent essays, 'Matisse und das

Goldene Zeitalter' in *Henri Matisse, Das Goldene Zeitalter* (1981) and '"The Figure in the Carpet", Matisse und das Dekorative' in *Henri Matisse* (1982), Pierre Schneider traces the theme of the Golden Age, which he sees as the principal motivating force behind Matisse's move to the decorative, culminating in his late paper cut-outs. However, apart from the catalogue *Henri Matisse: Paper Cut-Outs* (1977), the studies of Fauvism, and John Elderfield's useful introductory essay *The Cut-Outs of Henri Matisse* (1978), there are remarkably few books on the other periods in his long career. Among the many general accounts of Matisse's work which contain fresh insights and new information are: Roger Fry's *Henri-Matisse* (1935), Clement Greenberg's *Matisse* (1955), Jacques Lassaigne's *Matisse* (1959), Jean Guichard-Meili's *Matisse* (1967), Alan Bowness's *Matisse et le nu* (1969), John Russell's *The World of Matisse, 1869–1954* (1969), and John Jacobus's *Matisse* (1972). Numerous other useful books, articles, and catalogues are listed in the source references and bibliography. Theodore Zeldin's two volumes *France 1848–1945* (1973 and 1977) are indispensable reading for the social background of the period.

Ades, Dawn. *Dada and Surrealism Reviewed*. London, 1978.
Albers. *Interaction of Colour*. Yale, 1963.
Alpatow, Michael W. *Matisse*. Moscow, 1969 (Dresden, 1973).
Anderson, R. D. *France 1870–1914*. London, 1977.
Angrand, P. *Naissance des Artistes Indépendants*. 1884 (Paris, 1965).
Apollinaire. *Apollinaire on Art*. London, 1972.
Aragon. *Henri Matisse: a novel*. 2 vols. English edition, London, 1972.
Ardagh, John. *The New France*. London, 1981.
Ardalan, N. and Bakhtair, L. *The Sense of Unity*. Chicago, 1973.
Arnheim, R. *Visual Thinking*. London, 1970.
Ashton, Dore. 'Matisse and Symbolism'. *Arts Magazine*, May 1975.
Asplund, K. 'Henri-Matisse'. *Cahiers d'Art*, 1931.

Baltimore Museum of Art. *Paintings, Sculpture and Drawings in the Cone Collection*. Baltimore, 1955 (revised 1967).
Barnes, Albert C. *The Art in Painting*. New York, 1925.
—— and de Mazia, Violette. *The Art of Henri Matisse*. New York, 1933.
Barr, Alfred H., Jun. *Picasso: Fifty Years of his Art*. New York, 1946.
—— *Matisse: His Art and His Public*. New York, 1951.
Basler, Adolphe. *Henri Matisse*. Leipzig, 1924.
Bauman, Lydia, 'H. Matisse – illustrator of poetry, 1930–1950'. MA report, Courtauld Institute of Art, University of London, 1980.
Bazin, Germain. *Impressionist Paintings in the Louvre*. London, 1958.
Bell, Clive. *Art*. London, 1914.
—— 'Matisse and Picasso'. *New Statesman*, 1933.
Bernard, E. 'Souvenirs sur Paul Cézanne et lettres inédites'. *Mercure de France*, October 1907.
Bernard, Philippe. *La Fin d'un monde 1914–1929*. Paris, 1975.
Besson, Georges. *Matisse*. Paris, 1945.
—— 'Matisse et Renoir, il y a trente-cinq ans'. *Les Lettres Françaises*, December 1952.
Birren, Faber. *Color Perception in Art*. New York, 1976.

Blanc, C. M. *Grammaire des arts du dessin*. Paris, 1867.

Bock, Catherine C. *Henri Matisse and Neo-Impressionism*. Los Angeles, 1977.

Boime, A. 'Le Musée des copies'. *Gazette des Beaux-Arts*, vol. LXIV, 1964.

—— 'Georges Rouault and the Academic Curriculum'. *Art Journal*, vol. XXIX, fall 1969.

—— 'Jean Léon Gérôme, Henri Rousseau's Sleeping Gypsy and the Academic Legacy'. *Art Quarterly*, vol. 34, 1971.

—— *The Academy and French Painting in the Nineteenth Century*. London, 1971.

Bowness, A. *Matisse et le nu*. Paris and Lausanne, 1969.

Bowsma, O. K. 'The Expression Theory of Art' in Max Black (ed.), *Philosophical Analysis*. New York, 1950 and 1971.

Braquemond, F. *Du dessin et de la couleur*. Paris, 1885.

Brassaï. *Picasso & Co*. London, 1967.

—— *The Artists of My Life*. London, 1982.

Brereton, G. *An Introduction to the French Poets, Villon to the Present Day*. London, 1956.

Brezianu, Barbu (ed.). 'Correspondance Matisse–Pallady'. *Secolul 20*, no. 6, 1965.

—— 'Matisse et Pallady: leur amitié et leurs relations artistiques' in *Actes du 22ᵉ Congrès Internationale d'Histoire de l'Art*. Budapest, 1969.

Brill, F. *Matisse*. London, 1967.

Brookner, Anita. *The Genius of the Future*. London, 1971.

Brown. F. 'Impressionist Technique, Pissarro's Optical Mixture'. *Magazine of Art*, January 1950.

Brown, M. W. *The Story of the Armory Show*. New York, 1953.

Cachin, Françoise. *Paul Signac*. Milan, 1970.

Cahiers d'Art: no. 5, 1926; no. 7, 1926; no. 7/8, 1927; no. 7, 1928; no. 10, 1929; no. 2, 1930; no. 5/6, 1931; no. 3/4, 1940; 1940–4; 1947; no. 1, 1949.

Callen, Anthea. *Techniques of the Impressionists*. London, 1982.

Calmels, Norbert. *Matisse: 'La Chapelle du Rosaire des Dominicaines de Vence et de l'Espoir'*. Digne, 1975.

Carco, F. 'L'Ami des peintres'. *La Nouvelle Revue Française*, 1953.

Carlson, Victor I. *Matisse as a Draughtsman*. Exhibition catalogue, Baltimore Museum of Art, 1971.

Carpenter, J. M. *Color in Art*. Exhibition catalogue, Harvard University, 1974.

Cartier, J-A. 'Gustave Moreau, Professeur à l'École des Beaux-Arts'. *Gazette des Beaux-Arts*, May–June 1963.

Cassou, Jean. *Matisse*. London, 1948.

—— *Henri Matisse, carnet de dessins*. Paris, 1955.

Champa, K. S. *Studies in Early Impressionism*. Yale, 1973.

Chassé, C. *The Nabis and their Period*. London, 1969.

Chevreul, M. E. *De la loi du contraste simultane des couleurs*. Paris, 1839 (English edition, *The Principles of Harmony and Contrast of Colours and their Applications to the Arts*, New York, 1967).

Chipp, H. B. 'Orphism and Color Theory'. *Art Bulletin*, March 1958.

—— *Theories of Modern Art*. Berkeley and Los Angeles, 1968.

Clair, Jean. 'La Tentation de l'Orient'. *La Nouvelle Revue Française*, July 1970.

—— (ed.) 'Correspondance Matisse–Bonnard'. *La Nouvelle Revue Française*, July and August 1970.

Clark, T. J. *The Image of the People*. London, 1973.

Cobban, Alfred. *A History of Modern France. Vol. 3, 1871–1962*. London, 1965 (reprinted 1981).

Cogniat, Raymond. *Bonnard*. Milan, 1968.

Collingwood, R. G. *The Principles of Art*. London, 1970.

Compin, Isabelle. *Henri-Edmond Cross*. Paris, 1964.

Cooper, Douglas. *The Cubist Epoch*. London, 1970.

—— *Braque: The Great Years*. London, 1973.

—— and Potter, Margaret. *Juan Gris, catalogue raisonné de l'oeuvre peint*. Paris, 1977.

—— and Tinterow, Garry. *The Essential Cubism: Braque, Picasso, and their Friends 1907–1920*. Exhibition catalogue, Tate Gallery, London, 1983.

Courthion, Pierre. *Henri-Matisse*. Paris, 1934.

—— *Le Visage de Matisse*. Lausanne, 1942.

—— *Georges Rouault*. London, 1962.

Cowart, W. J. 'Ecoliers to Fauves, Matisse, Marquet, and Manguin Drawings: 1890–1906.'. Ph.D. dissertation, Johns Hopkins University, Baltimore, 1972.

—— 'Matisse's Artistic Probe: the Collage'. *Arts Magazine*, May 1975.

—— Introduction to catalogue *Henri Matisse: Paper Cut-Outs*. St Louis Art Museum and Detroit Institute of Arts, 1977.

—— '"Je sens le bois des îles"": Matisse at Vence'. *Art International*, vol. XXII/6, 1978.

Crespelle, Jean-Paul. *The Fauves*. London, 1962.

Cuno, James B. 'Matisse and Agostino Carracci'. *The Burlington Magazine*, July 1980.

Dauberville, J. and H. *Pierre Bonnard, catalogue raisonné de l'oeuvre*. 3 vols. and supplement. Paris, 1965–75.

Delacroix. *The Journal of Eugène Delacroix*. London, 1938.

Denvir, Bernard. *Fauvism and Expressionism*. London, 1975.

Derain. *Lettres à Vlaminck*. Paris, 1955.

Diehl, Gaston. *Henri Matisse*. Paris, 1954.

—— *Les Fauves*. Paris, 1971.

—— *The Fauves*. New York, 1975.

Doerner, M. *The Materials of the Artist*. London, 1976.

Dorival, Bernard. *Les Peintres du XXᵉ siècle*. Paris, 1957.

—— 'Henri Matisse ou le triomphe de l'intelligence' in *Actes du 22ᵉ Congrès International d'Histoire de l'Art*. Budapest, 1972.

Dorra, H. and Rewald, J. *Seurat*. Paris, 1959.

Dubief, H. *Le Déclin de la Troisième République 1929–1938*. Paris, 1976.

Dunlop, I. *The Shock of the New*. London, 1972.

Duthuit, Georges. *Les Fauves*. Geneva, 1949 (English edition, *The Fauvist Painters*, New York, 1950).

—— 'Le Tailleur de lumière'. *Verve*, 1958.

Dyer, Colin. *Population and Society in Twentieth-Century France*. London, 1978.

Eastlake, C. L. *Methods and Materials of Painting of the Great Schools and Masters*. New York, 1960.

Eckermann. *Conversations with Goethe*. London, 1935.

Elderfield, John. 'Matisse: Drawings and Sculpture'. *Artforum*, September 1972.

—— *The 'Wild Beasts': Fauvism and its Affinities*. Museum of Modern Art, New York, 1976.

—— with contributions from Riva Castleman and William S. Lieberman. *Matisse in the Collection of The Museum of Modern Art*. New York, 1978.

—— *The Cut-Outs of Henri Matisse*. London, 1978.

Elliot, E. C. 'Some Recent Conceptions of Colour Theory'. *Journal of Aesthetics and Art Criticism*, June 1960.

Elsen, Albert E. *The Sculpture of Henri Matisse*. New York, 1972.

—— *Origins of Modern Sculpture: Pioneers and Premises*. London, 1974.

Escholier, Raymond. *Matisse, ce vivant*. Paris, 1956 (English edition, *Matisse from the Life*, London, 1960).

Esteban, C. 'Une limpidité nécessaire'. *La Nouvelle Revue, Française*, vol. 36, no. 211, 1970.

Evans, R. M. *An Introduction to Color*. New York, 1948.

Evenepoel, H. 'Gustave Moreau et Henri Evenepoel'. *Mercure de France*, January 1923.

Fels, Florent. *Henri Matisse*. Paris, 1929.

Fénéon, F. *Au delà de l'impressionisme*, ed. Françoise Cachin. Paris, 1966.

Flam, Jack D. 'Matisse in 1911: At the Cross-Roads of Modern Painting' in *Actes du 22ᵉ Congrès International d'Histoire de l'Art*. Budapest, 1972.

—— 'Matisse's Backs and the Development of his Paintings'. *Art Journal*, vol. XXX, summer 1971.

—— *Matisse on Art*. London, 1973.

—— 'Some Observations on Matisse's Self-Portraits'. *Arts Magazine*, May 1975.

—— 'Matisse in Morocco'. *Connoisseur*, vol. CCXI, 1982.

Forer, Lois G. 'No Place for the Rabble'. *Horizon*, spring 1964.

Forge, A., Hodgkin, H. and King, P. 'The Relevance of Matisse'. *Studio*, July 1968.

Forges, M. T. Lemoyne de. *Signac*. Exhibition catalogue, Musée du Louvre, Paris, 1964.

Fourcade, Dominique. *Henri Matisse, écrits et propos sur l'art*. Paris 1972.

—— 'Rêver à trois aubergines'. *Critique*, vol. XXX, May 1974.

—— *Matisse au Musée de Grenoble*. Grenoble, 1975.

—— Introduction to catalogue *Henri Matisse: Dessins et Sculpture*. Musée National d'Art Moderne, Centre Georges Pompidou, Paris, 1975.

—— 'Autres propos de Henri Matisse'. *Macula*, no. 1, 1976.

Freud, Sigmund. *The Interpretation of Dreams*. English edition, London, 1913.

Fry, Roger. 'Henri Matisse in the Luxembourg'. *The Burlington Magazine*, May 1922.

—— 'Henri-Matisse'. *Cahiers d'Art*, 1931.

—— *Henri-Matisse*. London, 1935.
—— Translation of *Poems* by Stéphane Mallarmé. London, 1936.

Gage, John. *Colour in Turner, Poetry and Truth*. London, 1969.
—— 'Colour in History: Relative and Absolute'. *Art History*, vol. 1, March 1978.
Gauguin. *Noa-Noa*. 1901 (Paris, 1954).
—— *Avant et après*. English edition, New York, 1936.
—— *Intimate Journals*. Indiana, 1968.
Gauss, C. E. *The Aesthetic Theories of French Artists from Realism to Surrealism*. Baltimore, 1949.
Gauthier, M. *Othon Friez*. Geneva, 1957.
Gettens, R. J. and Stout, G. L. *Painting Materials*. New York, 1966.
Gide, André. *Les Nourritures Terrestres*. Paris, 1897 (English edition, *The Fruits of the Earth*, London, 1949).
—— 'Promenade au Salon d'Automne'. *Gazette des Beaux-Arts*, December 1905.
Gillet, L. 'Une visite à Henri Matisse'. *Candide*, February 1943.
Ginestier, P. *Montherlant*. Paris, 1973.
Ginsburg, M. 'Art Collectors of Old Russia: the Morosovs and Shchukins'. *Apollo*, December 1973.
Giraudy, D. (ed.). 'Correspondance Henri Matisse–Charles Camoin'. *Revue de l'Art*, no. 12, 1971.
—— *Camoin, sa vie, son oeuvre*. Marseilles, 1972.
Giry, M. 'Matisse et la naissance du fauvisme'. *Gazette des Beaux-Arts*, May 1970.
—— *Fauvism, Origins and Developments*. New York, 1981.
Goethe. *Theory of Colours*, trans. C. L. Eastlake. London, 1840.
Golding, John. *Cubism, a History and an Analysis*. London, 1968.
—— *Matisse and Cubism*. W. A. Cargill Memorial Lectures in Fine Art, University of Glasgow Press, 1978.
Goldwater, R. *Primitivism in Modern Art*. New York, 1938 (revised 1967).
Gombrich, E. H. *In Search of Cultural History*. Oxford, 1969.
—— *The Sense of Order*. Oxford, 1979.
Goodman, N. *Languages of Art*. Indianapolis, 1978.
Göpel, B. and E. (ed.). *Hans Purrmann Schriften*. Wiesbaden, 1961.
Gordon, D. E. *Modern Art Exhibitions 1900–1916*. Munich, 1974.
Goulinat, J. G. 'Les collections Gustave Fayet'. *L'Amour de l'Art*, 1925.
Goupil, F. A. *Traité méthodique et raisonné de la peinture à l'huile*. Paris, 1867.
—— *Manuel général de la peinture à l'huile*. Paris, 1877.
Gowing, L. Introduction to catalogue *Henri Matisse: 64 Paintings*. New York, 1966.
—— Introduction to catalogue *Matisse, 1869–1954*. Hayward Gallery, London, 1968.
—— *Matisse*. London, 1979.
Graham, C. *Vision and Visual Perception*. New York, 1965.
Gray, C. *The Great Experiment: Russian Art 1863–1922*. London, 1962.
Greenberg, C. *Matisse*. New York, 1955.
—— *Art and Culture*. New York, 1961.
—— 'Influences of Matisse'. *Art International*, November 1973.
Gregory, R. L. *The Intelligent Eye*. London, 1970.
Guichard-Meili, J. *Henri Matisse, son oeuvre, son univers*. Paris, 1967 (English edition, *Matisse*, London, 1967).
—— *Matisse: Paper Cut-Outs*. Paris, 1983 (London, 1984).

Haftmann, Werner. *Painting in the Twentieth Century*. 2 vols. New York, 1960.
Hahnloser-Ingold, Margit. 'Matisse und seiner Sammler' in *Henri Matisse*. Kunsthaus Zurich, 1982.
Hamilton, G. H. *Painting and Sculpture in Europe, 1880–1940*. London, 1967.
Hanson, Anne Coffin. *Manet and the Modern Tradition*. Yale, 1977.
Havard, H. *La décoration*. 2nd edn. Paris, 1892.
Henderson, W. O. *The Industrialization of Europe, 1780–1914*. London, 1969.
Herbert, R. L. (ed.). *Neo-Impressionists and Nabis in the Collection of Arthur G. Altschul*. Yale, 1965.
—— *Neo-Impressionism*. New York, 1968.
Hiler, H. *Notes on the Technique of Painting*. London, 1935.
Hilton, A. 'Matisse in Moscow'. *Art Journal*, vol. XXIX, winter 1969–70.
Hobbs, R. *Odilon Redon*. London, 1977.
Hohl, R. 'Matisse und Picasso' in *Henri Matisse*. Kunsthaus Zurich, 1982.
Holten, R. *L'Art fantastique de Gustave Moreau*. Paris, 1960.
Homer, W. I. *Seurat and the Science of Painting*. Cambridge, Mass., 1964.
House, J. P. H. *Claude Monet: His Aims and Methods c.1877–1895*. Ph.D.

thesis, Courtauld Institute of Art, University of London, 1976.
Huyghe, R. 'Matisse and Colour'. *Formes*, vol. 1, January 1930.
—— 'Colour and the Expression of Interior Time in Western Art' in *Colour Symbolism*. Zurich, 1977.
Hyslop, F. E. (ed.). *Henri Evenepoel à Paris lettres choisies, 1892–1899*. Brussels, 1971.

Itten, J. *The Art of Color*. New York, 1961.
Izerghina, A. *Henri Matisse: Paintings and Sculptures in Soviet Museums*. Leningrad, 1978.

Jacobus, J. 'Matisse's Red Studio'. *Art News*, September 1972.
—— *Matisse*. New York, 1972.
Jaffé, H. L. C. *De Stijl*. London, 1970.
Januszczak, Waldemar (ed.). *Techniques of the World's Great Painters*. Oxford, 1980.
Jedlicka, G. *Die Henri-Matisse-Kapelle in Vence*. Frankfurt, 1955.
—— *Der Fauvismus*. Zurich, 1961.
Jirat-Wasiulynski, V. *Gauguin in the Context of Symbolism*. Ph.D. dissertation, Princeton University, 1975.
Johnson, L. *Delacroix*. New York, 1963.
Joyes, C. *et al. Monet at Giverny*. London, 1975.
Judkins, W. *Fluctuant Representation in Synthetic Cubism*. Ph.D. dissertation, Harvard University, 1954.

Kahn, G. 'Au temps de Pointillisme'. *Mercure de France*, April 1924.
Kahnweiler, D-H. *Juan Gris, sa vie, son oeuvre, ses écrits*. Paris, 1946 (English edition, London, 1969).
Kandinsky, W. *Uber das Geistige in der Kunst*. Munich, 1912.
Kawashima, R. *Matisse*. Tokyo, 1936.
Kermode, F. *Romantic Image*. London, 1957 (4th impression, 1972).
Klee, P. *The Thinking Eye*. London, 1961.
Klein, A. B. *Coloured Light: An Art Medium*. London, 1937.
Kochno, B. *Diaghilev and the Ballets Russes*. New York, 1970.
Kostenevich, A. 'La Danse and La Musique'. *Apollo*, December 1974.

Lambert, Susan. *Matisse Lithographs*. London, 1972.
Larson, P. 'Matisse and the Exotic'. *Arts Magazine*, May 1975.
Lassaigne, Jacques. 'Dernières oeuvres de Matisse 1950–1954'. *Verve*, 1958.
—— *Matisse*. Geneva, 1959.
Lefranc et Cie. *Catalogue of Oil Colours*. Paris, 1898.
Lehman, A. *The Symbolist Aesthetic in France 1885–1895*. Oxford, 1950.
Lethève, J. *Daily Life of French Artists in the Nineteenth Century*. London, 1972.
Leymarie, Jean. *Fauvism*. Lausanne, 1959.
—— *Matisse*. Paris, 1970.
Liberman, A. *The Artist in his Studio*. London, 1969.
Lieberman, William S. *Matisse: Fifty Years of his Graphic Art*. New York, 1956.
Linker, K. 'Matisse and the Language of Signs'. *Arts Magazine*, May 1975.
Loevgren, S. *The Genesis of Modernism*. Indiana, 1971.
Loti, Pierre. *Au Maroc*. Paris, 1889 (English edition, trans. E. P. Robins, London, 1892).
Luzi, Mario and Carrà, Massimo. *L'opera di Matisse, 1904–1928*, Classici dell'Arte, vol. 49. Milan, 1971.
Lynton, Norbert. *The Story of Modern Art*. Oxford, 1980.
Lyons, L. 'Matisse: Work, 1914–1917'. *Arts Magazine*, May 1975.

McQuillan, M. 'An Aspect of the Relationship between Art and Theatre'. Ph.D. dissertation, Institute of Fine Art, New York University, October 1979.
Malraux, A. *Museum without Walls*. London, 1967.
Marcel, P. 'Matisse'. *L'Art d'Aujourd'hui*, spring and summer 1924.
Marchiori, G. *Henri Matisse*. Paris, 1967.
Maret, F. *Les Peintres luministes*. Brussels, 1944.
Marois, P. *Des goûtes et des couleurs*. Paris, 1947.
Marx, Roger. *Vuillard*. London, 1946.
Masson, A. 'Conversations avec Henri Matisse'. *Critique*, May 1974.
Mathieu, P-L. *Gustave Moreau*. Oxford, 1977.
Matisse, Henri. *Dessins-Thèmes et Variations*. Preface by Aragon, 'Matisse-en-France'. Paris, 1943.
—— 'De la couleur'. *Verve*, 1945.

BIBLIOGRAPHY

PRINCIPAL EXHIBITION CATALOGUES OF MATISSE'S WORK:

Matisse, 1869–1954. Introduction by Lawrence Gowing. Hayward Gallery, London, 1968.

Henri Matisse: Exposition du Centenaire. Introduction by Pierre Schneider. Grand Palais, Paris, 1970.

Henri Matisse: Dessins et Sculpture. Introduction by Dominique Fourcade. Musée National d'Art Moderne, Centre Georges Pompidou, Paris, 1975.

Henri Matisse: Paper Cut-Outs. Introduction by Jack Cowart. Essays by John Hallmark Neff, Jack D. Flam, and Dominique Fourcade. Technical Appendix by Antoinette King. St Louis Art Museum and Detroit Institute of Arts, 1977.

Henri Matisse 1869–1954: Gravures et Lithographies. Compiled by Margrit Hahnloser-Ingold and Roger Marcel Mayou. Musée d'Art et d'Histoire, Fribourg, 1982.

PRINCIPAL BOOKS ILLUSTRATED BY MATISSE:

Stéphane Mallarmé. *Poésies*. Lausanne, 1932.

James Joyce. *Ulysses*. New York, 1935.

Henry de Montherlant. *Pasiphaé: chant de Minos*. Paris, 1944.

Pierre Reverdy. *Visages*. Paris, 1946.

Marianna Alcaforado. *Lettres portugaises*. Paris, 1946.

Charles Baudelaire. *Les Fleurs du mal*. Paris, 1946.

Charles Baudelaire. *Les Fleurs du mal*. Paris, 1947.

André Rouveyre. *Repli*. Paris, 1947.

Jazz. Paris, 1947.

Pierre de Ronsard. *Florilège des amours de Ronsard*. Paris, 1948

Charles d'Orléans. *Poèmes*. Paris, 1950.

Échos. Texts by Jacques Prévert, André Verdet, and Nazim Hikmet. Paris, 1952.

André Rouveyre. *Apollinaire*. Paris, 1952.

Georges Duthuit. *Une fête en Cimmérie*. Paris, 1963.

John-Antoine Nau. *Poésies antillaises*. Paris, 1972.

Henri de Montherlant. *Pasiphaé*. Paris, 1981.

Mayer, R. *The Artist's Handbook of Materials and Techniques*. London, 1962.

Merrifield, M. P. *Original Treatises on the Arts of Painting*. 2 vols. London, 1849.

Meyer, F. 'Matisse und die Amerikaner' in *Henri Matisse*. Kunsthaus Zurich, 1982.

Monod-Fontaine, I. *Oeuvres de Henri Matisse (1869–1954)*. Musée National d'Art Moderne, Centre Georges Pompidou, Paris, 1979.

Morice, C. 'Le Salon des Indépendants'. *Mercure de France*, March–April 1906.

Moulin, R-J. *Henri Matisse, dessins*. Paris, 1968.

Mras, G. P. *Eugène Delacroix's Theory of Art*. Princeton, 1966.

Muller, J-E. *Le Fauvisme*. Paris, 1956.

Musée Cantini. *Moreau, Gustave et Ses Élèves*. Marseilles, 1962.

Musée National d'Art Moderne, Centre Georges Pompidou. *Paris–Moscou 1900–1930*. Paris, 1979.

Neff, John Hallmark. 'Matisse's Forgotten Stained Glass Commission'. *The Burlington Magazine*, 1972.

—— 'An early Ceramic Triptych by Henri Matisse'. *The Burlington Magazine*, December 1972.

—— 'Matisse and Decoration, 1906–1914'. Ph.D. dissertation, Harvard University, 1974.

—— 'Matisse and Decoration'. *Art Magazine*, May 1975.

—— 'Matisse and Decoration: The Shchukin Panels'. *Art in America*, July–August, 1975.

Negri, R. *Matisse e i Fauves*. Milan, 1969.

Nochlin, L. *Realism*. London, 1971.

—— 'The Imaginary Orient'. *Art in America*, May 1983.

Nordenfalk, C. 'Camouflage und Kubismus' in *Kunstgeschichte Gesellschaft*. Berlin, 1980.

Olivier, F. *Picasso et ses amis*. Paris, 1933 (English translation, London, 1964).

Oppler, E. C. 'Fauvism Re-examined'. Ph.D. dissertation, Columbia University, New York, 1969.

Orienti, S. *Henri Matisse*. Florence, 1971.

Osborne, H. *Abstraction and Artifice in Twentieth-Century Art*. London, 1979.

Pach, W. *Renoir*. New York, 1960.

Paladilhe, J-P. *Gustave Moreau*. London, 1972.

Physical Society. *Report on Colour Terminology*. London, 1948.

Piot, R. *Les Palettes de Delacroix*. Paris, 1931.

Pissarro, C. *Letters to his Son Lucien*. London, 1943.

Pleynet, M. 'Le Système de Matisse' in *L'Enseignement de la peinture*. Paris, 1971.

Pollock, G. *Millet*. London, 1977.

Polunin, V. *The Continental Method of Scene Painting*. London, 1927.

Portal, F. *Des couleurs symboliques*. Paris, 1837.

Prache, A. 'Souvenirs d'Arthur Guéniot sur Gustave Moreau et sur son enseignement à l'École des Beaux-Arts'. *Gazette des Beaux-Arts*, April 1966.

Purrmann, Hans. 'Aus der Werkstatt Henri Matisse'. *Kunst und Kunstler*, February 1922.

Puy, J. *L'Effort des peintres modernes*. Paris, 1933.

—— 'Souvenirs'. *Le Point*, July 1939.

Ratcliffe, R. W. 'Cézanne's Working Methods and their Theoretical Background'. Ph.D. dissertation, Courtauld Institute of Art, University of London, 1961.

Rawlence, C. *Matisse and Oriental Art*. MA report, Courtauld Institute of Art, University of London, 1969.

Read, H. 'Hommage à Henri Matisse. Le Sculpteur'. *XXᵉ Siècle*, 1970.

Rebérioux, M. *La République radicale? 1898–1914*. Paris, 1975.

Reff. T. 'Copyists in the Louvre'. *Art Bulletin*, December 1964.

—— 'Meditations on a Statuette and Goldfish'. *Arts Magazine*, 51, 1976.

Reiff, R. 'Matisse and Torii Kiyonaga'. *Art News*, February 1981.

Reverdy, P. 'Matisse dans la lumière et le bonheur'. *Verve*, 1958.

Rewald, J. *Pierre Bonnard*. New York, 1948.

—— 'Seurat: The Meaning of the Dots'. *Art News*, April 1949.

—— *Paul Cézanne*. New York, 1950.

—— *The History of Impressionism*. New York, 1961.

—— *The History of Post-Impressionism*. New York, 1962.

—— *Camille Pissarro*. London, 1963.

Rich, D. C. *Seurat and the Evolution of 'La Grande Jatte'*. Chicago, 1969.

Rilke, R. M. *Rodin*. London, 1946.

Ritchie, A. C. *Édouard Vuillard*. New York, 1954.

Romm, A. *Matisse, a Social Critique*. New York, 1947.

Rood, O. N. *Modern Chromatics*. New York, 1879 (reprinted 1973).

Rookmaaker, H. R. *Gauguin and Nineteenth-Century Art Theory*. Amsterdam, 1959.

Rosenthal, D. A. *Orientalism: The Near East in French Painting 1800–1880*. Rochester, 1982.

Rouault, G. *Sur l'art et sur la vie*. Paris, 1971.

Rubin, W. *Dada and Surrealist Art*. New York, 1969.

—— (ed.) *Picasso in the Collection of the Museum of Modern Art*. New York, 1972.

—— (ed.) *Cézanne: The Late Work*. London, 1977.

—— (ed.) *Pablo Picasso, a Retrospective*. Museum of Modern Art, New York, 1980.

Ruhemann, H. and Kemp, E. M. *The Artist at Work*. London, 1951.

Runge, P. O. *Schriften—Fragmente—Briefe*. Berlin, 1938.

Rusakov, Y. A. 'Matisse in Russia in the Autumn of 1911'. *The Burlington Magazine*, May 1975.

Ruskin. *Elements of Drawing*. London, 1857 (reprinted 1907).

Russell, J. *The World of Matisse, 1869–1954*. New York, 1969.

Salter, E. *The Lost Impressionist: A Biography of John Peter Russell*. London, 1976.

San Lazzaro. 'Découpages de Henri Matisse'. *XXᵉ Siècle*, 1954.

Sauret, A. *Portraits by Henri Matisse*. Monte Carlo, 1954.

Schapiro, M. 'Matisse and Impressionism'. *Androcles*, February 1932.

Scharf, A. *Art and Photography*. London, 1968.

Scheiwiller, G. *Henri Matisse*. Milan, 1933.

Schneider, P. Introduction to catalogue *Henri Matisse: Exposition du Centenaire*. Grand Palais, Paris, 1970.

—— 'Galeries Nationales du Grand Palais'. *La Revue du Louvre*, XXᵉ année, 1970.

—— 'Matisse's Sculpture: the invisible revolution'. *Art News*, March 1972.

—— 'Matisse à Marseille'. *L'Express*, 7 July 1974.

—— 'The Striped Pajama Icon'. *Art in America*, July–August 1975.

—— 'Puvis de Chavannes: The Alternative'. *Art in America*, May–June 1977.

—— 'Matisse und das Goldene Zeitalter' in *Henri Matisse, Das Goldene Zeitalter*. Kunsthalle Bielefeld, 1981.

—— '"The Figure in the Carpet", Matisse und das Dekorative' in *Henri Matisse*. Kunsthaus Zurich, 1982.

Scruton, R. *Art and Imagination*. London, 1974.
Selz, J. *Matisse*. Paris and New York, 1964.
Selz, P. *German Expressionist Painting*. Berkeley, 1957.
Sembat, M. *Henri Matisse*. Paris, 1920.
Serusier, P. *L'ABC de la peinture*. Paris, 1921.
Seuphor, M. *Piet Mondrian: Life and Work*. London, 1956.
Shattuck, R. *The Banquet Years*. London, 1969.
Shiff, R. A. *Impressionist Criticism, Impressionist Color and Cézanne*. Ph.D. dissertation, Yale University, 1973.
Short, R. *Dada and Surrealism*. London, 1980.
Signac, P. *D'Eugène Delacroix au Néo-Impressionnisme*. Paris, 1899 (reprinted, ed. Françoise Cachin, Paris, 1964).
Spalding, F. *Roger Fry: Art and Life*. London, 1980.
Starkie, Enid. *Baudelaire*. London, 1957.
Stein, G. 'Henri Matisse—Pablo Picasso'. *Camera Work*, August 1912.
—— *The Autobiography of Alice B. Toklas*. New York, 1933.
Stein, L. *Appreciation: Painting, Poetry and Prose*. New York, 1947.
Stevens, Mary Anne (ed.). *The Orientalists: Delacroix to Matisse*. Exhibition catalogue, Royal Academy of Art, London, 1984.
Stiles, W. S. 'Colour Vision: a Retrospect'. *Endeavour*, January 1952.
Strauss, E. 'Treatment of Light and Colour in the Oriental Painting of the Nineteenth and Twentieth Centuries' in *World Cultures and Modern Art*. Munich, 1972.
Sutter, J. *et al. Les Néo-Impressionnistes*. Neuchâtel, 1970.
Sutton, D. *André Derain*. London, 1959.
Swane, L. *Henri Matisse*. Stockholm, 1944.
Sylvester, D. 'The Sculptures of Matisse'. *The Listener*, 29 January 1953.

Tériade, E. 'Matisse Speaks'. *Art News Annual*, 1951.
Terrasse, A. 'La Force de l'instant'. *La Nouvelle Revue Française*, July 1970.
Thompson, D. V. *The Materials of Medieval Painting*. London, 1936.
Tisdall, C. and Bozzola, A. *Futurism*. London, 1977.
Tormey, A. *The Concept of Expression*. Princeton, 1971.
Trapp, F. A. 'The Paintings of Henri Matisse: Origins and Early Development, 1890–1917'. Ph.D. dissertation, Harvard University, 1952.
—— 'Art Nouveau Aspects of Early Matisse'. *Art Journal*, autumn 1966.
—— 'Form and Symbol in the Art of Matisse'. *Arts Magazine*, May 1975.
Tucker, W. 'The Sculpture of Matisse'. *Studio International*, July–August 1969.
—— 'Four Sculptors. Part 3, Matisse'. *Studio International*, September 1970.
—— *The Language of Sculpture*. London, 1974.

Vachon, M. *W.Bouguereau*. Paris, 1900.

Vallier, D. 'Matisse revu, Matisse à revoir'. *La Nouvelle Revue Française*, July 1970.
Van Gogh. *The Complete Letters of Vincent van Gogh*. 3 vols. London, 1959.
Van Hook, L. B. 'Robert Motherwell's Mallarmé's Swan'. *Arts Magazine*, January 1983.
Vauxcelles, L. *Le Fauvisme*. Geneva, 1958.
Verdet, A. *Prestiges de Matisse*. Paris, 1952.
Verneilh, B. de. 'Maximilien Luce et Notre-Dame-de-Paris'. *L'Oeil*, March 1983.
Verve: vol. IV, no. 13, 1945; vol. VI, nos. 21 and 22, 1948; vol. VII, nos. 27 and 28, 1952; vol. IX, nos. 35 and 36, 1958.
Vildrac, C. 'Henri Matisse'. *Das Kunstblatt*, July 1921.
Vlaminck, M. *Dangerous Corner*. London, 1961.

Waldemar, G. *Henri Matisse, dessins*. Paris, 1925.
Watkins, N. *Matisse*. Oxford, 1977.
—— 'A History and Analysis of the Use of Colour in the Work of Matisse'. M.Phil. thesis, Courtauld Institute of Art, University of London, 1979.
Wattenmaker, R. J. *The Fauves*. Art Gallery of Ontario, Toronto, 1975.
—— *Puvis de Chavannes and the Modern Tradition*. Art Gallery of Ontario, Toronto, 1975.
Webster, J. C. 'The Technique of Impressionism, a Reappraisal'. *College Art Journal*, vol. IV, no. 4, November 1944.
Wehlte, K. *The Materials and Techniques of Painting*. New York, 1975.
Weightman, J. *The Concept of the Avant-Garde*. London, 1973.
Wein, J. A. 'Delacroix's Street in Mekness and the Ideology of Orientalism'. *Arts Magazine*, June 1983.
Welsh-Ovcharov, B. *Vincent van Gogh: His Paris Period 1886–1888*. The Hague, 1976.
Wheeler, M. *The Last Works of Henri Matisse: Large Cut Gouaches*. New York, 1961.
Whitely, J. *Ingres*. London, 1977.
Whitford, F. *Expressionism*. London, 1970.
Wildenstein, D. *Monet vie et oeuvre: catalogue raisonné de l'oeuvre peint*. Paris, 1974.
Wilenski, R. H. *Modern French Painters*. London, 1940.
Wittgenstein, L. *Remarks on Colour*. Oxford, 1977.
Wollheim, R. *Art and its Objects*. New York, 1968.
Wright, G. *France in Modern Times*. Chicago, 1974.

Zeldin, T. *France 1848–1945*. 2 vols. Oxford, 1973 and 1977.
Zervos, C. *Henri Matisse: Cahiers d'Art*. Paris, 1931.
—— 'Peines d'esprit et joies de Matisse'. *Cahiers d'Art*, 1945–6.
Zoubova, M. *Dessins de Henri Matisse*. Moscow, 1977.

List of Plates

All pictures are oil paintings by Matisse unless otherwise stated.

Index

Figure numbers are given in *italic* and refer to both illustrations and captions.